Women in the Middle Ages and the Renaissance

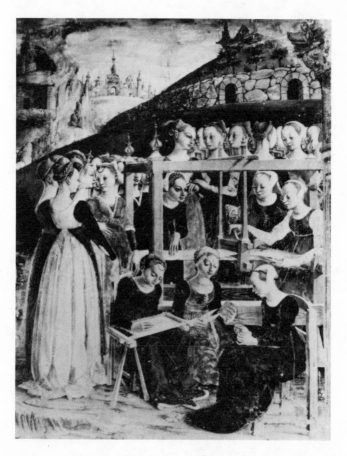

Detail of weaving women from the celestial zone of the March field of the Sala dei Mesi frescoes in the Palazzo Schifanoia, Ferrara. By Francesco del Cossa, c. 1470. *By permission of Gabinetto Fotografico Musei Civici D'Arte Antica, Ferrara.*

Women in the Middle Ages and the Renaissance

Literary and Historical Perspectives

Edited, with an Introduction, by
MARY BETH ROSE

SYRACUSE UNIVERSITY PRESS

The paper used in this publication meets the minimum requirements of American National Standard for Information Sciences—Permanence of Paper for Printed Library Materials, ANSI Z39.48-1984. ∞™

Janel M. Mueller's "Autobiography of a New 'Creatur': Female Spirituality, Selfhood, and Authorship in *The Book of Margery Kempe*" first appeared in *The Female Autograph*, edited by Donna C. Stanton, 1984, and is reprinted with the permission of the *New York Literary Forum*.

Library of Congress Cataloging-in-Publication Data

Main entry under title:

Women in the Middle Ages and the Renaissance.

Includes index.
 1. Women—History—Renaissance, 1450–1600—Addresses, essays, lectures. 2. Women—History—Middle Ages, 500–1500—Addresses, essays, lectures. 3. Women in literature—Addresses, essays, lectures. 4. European literature—Renaissance, 1450–1600—History and criticism—Addresses, essays, lectures. 5. European literature—Women authors—History and criticism—Addresses, essays, lectures. 6. Literature, Medieval—History and criticism—Addresses, essays, lectures.
 I. Rose, Mary Beth.
HQ1148.W66 1985 305.4′09′02 85-22153

ISBN 0-8156-2351-8
ISBN 0-8156-2352-6 (pbk.)

Manufactured in the United States of America

Contents

Illustrations

Contributors

MARY ELLEN LAMB is Associate Professor at Southern Illinois University. She has published on Shakespeare, Renaissance women, and Renaissance manuscripts in such journals as *RES, ELR,* and the forthcoming *Shakespeare Survey.* She has recently received an NEH grant to work at The Newberry Library on her book on Renaissance women as writers and readers.

CAROLE LEVIN is Assistant Professor of History and Coordinator of Women's Studies at State University of New York College at New Paltz. She has published articles both on propaganda and on images of women in Tudor England in various periodicals, including the *Sixteenth Century Journal* and the *International Journal of Women's Studies* and in the essay collection, *Silent But for the Word.*

LEAH S. MARCUS is Professor of English at the University of Wisconsin-Madison. She has published *Childhood and Cultural Despair* (Pittsburgh: University of Pittsburgh Press, 1978) and articles on Herrick, Jonson, Milton, Herbert, Medieval drama, masque structure, and civic entertainments. Her second book, *The Politics of Mirth,* is forthcoming, and she is at work on a third, *Shakespeare and the Unease of Topicality,* which will incorporate an expanded discussion of Queen Elizabeth's self-presentations and Shakespeare's plays.

WILLIAM MONTER is Professor of History at Northwestern University. Joint author of the American Historical Association's 1980 pamphlet, *Recent United States Scholarship on the History of Women,* he has also published "The Pedestal and the Stake" in *Becoming Visible: Women in European History* (Boston, 1977) and "Women in Calvinist Geneva 1550–1800" in *Signs* (1980). His current research topic is the regulation of sexual morality by the Mediterranean Inquisitions.

JANEL M. MUELLER is Professor in the Department of English, the Committee on General Studies in the Humanities, and the Committee on Art and Design at the University of Chicago. Her commitment to integrating feminism with

professional concerns began with service on various committees, especially MLA's Committee on Academic Freedom, which she chaired from 1974 to 1976. Most recently this commitment has given direction to her critical and scholarly work, including a rereading of Sophocles' *Antigone* and a monograph in progress on *Milton and the Ontology of Desire*.

MARY BETH ROSE is Director of the Center for Renaissance Studies at The Newberry Library. She has contributed articles and reviews on English Renaissance drama and Renaissance women to *ELR, Renaissance Drama, Shakespeare Quarterly, Shakespeare Studies,* and *Review.* She is currently completing a study of love and sexuality in English Renaissance drama.

TILDE SANKOVITCH is Associate Professor in the Department of French and Italian, Northwestern University. Her areas of research and publication are French Medieval and Renaissance literature. She has been director of, and has taught in, the Women's Studies program at Northwestern. She is currently working on sixteenth-century French women authors, examining the problems which these writers face as they prepare to enter into the realm of humanist learning and creativity.

JANE TIBBETTS SCHULENBURG is Professor of History in the Division of University Outreach at the University of Wisconsin-Madison. She has published several articles on women in Medieval society and the church and is currently completing a book, *Forgetful of Their Sex: Female Sanctity and Deviancy.*

MADELON SPRENGNETHER teaches at the University of Minnesota, where she is Professor of English. She has published articles (under the name Madelon S. Gohlke) on several Renaissance authors, including Spenser, Nashe, Lyly, and Shakespeare. She is co-editor, with Shirley Nelson Garner and Claire Kahane, of *The (M)other Tongue: Essays in Feminist Psychoanalytic Interpretation* and is currently at work on a book treating the representation of femininity in Shakespeare.

ELISSA WEAVER is Associate Professor of Italian, University of Chicago, and president of the American Boccaccio Association. A scholar of Italian Renaissance language and literature, she has published primarily on Ariosto, Boiardo, Berni, and the epic-chivalric poetry tradition. She is presently working on Italian convent theater and has just completed an edition of a sixteenth-century spiritual comedy, Sister Beatrice del Sera's *Amor di virtù*.

MERRY E. WIESNER is Assistant Professor of History at the University of Wisconsin-Milwaukee. She taught for six years at Augustana College in Rock

Island, Illinois, where she established the women's studies program. She has written several articles on working women and compiled an extensive bibliography on women in the sixteenth century for the Center for Reformation Research bibliography series. Her book, *Working Women in Renaissance Germany*, is forthcoming from Rutgers University Press.

Acknowledgments

*T*HIS BOOK emerges from "Changing Perspectives on Women in the Renaissance," a conference sponsored by the Center for Renaissance Studies at The Newberry Library in 1983; its interdisciplinary focus, as well as its inclusion of scholarship that examines original Medieval and Renaissance documents and attempts innovative approaches to its subject matter, all reflect the aims of the Center. I am grateful to my former colleague, John Tedeschi, who, when he was Director of the Center, encouraged this project. I would also like to thank Richard Brown, Academic Vice President of The Newberry, for his encouragement and support. Although the authors are responsible for any mistakes that remain, research assistants Jean Pedersen and Fran Dolan have saved us all from many errors. Their diligence, tact, perseverance, and skill have helped to raise the quality of the essays, and I, as always, am grateful to them both.

Chicago MBR
Spring 1985

Introduction

MARY BETH ROSE

HY DO WE know so little about women in the Middle Ages and the Renaissance? Until relatively recently, we had never really asked. Because female participation in Western cultural history became increasingly visible and articulate in the eighteenth and nineteenth centuries, most scholarship on the subject of women has focused quite naturally on the modern periods. Beyond Queen Elizabeth I, Christine de Pizan, Vittoria Colonna, and a few other isolated, exceptional figures, Medieval and Renaissance women seemed vague, shadowy presences, existing only on the periphery of history and in the margins of literary culture. But the study of women in the Middle Ages and Renaissance has for several years been experiencing a surge of vitality. A burgeoning amount of rich, interesting and important work is expanding the theoretical boundaries and augmenting the historical perspective of feminist studies by identifying new areas of analysis and interpretation and seeking to recover a lost past.

The essays in the present volume adhere to the purpose of the conference where the majority of them originated. "Changing Perspectives on Women in the Renaissance," which was sponsored by the Center for Renaissance Studies at The Newberry Library in May 1983, was organized on the assumption that the time was ripe to build on the findings of past scholarship and to identify and reformulate some major issues crucial to the study of Medieval and Renaissance women. The work of the pioneering feminist historian Joan Kelly makes clear that a comprehensive study of female identity and experience in any period requires a multi-faceted focus on predominant sexual ideologies, on women's social, economic, political, cultural, and religious activities, and on comparative studies of the regulation

of male and female sexuality.[1] In attempting to clarify and refine such large and varied goals, no single gathering or volume can hope to be exhaustive or comprehensive. Yet the diversity and range of the essays compiled in this collection reflect the editor's belief that a study of the full complexity of women's experience in the Middle Ages and the Renaissance, as well as the reassessment of those periods from the point of view of women, require both an interdisciplinary perspective and the drawing together of intellectual approaches often construed as mutually exclusive. Consequently the essays study the effect of sexual ideology on women, the representation of women in literature written by men, the role of women in education, the economy, and the Church, the status of women in politics and the law, and the participation of women in literary culture as patrons, translators, and writers. Archival work is juxtaposed with psychoanalytic theory, religious history with new criticism and political analysis, and the study of classic texts like Shakespeare with the examination of the unpublished works of obscure and forgotten women. It is hoped that, collected as a group, these diverse topics and perspectives will both enrich and enhance one another and constitute a significant step toward a fuller, deeper, and more nuanced view of Medieval and Renaissance women and the cultures in which they lived.

The essays attempt to convey the excitement of discovery generated by asking new questions of familiar material and by unearthing material that was, in many cases, entirely unexplored. Working toward the first end scholars have been seeking to establish the contours of Medieval and Renaissance sexual ideologies as these prescriptive systems are inscribed in moral, legal, medical, religious, and political writings as well as in literature, and have been re-examining familiar figures and texts from this point of view.[2]

Studying documents that idealize with uncanny reiteration chastity, modesty, silence, and obedience as desirable and necessary female traits makes readily apparent how pervasive and deeply ingrained these assumptions are in Medieval and Renaissance forms of expression.[3] In her essay Madelon Sprengnether analyzes an emotional substructure to these patriarchal ideas from a psychoanalytic point of view and argues that negative responses to femininity shape the structure of Shakespearean tragedy, while Jane Schulenburg explores the ways in which the misogynistic loathing of the body expressed so strongly in patristic writings may have influenced the actual behavior of nuns in the early Middle Ages. The study of sexual ideology that

idealizes subdued, modest female behavior also clarifies why it is that the few Medieval and Renaissance women whose lives and works stand out enough to be known to us were exceptional, often isolated and anomalous figures in their own culture.4 The essays by Carole Levin and Leah Marcus examine related ways in which patriarchal sexual ideology informs the consciously constructed public identity of one exceptional Renaissance woman, Elizabeth I, and the creation of classic Renaissance texts by Shakespeare and John Foxe.

The recognition of new meanings in familiar texts has been accompanied by an equally essential development in the study of Medieval and Renaissance women: the recovery of a lost past. Two major directions in this rehabilitative research have become clear. First, rather than focusing only on exceptional women, the aims of women's history also join those of the new social history in the effort to illuminate the lives of ordinary and obscure people in past centuries. The study of such evidence as legal cases, property transactions like dowries, religious treatises, records of guild organizations, and ecclesiastical court documents reveals how the lives of women affect or are affected by social issues like family, class, education, and work.5 In this volume essays by Merry Wiesner and William Monter demonstrate that religious movements and socioeconomic developments in the Middle Ages and the Renaissance are viewed in a new light when gender becomes the category of analysis by which evidence is evaluated.

A second major development in the reconstruction of a lost history is the discovery, editing, and interpretation of texts written by women themselves, a movement that is proceeding at a vigorous pace.6 While recognizing the importance of exploring the psychic roots of sexism in fear and the social roots in the need for traditional order and stability, the investigation and interpretation of female-authored texts emphasizes that aspect of women's experience *as women* which constitutes a unique perspective. For reasons that should be apparent, this scholarship often focuses on literary women who are usually educated and upper-class (although not always, which Janel Mueller's essay on the extraordinary figure of Margery Kempe shows). As Elissa Weaver's treatment of sixteenth-century Tuscan convent drama demonstrates, the linguistic skills and skills of historical extraction that characterize scholarship about the Medieval and Renaissance periods have been bringing to light documents by women that were almost completely unknown to us. And essays by

Mary Lamb, Tilde Sankovitch, and myself combine a focus on ideology and gender to reveal problems of authorship that are unique to literary women in the Renaissance.

Taken as a group, then, these essays reflect major developments in scholarship about Medieval and Renaissance women. Along with its representative quality this collection also reconsiders and works toward reformulating some of the basic issues in the study of Medieval and Renaissance women. The essays that focus on women writers and translators show how the description and narration that traditionally accompany the excavation of documents are now branching out into interpretation and analysis of the complex issues raised by these texts. What were the conditions that caused or allowed a Medieval or Renaissance woman to assert herself as an exception to her sex by writing? What was the price of being an exception? Could women find ways to reconcile their identities as writers with their sexual identities? Do texts written or translated by women reveal a complicity with patriarchal sexual assumptions? What are the strategies used by women writers for disregarding or subverting those assumptions? How do gender and sexual ideology contribute to the shaping of literary genres themselves? While none of the essays about women writers directly addresses the issue of canonization, the analyses of previously obscure or forgotten texts point away from concentration on the masterpiece and toward a focus on the text as a symbolic and/or representative cultural form.

In her seminal essay "Did Women Have a Renaissance?" Joan Kelly makes the crucial point that traditionally defined periods of history can look very different when viewed from the perspective of women.[7] Many of the essays in this collection contribute both to the elucidation and the reformulation of this central idea. Trying to trace the origins of the oppression of modern women, Kelly argues that the division of life into private and public spheres which accompanied the formation of the secular nation-state in the Renaissance restricted the freedom that at least aristocratic women enjoyed in the later Middle Ages. This conception of the opposition between public and private life has proved very useful to the analysis of the situation of women and informs many of the essays in this book. Yet several scholars have disputed Kelly's location of women's loss of stature in the Renaissance, as well as her interpretation of Medieval cultural phenomena like courtly love as enhancing female freedom and power.[8] A strong sense, reflected in this volume, emerged from the conference at The

Newberry that evaluating Medieval and Renaissance women solely in terms of relative freedom and oppression is finally inadequate; as Natalie Davis has argued, there is always both gain and loss in the process of change.[9] Indeed the logical implications of Kelly's own insight about the centrality of gender as a category of analysis demands a re-focused discourse. How, exactly, did women participate in the economic, political, religious, and cultural life of the Middle Ages and the Renaissance? In what ways did women contribute to processes of change? What is the relationship between prescriptive ideological literature and the lives of actual women insofar as these can be reconstructed? The bitter legacy of inequality and exclusion must always be part of such an inquiry; yet injustice and its consequences should be treated as one issue among a host of complicating questions that are crucial to investigate when studying the rich variety of women's lives and accomplishments.

The recognition of these issues in scholarship about Medieval and Renaissance women parallels a development in the study of women in the modern centuries which, to paraphrase one critic, constitutes a swerve away from male bias and toward female experience as the center of analysis.[10] Consequently the essays in the first part of this volume are concerned with the effects of patriarchal sexual ideology on women's lives and on the creation of classic Medieval and Renaissance texts by men, while the second group of essays concentrates on analyses of texts written by women. Yet it would be contrary to the intention of this collection if "female experience" were interpreted simplistically. Just as a uniform focus on inequality and victimization (or their opposite—unquestioning celebration or idealization of women's achievements) can distort the study of women, so polarization of discussion into an antithesis of "male vs. female" would reduce the importance of the inquiry and diminish its complexity. Rather female experience is conceived as a multi-faceted interplay between men and women and the assumptions that order their individual lives, cultural artifacts, and collective institutions in diverse, often unpredictable ways.

Merry E. Wiesner's study, "Women's Defense of their Public Role," illustrates the movement of current feminist scholarship toward the formulation of complexity. Building on the pioneering work of such historians as Kelly and Davis, Wiesner takes up the question of whether or not female freedom was decreased or augmented in the Renaissance and attempts to re-define it by broadening

the level of inquiry. She accepts the idea that an increasing disjunction between public and private life worked to restrict female activity to the domestic sphere during the Renaissance. But she moves beyond the study of male definitions and limitations on female freedom as they appear in law codes, sermons, guild restrictions, prescriptive treatises, and literary models to examine evidence that documents the actual responses of women to their condition.

Wiesner argues that, for women, freedom meant the ability to participate in public life. In a broadly sweeping view of "the contraction of women's public role" from the thirteenth through the seventeenth centuries, she surveys European women's reactions to law codes regulating their control over financial and property arrangements, the increasing restrictions placed on their ability to work, and the obstacles facing their attempts to participate in intellectual and literary life. Wiesner's evidence demonstrates not only that women consistently and explicitly defended their right to a public role, but also that they devised strategies enabling them to continue to participate in what was now construed as public life.

Wiesner's analysis suggests the richness and variety of female response by highlighting, for example, the difference between managing survival and attaining prestige, between upper-class women who sought education and cultural accomplishments and middle- or lower-class women who sought the right to work. The range of her investigation indicates the discrepancy between theoretical and actual restrictions on women: despite the articulated limitations placed on their behavior, they continued to work, to buy and sell goods, to own property, and to write. Yet she also recognizes the constricting effects that theoretical restrictions can and do have on actuality. Compelled to defend their activities, women were often ironically forced into anti-feminist postures as a means of remaining in public life. However, after listening, as she says, to women's voices in the documents she examines, Wiesner concludes that the beginnings of a modern feminist awareness began to emerge in the Renaissance.

The sweep of Wiesner's survey introduces a variety of problems that are treated in the papers that follow. In "The Heroics of Virginity: Brides of Christ and Sacrificial Mutilation," Jane Schulenburg analyzes cases of women committing self-mutilation and/or suicide when defending their virginity against sexual assault in the early Middle Ages. Reviewing several dramatic, often bizarre instances of self-mutilation in defense of chastity recorded in the saints' lives of the

period, Schulenburg explores the possibility that the self-disfiguring acts of martyrdom valorized in these accounts were real. She shows that such acts appear less grotesque and improbable when we consider the striking emphasis on the value of absolute sexual purity that the early Church fathers shared with pagan Germanic society, and which they sought to instill in women by stressing the aggressive perseverance required to maintain virginity, as well as the great rewards available to those who succeed in doing so.

Examining patristic writings, papal pronouncements, and canons of Church councils on the subject, Schulenburg argues that the early Medieval Christian "didactic campaign" encouraging the heroic defense of virginity must be viewed in its contemporary context of the continual invasions that constituted the "violence and disorders" of early Medieval society. In its determined exploration of a phenomenon that is at once horrible and peculiar, violent, marginal, and odd, Schulenburg's essay demonstrates the negative forms that female self-assertion can take when constrained and determined by patriarchal sexual ideology. Connecting early Christian conceptions of female sexuality to the catastrophe of the early Medieval invasions, the essay also traces a legendary female behavior pattern (that is, virgin self-sacrifice) to one of its origins in a convergence of ideology and historical circumstance.

William Monter provides some equally intriguing suggestions about the possible pragmatic effects of male views of women on women's lives. In "Women and the Italian Inquisitions," he observes that the psychological/anthropological and statistical dimensions of the new social history have given rise to a renaissance of scholarship about the Spanish, Roman, and Portuguese Inquisitions, but that the category of gender has not yet been introduced into the analysis. His essay makes what he describes as a "preliminary reconnaissance" in this direction.

Breaking down by gender data compiled from the various branches of the Roman Inquisition, Monter discovers some surprising discrepancies between men and women, in terms of both accusation and punishment for various crimes. Among offenses condemned by the Inquisition, he considers comparison by gender among Judaizing, Protestantism, blasphemy, bigamy, and illicit magic, analyzing differences both by time period—early and late sixteenth century vs. the seventeenth century—and by location—Sicily vs. Venice, Naples, and the Friuli. Monter also introduces evidence from individual cases

into his statistical analysis. He concludes by suggesting that the Italian Inquisitions did not, as a whole, take women offenders very seriously, in parallel cases often employing much less drastic measures against female offenders than those suffered by their male counterparts. Despite their obvious determination to control autonomous female religious figures, the Inquisitors' patterns of accusation and punishment demonstrate their belief that female offenders were primarily foolish rather than dangerous, "pawns of male figures [that] . . . need not be punished with undue severity."

Like Jane Schulenburg's account of female self-sacrifice, Monter's essay suggests the ways in which women's lives can be construed as artifacts of the patriarchal imagination, a condition which, rhetorically, crosses the border between fiction and nonfiction. Madelon Sprengnether's psychoanalytic approach to the male-centered world of Shakespearean tragedy—"Annihilating Intimacy in *Coriolanus*"—also illuminates the sexual and spiritual position of woman as it appears to the outsider; that is, as femininity appears from the point of view of a doomed male hero whose alienation can be equated with the intense ambivalence he feels toward woman as the perceived source of both life and death.

Sprengnether shows that the association of women with ambiguity and involvement in contradiction becomes, in Shakespearean tragedy, a dramatic projection of the male hero's destructive ambivalence toward the feminine. Fearing to incur loss of masculine selfhood in the union with a woman that he nevertheless desires, the tragic hero either represses the awareness of his vulnerability to the feminine or avoids heterosexual relationships altogether, seeking to establish absolute sexual differentiation by bonding with a male rival. In either case he submits inevitably to the destructive union he had attempted to avoid. Sprengnether argues that *Coriolanus* dramatizes both of these patterns of what she calls "annihilating intimacy." This late play (1608), with its formidable mother figure, therefore starkly reveals an inexorable emotional logic at the heart of all Shakespearean tragedy: union with a woman is dangerous or fatal to the hero. Sprengnether frames her argument—that femininity in Shakespeare's tragedies is viewed as opposing itself to civilization—in terms of the psychoanalytic conception that an infant's first experience is union with its mother, from whom it must undergo a subsequent process of separation and individuation. Masculine identity is therefore not given, but achieved precariously, always at risk of becoming lost in an original feminine matrix.

The universalizing tenets of the psychoanalytic myth of development provide a sense of continuity by reminding us of the ways in which certain structures of human needs and emotions endure while our mental formulations of them change. In "John Foxe and the Responsibilities of Queenship," Carole Levin shows how the influential Protestant historian's mixed feelings about Queen Elizabeth I derive, like the ambivalence of Shakespearean tragic heroes, from a sense of the conflicting claims of women's political, sexual, and spiritual roles. Levin observes that one of the major functions of Foxe's influential book, *Acts and Monuments* (1563), was to instruct Queen Elizabeth in her duty of defending the true reformed Church. A returned Marian exile who remained unsatisfied with the Anglican Church settlement, Foxe did not want either to jeopardize the Protestant cause or to risk danger by openly criticizing the Queen. Levin argues that Foxe exhorted Queen Elizabeth indirectly in his book by presenting examples of the destinies of earlier English queens.

In her examination of Foxe's portrayal of Medieval and Tudor queens, Levin illustrates the ways in which Foxe's providential view of Elizabeth as an instrument of God chosen to usher in a new age of faith was qualified by the fact that his monarch was a woman. She places *Acts and Monuments* in the context of the debate about female rule that went on throughout the sixteenth century. Surveying the works of, among others, Juan Vives, Thomas Elyot, John Knox, John Aylmer, and John Jewel, Levin shows how Foxe's view of female rule as embodied in his account of queens perpetuated the ideas of these commentators. Although, unlike John Knox, he did not directly oppose female rule, Foxe did, like Aylmer and Jewel, view the requisite, active virtues of a monarch (courage, strength, leadership) as contrasting with the traditional, passive virtues of femininity (silence, modesty, obedience). As Levin shows, the distortions of actual history in Foxe's accounts of earlier queens reveal his ambivalence: he envisions Elizabeth's reign as a gift from God that is nevertheless perpetually fragile and endangered.

Leah Marcus's essay, "Shakespeare's Comic Heroines, Elizabeth I, and the Political Uses of Androgyny," continues discussion about the combination of unconventional sexuality and sovereign power embodied in the Virgin Queen. Using the approach of what is often termed the "new historical" literary criticism, Marcus is interested in the ways in which literature subverts or enhances political power. In her essay she explores the concept of androgyny as a vision of unity, wholeness, and harmony in which conventional gender polarities and

male dominance are transcended, to compare Queen Elizabeth's public presentation of her sexuality with Shakespeare's creation of comic heroines in *Much Ado About Nothing, As You Like It, Twelfth Night,* and *The Merchant of Venice.*

Focusing on Elizabeth's rhetoric, Marcus shows how the Queen defined herself officially as both a man and a woman, placing an increasing emphasis on the former identification as her reign progressed. Marcus then equates what she calls the sexual "layering" involved in this process of self-presentation with the identities of disguised actor-characters in Shakespeare, contending that Queen Elizabeth's androgyny presents a contemporary analogue to the sexually composite nature of Shakespeare's comic heroines. Like the Queen, and unlike the disorderly figure of the "woman on top" who appeared in later Jacobean drama, the Shakespearean comic heroine never allows her world to become anarchic; she always sets limits and leads her society back to a principle of order. Marcus concludes by arguing that Shakespeare's optimistic use of androgyny at the end of Elizabeth's reign, when the Queen was in fact old and infertile, makes his comedies appear, in this respect, conservative and nostalgic.

By raising the important point that a powerful female ruler on the throne of England served as an androgynous symbol that enriched the imagination of Renaissance male poets and exploring the ways in which Elizabeth actively encouraged this vision, Marcus develops the idea introduced in Wiesner's essay: that female experience can be characterized in terms of a complex interplay between men and women. The second group of essays concentrates on women writers and attempts both to analyze their work and to examine the specifically female problems of self-definition they faced when asserting themselves as writers in a literary culture dominated by men.

Janel Mueller's essay, "Autobiography of a New 'Creatur': Spirituality, Selfhood, and Authorship in *The Book of Margery Kempe* (1438)," immerses us in the perspective of one fifteenth-century woman who struggled successfully to reconcile the apparent contradictions posed by her spiritual integrity, her social position, and her imaginative energy. Margery Kempe was the first English autobiographer of either sex, and, as Mueller shows, her story can be understood as an endeavor to integrate her spiritual calling as the chaste bride of God with her social and worldly status as the wife of the burgess of Lynn and the mother of fourteen children. Mueller's analysis of the Kempe manuscript makes vivid the details of Mar-

gery's effort to overcome the disjunctive thinking of the male-dominated society that regarded her attempts at self-creation as a scandalous anomaly. When Margery obtains permission to dress publicly as the bride of God, her white wool clothing and engraved gold ring come to symbolize her unique ability to reconcile aspects of female identity (absolute purity and wife/motherhood) which, as Schulenburg's essay clarifies, had traditionally been disjoined.

As Mueller suggests, thematic significance and narrative purpose combine in the symbol of Margery's outfit, clarifying her attempt to give her life and her book a meaningful structure. Margery neither rejects nor seeks to transcend her sexual past, but rather to reinterpret and reincorporate it into her spiritual vocation, a process revealed in her return to care for her senile husband, when she defines anew her lifetime of physical involvement with him. For Margery Kempe, then, one phase of life became the means of completing and fulfilling another, a vision of growth which informs the narrative development of her autobiography. Mueller argues that Margery's spirituality was specifically womanly in its compassion and inclusiveness; furthermore Margery's unique transvaluation of her given social and sexual roles made her resolve to preserve her experiences in autobiography.

Elissa Weaver's essay, "Spiritual Fun: A Study of Sixteenth-Century Tuscan Convent Theater," comprises an invigorating recovery of lost voices. As Weaver remarks at the beginning of her essay, in sixteenth-century Italy most of the unmarried women of the patriciate lived in convents, where they were provided with a comfortable life and some form of education. Consequently the majority of women writers in the period were nuns, who have left translations, meditations, chronicles of their convents, biographies, letters, poetry, and plays. Yet despite their prolific contribution to a variety of literary genres, "among the nuns only the saints have been remembered."

In her account of convent drama in sixteenth-century Tuscany, then, Weaver is bringing us news. She begins her essay by discussing the nuns' education and goes on to present the evidence she has accumulated about the audiences, scenery, authors, performers, and performances of the plays. Turning to the plays themselves, Weaver places them in the tradition of the *sacre rappresentazioni,* vernacular dramas that developed in the fifteenth century, and the *commedie sacre* or *spirituali,* religious drama of the sixteenth century which, borrow-

ing from classical and contemporary secular theater, was written for monastic audiences and organizations of lay piety.

Stressing the way in which noble, heroic stories are conjoined with humorous sub-plots full of homely, realistic detail, Weaver argues that the combination of sacred and profane elements in these plays signals close ties between the religious and lay communities and suggests that this theater served partially to connect the convent subculture to the outside world. She examines in detail one particularly fine play, Sister Beatrice del Sera's *Amor di Virtù,* which she interprets as, among other things, a moving autobiographical statement containing an explicit protest against female confinement. Yet, Weaver concludes, the play also suggests an optimistic promise of release, not only in the author's hope of salvation in the life to come, but also in her delighted participation in the act of poetic creation.

Like Weaver's assessment of Tuscan convent drama, Mary Ellen Lamb's examination of three sixteenth-century English translations by the Countess of Pembroke suggests the ways in which these works reveal problems of, as well as solutions for, female authorship in the Renaissance. In "The Countess of Pembroke and the Art of Dying," Lamb argues that, taken as a group, the translations express an attraction to re-creating a model of female heroism that neither contradicts nor defies patriarchal sexual values.

Lamb analyzes the Countess's translations that share an interest in death: *The Discourse of Life and Death* (1590), from Philippe de Plessis Mornay's *Discours de la vie et de la mort,* the *Antonie* (1590), from Robert Garnier's *Marc Antoine,* and the *Triumph of Death* (c. 1599), from Petrarch's *Trionfo della Morte.* She places the Countess's attraction to the subject in several contexts: her personal life (for example, Holinshed's account of her mother's excellent death); the *ars moriendi* tradition that, particularly in its relation to Stoicism, exercised substantial intellectual authority in late sixteenth-century England; and sexual values that idealized passivity, modesty, silence, and obedience as the virtues of the perfect woman and wife. Lamb argues that the latter ideology encouraged a dynamic of female heroism that constituted a form of negative self-assertion: that is, women could best demonstrate courage and integrity without violating the norms of female behavior only by dying well. While she believes that Renaissance sexual ideology had a damaging and restrictive effect on the female imagination, Lamb, like Weaver, also views one Renaissance

woman's active participation in literary culture as providing a signifi-
cant form of independence and release.

The theme of the woman writer's identity and experience as
restricted and problematic that Mueller, Lamb, and Weaver raise
becomes the central focus of Tilde Sankovitch's analysis, "Inventing
Authority of Origin: The Difficult Enterprise." Sankovitch is con-
cerned with sixteenth-century French women who had ambitions as
poets. She observes that male poets could assume their vocation with
confidence, placing themselves as legitimate heirs in a long, pres-
tigious line of self-appointed descendants from Apollo, Orpheus, and
the Muses. Pointing out the difference between the humanist theories
of imitation and belief in self-fashioning and modern theories of
"anxiety of influence," Sankovitch argues that Renaissance male poets
had a "basically optimistic approach to the problem of intertex-
tuality." In contrast, women poets had no such historical tradition
with which to ally their pursuits, and they found themselves in
isolation.

Sankovitch focuses on two sixteenth-century female poets,
Madeleine and Catherine des Roches, a mother and daughter who
were well-known and widely admired in their own day and who
published a substantial body of work in various literary genres. She is
interested in the fact that the des Roches explicitly acknowledge their
sense, as women, of alienation from literary tradition and take steps
to overcome it. Exploring the des Roches' poems in detail,
Sankovitch locates several different strategies that they employ in
searching for authority of literary origin. The authors try, for exam-
ple, to invent their origin, both by reinterpreting traditional myths
(Ceres/Persephone and the Amazons) or by creating myths of their
own (Agnodice, a poet-healer who encourages women to write). As
Sankovitch shows, they feel continually torn between preserving
their basically domestic identities as women, to which they are pro-
foundly attached, and developing their identities as writers in a
largely male literary tradition. This ambivalence becomes most
pointedly discernible in their poems through the metaphor of spin-
ning, with its mixed connotations of accomplishment and distrac-
tion, achievement and drudgery. Sankovitch concludes by observing
that a melancholy ambivalence about sexual identity ultimately de-
feated the poetic aspirations of the des Roches.

My essay, "Gender, Genre, and History: Seventeenth-Century

English Women and the Art of Autobiography," also explores the specifically female problems facing women writers who attempt to reconcile in their work the conflicting demands of their public and private lives. The essay seeks to account for the anomalous fact that in the late seventeenth century, despite all the entrenched moral injunctions against female self-expression, traditional English women began to write secular autobiography. The women with whom I am concerned were neither defying the established order nor writing accounts, like Margery Kempe, of religious experiences that exempted them from conventional sexual arrangements. They were instead traditional wives and mothers of the Anglican upper classes, deeply attached to conservative, patriarchal values.

I argue that a fortuitous combination of gender, genre, and history coalesced in the late seventeenth century and allowed these women to write. As I try to illustrate through the detailed examination of four examples, the intervention of the English Civil War in these women's lives upsets the traditional familial arrangements to which they adhere. Being on the losing, Royalist side of the conflict, they witness the loss of the social superiority and political hegemony of the men who dominate their world, and their consequent attempts to rectify and compensate for this loss of status, money, and power give their lives an added public dimension that drastically alters their horizons.

By examining four autobiographies by the Duchess of Newcastle, Ann, Lady Fanshawe, Alice Thornton, and Anne, Lady Halkett, in relation to their cultural context (that is, Renaissance sexual ideology and the English Civil War) and to their literary context (that is, the development of autobiography as a literary form), the essay attempts to illuminate the connections among gender, genre, and history that comprise the creation of a literary text. Emphasizing the role that the Civil War played in the lives and work of traditional seventeenth-century English women, it also suggests the way that social chaos can generate female creativity.

The essays demonstrate a collective awareness of gender as a determining factor in the creation of texts and in the constitution of social life and individual identity. Together they assess the condition of Medieval and Renaissance women as a composite of diverse, often conflicting claims. Examining their subject from a wide range of intellectual perspectives and focusing on several national and cultural traditions, these studies present a detailed and complex picture of

female experience and accomplishments in the Middle Ages and the Renaissance. It is hoped not only that this volume will provide new information and suggest new categories of analysis and interpretation with which this subject can be studied and discussed, but that it will also reveal the rich potential for future scholarship. We have only just begun to learn about the women of the past.

NOTES

1. Joan Kelly, *Women, History, and Theory*, Introd. by Blanche W. Cook, Clare Coss, Alice K. Harris, Rosalind P. Petchesky, and Amy Swerdlow (Chicago: University of Chicago Press, 1984), p. xix.

2. Four examples of the many rapidly emerging recent studies that treat Medieval and Renaissance sexual ideologies are Diane Bornstein, *The Lady in the Tower: Medieval Courtesy Literature for Women* (Archon Books, 1983); Ian Maclean, *The Renaissance Notion of Woman: A Study in the Fortunes of Scholasticism and Medical Science in European Intellectual Life* (Cambridge: Cambridge University Press, 1980); Linda Woodbridge, *Women and the English Renaissance: Literature and the Nature of Womankind, 1540–1620* (Urbana: University of Illinois Press, 1984); and Penny Schine Gold, *The Lady and the Virgin: Image, Attitude, and Experience in Twelfth-Century France* (Chicago: University of Chicago Press, 1985). A comprehensive and pioneering study is Ruth Kelso, *Doctrine for the Lady of the Renaissance* (Urbana: University of Illinois Press, 1956).

For a recent theoretical statement about the value of analyzing ideology for feminist research, see Marilyn L. Williamson, "Toward a Feminist Literary History," *Signs*, 10 (Autumn, 1984): 136–47.

3. See Suzanne W. Hull, *Chaste Silent & Obedient: English Books for Women 1475–1640* (San Marino: The Huntington Library, 1982).

4. See, for example, Pearl Hogrefe, *Women of Action in Tudor England: Nine Biographical Sketches* (Ames, Iowa: Iowa State University Press, 1977); J. R. Brink, ed., *Female Scholars: A Tradition of Learned Women Before 1800* (Montreal: Eden Press, 1980); and Patricia H. Labalme, ed., *Beyond Their Sex: Learned Women of the European Past* (New York: New York University Press, 1980).

5. See, for example, Susan Mosher Stuard, ed., *Women in Medieval Society* (Philadelphia: University of Pennsylvania Press, 1976); Renate Bridenthal and Claudia Koonz, eds., *Becoming Visible: Women in European History* (Boston: Houghton Mifflin Company, 1977); Suzanne Fonay Wemple, *Women in Frankish Society: Marriage in the Cloister 500–900* (Philadelphia: University of Pennsylvania Press, 1981); Natalie Zemon Davis, *Society and Culture in Early Modern France* (Stanford: Stanford University Press, 1979); Julius Kirshner and Suzanne Wemple, eds., *Women of the Medieval World* (Oxford: Basil Blackwell, 1985); Christine Klapisch-Zuber, *Women, Family, and Ritual in Renaissance Italy*, trans. Lydia G.

Cochrane (Chicago: University of Chicago Press, 1985); and Gold, *The Lady and the Virgin*.

6. See, for example, Peter Dronke, ed., *Women Writers of the Middle Ages: A Critical Study of Texts from Perpetua (+ 203) to Marguerite Porete (+ 1310)* (Cambridge: Cambridge University Press, 1984); Katharina M. Wilson, ed., *Medieval Women Writers* (Athens: University of Georgia Press, 1984); Margaret L. King and Albert Rabil, Jr., eds., *Her Immaculate Hand: Selected Works By and About the Women Humanists of Quattrocento Italy* (Binghamton, N.Y.: Center for Medieval and Early Renaissance Studies, 1983); Joan Goulianos, ed., *By a Woman Writt* (Baltimore: Penguin Books Inc., 1973); Mary R. Mahl and Helene Koon, eds., *The Female Spectator: English Women Writers before 1800* (Bloomington: Indiana University Press, 1977); and Betty Travitsky, ed., *The Paradise of Women: Writings by Englishwomen of the Renaissance* (Westport, Conn.: Greenwood Press, 1981); and *ELR* 14 (1984).

7. Kelly, *Women, History, and Theory*, pp. 19–50.

8. See, for example, E. William Monter, "The Pedestal and the Stake: Courtly Love and Witchcraft," in *Becoming Visible: Women in European History*, ed. Bridenthal and Koonz, pp. 119–36; Jo Ann McNamara and Suzanne F. Wemple, "Sanctity and Power: The Dual Pursuit of Medieval Women," in *Becoming Visible*, eds. Bridenthal and Koonz, pp. 90–118; and Stuard, ed., *Women in Medieval Society*, p. 10.

9. Davis, "City Women and Religious Change," in *Society and Culture in Early Modern France*, pp. 65–95. Also see Davis' introduction to Georges Duby's *The Knight, the Priest and the Lady: The Making of Modern Marriage in Medieval France*, translated by Barbara Bray (New York: Pantheon Books, 1983), p. xiii, where she remarks, "Subject to the authority of fathers and husbands though these women were, no one has been tempted to see them only as victims. Rather, one asks about them—as about any group with limited access to power—what options did they have and how creatively did they use them?"

10. See Elizabeth Abel, ed., *Writing and Sexual Difference* (Chicago: University of Chicago Press, 1982), p. 1.

Women in the Middle Ages and the Renaissance

Women's Defense of Their Public Role

MERRY E. WIESNER

\mathcal{T}HE QUESTION which Joan Kelly posed a decade ago, "Did women have a Renaissance?" is one which has led to a great deal of re-examination and rethinking of that particular period. Kelly examined courtly love literature, Castiglione's *The Courtier,* and the experience of Italian upper-class women to answer the question with a resounding "no." Instead of expanding opportunities and increasing liberation from ideological constraints, she argues, these women "experienced a contraction of social and personal options that men of their classes . . . did not."[1] Kelly further describes this contraction as a "new division between personal and public life," a division which also relegated women to the personal, private realm.[2]

Kelly primarily uses prescriptive literature written by men to make her points, but the voices of actual women from the period indicate that they were aware of what was happening to them. They felt both the shrinking of opportunities in a variety of areas and the increasing split between public and private life. Their objections to this growing constraint took on many different forms but generally center on women's right to a public role. While male writers, officials, theologians, workers, and professionals were attempting to limit women's activities to the private realm, women consistently defended their public role.

These defenses are closely linked to the question of the nature and degree of women's freedom in the Renaissance. Most scholarly discussions of female freedom focus on male definitions and limitations of that freedom—law codes, sermons, guild restrictions, prescriptive treatises, literary models. In all of these, the word "free" would rarely have been used when referring to women. Classical authors, to whom the Renaissance writers looked for models of

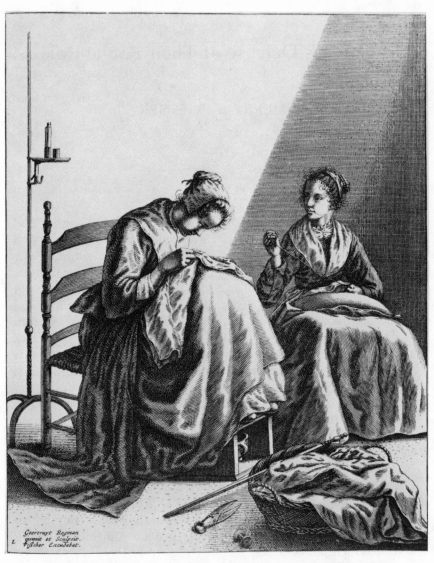

Die Nätherinnen (seventeenth century). By Gertrud Roghman. From Hirth, ed., *Kulturgeschichtliches bilderbuch aus drei jahrhunderten*, Munich, Knorr & Hirth, 1881–90. *Courtesy of the John M. Wing Foundation, the Newberry Library, Chicago.*

thought and language, would not have done so, as "free" meant to them enjoying the rights and privileges of a citizen and possessing an educated capacity for reason, neither of which was possible for women. Italian humanists, while occasionally allowing women some rational capacity, sharply restricted the avenue by which a woman could develop that capacity; her course of study was to be neither as "free" nor as "freeing" as a man's. It is only in a religious sense that the word "free" is applied to women in the Renaissance. According to Erasmus, a woman had the same "free will," the same moral responsibility to do good, that a man did. According to Luther, of course, no one had free will, but a woman could receive God's grace and come to faith the same as a man, participating thereby in the "freedom of a Christian" which resulted from this faith.

Philosophical discussions of "freedom" as it was defined by male authorities may be leading us somewhat astray, however. While Renaissance women used a variety of philosophical, legal, rational, and religious justifications to argue their case, they in fact had a much more pragmatic definition of the word: "freedom" to them meant the ability to participate in public life. Their voices tell us a great deal about female self-conception during the Renaissance, which never emerges when listening to male voices alone. It is true that women's sphere in most cultures has been defined by men, as have the limits of what is considered "public" and what "private"; but women have often objected to or ignored those limitations, and at no time more than during the Renaissance when they were aware that restrictions on them were increasing.

The contraction of women's public role, and their responses to it, occur in a variety of realms of life during the Renaissance and may best be explored realm by realm. It will also be instructive to look at examples from somewhat later periods, for this process continued over centuries, eventually restricting not only the upper-class women who are the focus of Kelly's study, but middle- and lower-class women as well. As Natalie Davis has noted, "Women suffered for their powerlessness in both Catholic and Protestant lands in the late sixteenth to eighteenth centuries as changes in marriage laws restricted the freedoms of wives even further, as female guilds dwindled, as the female role in middle-level commerce and farm direction contracted, and as the differential between male and female wages increased."[3]

The theoretical limits of female freedom in economic, political, and familial life were set by a variety of municipal, national, and regional law codes. These differed widely from area to area throughout Europe, but some general trends can be seen by examining changes in them from the thirteenth through the seventeenth centuries.

In regard to the basic obligations and duties of citizenship, little distinction was made between men and women; all heads of households were required to pay taxes, provide soldiers for defense, and obey all laws. Beyond that, however, there were clear legal restrictions on what the female half of the population could do. Women differed from men in their ability to be witnesses, make wills, act as guardians for their own children, make contracts, and own, buy, and sell property. These limitations appear in the earliest extant law codes and were sharpened and broadened as the law codes themselves were expanded.

A good example of this process can be seen in the restrictions on women buying and selling goods, or loaning, borrowing, or donating money without their husbands' or guardians' approval. The earliest law codes (for example, Lübeck 1220–26), simply prohibited any woman from engaging in these transactions, unless her occupation required it, an exception so broad as to make the law meaningless.[4] As the occupations that were to be excluded were described more specifically, this list shrank gradually over centuries. When one goes beyond law codes to actual court proceedings, however, it is apparent that women were making contracts, buying, selling, and trading goods all the time. Perhaps because theoretical restrictions were bypassed, evaded, or ignored in so many cases, we can find few objections by women when they were added or expanded.

Other types of legal restrictions began to appear in the sixteenth and seventeenth centuries and were opposed both by women and by individual men. Most areas began to tighten their system of guardianship, demanding that all widows and unmarried women choose a male guardian, who was to oversee their financial affairs and appear for them in court.[5] Women not only took these guardians to court when they felt their rights had been violated and demanded new guardians; they also objected to being required to have a guardian at all.[6] Women had appeared before city courts in the past in regard to financial matters and had been handling their own property and inheritance, they argued, so why did they now need male guardians to do the same things?

Some cities were very frank as to why they were requiring guardians; the Strasbourg city council demanded this expressly to prevent women from going into convents and deeding all their property to the convent, "by which their relatives are disinherited and the city loses people who provide it with horses" (that is, taxpayers).[7] Because such personal decisions by women ultimately had repercussions in the public realm, the council felt they were really public affairs and thus should be placed under male control.

The prominent Catholic preacher and moralist Geiler of Kaysersberg opposed this move, seeing it as an infringement on individual women's opportunities to perform works of charity. In a sermon from 1501 he comments:

> Arranging a guardian for widows who are responsible and sensible persons is a novelty that has arisen in this city supposedly for the common good. In truth, as I will report, it is a self-seeking move by those who were in power . . . Everyone who is bothered by something always says it harms the common good, but it really involves his own affairs . . . The Gospel tells us directly—if you want to be saved, go out and sell everything you have and give it to the poor. It doesn't say to give it to your heirs and relatives. This law is totally against the word of Christ. It is a mockery of God, a haughty service of the devil to forbid a pious person to give everything she owns for the will of God.[8]

The thrust of Geiler's argument here is that such decisions were personal matters and should be left up to the individual woman without city interference. He thus at least tacitly agrees with the city council that women should not have a public role, but sets the boundary between private and public differently. This line of argument will emerge in male defenses of women's activities in other realms as well. Men, whether humanists, reformers, or political thinkers, often argued that the activity concerned—such as writing, education, or inheriting an estate—was essentially private and thus should be open to women.

Women's objections to guardians follow a very different line of reasoning. This was a period when the division between public and private was not as sharp and distinct as it would become later, and when the household, as a legal and economic unit and as the location of most production, was clearly within the public sphere.[9] City

councils recognized this fact, for they taxed households, not persons, as did Protestant reformers who spoke of the family as a little commonwealth, from which basic unit the larger society was made. Women also recognized this and were aware that they were making "political" decisions, or certainly decisions which had effects beyond the immediate household, when they were planning something as simple as whether to cook fish or meat on fast days, whether a political or religious refugee was to be fed, or what quality and amount of food journeymen were to receive.[10] They, along with their husbands, were held responsible by municipal and regional authorities for maintaining order within the household and keeping children and servants under control.[11] Thus they saw their legal and financial activities in the larger sphere as no different from, or simply an extension of, those activities in which they were already involved within the household.

Though Geiler and the women were arguing for the same thing—women's ability to make financial decisions without the aid of a guardian—and though the underlying issue was an economic one which had little to do with women's rights *per se*—the tax base of the city—and though none of the arguments was successful in this case, the differences between their justifications are very important. As the split between public and private hardened, and as the public realm expanded to include education, administration of public welfare, and a growing number of occupations, Geiler's line of reasoning resulted in an ever-shrinking female sphere. The assertion by the Strasbourg women that the household was part of the public realm allowed for an augmented, or at least for a stable, female sphere. Had the women's line of reasoning ultimately triumphed, the gender divisions which evolved in Early Modern Europe might have looked somewhat different. The advent of national governments and the end of the household form of production may have made the public/private, work/home, male/female divisions which did develop inevitable, but the speculation is still an interesting one.

Along with increasing restriction of women's ability to make financial decisions and to handle their own property, the Renaissance and Early Modern periods saw a restriction of women's work. This issue is very complex and may be partially attributed to nearly every major eco-

nomic change that was going on: the decline of the craft guilds and the rise of journeymen's guilds, the shift in trade patterns, the general inflation, the decline of old manufacturing centers and the growth of new ones, formalization of training requirements, the rise of capitalism. In addition to strictly economic factors, political and ideological ones also affected women's work: the rise of territorial states, dislocation caused by the religious wars, increasing suspicion of unmarried women, secularization of public welfare, campaigns against prostitution and begging, new ideas about women's "proper" role and ability to be trained. Whatever the reasons behind it, in every occupation in which women's work was restricted, the women themselves objected. In this arena we can hear most clearly the voices of lower- and middle-class women defending their public role.

Some of the most vocal individuals were widows of master craftsmen. The earliest guild ordinances rarely mention widows, who seem to have had unrestricted rights to carry on their husband's shop after his death, or at least as long as they remained unmarried.[12] Beginning in the mid-fifteenth century, nearly every craft began to impose limitations; widows could only continue operating the shop for a few months or finish work that was already started and could not take on apprentices, hire new journeymen, or buy any new raw materials. Such restrictions were particularly strict in crafts which were declining and whose craftsmen were thus feeling threatened or in those with strong journeymen's guilds, as the journeymen saw widows as a block to their being able to open their own shops.[13]

Individual widows frequently brought requests to guild authorities, city councils, ducal courts, and other governing bodies that they be excused from the normal restrictions. Each used a variety of tactics, stressing her age or infirmity, number of dependent children, good reputation, and quality products. These requests referred primarily to the individual facts of the case, but an occasional supplication also mentioned widows' rights in general: "I bring my humble request . . . that the apprentice be allowed to stay with me, as it is the practice everywhere else in the entire Holy Roman Empire that widows who run a workshop with journeymen are allowed to retain an apprentice until he has finished his training."[14]

The individualized nature of widows' requests is not terribly surprising, given the fact that there were very few women's guilds or other corporate bodies in which women could develop a sense of group work identity. In the few cases in which they did, their objec-

tions to restrictions on their work are couched in corporate terms. A group of unmarried veil weavers in Augsburg objected to an ordinance which forbade them to continue weaving "because this is a fine and honorable female trade."[15] Ceremonies which celebrated women's work identity were very rare, in contrast to the huge number of parades, banquets, drinking parties, and festivals in which men participated as members of a craft. In the few instances in which such ceremonies had been established, the women fervently defended their right to continue holding them. The Strasbourg midwives, for example, required each new midwife to provide all the others with a "welcome meal" when she was taken on. The older midwives justified this ritual with the comment that the city council had a similar requirement for new council representatives and ambassadors, holders of offices which, they said, were certainly no more important or honorable than midwifery.[16] They recognized that such events were important in establishing work identity and publicly demonstrating group cohesion. Midwives in general seem to have had the strongest sense of work identity found among women, as they were always careful to mention their occupation when appearing in court, making an appeal, or acting in any legal or public capacity.

While journeymen and guild masters were fighting against widows' rights, professionalization and the formalization of training requirements worked against women's labor in several fields, most prominently in medicine. Until about 1500 there seems to have been little opposition to women practicing medicine of all kinds. Women are listed as doctors in early tax lists and were even rewarded for special medical services.[17] Every housewife was expected to have some knowledge of herbs, salves, and ointments, and care of others was seen as an extension of household healing. A fourteenth-century law from Calabria even notes, "It is better, out of consideration for morals and decency, for women rather than men to attend female patients."[18]

Gradually, however, under pressure from barber-surgeons, physicians, and apothecaries, cities and territories began to pass regulations expressly forbidding "women and other untrained persons" to practice medicine in any way.[19] These ordinances did not keep women from practicing, however, nor prevent people from going to them if they felt they were skillful and effective. When male medical practitioners brought complaints, the women defended their activities with a strong sense of the value of what they were doing.

Maria Marquardt, an Augsburg woman, noted that she had been working as a healer for thirty-three years, using "the gift and skill which has been given to me by God."[20] Elizabeth Heissin, a woman in Memmingen, when asked where she had learned her skill, answered that it came from "God in Heaven who gave me soul and body, reason and understanding, for which I have to thank him daily." She asked to be allowed to continue treating people, making the comment that such activities "were done by honorable women not only here but also in other cities just as large and important as Memmingen. Such are fine things for women to do."[21]

Occasionally women were even more forceful in their arguments, noting that in some cases women were better medical practitioners. Katharine Carberiner testified to the Munich city council:

> I use my feminine skills, given by the grace of God, only when someone entreats me earnestly, and never advertise myself, but only when someone has been left for lost, and they ask me many times. I do whatever I can possibly do out of Christian love and charity, using only simple and allowable means that should not be forbidden or proscribed in the least. Not one person who has come under my care has a complaint or grievance against me. If the doctors, apothecaries or barber-surgeons have claimed this, it is solely out of spite and jealousy.
>
> At all times, as is natural, women have more trust in other women to discover their secrets, problems and illnesses, than they have in men (as long as no unchristian means are used)—but perhaps this jealousy came from that. Undoubtedly as well, husbands who love and cherish their wives will seek any help and assistance they can, even that from women, if the wives have been given up (by the doctors) or otherwise come into great danger.
>
> Because I know that I can help in my own small way, I will do all I can, even, as according to the Gospel, we should help pull an ox out of the well it has fallen into on Sunday.[22]

Like the widows who asked to keep operating their shops, these women all argued their cases as individuals, stressing their practical abilities and effectiveness, not their formal training or legal rights. Though they occasionally mentioned that other women were also practising, each pictured herself as blessed with extraordinary God-

given healing powers, for which she should be granted special dispensation. The idea of divine favor as a justification for public activity will appear again when we examine women who carried out religious activities.

Another theme emerges from the requests of female medical practitioners, however, and can be seen as well in women's requests to work in other occupations. Women constantly stressed the fact that others were dependent on them: their patients—"especially the poor and needy"—, their elderly parents, their invalid or ailing husbands, their young children—"my young and helpless child still nursing at my breast."[23] While this tactic may at first appear to be simply a play on the authorities' sense of pity—and in some cases it clearly was— recent studies of women's psychological and moral development indicate that the approach may stem from something deeper. Carol Gilligan, in *In a Different Voice: Psychological Theory and Women's Development*, finds that women describe themselves in terms of their relationships with others, relationships they see as a network rather than a hierarchy. When confronted with moral problems, women justify their solutions and the actions they take with a value system based on responsibility in relationships and care, rather than a value system based on rights and rules. "The logic underlying an ethic of care is a psychological logic of relationship, which contrasts with the formal logic of fairness that informs the justice approach."[24] Because of this approach, women are much less likely to base their decisions or actions on abstract principles or absolutes, but instead to insist that each case must be seen in its context.

Although the dangers of applying twentieth-century psychological theory to earlier periods are evident (as *Young Man Luther* so clearly demonstrates), the parallels between the women Gilligan studies and the Renaissance women making supplications about their work are very striking. The Renaissance women also based their appeals on their responsibility to others, to people who were actually related to them or to people they cared about. They saw themselves first as part of a network of relationships which included family, relatives, friends, neighbors, and acquaintances, rather than as members of a hierarchical system such as a guild. They, too, rarely argued that they had a "right" to do something because of precedent or regulations, but that the circumstances surrounding their cases might even warrant a break with the rules and the past. Though the appeals that were successful often involved the woman throwing herself on

the mercy of the authorities "as the protector and shield of poor widows and orphans," she may have done this not out of any feelings of her own helplessness, but out of feelings of her responsibility to others and a recognition that this kind of rhetoric might ultimately help her to live up to those responsibilities.[25] She recognized that male authorities thought of widows as a group deserving charity and pity, and saw that her request was more likely to be granted if they felt she was especially needy and would otherwise need public poor relief. Whether these women—who hired someone to write the supplication, provided the facts of the case, and appeared personally before city councils, ducal courts, and other bodies—were in fact as weak and pathetic as they attempted to appear is somewhat doubtful.

Trying to reconstruct women's thought patterns or determine which phrases were their own and which the notaries' in these supplications is very difficult and must always be done with reservations. An additional problem is that an ethic of care could—and did—lead some women to argue against their right to work. For example, if a woman had been an active participant in her husband's business, at his death she was required to pay back all debts. If these were high, it would be to her and her family's advantage to claim she had known nothing about, made no contribution to, and did not want to continue, the family business, for she could then retain her dowry and a share of the inheritance no matter how high the debts were. Because of her feelings of responsibility toward her family, she was thus forced into the curious position of denying her own competence and knowledge.[26]

Such occurrences were rare, however. A woman's assessment of her private responsibilities led much more often to a request for a public role, at least in the world of work. She asserted that she should be free to work because of, not despite, her private life. Thus in the realm of work as well as in financial decision making, women stressed the connection, not the distinction, between public and private.

In a few instances, women's concern for their families went beyond matters of survival and support to matters of prestige. Jeanne Giunta, a book-publisher in Lyon, presented herself in a 1579 dedication as "devoted to the typographical art, lest the honor that her father and Florentine ancestors won thereby be lost."[27] She says,

It is not new or unheard of for women to have such a trade, and one can find many of them who exercise not only the typographical art,

but others more difficult and arduous, and who obtain thereby the
highest of praise.[28]

Giunta's eloquence in praise of her family's honor sounds more
like the voice of a Renaissance female writer than the voice of a typical
Renaissance working woman. Perhaps this stems from the fact that
the trade in which she was involved—printing—brought together
individuals who were artisans, entrepreneurs, and scholars. She also
came from a Florentine family, and so most likely had contact with
the humanist tradition, a tradition that regarded public praise and
honor as more important than political power, economic freedom, or
legal rights. It is from women trained in this tradition, the learned
women of the Renaissance, that we hear very different reasons for and
a very different conception of a "public role."

Humanists since Petrarch had been concerned to choose between the
"vita activa" and the "vita contemplativa," between public and pri-
vate life, but had gradually opted for the active life. The best life, the
one which earned oneself and one's family the most honor, was that
which included not only scholarly activity, but also political and
public service. Such a life was impossible for women, however, not
only because of the realities of Renaissance politics, but also because
for a woman, a public reputation was dishonorable, a sure sign of
immorality and scandal.[29]

Male commentators linked women's educational achievements,
if they were displayed in public, with unnatural sexuality; in the
words of one, "an eloquent woman is never chaste; and the behavior
of many learned women confirms (this) truth."[30] Thus educated
women were caught in an internal conflict between humanist ideals
and the traditional female role. They recognized that convention
forced them to choose between these ideals; they could not be truly
learned, or at least publicly learned, and still be ladies. Several female
writers express this choice very clearly and often describe it in sym-
bolic terms. Olympia Morata (1526–55), a Ferrarese Greek and Latin
scholar who married a German physician and died at twenty-nine of
the plague in Heidelberg, wrote, in Greek:

I, a woman, have dropped the symbols of my sex,
Yarn, shuttle, basket, thread.
I love but the flowered Parnassus with the choirs of joy.
Other women seek after what they choose.
These only are my pride and my delight.[31]

For most women the call of the spindle was too strong to resist. Even those who had been famous for their learning as girls gave up further study when they married and had families.[32] If they decided to write, they chose religious subject matter and often addressed their writings to their daughters or close female relatives. As Ruth Kelso and Ann Jones have pointed out, women's audiences and their themes were private.[33]

Those who chose the life of learning were generally forced to give up a normal family life. Most lived chaste lives of scholarly solitude in "book-lined cells." They chose celibacy because their desire for learning required it; their male admirers—and there were many—applauded that decision as they felt no woman could be both learned and sexually active. By becoming learned, she had penetrated a male preserve, which was only tolerable if she simultaneously rejected the world of women. As Margaret King has noted, "Chastity was at once expressive . . . of the learned woman's defiance of the established natural order and of the learned man's attempt to constrain her energies by making her mind the prison for her body."[34]

Both of these choices proved unacceptable to those searching for public honor and the opportunity to express themselves openly, as well as to those who wanted somehow to combine the two worlds. This latter ambivalence is best expressed in a poem by Catherine des Roches (1542–87), who, incidentally, chose never to marry and to remain with her mother until her death:

To my Spindle

My spindle and my care, I promise you and swear
To love you forever, and never to exchange
Your domestic honor for a good which is strange,
Which, inconstant, wanders, and tends its foolish snare.

With you at my side, dear, I feel much more secure
Than with paper and ink arrayed all around me

For, if I needed defending, there you would be
To rebuff any danger, to help me endure.

But, spindle, my dearest, I do not believe
That, much as I love you, I will come to grief
If I do not quite let that good practice dwindle

Of writing sometimes, if I give you fair share,
If I write of your merit, my friend and my care,
And hold in my hand both my pen and my spindle.[35]

Public honor and expression were also justified eloquently by a variety of women. Many of these justifications ironically had a decidedly anti-female or at least anti-feminist bias. Most literary women, particularly those trained in Italy, accepted the male assessment of female inferiority and weakness as true for most women; they themselves, they felt, were simply exceptions. They often regretted being women because of "the boundaries of my sex and mental powers" and sought to distance themselves from other "babbling and chattering women."[36] They recognized they had a special gift, a love of learning aided by hard work, which could be available to any woman, but which only a few had the energy and will to develop. Laura Cereta, a fifteenth-century Brescian aristocrat, chided other women for their laziness: "For knowledge is not given as a gift, but through study. . . . The free mind, not afraid of labor, presses on to attain the good."[37] These women had accepted the Renaissance notion of the power of the individual will, which kept them from placing the responsibility for women's intellectual inferiority on anything but the women themselves. They argued that because they themselves had transcended this inferiority, they should have the right to claim public honor and gain a public reputation, in the same way that a few outstanding women had done throughout history.[38]

There are a few women as early as the sixteenth century who recognized that the low intellectual status of their sex may not have been the responsibility of "nature," or of the women themselves. Louise Labé (1520–66), a middle-class Lyonnaise poet who published her own poetry, was ambivalent about the matter, accusing both women and men. In 1555 she wrote,

Since a time has come, Mademoiselle, when the severe laws of men no longer prevent women from applying themselves to the sciences

and other disciplines, it seems to me that those of us who can should use this long-craved freedom to study and to let men see how greatly they wronged us when depriving us of its honor and advantages. And if any woman becomes so proficient as to be able to write down her thoughts, let her do so and not despise the honor but rather flaunt it instead of fine clothes, necklaces, and rings. For these may be considered ours only by use, whereas the honor of being educated is ours entirely . . . If the heavens had endowed me with sufficient wit to understand all I would have liked, I would serve in this as an example rather than an admonishment. But having devoted part of my youth to musical exercises, and finding the time left too short for the crudeness of my understanding, I am unable, in my own case, to achieve what I want for our sex, which is to see it outstrip men not only in beauty but in learning and virtue. All I can do is to beg our virtuous ladies to raise their minds somewhat above their distaffs and spindles and try to prove to the world that if we were not made to command, still we should not be disdained as companions in domestic and public matters by those who govern and command obedience. Apart from the good name that our sex will acquire thereby, we shall have caused men to devote more time and effort in the public good to virtuous studies for fear of seeing themselves left behind by those over whom they have always claimed superiority in practically everything. . . .[39]

It was not until the late seventeenth century, however, that women began to express publicly sentiments that might be labelled truly feminist, recognizing that women as a group suffered discrimination and should be given rights and privileges because of, not despite, their femaleness.[40]

Learned women in northern Europe also felt the need to justify writing for a larger public than family and friends, and they too expressed their reasons in terms of possessing special gifts. These gifts could mean something as simple as being in the right place at the right time. Margaret Cavendish, the Duchess of Newcastle, introduces her biography of her husband with the comment,

Nor is it inconsistent with my being a woman to write of wars, that was neither between Medes and Persians, Greeks and Trojans, Christians and Turks, but among my own countrymen, whose customs and inclinations, and most of the persons that held any considerable place in the armies was well known to me.[41]

A woman's gift could also be the inspiration provided by the life of another, a motivation for writing frequently expressed in dedicatory prefaces, for example, one by Aemilia (Bassano) Lanyer:

> To thee great Countess now will I applie
> My Pen, to write thy never dying fame;
> That when to Heav'n thy blessed Soule shall flie,
> These lines on earth record thy reverend name:
> And to this taske I meane my Muse to tie,
> Though wanting skill I shall but purchase blame:
> Pardon (deere Ladie) want of womans wit
> To pen thy praise, when few can equall it.[42]

This inspiration could even come to women who had received little formal education and could thus justify their writing. Mary Oxlie, a Scotswoman, began a poem in praise of the poet William Drummond:

> I Never rested on the Muses bed,
> Nor dipt my Quill in the Thessalian Fountaine,
> My rustick Muse was rudely fostered,
> And flies too low to reach the double mountaine.
>
> Then do not sparkes with your bright Suns compare,
> Perfection in a Womans worke is rare;
> From an untroubled mind should Verses flow;
> My discontents makes mine too muddy show;
> And hoarse encumbrances of household care
> Where these remaine, the Muses ne're repaire.[43]

Gifts such as these could come to any woman, not only those who were particularly strong and energetic; as a result these writers did not see themselves as set apart from other women because of their writing. Rachel Speght, in her answer to a particularly vicious attack on women published in 1621, apologized for her writing and then noted, "This my briefe Apologie (Right Honourable and Worshipfull) did I enterprise, not as thinking my selfe more fit then others to undertake such a taske, but as one, who . . . did no whit dread to combate with our said malevolent adversarie. . . . This I alleage as a

paradigmatical patterne for all women, noble and ignoble, to fol-low."[44]

The most common reason women gave for writing was that they had received divine inspiration. Marie de France expressed this in the prologue to the *Lais:*

> Whoever has received knowledge
> and eloquence in speech from God
> should not be silent or conceal it,
> but demonstrate it willingly.[45]

Rachel Speght, in an allegorical poem entitled "The Dream," argued:

> Both man and woman of three parts consist,
> Which *Paul* doth bodie, soule, and spirit call:
> And from the soule three faculties arise,
> The mind, the will, the power; then wherefore shall
> A woman have her intellect in vaine,
> Or not endevour *Knowledge* to attaine.
>
> The talent, God doth give, must be imploy'd
> His owne with vantage he must have againe:
> All parts and faculties were made for use;
> The God of *Knowledge* nothing gave in vaine.[46]

Anne Wheathill, a middle-class woman, thus introduced her volume of prayers and meditations:

> Whereupon of the learned I may be judged grose and unwise; in presuming, without the counsell or helpe of anie, to take such an enterprise in hand; nevertheless, as GOD doth know, I have doone it with a good zeale, according to the weaknes of my knowledge and capacitie.[47]

Women used divine inspiration not only as a justification for writing literary works, but also, of course, for writing or speaking about religion. Female mystics, anchoresses, abbesses, and even simple nuns throughout the Middle Ages had spoken and written on

religious matters, asserting that God or the Holy Spirit had given them an insight which they were compelled to communicate to others. During the Reformation, women emerged both as supporters of the Protestants and defenders of the old faith, again stressing that the Spirit had given them understanding or was even forcing them to speak in public. When they were criticized for speaking out, a criticism usually supported by references to St. Paul's admonitions against women speaking in church, they also defended their actions with Biblical references, using both the Old and New Testaments.

Argula von Grumbach, a German noblewoman, wrote to the faculty of the University of Ingolstadt protesting the University's treatment of a young teacher accused of Lutheran leanings:

> I am not unacquainted with the word of Paul that women should be silent in church [1 Tim. 1:2] but, when no man will or can speak, I am driven by the word of the Lord when he said, "He who confesses me on earth, him will I confess, and he who denies me, him will I deny" [Matt. 10, Luke 9] and I take comfort in the words of the prophet Isaiah [3:12, but not exact], "I will send you children to be your princes and women to be your rulers."[48]

A student at Ingolstadt responded to von Grumbach's protest with an anonymous satirical poem criticizing her actions:

> You forgot that you're a maid
> And are so fresh you're not afraid
> To assume the role of doctor
> and teach new faith to prince and proctor.
> By your stupidity inflated
> Ingolstadt is castigated.[49]

To which she replied:

> I answer in the name of God
> To shut the mouth of this bold snob.
> Reproaches me with lack of shame
> When he is scared to give his name.
> A "free student" at Ingolstadt,
> I will not give him tit for tat.
> If, as he boasts, he is so free

Why not give his name to me?
He tells me to mind my knitting.
To obey my man indeed is fitting,
But if he drives me from God's Word
In Matthew ten it is declared
Home and child we must forsake
When God's honor is at stake.[50]

Sarah Fell, Margaret Fell Fox's daughter, used the example of Hannah to make a similar point:

Hannah prayed, and Oh! the gracious words, and prayer, that proc-
ceeded out of her mouth, by the powerful demonstration of the
Eternall spirit, and the power of the almighty God in her . . . which
all the adversaries and gainsayers against womens meetings, and
womens speakings, is not able to gainsay, nor resist . . . the Lord
hath regard unto and takes notice of the women, and despises them
not.[51]

The Mary and Martha story was also mentioned frequently, as was the fact that the three women who discovered Christ's empty tomb were really the first preachers of the Resurrection.

Women were most sharply criticized when they were writing or speaking on matters that involved theology or dogma rather than piety. As Roland Bainton has noted in his studies of women of the Reformation throughout Europe, women were more accepted and more active in any movement, from the *Alumbrados* in Spain to the Quakers in England, in which piety was more important than dogma, in which religious ideas were expressed in emotional terms rather than as systematic theology.[52] Women could not receive formal theological training in Europe, so any woman who did discuss theology stressed that the Spirit had given her understanding beyond that of most women, enabling her to write about such complicated matters. Argula von Grumbach wrote, "I send you not a woman's ranting, but the Word of God."[53] Katharina Zell, the wife of Matthias Zell and a tireless worker for the Reformation in Strasbourg, wrote that she should be judged, "not according to the standards of a woman, but according to the standards of one whom God has filled with the Holy Spirit."[54]

Elizabeth Gottgabs, the abbess of Oberwesel convent, published a tract against the Lutherans in 1550 in which she noted:

What can a poor woman do? What can she contribute as she has no arts or skill at arguing? If I am inexperienced and a child in such matters, so will my work be judged. But if it comes from the Spirit and is thus filled with the appropriate religious truth, then it will undoubtedly be noticed and accepted.[55]

These Northern European religious writers felt their inspiration set them apart from other women but did not make them superior. Unlike the women trained in the Italian humanist tradition, they downplayed their own merits and felt the Spirit could come to anyone. This attitude may have helped them maintain feelings of kinship with other women, but it created different problems. As Keith Thomas has noted:

Appeal to divine inspiration was of very questionable value as a means of female emancipation. The whole emphasis was placed upon the omnipotence of God and the helplessness of his chosen handmaid should she be thrown upon her own resources. "I am a very weak, and unworthy instrument," wrote Mary Cary in the preface to one of her Fifth-Monarchy pamphlets, "and [I] have not done this work by any strength of my own, but have been often made sensible, that I could do no more herein . . . of myself, than a pencil, or pen can do, when no hand guides it: being daily made sensible of my own insufficiency to do anything as of my self." We should not overemphasize this objection: after all, Cromwell said the same sort of thing about his victories in battle without it noticeably diminishing their impact; but it does seem in this case that the language in which such writing was couched must have served to perpetuate the legend of women's inferiority.[56]

While female religious writers did stress female inferiority, both vis à vis God and vis à vis learned men, they also stressed, at least implicitly, the spiritual equality of all men and women. In the words of Anne Locke,

But because great things by reason of my sexe, I may not doe, and that which I may, I ought to doe, I haue according to my duetie, brought my poore basket of stones to the strengthening of the wals of that Ierusalem, whereof (by Grace) we are all both Citizens and members.[57]

This recognition of spiritual equality did not lead women to demand political or social equality; there were no calls for woman's

suffrage in the Renaissance. In this divided awareness they followed the thinking of most Catholic and main-line Protestant leaders, for whom spiritual equality was a private, internal matter and so was no justification for upsetting or opposing the established social order. The reaction against those who took the spiritual message to be a social, political, or economic one was sharp and swift, whether they were German peasants in 1525, English Diggers and Ranters in the 1640s, or Anabaptists throughout Europe in the sixteenth century.

Some women did feel, however, that spiritual equality or divine inspiration allowed them to speak or write about all matters concerning the church, including doctrine, church government, and finance. They were castigated for this approach, not only because they had no formal theological or legal training, but also because such matters were seen as public issues. Women were free to write and speak on religious matters as long as these were private and familial; prayer books, religious poetry, books of religious instructions for children, and devotional literature were perfectly acceptable. Sermons, exhortations, theological treatises, or doctrinal statements were not, however, both because they were more often presented publicly and because they concerned the church—any church, whether Protestant or Catholic—as a public institution.

Women challenged this division between private and public. They argued either that the Spirit had indeed given them the right to address public religious matters or else that there simply was no basis for division between public and private in matters of religion. Argula von Grumbach based her argument on Matthew 10, 11–14, noting that cities, towns, and households are all held equally responsible for their "worthiness" before God; thus the borders of concern and activity for the pious housewife were at least the town walls, if not beyond.58 Katharina Zell agreed, noting, "I have never mounted the pulpit, but I have done more than any minister in visiting those in misery. Is this disturbing the peace of the Church?"59 Like the Strasbourg women opposing the imposition of guardians, these women saw a continuum from the household to the world beyond rather than a sharp split between public and private.

In a variety of realms of life, the Renaissance experienced the "new division between public and private life" that Kelly describes, a division which continued to grow until it had expanded into a chasm

by the nineteenth century. The period also saw opposition by women both to that division itself and to their being relegated to the private sphere. Widows, working women, writers, medical practitioners, midwives, and female religious thinkers all defined a "public role" somewhat differently. For some, it was the ability to bring their own suits to court; for others, the right to keep operating a shop, to use skills they had mastered, or to support their families or defend their church; for still others, the opportunity to write something that would be remembered forever.

Women's arguments often involved setting themselves apart from other women because of their particular economic situation, strength of intellect, or contact with God, and thus they sound anti-feminist. As restrictions increased, however, these women also showed the beginnings of a recognition that their situation and circumstances resulted more from their sex than from their social status, economic class, or innate abilities; they showed, in other words, the beginnings of what we might call a feminist analysis of their situation. They usually presented their cases only in individualized terms, either because they felt this approach would be more effective, they really did perceive their circumstances as extraordinary, or they did not realize the larger implications of their arguments; however, a few spoke for all women: "This is a fine and honorable female trade"; "Women have more trust in other women"; "What I want for our sex is to see it outstrip men"; "The Lord hath regard unto and takes notice of women"; "Such are fine things for women to do." Thus one of the unforeseen results of the sharp public/private, male/female division was individual women's own realization that society viewed them, first of all, as women; and that any claim to a public role would have to be based on either a rejection of their female nature or on support for all women. Women since the Renaissance have faced the same choice.

NOTES

This article was written in response to one of the workshops in the conference "Changing Perspectives on Women in the Renaissance" at The Newberry Library in May 1983, and it specifically addresses the question posed by that workshop: "How free were women in the Renaissance?" It is very much a working paper, exploring a wide variety of disparate material with that particular question in

mind, rather than culminating extensive research on one particular aspect of the issue. Much of the German material comes from city archives where I was carrying out research on working women. My thanks to the American Council of Learned Societies and the Deutsche Akademische Austauschdienst (DAAD) for their support for that research. All translations are my own, unless otherwise noted.

1. Joan Kelly-Gadol, "Did Women Have a Renaissance?" in *Becoming Visible: Women in European History,* ed. Renate Bridenthal and Claudia Koonz (Boston: Houghton Mifflin, 1977), p. 139.

2. *Ibid.,* p. 160.

3. Natalie Zemon Davis, "City Women and Religious Change," in her *Society and Culture in Early Modern France* (Stanford: Stanford University Press, 1965), p. 94.

4. Wilhelm Ebel, *Forschungen zur Geschichte des lübischen Rechts* (Lübeck: M. Schmidt-Römhild, 1950); Luise Hess, *Die deutschen Frauenberufe des Mittelalters* (Munich: Neuer Filser-Verlag, 1940), p. 52; A. Abram, "Women Traders in Medieval London," *Economic Journal* 26 (June 1916):280; Inger Dübeck, *Købekoner og Konkurrence* (Copenhagen: Juristforbundets Forlag, 1978), pp. 184ff.

5. Strasbourg, Archives municipales (SB), Statuten, Vol. 24, fol. 62 (1464), Vol. 18, fol. 104 (1471); Augsburg, Stadtarchiv (AB), Verordnungen, Vol. 16, fol. 272–73 (1615), Anschlage und Dekrete, "Erneuerte Witwen und Waisenordnung" (1668).

6. SB, Akten der 15, 1633, fol. 26; Frankfurt, Stadtarchiv (FF), Bürger-meisterbücher 1608, fol. 184, 1609, fol. 136; Munich, Stadtarchiv (MU), Rat-sitzungsprotokolle, 1522; Stuttgart, Hauptstaatsarchiv (ST), 1540 Witwen und Waisen Ordnung. My specific examples here are all German, but similar developments were occurring in other parts of Europe, as Natalie Davis has discovered in Lyons ("Women on Top," in *Society and Culture,* pp. 124–51) and Pearl Hogrefe in England ("Legal Rights of Tudor Women and their Circumvention by Men and Women," *The Sixteenth Century Journal* 3 (April 1972): 97–105.

7. SB, Statuten, vol. 18, fol. 104 (1477).

8. Die Aelteste Schriften Geiler von Kaysersberg (Freiburg, 1877).

9. Heide Wunder, "Frauen in den Leichenpredigten: Personen, Bilder, Rollen?" unpublished paper.

10. I am grateful to Lyndal Roper for pointing this out to me, both in private conversation and in her unpublished paper, "Urban Women and the Household Workshop Form of Production: Augsburg 1500–1550."

11. Heide Wunder sees this recognition of the wife's authority within the household and of her importance to the smooth operating of society as the reason that there were numerous funeral speeches for women not only written and given, but also printed. (See note 9 above.)

12. Karl Bücher and Benno Schmidt, *Frankfurter Amts- und Zunfturkunden bis zum Jahre 1612* (Frankfurt: J. Baer, 1914) and numerous guild ordinances in city archives.

13. MU, Ratsitzungsprotokolle, 1461, fol. 39 & 42; SB 15, 1612, fol. 201, 1634, fol. 116, 127; FF, Bürgermeisterbücher 1580, fol. 189b; FF, Zünfte, C–54M (1640); Ugb. D3L (1588 & 1596), Ugb. C59, Gg; Memmingen Stadtarchiv (MM), Hutmachern 51, Nr. 3 (1613); Nuremberg Staatsarchiv (N), Ratsbücher, 2, fol. 282 & 318 (1479), 2, fol. 31 (1475), 11, fol. 324 (1520), 22, fol. 236 (1544).

14. FF Zünfte, Ugb. C–32, R no. 1 (1663). Widows' supplications and requests can be found in many city archives.

15. Claus-Peter Clasen, *Die Augsburger Weber: Leistungen und Krisen des Textilgewerbes um 1600* (Augsburg: Verlag Hieronymus Mühlberger, 1981), pp. 130–32.

16. SB, 15, 1584, fol. 121.

17. Hess, *Die deutschen Frauenberufe des Mittelalters*, p. 101. Helmut Wachendorf, *Die Wirtschaftliche Stellung der Frau in den Deutschen Städten des Späteren Mittelalters* (Quackenbrück: C. Trute, 1934) pp. 23–26; Karl Bücher, *Die Berufe der Stadt Frankfurt a. M. im Mittelalter* (Leipzig: B. G. Teubner, 1914); Gerd Wunder, "Die Bürgerschaft der Reichsstadt Hall von 1395–1600," *Württembergische Geschichtsquellen*, vol. 25 (Stuttgart: W. Kohlhammer, 1956); FF, Bürgermeisterbücher 1436, fol. 17, 1446, fol. 47, 1491, fol. 96.

18. *Collectio Salernitana*, III, p. 338, quoted in *Not in God's Image: Women in History from the Greeks to the Victorians*, ed. Julia O'Faolain and Lauro Martines (New York: Harper and Row, 1973), p. 165.

19. Karl Weinhold, *Die Deutschen Frauen in dem Mittelalter* (Vienna: C. Gerold, 1851) 1:160; ST, Polizeiakten A–38, Württembergische Landesordnung; AB, Schätze, no. 282.

20. Handwerksakten Barbierer und Wundärzte, Nov. 21, 1571, quoted in Roper, p. 17.

21. MM, Zünfte, 405, no. 12 (1603).

22. MU, Gewerbeamt, no. 9.

23. SB, 15, 1619, fol. 74 and 179; 1665, fol. 15–83 *(passim)*; FF, Zünfte, Ugb. C–32, R1 (1663); D–24, L4 (1698); Dübeck, pp. 395–404.

24. Carol Gilligan, *In a Different Voice* (Cambridge, Mass: Harvard University Press, 1982), p. 73.

25. FF, Ugb. D–24, L4, Bierbrauer (1698).

26. Ebel, pp. 110, 121; MU, 867, Schuldsachen (1598); SB, Grosse Ratsbuch, no. 89 (1552); *Nürnberg Reformation 1564*, section 27:6; *Frankfurt Reformation* (Frankfurt, 1578) Part 3, Tit. 7, p. xii.

27. Quoted in Natalie Zemon Davis, "Women in the *Arts Mécaniques* in Sixteenth Century Lyons," in *Lyon et l'Europe: Hommes et Sociétés* (Lyons: Presses Universitaires de Lyon, 1980), p. 155.

28. *Ibid.*, p. 139.

29. Judith Brown, in an unpublished paper entitled "A Woman's Place Was in the Home: Women's Work in Renaissance Tuscany," links this with patterns of employment in Renaissance Florence as well. She finds no women in occupations such as itinerant vendors, which did not require extensive training or capital

investment and did have flexible hours (and thus would be possible for women with household chores), precisely because this was a publicly visible role. This is very different from the situation in northern Europe, in which no objection was made to female vendors or market-women on the grounds of their sex; they were frequently charged with hoarding, over-charging, making too much profit, selling spoiled food, or deceiving their customers, but so were male vendors. Brown finds particular opposition to women selling not only because they might be led into immoral behavior, but because they might talk other women into buying something they didn't need—hadn't Eve talked Adam into something?—and thereby hurt their husbands. The exclusion of women from public life was so thorough that one commentator noted in 1610: "In Florence women are more enclosed than in any other part of Italy; they see the world only from the small openings in their windows." One is tempted to link this with the Florentine humanists' attempts to return to the values of classical Athens, where the cloistering of citizen women within the house was even more complete, though the humanist writers never specifically mention this. In comparing the Italian situation with that of northern Europe, one is struck by how much earlier a sharp division between public and private was made in Italy, and how much more often this division came about as a conscious move based on moral grounds—like protecting women's honor. In Northern Europe, the division was more gradual, and often came about as the unintentional result of something else—for example, the effort of Strasbourg to prevent the erosion of the city tax base, as noted above. At this point, I have not discovered any objections by Florentine women which would parallel those of the French and German women discussed above, although they probably exist somewhere. Brown does note the fact that opportunities for paid employment were increasing for Florentine women during the Renaissance as the silk industry expanded, which was work that could be carried out within the home. Thus their objections to restrictions in other fields may have been muted somewhat by the expanded opportunities in sericulture, silk-winding, and weaving.

30. From the text published by A. Segarizzi in his "Niccolò Barbo, patrizio veneziano del secolo XV e le accuse contra Isotta Nogarola," *Giornale storico della letteratura italiana* 43 (1904): 53, quoted and translated by Margaret L. King, "Thwarted Ambitions: Six Learned Women of the Early Italian Renaissance," *Soundings* 76 (1976): 284.

31. *Carmina* in the *Opera* (Basel, 1570), quoted and translated by Roland H. Bainton in *Women of the Reformation in Germany and Italy* (Minneapolis: Augsburg Publishing House, 1971), p. 254. Similar sentiments are expressed by Madeleine des Roches (1520–1587), quoted in Tilde Sankovitch's essay, "Inventing Authority of Origin: The Difficult Enterprise," published in this volume.

32. King, "Thwarted Ambitions," *passim.*

33. Ruth Kelso, *Doctrine for the Lady of the Renaissance* (Urbana: University of Illinois Press, 1978), p. 25; and Ann Jones, "City Women and their Audiences: Louise Labé and Veronica Franco," unpublished paper, p. 1.

34. Margaret L. King, "Book-Lined Cells: Women and Humanism in the Early Italian Renaissance," in *Beyond Their Sex: Learned Women of the European Past*, ed. Patricia H. Labalme (New York: New York University Press, 1980), p. 78.

35. Translated and quoted in Sankovitch. Catherine's ambivalence and the complex symbolism surrounding the pen and spindle—both may be identified with the penis, and the latter also with the female sexual organ in virginity as well as the mindless, female task of spinning—has been thoroughly analyzed within the context of recent feminist literary criticism by Sankovitch in this paper.

36. Cassandra Fedele, *Epistolae et orationes* (Padua, 1636), p. 193 and Laura Cereta, *Epistolae* (Padua, 1640), p. 122, quoted and translated by King in "Book-Lined Cells," pp. 71 and 73.

37. Cereta, p. 192, quoted and translated by King in "Book-Lined Cells," p. 73.

38. As Hilda Smith has recently noted, sixteenth-century defenses of women, written by both men and women, always include a list of "women worthies," women who have transcended their sex and made important contributions. These were implicitly anti-feminist, however, as they suggested that women could live up to male standards of accomplishment and action if only they tried hard enough. Hilda L. Smith, *Reason's Disciples: Seventeenth-Century English Feminists* (Urbana: University of Illinois Press, 1982), p. 7.

39. J. Aynard, ed., *Les Poétes Lyonnais Précurseurs de la Pléiade* (Paris: Bossard, 1924), pp. 157–59, quoted and translated in *Not in God's Image*, ed. O'Faolain/Martines, pp. 184–85.

40. Smith, *Reason's Disciples, passim*.

41. Quoted in Natalie Zemon Davis, "Gender and Genre: Women as Historical Writers, 1400–1820," in Labalme, *Beyond Their Sex*, p. 164.

42. *Salve Deux Rex Judaeorum* . . . (London: Valentine Simmes for Richard Bonian, 1611), quoted in Betty Travitsky, *The Paradise of Women: Writings by Englishwomen of the Renaissance* (Westport, CT: Greenwood Press, 1981), p. 98.

43. *Poems by that most Famous Wit, William Drummond of Hawthornden* (London: R. Tomlins, 1656), in Travitsky, *The Paradise of Women* pp. 139–40.

44. *A Mouzell for Malestomus*. . . (London: Nicholas Okes for Thomas Archer, 1617), in Travitsky, *The Paradise of Women*, p. 152.

45. Labalme, *Beyond their Sex*, pp. 27–28.

46. *Mortalities Memorandum with a Dreame Prefixed* (London: Edward Griffin for Jacob Bloome, 1621), in Travitsky, *The Paradise of Women*, p. 132.

47. *A handfull of holesome (though homelie) hearbs* . . . (London: H. Denham, 1584), in Travitsky, *The Paradise of Women*, p. 146.

48. "Wie ain Christliche Fraw des Adels . . . Sendtbrieffe/die Hohenschul zu Ingolstadt" (1523), quoted and translated in Bainton, *Women of the Reformation in Germany and Italy*, pp. 97–98.

49. Th. Kolde, "Arsacius Seehofer und Argula von Grumbach," *Beiträge zur Bayerischen Kirchengeschichte* XI (1905), quoted and translated in Bainton, *Germany and Italy*, p. 104.

50. Idem.

51. Milton D. Speizman and Jane C. Kronick, "A Seventeenth-Century Quaker Women's Declaration," *Signs* 1 no. 1 (Autumn 1975): 237.

52. Bainton, *Women of the Reformation: From Spain to Scandinavia* (Minneapolis: Augsburg Publishing House, 1977), pp. 10–11.

53. Bainton, *Germany and Italy,* p. 100.

54. Robert Stupperich, "Die Frau in der Publizistik der Reformation," *Archiv für Kulturgeschichte* 37: p. 226. Susan C. Karant-Nunn has also found that women preaching in Zwickau in the 1520s claimed to be divinely inspired. ("Continuity and Change: Some Effects of the Reformation on the Women of Zwickau," *The Sixteenth Century Journal* 13, no. 2 (Summer 1982): 37–38.

55. *Ein Christlicher bericht* . . . (Mainz, 1550), in "Literarische Gegnerinnen Luthers," *Historische-politische Blätter für das Katholische Deutschland* 139 (1907): p. 382. Teresa of Avila also expressed the same sentiments, as noted in Bainton, *Spain to Scandinavia,* p. 60.

56. Keith Thomas, "Women and the Civil War Sects," *Crisis in Europe, 1560–1660,* ed. Trevor Aston (Garden City, NY: Doubleday, 1967), p. 355.

57. *The Markes of the Children of God* (London, 1609), in Bainton, *Spain to Scandinavia,* p. 93.

58. Stupperich, "Die Frau," p. 223.

59. "Ein Brief an die Genze Bürgerschaft der Stadt Strassburg . . ." in Bainton, *Germany and Italy,* p. 72.

2

The Heroics of Virginity

Brides of Christ and Sacrificial Mutilation

JANE TIBBETTS SCHULENBURG

"Male ulciscitur dedecus sibi illatum, qui amputat nasum suum."
Peter of Blois, *De Hierosolymitana peregrinatione acceleranda*[1]
"Qui son nez cope deshonore son vis."

Garin le Loheren[2]

THE RATHER CURIOUS EPIGRAM "to cut off your nose to spite your face" can be found for the first time in the sources of the twelfth century. Peter of Blois, writing in the late twelfth century, notes that this phrase was already a popular proverb *(proverbium vulgare)*, perhaps indicative of an earlier origin.[3] The source and original meaning of this rather bizarre and graphic epigram seem to have escaped scholarly inquiry; however, a rather exciting and viable possibility will be advanced in the course of this examination of the heroics of virginity.

This study explores the ideal of virginity, a mindset especially crucial to women in the early medieval period, focusing on the ecclesiastical preoccupation with sexual purity for women, the virginal conditioning of women in religion, and the often necessary prerequisite of virginity for sanctification. It will specifically examine the aggressive defense of female saints when confronted with sexual assault during the early Middle Ages (approximately 500–1100). It is indeed a tentative effort to explore a rather extraordinary but yet unprobed area of medieval mental attitudes and responses.

In order to understand the dramatic defenses of these medieval women, it is necessary to approach the mental climate of this early period through a brief survey of patristic and early monastic writings on virginity. For the heroics of virginity reflect in part a combination of the rather effective conditioning of these ecclesiastical doctrines along with the Germanic values of the age.

The Magdalene (sixteenth century). By the Master of the Female Half-Lengths. From Friedländer, *Early Netherlandish Painting*, Brussels, A. W. Sijthoff, 1975. *Courtesy of Martinus Nijhoff, Holland.*

THE POLITICS OF *VIRGINITAS*

For much of the Middle Ages the ideal state for woman, the perfect life as articulated by the Church, was that of *integritas,* total virginity, that is, uncorrupted sexual and spiritual purity. In the view of church-men, there was only one way in which women could transcend their unfortunate sexuality and free themselves from their corporeal shackles, and this was through a life of sexless perfection.[4]

Although in the early Church, and within the monastic environ-ment, the rigors of the chaste life were equally upheld for both sexes, an exaggerated emphasis was placed on chastity for women; that is, there was a heavily disproportionate admiration for female virginity.[5] From the beginning, virginity for men was not emphasized in the same way as it was for women. It never dominated the total mode of perception of the male religious, nor defined the parameters for the state of masculine perfection as it did for women. For women, it was the single most essential prerequisite for a life of Christian perfection; and through it they would be granted entry into heaven or the celestial gynaeceum.[6] Therefore, the necessary responses dictated by this value system, the extremes to which individuals might be driven to preserve their virginity in hopes of salvation or ultimate sanctifica-tion, were defined in part by one's sex.

There is a great deal of continuity in the didactic works on virginity. Beginning with St. Paul's injunction on the superiority of virginity, the writings of the Church Fathers firmly implant this concept in the mentality of the Latin West. Tertullian, Cyprian, Ambrose, Jerome, and Augustine are especially articulate in their treatment of virginity for women. In general, the patristic tracts share a dichotomized view of the nature of woman. On the one hand, as ascetics, and in some cases fanatical celibates, they feared and also abhorred female sexuality. Thus their writings focus on the inherent dangers of woman's physical attractiveness for the male celibate. Based on their distorted perceptions of woman, they direct their vituperative tirades against her sensual, lustful, and polluting character. The Church Fathers describe the female body in abusive and disdainful terms. Although deceptively attractive, it was to be shunned as an ugly, repulsive receptacle. They therefore admonish consecrated virgins to negate their visual images so as not to be responsible for seducing "innocent" men, as well as causing the loss of their own chastity.

As part of this double current, these same patristic writers placed the ultimate value on the denial of female sexuality and the espousal of the ideal of total virginity. In this tradition, they have nothing but the highest praise and concern for the virginity of Christian women. The virgin's body was seen as a jewel, a treasure, a sacred vessel to be cherished. As bride of Christ she needed to be carefully guarded so as to remain "unwounded" or "untarnished" for her eternal bridegroom. According to the patristic writers, these Christian models of virginity had successfully repudiated their own sexuality; they had negated their unfortunate female nature; and only in this way were they able to transcend the weaknesses and limitations of their sex. Thus as sexless beings, these virgins were viewed nearly as spiritual equals. For their espousal of virginity, they often won the highest patristic compliment: they were praised for becoming "male" or "virile." For the heroic defenses of their virginal purity, they were often designated as saints/martyrs.[7]

St. Jerome (ca. 340–419), in his celebrated "Letter to Eustochium," provides some of the classic admonitions and encouragements for the life of virginal perfection. In this letter he stresses the need to guard one's virginity with jealous care. A strong eschatological concern underlies his patristic admonitions. The bride of Christ must spend her earthly life alternating between a continual fear of defilement and the steadfast hope of eternal life with her bridegroom, Christ. Jerome warns Eustochium of the hard road that she has chosen to follow: "I do not wish pride to come upon you by reason of your decision [to espouse virginity], but fear. If you walk laden with gold, you must beware of a robber. This mortal life is a race. Here we struggle, that elsewhere we may be crowned. No one walks without anxiety amid serpents and scorpions."[8]

St. Jerome also underlines the very real dangers involved in a virgin leaving her protective environment and venturing outdoors:

> Go not out from home, nor wish to behold the daughters of a strange country. . . . Diana went out and was ravished. I would not have you seek a bridegroom in the highways, I would not have you go about the corners of the city. . . . Your Spouse cannot be found in the broad ways. *Narrow and strait is the way that leadeth to life.* . . . You will be wounded, you will be stripped, and you will say, lamenting: "The keepers that go about the city found me, struck me, wounded me; they took away my veil from me."[9]

Thus if the virgin failed to walk the straight and narrow course and did not endure to the end, Jerome warns that she will not be saved, but rather turned away from Christ's bridal chamber to feed the goats which shall be on the left hand. Again he admonishes Eustochium: "Take care, I pray, lest sometime God may say of you: the virgin of Israel has fallen; there is none to raise her up."10 And of critical importance, Jerome stresses, "although God can do all things, He cannot raise up a virgin after she has fallen. He has power, indeed, to free her from the penalty, but *He has no power to crown one who has been corrupted.*"11

Jerome also skillfully utilizes negative conditioning in his vivid description of the fallen virgin or the virgin daughter/great prostitute who sitteth on the waters. According to Jerome, she shall "no more be called delicate and tender. Take a millstone and grind meal, strip off thy covering, make bare thy legs, pass over the rivers. Thy nakedness shall be discovered and thy shame shall be seen."12 He further elaborates on the great humiliation of the fallen virgin:

[She] shall be stripped and her hinder parts shall be bared in her own sight. She shall sit by the waters of solitude and putting down her pitcher shall open her feet to everyone that passes by and shall be polluted from head to foot. It would have been better to have submitted to marriage with a man, to have walked on the level, than to fall into the depths of hell while striving to attain the heights.13

In contrast to the negative reinforcement and shame-instilling imagery of fallen virgins, Jerome also provides encouragement for virgins who might suffer in maintaining their chastity. He cites St. Matthew: "He that shall persevere unto the end, He says, he shall be saved."14 As a further source of inspiration Jerome furnishes his contemporary virgins with heroic role models, exemplars of early Christian saints and martyrs. He describes the anguish involved in virginal maintenance and then the experience of the joy of victory, rather than having become "slaves forever because of failure to endure a single hour."15 Jerome adds that no task is too difficult for the love of Christ and the wish to ever seek his embraces. He then waxes in glorious detail on the rewards awaiting the undefiled virgin; the splendor of that day when Mary, attended by her band of virgins, and Christ her eternal spouse, shall come to meet her. According to

Jerome, the end result is immense incredible joy, indeed well worth the perseverence and struggle. Although utilizing masculine language, he describes the celestial assemblage to Eustochium as follows:

> Then the hundred and forty-four thousand [virgins] shall hold their harps before the throne and in sight of the ancients and shall sing a new song: and no man will be able to say the canticle except the appointed number. These are they who were not defiled with women, for they have remained virgins. These are they who follow the Lamb withersoever He goeth.[16]

In addition to his encomiums of virginity, Jerome briefly mentions a potential response for virgins threatened with sexual assault, namely suicide. In his *Commentary on Jonah,* he states: "It is not man's prerogative to lay violent hands upon himself, but rather to freely receive death from others. In persecutions it is not lawful to commit suicide *except when one's chastity is jeopardized.*"[17] This position is further supported by Jerome in his *Against Jovinian.* Here he cites a number of examples from Greek and Roman history of pagan virgins who were celebrated for killing themselves in the preservation of their chastity.[18]

It is interesting that St. Ambrose (ca. 340–97), adopts this same stance on suicide in defense of chastity in his work *Concerning Virgins.* Here he responds to his sister Marcellina's concerns about the potential rape of consecrated virgins, and what in fact should be thought of those women who committed suicide rather than permit themselves to be violated. Ambrose notes the basic problem of reconciling selfmartyrdom with the Scriptures which forbid a Christian to kill herself. However, through the use of *exempla* of famous virgin/martyrs (specifically the virgin Pelagia and her mother and sisters, and the blessed Sotheris, who was one of Ambrose and Marcellina's ancestors), Ambrose justifies the practice of suicide in the preservation of virginity.[19]

St. Augustine's *City of God* (413–26) is especially relevant to the mental conditioning of virgins in regard to the maintenance of chastity. In Book I of the *City of God,* Augustine discusses the different appropriate responses required in the face of the present barbarian onslaughts—specifically as they affected the violation of Christian women. Again Augustine is very much concerned with "total virginity," *integritas,* and the interior disposition of the virgin, as well as

her physical incorruptibility. In offering consolation to those women within the Christian fellowship who had been sexually assaulted, Augustine assures them that "violation of chastity, without the will's consent, cannot pollute the character."[20] He elaborates further on this dichotomy between body and soul:

> In the first place, it must be firmly established that virtue, the condition of right living, holds command over the parts of the body from her throne in the mind, and that the consecrated body is the instrument of the consecrated will; and if that will continues unshaken and steadfast, whatever anyone else does with the body or to the body, provided that it cannot be avoided without committing sin, involves no blame to the sufferer.[21]

However he also stresses:

> But there can be committed on another's body not only acts involving pain, but also acts involving lust. And so whenever any act of the latter kind has been committed, although it does not destroy a purity which has been maintained by the utmost resolution, still it does engender a sense of shame, because it may be believed that an act, which perhaps could not have taken place without some physical pleasure, was accompanied by a consent of the mind.[22]

In this statement Augustine then underscores the inevitable relationship which exists between the soul and body, and that corruption of the soul necessarily precedes corruption of the body. The fine line between "innocence" and "guilt" in the case of rape thus rested essentially within the conscience of the woman. In introducing this "pain/lust" concept Augustine then suggests that in some cases it may be believed that women secretly wanted to be raped; that is, the act was actually "accompanied by a consent of the mind" and "some physical pleasure."

After this discussion, Augustine turns to the question of extreme solutions adopted by women in the past in response to sexual assault. He notes that some women committed suicide in order to avoid being subjected to rape; this action should be excused but not totally condoned. He reiterates that when a woman has been violated without her consent, and forced by another's sin, she has no reason to punish herself by a voluntary death; still less, he contends, before the

event (in anticipation of rape), in case she should commit murder while the offense, and another's offense at that, still remains uncertain. He maintains that in these cases guilt is attached only to the rapist and not at all to the woman forcibly raped.[23]

Augustine contrasts the behavior of contemporary Christian women with that of the famous pagan hero, Lucretia, who had committed suicide to protect her chastity. He notes approvingly that when they were raped, they did not kill themselves for another's crime; rather, they bore this crime with Christian patience and resignation.

> They would not add crime to crime by committing murder on themselves in shame because the enemy had committed rape on them in lust. They have the glory of chastity within them, the testimony of their conscience. They have this in the sight of God, and they ask for nothing more. In fact there is nothing else for them to do that is right for them to do. For they will not deviate from the authority of God's law by taking unlawful steps to avoid the suspicions of men.[24]

Thus in contrast to Ambrose and Jerome, Augustine contends that Christians were not permitted to commit suicide "to prevent themselves, and not others, from sinning for fear that their own lust might be excited by another's and that they might consent."[25]

In addition to the patristic writings on the maintenance of virginal perfection and potential responses to sexual assault, papal pronouncements and canons of Church councils dealt with these issues. Of special interest is the position taken by Pope Leo I (440–61) in a letter to the bishops of Africa. Here he maintains that the servants of God who lost the purity of chastity (*integritatem pudoris*) through the violence of the barbarians will be praiseworthy in their modesty and feeling of shame, *so long as they dare not compare themselves to unpolluted virgins.* Although certainly each sin arises out of the will, the body alone will be corrupted and the soul will remain intact.[26] In another section of the letter, Pope Leo also argues that those virgins who had to support the violence of the barbarians were not to be punished; for while the body alone would be corrupted, the spirit remained intact. Moreover, if they persevered in their chastity, it was necessary to readmit them into the bosom of the community. Again the pope states that it was unjust to blame or reprimand these women

because it was not of their own free will that they lost their chastity but by the force of the enemy.[27] It is interesting that his insistent repetition that women were not to be blamed or punished for their own victimization seems to be directed against an underlying assumption of their basic guilt and complicity in the act. Also the difficult, if not intolerable position in which these violated female religious now found themselves should be underlined. They were shamed, ostracized; they no longer dared to compare themselves to virgins, nor were they to be considered as widows; and only if they "proved themselves" through rededication and perseverance in chastity would they be readmitted into the Church.

In the monastic literature of the early Middle Ages one finds repetition and elaboration of the patristic ideas on virginity. For example, the didactic tract, *De Laudibus Virginitatis* by Aldhelm (d. 709), directed to Abbess Hildelitha of Barking Abbey, further reinforces the patristic exhortations for the life of virginal perfection.[28] This work borrows heavily from Sts. Cyprian, Ambrose, Jerome, and other Church Fathers, and was immensely popular up to the Norman Conquest. In this encomium, Aldhelm underscores the need for total virginity: "integritas" is the queen of all virtues and the fruit of perpetual virginity.[29] Aldhelm thus encourages his "gymnosophists" in the heroic perseverance of maintaining a pure, uncontaminated form of chastity.[30] His work is filled with specific virginal references such as "pure," "intact," "incorrupt," "inviolable," "uncontaminated," etc. He sees the glory of virginity as sister to the angels: "virginitas soror est angelorum."[31] Also, in the patristic tradition, Aldhelm describes in vivid detail the apocalyptic rewards awaiting the virgin who perseveres to the end in a life of unblemished chastity.

However of special interest to the topic of the heroics of virginity is the long section of Aldhelm's tract which is dedicated to the specific problem of the preservation of virginity against sexual assault. He writes, "Therefore great is the privilege of purity, which someone who by force was compelled to give up, if on account of this hateful human coupling she willingly deprived herself of ordinary life, she will be gloriously honored in the heavenly bedchamber among the 144,000 singing with one voice the virginal song."[32] Aldhelm then cites the historian Eusebius, Bishop of Caesarea (d. 399), who provides evidence of virgins devoted to God "who in order to preserve the virtue of chastity threw themselves headlong

into the channel of the river."³³ He also notes a "certain Father [St. Jerome] who says it is not permitted to perish by one's own hand, *except to that end when chastity is jeopardized*."³⁴

Aldhelm's exhortation to the nuns of Barking Abbey continues with a lugubrious account of the violent conditions of his own age, and therefore the special dangers and difficulties involved in the maintenance of virginity. He thus encourages his nuns to espouse the heroics of virginity:

> Even though she [the virgin] was struck by the drawn sword and was without the outward sign of her chastity which had remained intact in the genitals alone, she preferred to die in a cruel manner run through by the sharp point of a sword, rather than to defend her life by profaning the duties of chastity, never fearing the danger of the soul if the condition of her intact virginity was preserved by the pouring forth of blood.³⁵

After this section of his encomium of virginity, Aldhelm then presents as encouragement to contemporary nuns, a very long and impressive catalogue of female and male saints. Especially prominent are those women who had won the "palm of virginity and triumph of martyrdom" and therefore served as models for the nuns of Barking Abbey. Included among these illustrious *exempla* were such early Christian saints as Cecilia, Agatha, Lucy, Eustochia, Eugenia, Agnes, Tecla, Eulalie, etc.³⁶ Their shortened *vitae* emphasized the excessive tortures and trials endured by these women when faced with the loss of their virginity. Their model lives were to be kept before the eyes of the nuns to underline the reality that virginity entailed inordinate struggle, aggressive defense, but also ultimately great rewards.

Thus within the violent context of his own age, Aldhelm, like Jerome and Ambrose, advocates suicide as a positive means of virginal defense. He assures his contemporary readers that those who had sacrificed their earthly/physical lives in the maintenance of virginity would receive, as brides of Christ, eternal rewards.

The popular Old English poem *Judith* (ascribed to the early tenth century), also provided an important *exemplum* for early medieval nuns and the defense of their virginity. According to the *Apocrypha,* Judith, the wise and devout widow of Manasses, delivered her city of Bethulia from the siege of the Assyrian general, Holofernes. As the chosen instrument of God, she used her great beauty to lure

the general to his destruction. Through this means, Judith succeeded in beheading Holofernes and rescuing her people without compromising her chastity or honor. However the poet of the Anglo-Saxon poem refashioned the historical Jewish widow/heroine into a bold virgin who espoused the ideals and values of the early Christian period. According to the epic, Judith's ability to maintain her chastity against the advances of Holofernes, and her heroic act of killing him, were essentially predicated on her virginal purity. For virginity contained in itself extraordinary power; it was credited as the source of Judith's invulnerability.[37]

It is of interest to note that this popular poem was written during the period of the Danish invasions of England and the prefiguration of the hostile Danes by the pagan Assyrians was astutely noted in the sources of the time.[38] And indeed the role model of Judith seems to have been especially pertinent to contemporary nuns/virgins faced with similar threats of sexual assault at the hands of the Viking invaders.

In the late tenth century, Aelfric, an Anglo-Saxon abbot, appended a moral to the poem *Judith* which was directed to contemporary nuns. Here Aelfric emphasizes the seriousness of the commitment to consecrated virginity and stresses that to be worthy of becoming *sponsa Christi* necessitated great struggle. The life of one committed to God he describes as a "martyrdom," with nuns specifically denoted as "Christ's martyrs."[39] In order to maintain their untarnished chastity they must be involved in daily battle. Aelfric also underlines the guilt before God of those who had broken their vows of chastity. He thus elaborates upon the fate of lapsed virgins and their future punishments in hell.[40] As Sr. Mary Byrne notes: "But lest the nuns to whom he is directing the moral lose confidence in their power to resist evil as Judith had resisted it, he explains to them . . . that maidenhood and purity contain in themselves very great might."[41]

Although male ecclesiastical writers monopolized this didactic tradition which celebrated virginity and emphasized the need for virginal maintenance, one important example of the *vox femina* is that of Hrotswitha of Gandersheim. A tenth-century writer within the monastic tradition, she herself interprets her name as meaning the "strong voice" of Gandersheim.[42] As a product of her age and a German nun, Hrotswitha shares with her male ecclesiastical contemporaries a deep concern about the need for female virginity. Her dramatic works focus on hagiographic *exempla*. They exalt early

Christian female saints/martyrs and the defense of their chastity against pagan lechery. Her plays were thus written to demonstrate women's steadfast adherence to their vows of chastity and to encourage similar heroics among her sisters. Her writings are especially relevant for a female monastic audience and portray strong, forceful virgins successfully resisting temptation and seduction. In her preface she stresses that the greater the struggles or temptations, "the greater the merit of those who resist, especially when it is fragile woman who is victorious and strong man who is routed with confusion."[43] Thus encouraged by eschatological rewards, her heroines die glorious "happy" deaths after fearlessly preserving their virginity.

Therefore this didactic campaign, with its extravagant praise of virginal perfection, as well as its fear- and guilt-instilling mechanisms perpetuated by the loss of virginity, was an essential part of the female religious experience in the early medieval period. The importance of the basic male ordering of female values and their control of female sexuality—with the constant repetition of these ideals and behavioral models, as well as women's accommodation to these mindsets— needs to be underscored. Patristic and monastic treatises, homilies, and lives of saints were read to the nuns during their meals or read privately during their reading periods. In their *scriptoria* they copied, glossed, and illuminated these works. They embroidered religious vestments and hangings vividly depicting scenes from the lives of virgin/martyrs. They also no doubt received continual visual reminders and encouragement of virginal maintenance through the sculptural programs of their cloisters and churches, as well as from wall paintings and hangings, manuscript illuminations, etc. They saw or performed plays focusing on themes of virginity. This ideology was further underlined in their regular services, sermons, prayers, hymns, and saints' days. The major emphasis, for example, in the ceremony of the nun's final vows was placed on the necessity of preserving one's virginity "entire and spotless" so that she would be "worthy of the virgin's crown."[44]

Thus through this brief survey of early medieval didactic literature written for religious women, there emerges a very real concern or even obsession with the perfect life which entailed the preservation of total virginity. The virgin must at all costs remain both spiritually and physically intact. However, before turning to the heroics of virginity, it is necessary to mention that although the Church was especially singleminded and articulate in its establishment of virginity

as *the vita perfecta* for women, this religious ideal also merged with the Germanic tradition.

Very briefly, the Germanic peoples seemed to place an equally high value on sexual purity for women. *The Germania,* by Tacitus, the Germanic law codes, and other sources, all underline the high value allotted to chastity, along with the serious punishments exacted for women accused of losing their virginity or involvement in adultery. Generally Germanic women were made to assume a disproportionate amount of the blame and humiliation in the loss of their sexual purity. The onus of the crime was placed on the female for her complicity in this "evil act."[45] The Germanic peoples also provided their own *exempla* of heroic behavior in defense of chastity. For example, the Cimbri women were especially celebrated for banding together against the Roman conquerors to preserve their chastity and freedom. After killing their children, they allegedly hanged themselves with ropes and the reins of horses. This was done in order that their chastity would not be dishonored and also to avoid subjection to the derision of the conquerors.[46]

Thus the early medieval Christian tradition of the heroics of virginity shared with pagan Germanic society a high value on sexual purity/chastity. And it appears that the newly converted Germanic women found it especially easy to assimilate the essential Christian ideals and practices of virginity with their own values. Nevertheless, the problems of theory and reality demonstrate that the actual commitment to put into practice these ideals would continually be tested by the violence and disorders of early medieval society.

PRACTICE: THE HEROICS OF VIRGINITY

In practice, the monastic institutions of the early Middle Ages met the needs of many religious women concerned with espousing a life of virginity and future heavenly rewards. Monasticism also afforded for the first time an honorable alternative to forced marriages and provided an effective escape from the very real fears and dangers of childbirth. Members of the religious community received an excellent education and a chance for a certain amount of autonomy, independence, and power. Also the institution theoretically offered consecrated virgins a haven; it was compared to an ark which would

shelter these women from the tempests and perils of the world.[47] The monastery was to protect its "holy fold" from the "jaws of the spiritual wolves."[48] However the chronicles, councils, laws, charters, letters, and saints' lives of the period all tell us something quite different: these monasteries and their inhabitants were instead often primary targets of violence, rape, and plunder.

The monastic rule of Caesarius of Arles, written for his sister Caesaria (6th c.), responded to the special needs of women in his diocese who wanted to live the virginal life but were faced with the constant fear of becoming victims of attack. One of Caesarius' basic concerns was therefore with a protective, urban setting for women's monasteries. He developed a model convent in his diocese situated within the walls of the city. Its location thus provided protection from the attacks of the invaders.[49] Also, fearing for the safety of his nuns, Caesarius instituted a policy of strict protective enclosure. He warned in his *Regula:* "If a girl leaving her parents, desires to renounce the world and enter the holy fold to escape the jaws of the spiritual wolves by the help of God, she must never, up to the time of her death, go out of the monastery, nor into the basilica, where there is a door."[50]

The need for strict claustration as a response to the extreme disorders and violence of the period can also be found in the establishment of other monasteries for women. For example, the *Regula monacharum,* originally found among the works of St. Jerome but perhaps dating to the ninth century, was concerned with problems of security for nuns and the primary need of protecting their virginity through enclosure. The Rule warns:

On account of this, dearest one, let your convent become your tomb: where you will be dead and buried with Christ, until rising with Him you will appear in His glory. Finally, the thing that is most frightening to the one lying in a burial mound is the grave robber who sneaks in at night to steal precious treasure. Thieves dig this up, to steal with infinite skill the treasure that is inside. Therefore the tomb is watched over by a bishop whom God installed as the primary guardian in His vineyard. It is guarded by a resident priest who discharges his duty on the premises: so that no one enters recklessly nor that anyone tries to weaken the tomb. . . . Believe me "there is fear for a treasure in the dead of night. From an arrow flying in daylight, from trouble walking around in shadows, from attack and the Devil at midday." All hours should be suspect to chaste minds.[51]

There are a number of other indices which point to an uneasiness of the period and the special need for safeguarding the female religious. For example, the chronicles of the time note the violation of nuns, especially by the royalty or nobility. Gregory of Tours in his *History of the Franks* reports devastation in the Limousin area by Theudebert, son of Chilperic: "He burned the churches, stole their holy vessels, killed the clergy, emptied the monasteries of monks, raped the nuns in their convents and caused devastation everywhere."[52] In a denunciatory letter directed to King Ethelbald of Mercia, Boniface and other bishops condemned the king for his sacrilege of adulterous behavior "committed in convents with holy nuns and virgins consecrated to God."[53] King Edgar (959–75) was also severely reprimanded by the Church for his abduction and violation of nuns.[54] Swein, brother of Harold Godwinson, was chastized for his abduction of Edgiva, Abbess of Leominster, in 1046. After keeping her for a year, he was finally forced through episcopal mandate to return her to her monastery.[55]

In a tract entitled *De coercendo et exstirpando raptu viduarum, puellarum ac sanctimonialium* Hincmar, Archbishop of Reims (d. 882), discusses the conditions of his age and the seriousness of the problem of violence toward women. He notes specifically the devastating effects of the violation of nuns on their vows of chastity and integrity. This work was addressed to the king and implored his help against the brutality and disorders of the period.[56]

Law codes, canons of church councils, and penitentials continually warn of severe punishments for those who dishonored, abducted, violated, or killed women consecrated to God.[57] To provide added deterrents, the reparations established to protect female religious from violence or abduction were usually higher than those required for the same crimes committed against laywomen. For example, *The Lombard Laws* (713–35) warn: "He who abducts such a woman [one who has taken the veil] shall pay 1,000 solidi as composition in order that a case involving someone dedicated to God may exceed [the usual payment] to the amount of 100 solidi; for a composition of 900 solidi has been established in the edict for the abduction of an unconsecrated woman."[58] *The Bavarian Laws* (744–48) discuss the abduction of a nun from her convent. The abductor is required to return the female religious to her monastery, plus pay a compensation of twice that which is customarily owed by one who steals another's betrothed. The law states: "We know that the abduction of another's betrothed is a punishable crime; how much more

punishable is a crime which usurps the betrothed of Christ."⁵⁹ *The Laws of Alfred* (871–99), for example, stipulate: "If anyone in lewd fashion seizes a nun either by her clothes or her breast without her leave, the compensation is to be double that we have established for a lay person."⁶⁰ The repetition of these admonitions seems to point to the very real prevalence of violence toward consecrated virgins as well as the extreme difficulties of maintaining order and providing protection for female religious.

Another index of the special need to safeguard women in the Church can be noted in the number of female communities which were moved for reasons of security from earlier "open sites" to protective sites *intra muros,* within the city walls.⁶¹ Also, in response to the conditions of the time, some female houses were built within castles, while others became strongly fortified and in turn served as shelters for nuns fleeing from the invaders.⁶² Some monasteries were provided with special retreats in case of attack. For example, the very powerful and wealthy monastery of Shaftesbury was given an *ecclesiola* (a little church) with an adjacent manor by King Aethelred II (1001) at Bradford-on-Avon which was to provide the nuns and their precious relics of King Edward with a safe, impenetrable retreat *(impenetrabile confugium)* in case they were attacked at Shaftesbury by the Danes.⁶³

Nevertheless, despite these attempts to provide special protection and security for the monasteries of women, these brides of Christ continued to fall victim to attack. Many convents, along with their nuns, suffered repeated devastation and violence from the Viking, Magyar, or Saracen incursions. We have been rather well informed in regard to the invasions and their effects on the male monastic establishments. Perhaps best known is the sad plight of the Lindisfarne monks whose wanderings lasted nearly a century; or the lugubrious accounts of the monks of Noirmoutier who, fleeing the invaders, ended their migrations at Tournus, more than 300 miles from their original house at Noirmoutier.⁶⁴ However studies of early medieval society have not similarly noted the effects of these incursions on monastic life for women. For example, how did the female monastic communities, their nuns and abbesses, meet this imminent danger? How did they cope with their very real and persistent fears, as well as the reality of rape and the loss of their virginity? How did they respond to the potential destruction and loss of their *raison d'être,* that is, their investment in *integritas,* in total virginity? Indeed, in

facing this "fate worse than death," these brides of Christ had a great deal more to lose than did their contemporary male religious.

Saints' lives, chronicles, and monastic charters of the period tell us that the basic response of most nuns to the invasions was the same as that of the monks: to flee, escape with their relics and treasures (if time allowed), but especially with their lives. In his chronicle, Sigebert de Gembloux describes the disasters provoked by the Vikings. He notes that when they were able, the "sacri ordinis in utroque sexu ministri" hid themselves and their relics from the invaders.[65] The nuns of Whitby, for example, fled from the devastations of the Danes, first to Hartlepool and then, as the invaders approached, on to the strongly fortified monastery of Tynemouth.[66] We learn that two nuns from the monastery of Jouarre escaped from the Vikings and took refuge on the lands of their father.[67] Or according to the *Vita Gudilae*, the nuns of Moorsel suffered greatly from the Viking invasions and perhaps took refuge at Chevremont to escape the invaders.[68]

In surveying the old monastic foundations of Britain, it appears that few houses for women escaped destruction by the Danish invaders. Their litany of woe is indeed rather consistent. Based on Knowles and Hadcock's *Medieval Religious Houses: England and Wales,* at least forty-one monasteries for women (including double houses), were destroyed by the Viking invaders. Thus by the time of the Norman Conquest, there were only nine houses for women still in existence in Britain.[69] Some of these monastic foundations which suffered destruction at the hands of the invaders were unfortunately ill-situated. Sexburga's house at Minster in Sheppey, for example, was a favorite landing place for the Danes and probably suffered repeated devastation from the invaders.[70]

Therefore the sources of the early medieval period mention many houses destroyed by the invaders with their nuns often becoming a new generation of martyrs. St. Osith, a nun of the monastery of Chich (Essex), became one of the first of these virgin/martyrs. She was allegedly beheaded by the Danes for not renouncing her faith.[71] St. Reyneld, another virgin/martyr, was killed by the barbarians in 860; St. Viborada, a recluse of St. Gall, was put to death by the Hungarian invaders in 925; and so the list continues.[72] Barking Abbey, for example, was destroyed in 870 by the Danes when they ravaged the eastern shores of England. According to our sources, all of the nuns of this community were burned alive inside of their

monastery.[73] (As noted earlier in this study, it was for Barking Abbey that Aldhelm wrote his didactic tract entitled *De Laudibus Virginitatis,* which encouraged the heroics of virginity.) Also, in the same year, we learn that the monastery of Ely, the church and its nuns were destroyed together by the Danes under Inguar and Hubba.[74] The sources mention that St. Mildred's monastery in Thanet was plundered and burned by the Danes in 980. Again, during the invasion of 1011, the abbess of St. Mildred's was taken captive by Swein, after which the nuns dispersed.[75]

However there are four rather extraordinary cases in this tradition of the heroics of virginity which emerge from a study of chronicles and hagiographic literature: they are especially arresting and perhaps for some scholars, implausibly dramatic. Needless to say, one must be extremely cautious in the utilization of especially saints' lives as historical sources. Written with a didactic purpose in mind—to edify and persuade, to serve as *exempla,* to inspire or encourage their readers—these sources are rich in fantasy and exaggeration. Mental constructs such as literary *topoi,* paradigmatic or stereotypical examples of saintly behavior, are intertwined with factual, historical information. Yet these limitations do not necessarily reduce the reliability of contemporary hagiography; rather saints' lives are especially invaluable as an indirect index for this early period which witnesses a dearth of source material.[76] On one level, saints' lives inadvertently provide unique details of social and ecclesiastical life found in no other sources of the time. In addition, as Le Goff has noted, they are especially valuable for providing information about the collective consciousness, the mental structures of society.[77] They tell us a great deal about the reality of contemporary beliefs; they mirror social values and concerns. Thus in the study of the collective mentality surrounding the heroics of virginity, the *vitae* of saints and chronicles are especially crucial sources. Although the virginal stratagems celebrated in hagiography and chronicles might initially seem extreme or crude to us today, they should not be summarily dismissed as mere fantasy or hagiographic exaggeration; rather, within the mental structures of the period and corroborated by other contemporary evidence, they reflect a certain reality of the age.

The first case of what might be called "sacrificial self-mutilation" as a heroic response to certain sexual assault can be noted in the south of France at the monastery of St. Cyr, near Marseille (ca. 738.)[78] According to the *Lessons of the Office of Saint Eusebia:*

The virgin Eusebia, of distinguished piety, governed the monastery of nuns that the blessed Cassian founded in the past, in the territory of Marseille, not far from the Church of Saint-Victor. The infidels burst into the monastery, and Eusebia urged the holy virgins, caring more for preserving their purity than their life, to cut off their noses in order to irritate by this bloody spectacle the rage of the barbarians and to extinguish their passions. With incredible zeal, she [Eusebia] and all of her companions accomplished this act; the barbarians massacred them in the number of forty, while they confessed Christ with an admirable constancy. Their bones deposited in the underground Church of St. Victor, are scrupulously honored there. It is the tradition in their monastery, which moved within the walls of the city and had flourished a long time ago under the name of St. Sauveur, that in the past when a virgin was admitted to enter the noviciate or to make her vows, the priest recalled the martyrdom of the Abbess Eusebia and of her companions as a noble example of steadfastness.[79]

Perhaps the best known case of self-disfigurement as an extreme measure of virginal defense is that of St. Ebba and her nuns of Coldingham. Ebba the Younger, daughter of Ethelfred, King of Northumbria, was abbess of the monastery of Coldingham during one of the especially active periods of the Danish invasions (ca. 870). (Coldingham was located on an isolated site on the coast of Scotland overlooking the North Sea.) According to the earliest extant entry, which is found in the chronicle of Roger of Wendover, the invaders "cut the throats of both young and old who came in their way, and shamefully entreated holy matrons and virgins."[80] He continues his description of the "admirable act of the holy abbess Ebba":

The rumour of their merciless cruelty having spread throughout every kingdom, Ebba, the holy abbess of the monastery of Collingham, fearing lest both herself and the virgins of whom she had the pastoral care and charge should lose their virgin chastity, assembled all the sisters and thus addressed them, "There have lately come into these parts most wicked pagans, destitute of all humanity, who roam through every place, sparing neither the female sex nor infantine age, destroying churches and ecclesiastics, ravishing holy women, and wasting and consuming everything in their way. If, therefore, you will follow my counsels, I have hope that through the divine mercy we shall escape the rage of the barbarians and preserve our chastity." The whole assembly of virgins having promised im-

plicit compliance with her maternal commands, the abbess, with an heroic spirit, affording to all the holy sisters an example of chastity profitable only to themselves, but to be embraced by all succeeding virgins for ever, took a razor, and with it cut off her nose, together with her upper lip unto the teeth, presenting herself a horrible spectacle to those who stood by. Filled with admiration at this admirable deed, the whole assembly followed her maternal example, and severally did the like to themselves. When this was done, together with the morrow's dawn came those most cruel tyrants, to disgrace the holy women devoted to God, and to pillage and burn the monastery; but on beholding the abbess and all the sisters so outrageously mutilated, and stained with their own blood from the sole of their foot unto their head, they retired in haste from the place, thinking it too long to tarry there a moment; but as they were retiring, their leaders before-mentioned ordered their wicked followers to set fire and burn the monastery, with all its buildings and its holy inmates. Which being done by these workers of iniquity, the holy abbess and all the most holy virgins with her attained the glory of martydom.[81]

The third incident in this heroic pattern of virginal defense concerns the famous, early medieval Spanish monastery of St. Florentine, just outside Ecija. A later chronicle notes that this was a large monastery of about 300 nuns which strictly followed the rules of St. Benedict and St. Leander (Florentine's brother).[82] And it was during the invasions of the Saracens that the abbess and nuns of the monastery proved that they were true daughters of St. Florentine. Realizing "that the infidels planned to attack their monastery, the nuns feared the danger of being shamed and of losing the treasure of their virginity which they had preserved for so many years. Thus in their attempts to make themselves ugly and detestable they decided to lacerate their faces." The account then notes that, "Their strategy and rather extraordinary plan turned out very well because with it they accomplished their intention: they triumphed over the Moors. For when the barbarians saw the virgins bloody and ugly, they became angry because of this. They therefore killed all of the nuns with the sword, and to the halo and crown of virginity was added that of martyrdom."[83]

A later and historically well-documented case of self-mutilation is that of the blessed Oda of Hainault who died in 1158. A contemporary saint's life describes in some detail Oda's heroics.[84] Despite Oda's personal dedication to virginity and Christ, her parents made ar-

rangements for her marriage. Thus during the wedding ceremony, Oda courageously responded that she would not have this man, nor any other mortal man for her husband, since she had already chosen her heavenly spouse. According to her *vita,* while things remained in confusion at the church, Oda returned home. Fearing what her angered father might do to her, she withdrew to her mother's bedroom where she prayed for God's help. She then took the sword which was hanging at the head of the small bed and cut off her nose. Her saint's life explains that she thus preferred to disfigure the beauty of her outward appearance, namely, to live deformed, than to marry and live in shame a worthless secular life. The author of her saint's life then mentions other holy women, who, when their own chastity had been assailed, either killed themselves with swords, drowned themselves, perished by fire, or fell headlong from a precipice. Because these women chose to die heroically rather than suffer the loss of their chastity, they were revered as martyrs. The author then argues that the virgin Oda's act of self-disfigurement for the love of Christ and the maintenance of chastity was also a major type of martyrdom. She was both virgin and martyr because virginity was not possible without martyrdom. It was then soon after this heroic defense that Oda became a nun, and ultimately was named prioress of a Praemonstratensian monastery.[85]

This same heroic pattern of self-disfigurement is mentioned as a potential response, that is, as a means of virginal maintenance, in the life of St. Margaret of Hungary (d. 1270). According to her saint's life, Margaret refused marriage proposals from the Duke of Poland, the King of Bohemia, and the King of Sicily. When she heard that the pope was dispatching a marriage arrangement for her, she expressed her strong displeasure by responding that sooner would she cut off her nose and lips and tear out her eyes than consent to marriage. Also, when it was reported that the Tartars were invading Hungary, and that among other atrocities they were known for their sexual assault of virgins, Margaret asserted, "I know what I will do: I will cut off my lips *(labia mea detruncabo)* and then when they see me disfigured, they will leave me untouched *(intactam).*"[86]

In general, while the Church provided the ideological context for these desperate acts of virginal defense, the methodology of facial disfigurement which these female religious utilized in their heroics of virginity was part and parcel of the Germanic tenor of the time. Mutilations, although not self-inflicted, were by no means unusual in

this period; rather, they were common injuries or a means of punishment. In the Germanic law codes repetition of this type of behavior is found in the treatment of criminal offenses. For example, eight chapters of the *Lombard Laws* and five chapters of the *Laws of the Alamans* deal with the necessary reparations for cutting off the noses and lips of members of the different classes of society.[87] However during this period the use of facial disfigurement as a type of punishment often seems to have been sex-specific. That is, it was exacted as a chastisement directed specifically toward women who had dared to transgress the laws—especially regulations of sexual behavior. The following provision is found, for example, in the *Laws of Cnut* (1020–23): "If a woman during her husband's lifetime commits adultery with another man, and it becomes known, let her afterwards become herself a public disgrace and her lawful husband is to have all that she owns, and she is to lose her nose and ears."[88] It is also interesting to note that the *Lex Pacis Castrensis* (1158), issued by Frederick Barbarossa, has a provision to keep prostitutes from following his armies. Soldiers caught with these women were severely punished, while the women had their noses cut off "et mulieri nasus abscidetur."[89] Another example of this type of mutilation as specific punishment for female offenders can be noted in Layamon's *Brut* (ca. 1190). It describes one of King Arthur's banquets which ended in a brawl with a number of knights attacking and killing one another. As punishment for their behavior, Arthur specified that the instigator of the fight be buried alive in the fen, his nearest kin beheaded; while "the women that ye may find of his nearest kindred, carve ye off their noses, and let their beauty go to destruction."[90]

No doubt the conviction underlying these punitive measures was that this type of chastisement would be especially devastating to woman, as her physical attractiveness would be totally destroyed. It would make the woman an outcast, so physically repulsive that she would no longer be desirable to any man. Facial disfigurement as a punishment would therefore achieve the desired result: it would terminate woman's adulterous involvements as well as activities in prostitution. Thus during this period of disorder and violence, facial disfigurements were not uncommon as injuries or means of punishment. Although this of course did not make self-disfigurement any less extreme an act, perhaps within the context of the age and in circumstances of extreme desperation, its credibility as a potential methodology adopted by women against sexual assault is increased.

The evidence of self-disfigurement in defense of chastity is

further corroborated by a number of other early medieval hagiographic references. These cases focus essentially on various strategies utilized in avoiding unwanted marriages. According to the saints' lives, these young women prayed for some kind of disfigurement or disease to make them physically "ineligible" for marriage. And in answer to their prayers, they became "miraculously disfigured": they were "made" blind, or became seriously ill, or contracted scrofulous tumors, or even leprosy.

Several of the saints' lives, for example, describe injuries to the eyes. One of the best-known cases is that of St. Brigid. Determined to remain a virgin and to consecrate her life to the service of God, she prayed that some deformity might "save" her from an imminent marriage proposed by her parents. Immediately one of her eyes "burst" in her head, thus destroying all of her beauty. She was then permitted to become a consecrated virgin, and as she knelt to receive the veil, her "lost" eye was miraculously restored.[91]

In this same tradition are a number of interesting cases of virgins who became disfigured through illness in order to avoid unwanted, impending marriages. According to hagiographic tradition, the seventh-century St. Enymia (perhaps the daughter of Lothar II), dedicated herself at an early age to a life of virginity. Despite her wishes, Enymia's parents made plans for her marriage. Thus, in response to her desperate prayers to be spared marriage and to maintain her virginity, she became a leper ("lepra ob virginitatis custodiam"). Soon after her marriage was called off, Enymia's health was restored. And then, with her brother's help, Enymia built a double monastery and became the first abbess of the house.[92]

The *vita* of St. Licinius, Bishop of Angers (seventh century), notes a similar pattern. Against his own wishes Licinius ultimately consented to marriage. But on the eve of his wedding, Licinius' betrothed contracted leprosy. Deeply affected by this, Licinius then resolved to follow his earlier inclination of renouncing the world.[93]

St. Burgundofara (Fara), another seventh-century saint, had been consecrated to God by St. Columbanus. However, when her father agreed to her betrothal, St. Fara contracted a burning fever and her eyes became gravely affected by her crying. It was only after her father promised that he would no longer prevent her from living a life of virginity that Fara found herself completely cured. Later her father gave her lands for a double monastery (Faremoutiers-en-Brie), with St. Fara becoming its first abbess.[94]

Another seventh-century example is that of St. Angadresima,

Abbess of Oroer. According to our sources she was betrothed to a certain Ansbertus. However, for religious reasons, both wished to remain celibate and not marry. They prayed that they would be preserved from carnal love and pleasures, and Angadresima specifically prayed that she might become disfigured ("ut speciositas illius in deformitatem verteretur.") According to the *vita* of Ansbertus, her prayers were favorably received, for her face was soon completely covered with sores and "the most foul leprosy." After a team of doctors was unable to cure her, her father began to understand the problem and asked Angadresima whether she wanted to dedicate her life to virginity. She responded that she would now become the bride of Christ who had himself caused these difficulties to her body. Angadresima then went to Rouen where she received the veil; and as soon as this was accomplished, her former beauty was restored.[95]

Another example in this physiological pattern concerns St. Idaberg/Gisla (d. ca. 770/780) who was said to have been the sister of Charlemagne. She had again chosen a life of virginity only to be forced by her parents into an unwanted marriage. Gisla prayed for some disfigurement to make her ineligible for this earthly union, and consequently she acquired a fever and strumas (scrofulous tumors). It was then revealed that if freed from her nuptials, she would be cured by devouring a fish from the river Lys. By following this remedy she was cured and later became a nun.[96]

A final rather interesting case in this pattern concerns St. Ulphia, an eighth-century virgin/recluse. According to her saint's life, Ulphia's strategy for virginal maintenance and avoiding a forced marriage was feigned insanity. She ran here and there. Her face pale with fasting; bareheaded, with her hair untied, dishevelled and falling over her shoulders, she appeared to be out of her senses. Thus, according to her *vita,* with "this contemptible deception" she was able to "disfigure her beauty" ("pulchritudinem deformare") and to ward off the "carnally panting." She then lived the life of a hermit with the aged St. Domitius.[97]

These cases of leprosy, strumas, temporary blindness, and insanity might initially seem extreme or merely hagiographic convention, *exempla,* stressing the heroic actions condoned by the Church as necessary for the maintenance of chastity. There is also, however, a very strong possibility that these responses reflect reality or actual situations. For example, corroborative evidence can be found in the laws of the period. One law in the *Lombard Codes*

specifically concerns women who became disfigured after their betrothals:

> If it happens that after a girl or woman has been betrothed she becomes leprous or mad or blind in both eyes, then her betrothed husband shall receive back his property and he shall not be required to take her to wife against his will. And he shall not be guilty in this event because it did not occur on account of his neglect but on account of *her weighty sins and resulting illness*.[98]

It is then interesting that both in the law and in hagiographic literature it was invariably the woman, rather than the man, who, perhaps as a last resort, adopted a strategy of affliction, in this way becoming disfigured and thus ineligible for marriage. It seems, therefore, very probable that some these rather fascinating and "devious" maneuvers in defense of virginity actually did occur and perhaps were not all that uncommon. No doubt some of the young girls who had been heavily indoctrinated in the ideals of virginity and then suddenly forced by their families into marriages of convenience might have had an especially strong, even hysterical aversion to the concept of matrimony. Confronted with problems for which they saw neither hope of solution nor satisfactory escape, and limited by social structures which offered no other available or appropriate means to respond to these conflicts, the assumption of a convenient illness or affliction provided a weapon or strategy with which to cope. The public exploitation of adversity and afflictions gave them an effective vehicle to manipulate their family or society; it provided a means to achieve ends which they could not readily attain directly.[99] The strategy of affliction was then a realistic response, an assertive oblique tactic, or a type of "thinly disguised," indirect protest which could be used by women to their advantage. As a limited deterrent, it could be used to gain time in a traumatic situation, to achieve a viable accommodation or, in general, to forward their own demands.[100] Thus confronted with desperate situations, the *mulieres sanctae* might show symptoms mimicking those of many illnesses; or through auto-suggestion they might artificially induce disorders such as temporary blindness, leprosy (hives or other skin diseases), strumas, insanity, etc. While some of these illnesses were no doubt genuine, others seem to have been largely psychogenic/psychosomatic: they originated in, or were aggravated by, the psychic or emotional processes of these young

women. Frequently they appear to have been of spurious inspiration
or simulated. Nevertheless, all of these "miraculous" afflictions de-
scribed in the *vitae* seem to have been diagnosed and treated by the
saints' families and society as indeed real and serious.

Although perhaps less extreme than the cases of self-disfigure-
ment and strategies of affliction are three equally "successful" and also
rather unique examples of the heroics of virginity. The first case can
be found in the *Life of St. Gertrude,* the first abbess of Nivelles (d.
658/664). In response to the violence of the period, St. Gertrude's
mother feared for her beautiful daughter's safety. She therefore took a
pair of shears and cut off her hair in the likeness of a crown, that is,
she tonsured her. According to her saint's life, St. Gertrude rejoiced
that she merited wearing this tonsure for Christ's sake during this
brief life, and that in the future, the integrity of her body and mind
would be worthy of a perpetual crown.[101]

One of the most common and practical strategies of avoiding
forced marriages or sexual assault in the early Middle Ages was that
of "taking the veil." It appears that many young girls and women
entered convents or "took the veil" simply as a means of protection,
without the slightest intention of embracing the monastic life. An
especially fascinating case concerns one of the most famous monastic
refugees from Norman violence, Matilda, daughter of Queen Mar-
garet of Scotland. Eadmer, in his *History of Recent Events in England,*
records Matilda's description of her "taking the veil." In a meeting
with St. Anselm, Matilda denied that she had been dedicated as a
bride of Christ, and also that she had been veiled with her own
consent.

> But, that I did wear the veil, she said, I do not deny. For, when I was
> quite a young girl and went in fear of the rod of my Aunt Christina,
> whom you knew quite well, she to preserve me from the lust of the
> Normans which was rampant and at that time ready to assault any
> woman's honour, used to put a little black hood on my head and,
> when I threw it off, she would often make me smart with a good
> slapping and most horrible scolding, as well as treating me as being
> in disgrace. That hood I did indeed wear in her presence, chafing at it
> and fearful; but, as soon as I was able to escape out of her sight, I tore
> it off and threw it on the ground and trampled on it and in that way,
> although foolishly, I used to vent my rage and the hatred of it which
> boiled up in me. In that way, and only in that way, I was veiled, as
> my conscience bears witness.[102]

Matilda's case was therefore decided in her favor: she was free to dispose of her person in whatever way she legally wished to do so.[103] The council cited as precedent a similar ruling by Lanfranc which dealt with a number of women who, also in fear of being raped by the Normans, had taken the veil for protection.[104]

A final rather extraordinary case of virginal defense concerns the creative strategy of two early medieval Lombard women. Their very simple but effective response to the Avar invaders is found in Paul the Deacon's *History of the Lombards* (ca. 774). He tells us that the two noble daughters of the "abominable harlot" Romilda who had been a traitor to the Avars, did not follow the sensual inclination of their mother.[105] Rather, he writes approvingly:

> But striving from love of chastity not to be contaminated by the barbarians, they put the flesh of raw chickens under the band between their breasts, and this, when putrified by the heat, gave out an evil smell. And the Avars, when they wanted to touch them, could not endure the stench that they thought was natural to them, but moved far away from them with cursing, saying that all the Langobard women had a bad smell. By this stratagem then the noble girls, escaping from the lust of the Avars, not only kept themselves chaste, but handed down a useful example for preserving chastity if any such thing should happen to women hereafter.[106]

This common sense model of virginal defense is incorporated into later works as a "useful example." Indeed, Christine de Pizan cites it in her *Book of the City of Ladies*.[107] This edifying strategy is also referred to in François de Billon's work, *Fort inexpugnable de l'honneur du sexe Femenin* (1555).[108]

We have thus surveyed a wide variety of fascinating heroic responses allegedly utilized by early medieval women threatened by sexual assault or forced marriages. However taken together, the chronicles, laws, and lives of saints reinforce the credibility of the adoption of self-mutilation by certain enthusiastic religious women as an extreme response to the desperate straits of the period.[109] It is also of interest to note that these acts of self-disfigurement are recorded as occurring in rather diverse areas (that is northern England, northern and southern France, and Spain), and in different centuries (eighth, ninth and twelfth centuries). In addition, each source is quite unique

and not formulaic; it does not seem to borrow directly from another tradition.

There are, however, a few difficulties which should be mentioned in regard to the source material. Although the *vita* of blessed Oda of Hainault is written by a contemporary, and it is unlikely that the events of her life are invented or distorted, some of the other primary source material on self-disfigurement as a virginal defense is not contemporary to the actual event. The evidence, for example, which refers to the mutilations of the nuns of St. Cyr and Coldingham is relatively late. The earliest extant documentation for the events at Coldingham are two chronicles dating to the thirteenth century: the writings of Roger of Wendover (d. 1236) which were then copied by Matthew of Paris in his chronicle (d. 1259). Although written several hundred years after the event, other information which these chroniclers recorded for this early period is accurate and is indeed corroborated by early contemporary sources. The detailed description of the heroics of the nuns of St. Florentine's monastery in Spain is recounted in a sixteenth-century chronicle of the Benedictine order. This information is again based on earlier sources which are no longer extant. However, evidence for St. Cyr, Marseille is more problematic. What we know of the events surrounding the martyrdom is based simply on a long-standing local popular saint's cult, the relics of Eusebia and her nuns, and other indirect documentary evidence.[110]

Although the incident of self-disfigurement at Coldingham has not been treated extensively by scholars, the case of St. Cyr has traditionally been dismissed as merely an hagiographic legend. Delehaye, in his classic study, *Les légendes hagiographiques,* discusses the role of popular imagination in the production of legend, and how specifically pictures and statues, which are wrongly interpreted, form the starting point for the creation of strange legends. He writes in regard to the "strange legend" of Eusebia and her virgin/martyr nuns:

> An inscription now in the museum at Marseille, refers to a certain Eusebia, abbess of Saint Quiricus [Cyr]: Here rests in peace Eusebia nun, *magna ancella Dei,* without indication that any cultus was accorded to this worthy woman. But her body had been laid in an older stone coffin, which bore the carved image of the dead person for whom it had originally been intended; it was the head and shoulders of a clean-shaven man, which in the course of time had

become worn and damaged. This was enough to give birth to a legend, which related that St. Eusebia, abbess of a convent at Marseille, together with her forty companions, cut off their noses to escape outrage by the Saracens.[111]

Thus in perhaps over-reacting to this traditional confirmation of the legend—based simply on an effigy with a mutilated face and severed nose—Delehaye summarily dismisses the validity of Eusebia's existence, and the concept of self-disfigurement to avoid rape, as merely a strange legend. Needless to say, the effigy alone does nothing to prove or confirm the cult: one needs simply to think of all of the medieval statuary in Europe now in this same damaged condition. Nor, however, does this effigy necessarily disprove the cult of Eusebia and her heroics of virginity. That is, the popular tradition of Eusebia and her martyrs did not necessarily stem simply from the mutilated sarcophagus. It seems to have been originally a popular local cult based on a much older, well-established tradition. In the aftermath of the Saracen attack, with its mass chaos and confusion, the original burial of Eusebia and her forty nuns was no doubt accomplished in haste. Their bodies were apparently brought to Marseille and buried in the crypt of the monastery church of St. Victor.[112] The special marble inscription which marked Eusebia's tomb seems to date to this early period, perhaps to the eighth century.[113] However, the earlier sarcophagus had been originally intended for someone else and then "borrowed" for Eusebia's burial. (The recycling of sepulchres seems to have been rather common during this early period.)[114] Very briefly, in addition to the inscription and tomb, one can find other isolated references to St. Eusebia and her martyrs in ceremonies, charters, and an early saint's life. This popular tradition was also perpetuated in the local vocabulary.[115] A very prevalent, ancient usage designated the ruins of the later Praemonstratensian monastery, which had been built on the ruins of St. Eusebia's convent, as "deis Desnarrados," "leis Desnazzados," or "leis Desnarrados," namely, the monastery of the nuns who cut off their noses.[116]

Coinciding with this local usage and tradition in the south of France, apparently reflecting the heroics of St. Eusebia and her nuns, is the rather interesting appearance in the north of France and in England of the popular epigram "to cut off your nose to spite your face." This maxim is found in the Latin work, *De Hierosolymitana*

peregrinatione acceleranda, by Peter of Blois, (Archpriest of Bath, 1175–ca. 1191), and in the Old French epic, *Garin le Loheren.*[117] It is then perhaps tempting to speculate that these traditions we have been tracing in the heroics of virginity might have provided the original context or occasion for this popular epigram. However, already in its twelfth-century usage there is no hint of a female/religious origin; rather this epigram is found in a negative, admonitory, masculine context which underlines the senselessness or futility of an anticipated act.

Although our traditional sources do present some difficulties and do not allow us to prove historically that each of these cases of virginal defense actually occurred, or whether they were simply *topoi* or paradigmatic examples of saintly behavior, they still provide invaluable insight into the social values and the collective consciousness of the time, especially the deep concern about the need for female virginity. (They also shed light on the ideal of virginity for the later age which recorded these events.) However, self-mutilation as an actual defence against sexual assault can definitely be understood against the background of this early period: this age obsessed with the value of sexual purity, yet filled with violent, traumatic situations for women.

On one level we can imagine the incredible fear and the initial helplessness which must have gripped these female religious in anticipation of the invasions and certain sexual assault. Unable to flee to a place of safety, nor count on local protection, they found themselves in a totally vulnerable situation, completely dependent on their own defenses and ingenuity. In addition to the impracticality of successfully fleeing from the barbarian invaders, some of these early female monastic houses also embraced a policy of strict, unbroken enclosure. Their uncompromising adherence to this severe rule can be seen in a few cases where, even though their monasteries were engulfed in flames and their very lives were threatened by fire, they refused to leave their cloisters.[118] (This restrictive policy then may also have entered into the decision of self-mutilation as a defense: the female religious may have preferred this strategy, along with martyrdom, to the breaking of their enclosure.)

In general, these *mulieres sanctae* feared for their lives: they faced the very real possibility of being slaughtered or burned alive within their own monasteries. Abbesses seemed to have occupied an es-

pecially unenviable and frightening position during this period. They were no doubt well aware of their own special worth and position in the eyes of the invaders as potential captives or hostages. Abbesses were also responsible for the welfare of their convents. In these extremely difficult times they would make the final decisions for the safety of their communities which the nuns, in monastic obedience, would be called upon to implement.

Nevertheless, in addition to fearing for their lives, these religious women also had a "higher fear" to contend with, that "fate worse than death," namely, sexual assault. Although early medieval virgins/nuns had always lived with the very real and also imagined fear of rape, the atmosphere of the invasions, no doubt, helped to foster a protracted and exaggerated anxiety about sexual assault. The nuns could not help but be very familiar with the destructive activities of the invaders and their predictable violation of religious women and others. Tales of horror must have circulated among the houses of nuns and monks, further exacerbating their basic "normal" morbid fear of sexual assault. The level of fear that was experienced at the prospect of actual rape was probably developed and enhanced by the fantasy of rape. And as might be expected, modern studies on rape victimology report that the women most traumatized by rape are religious and sheltered women.[119]

Tied to the fear of imminent physical violence was perhaps the very real fear and guilt of actually surviving the sexual assault: now living out their lives as polluted, former brides or perhaps even "adulteresses" of Christ?; shamed, with all hope for the next life extinguished. Despite the fact that patristic writings and canon law paid sympathetic lip service to the unfortunate fate of these women, on the bottom line, as we have noted, they were still perceived as somehow at fault; and as disgraced persons, the onus of the burden was on them. (Also after the assault, their tolerated but extremely nebulous position—no longer virgin nor widow—would have been difficult, if not impossible for them to live with.)

After these various considerations, one might then ask what options were actually available to these female religious under these difficult circumstances? Suicide was a possibility. However, as we have noted, churchmen did not seem to be in total agreement in condoning suicide to avoid sexual assault. Self-mutilation, less extreme than suicide, was then a very practical methodology which

would accomplish the desired end, that is, make the brides of Christ so hideously disfigured that no man would be tempted to sexually assault them.

The motives behind the heroics of virginity which we have been exploring in this study are complex but definitely understandable. The responses of the nuns at St. Cyr, Coldingham, Ecija; of St. Oda and the others, were all in tune with the Christian, as well as classical and Germanic, high appraisal of virginal purity. Within the condensing lens of their own age, they were simply applying to their own desperate situations the religious values/martyrdom ethics as delineated by the Church Fathers, saints' lives, canon laws, etc, but as they perceived and interpreted them. Convinced that rape was a crime of passion rather than of violence, they were following to the letter the constant admonitions for female religious to negate their physical beauty as a basic means of virginal defense.[120] The eschatological implications of their actions were especially important in the adoption of their heroic responses. Conditioned that virginity was not possible without martyrdom and with the virgin/martyr models always before their eyes, for some this fear could be translated into a desire to meet actively the fate which they courted, that is, martyrdom/sanctity. Ambitious for martyrdom, they were ready to suffer anything to prove their determination as brides of Christ. This methodology was in the same tradition as, for example, the self-inflicted acts of ascetic martyrdom accomplished by St. Radegund. She no doubt would have welcomed the invasions which provided that much "needed" persecutor or the opportunity for dramatic heroic actions to increase her spiritual worth. As Fortunatus noted in his *vita* of St. Radegund, "thus armed with courage to face the suffering, since the time of persecution had passed, she prepared to make a martyr of herself."[121] Self-mutilation was then also a public act which would prove to the world the seriousness of the nuns'/virgins' commitment as *sponsae Christi*. It would demonstrate beyond a doubt their innocence, namely, they did not share the guilt as willing accomplices in the loss of their virginity. This act would thus prove to their contemporaries and those in years to come the purity of their consciences.

In considering these extreme responses, timing was also of crucial importance. Forcible rape by the invaders was not something sudden or unexpected. The nuns were not caught off guard or paralyzed with fear. Rather they had time to formulate a strategy: these violent acts could then be met with some type of aggressive,

"positive" action. Instead of fleeing, only to be inevitably raped and killed on the road or within the defenses of a castle or town; or to be raped and then killed (in this order) in their own monastery, their tactics of self-disfigurement were aimed solely at maintaining their *integritas*, their total virginity. They were not primarily concerned with saving their physical lives, rather with safeguarding at any cost their all-important spiritual lives. Right here and now they would either go to heaven as *sponsae Christi* or be raped and then killed. In this latter case, they would no longer be suited for the heavenly gynaeceum; they would be turned away from Christ's bridal chamber to feed the goats which shall be on the left hand. As St. Jerome warned, "Many tried virgins have lost their grip on the undoubted crown of chastity at the very threshold of death."[122] He also admonished his *mulieres sanctae*, "who of the saints was crowned without a struggle? . . . Is it not better to fight for a short time . . . and afterwards to rejoice as a victor, than to be slaves forever because of failure to endure a single hour? . . . Unless you use violence, you will not take the kingdom of heaven."[123]

Perhaps another consideration for understanding the motivations behind these heroics, and definitely in accord with the mindset of the age, is the very real possibility that these nuns believed in some sort of miraculous intervention on their behalf which would include the restoration of their own mutilated features. Fed on the heroics of the early Christian hagiographic traditions of, for example, St. Agatha, whose severed breasts were miraculously restored; Sts. Rodena and Euphemia, whose noses and lips were restored; Sts. Brigid, Lucy, and others, it seems very probable that the nuns might nurture blind illusions or false hopes for their own "martyrdoms."[124] Some were probably convinced that as a sign of divine approval for their heroics, they too would be "protected" and have their beauty restored.

Another variable about which we are unfortunately ill-informed, but of significance for the heroics of virginity, is the age of the abbesses and their nuns. Our sources for Coldingham and for St. Florentine's monastery, Ecija, do not provide this information. One would expect that Blessed Oda, who disfigured herself to avoid marriage, would have been in her early teens—the normal age for females to marry. Eusebia, saint/abbess, who is associated with the events of self-mutilation at St. Cyr supposedly died at the age of sixty-four years.[125] However, we do know that a number of houses in

this early period were ruled by rather young abbesses, between the ages of twelve and eighteen, and perhaps also had a strong composition of young members. In addition, many of the early Christian virgin/saints suffered martyrdom while they were very young—often in their teens. Age then might very well be another important consideration in regard to the rather "extravagant" responses in this pattern of the heroics of virginity.

Fact, reality, or hagiographic models? Perhaps in the final analysis the distinction is not all that important. As a new Germanic breed of virgin/martyrs, they in turn provided heroes for future generations. As Matthew of Paris wrote in regard to St. Ebba's heroics: "That abbess of admirable courage, openly giving to all the sisters an example of chastity which should be profitable not only to those nuns, but which should be worthy of being followed by all succeeding virgins, and by all who should at any time exist. . . ."[126]

Although there has been a very long and persistent tradition in the heroics of virginity,[127] the concern with virginity and the need for *integritas* seem to have had a special hold on the religious collective consciousness of the medieval world. In the early Middle Ages those who had chosen this "higher life" were constantly warned that although this "privileged" status gave them special strength, it also entailed inordinate struggle: it was a "martyrdom" filled with suffering. Therefore, in fiercely defending their chastity, these strong, early medieval women put into action the demands of their "new" religion within the context of their own Germanic milieu. The oblique aggressive strategies which they adopted were idioms of strength and defiance as well as hopelessness and desperation. They were truly weapons of the last resort.[128] Despite the cost, these brides of Christ were not to be denied the meaning of their existence, nor their just rewards for perseverance in virginal perfection. After all of their years of practice, they were not about to miss the joys of singing with the 144,000 virgins the song they alone could sing![129]

NOTES

This is a substantially revised and also combined version of two papers: "Brides of Christ and Sacrificial Self-disfigurement in the Period of the Invasions," presented at the Twelfth International Congress on Medieval Studies, Western

Michigan University, Kalamazoo, Michigan, May 6, 1977; and "The Price of Virginity: A Study of Early Medieval Heroics," presented at the Fourth Berkshire Conference on the History of Women, Mt. Holyoke College, August 24, 1978. I should like to express my thanks to the National Endowment for the Humanities for a 1981–82 Fellowship which has made this article possible.

1. Peter of Blois, *De Hierosolymitana peregrinatione acceleranda* in *Patrologiae cursus completus: series Latina,* J. P. Migne, (Paris, 1844–80) 207: 1059—hereafter cited *P.L.*

2. Josephine E. Vallerie, *Garin le Loheren, According to Manuscript A* (Bibliothèque de l'Arsenal 2983), *with Text, Introduction and Linguistic Study* (Ann Arbor: Edwards Brothers, 1947), p. 240.

3. Peter of Blois, *P.L.* 207: 1059.

4. There is a great deal of literature on this subject. See for example, John Bugge, *Virginitas: An Essay in the History of a Medieval Ideal* (The Hague: Martinus Nijhoff, 1975); Demetrius Dumm, *The Theological Basis of Virginity According to St. Jerome* (Latrobe, Penn.: St. Vincent Archabbey, 1961); R. R. Ruether, ed., *Religion and Sexism: Images of Woman in the Jewish and Christian Traditions* (New York: Simon and Schuster, 1974), pp. 150–83; Jo Ann McNamara, "Sexual Equality and the Cult of Virginity in Early Christian Thought," *Feminist Studies* 3, no. 3/4 (Sp/Sum 1976): 145–58.

5. Carolly Erickson, *The Medieval Vision: Essays in History and Perception* (New York: Oxford University Press, 1976), pp. 189–95.

6. *Ibid.* Also see my article, "Sexism and the Celestial Gynaeceum—from 500–1200," *Journal of Medieval History* 4 (1978): 117–33.

7. See Ruether, *Religion and Sexism,* pp. 150–83; McNamara, "Sexual Equality," pp. 152–54, Bugge, *Virginitas.*

8. Jerome, *The Letters of St. Jerome: Ancient Christian Writers,* trans. Charles Christopher Mierow (Westminster, Md.: Newman Press, 1963) 1: 135.

9. *Ibid.,* p. 158.

10. *Ibid.,* p. 138.

11. *Idem.*

12. *Ibid.,* citing Isa 47.1 ff.

13. *Ibid.,* pp. 138–39.

14. *Ibid.,* p. 156, citing Matt. 10.22 and 24.13.

15. *Ibid.,* p. 177.

16. *Ibid.,* pp. 178–79.

17. S. Jerome, *Commentariorum in Jonam Prophetam Liber Unus, P.L.* 25: 1129. "Unde et in persecutionibus non licet propria perire manu, absque eo ubi castitas periclitatur" (emphasis mine). See also P. Abelard, *Sic et Non, P.L.* 178: 1603.

18. S. Jerome, *Adversus Jovinianum, P.L.* 23: 270–73, no. 41.

19. S. Ambrose, *Concerning Virgins* in *St. Ambrose: Select Works and Letters, A Select Library of Nicene and Post-Nicene Fathers of the Christian Church* (Second

Series), eds. Philip Schaff and Henry Wace (New York: The Christian Literature Company, 1896) 10: 386–87.

20. S. Augustine, *City of God,* ed. David Knowles, trans. Henry Bettenson (Harmondsworth: Penguin Books, 1972), Bk. 1, ch. 16, p. 26.

21. *Idem.*

22. *Idem.*

23. *Ibid.,* Bk. 1, chs. 17–18, pp. 26–28.

24. *Ibid.,* Bk. 1, ch. 19, pp. 30–31.

25. *Ibid.,* Bk. 1, ch. 25, p. 36.

26. S. Leo, *Epistola XII, P.L.* 54:653, cap. 8 (emphasis mine).

27. *Ibid., P.L.* 54:655, cap. 11. See also Burchard of Worms, *Decretorum liber octavus , P.L.* 140: 806, cap. 69.

28. S. Aldhelm, *De laudibus Virginitatis, P.L.* 89: 103–62. See also Sr. Mary Byrne, *The Tradition of the Nun in Medieval England* (Washington, D.C.: The Catholic University of America, 1932), pp. 25–43.

29. Aldhelm, *P.L.* 89:121, no. 23.

30. *Ibid., P.L.* 89:104, no. 2.

31. *Ibid., P.L.* 89:121, no. 23.

32. *Ibid., P.L.* 89:128, no. 31.

33. *Idem.*

34. *Ibid., P.L.* 89:128–29 (emphasis mine).

35. *Ibid., P.L.* 89:129.

36. *Ibid., P.L.* 89:141–52, nos. 40–52.

37. *Judith* in *Poems from the Old English,* trans. Burton Raffel (Lincoln: University of Nebraska Press, 1960). See also Bugge, *Virginitas,* p. 51.

38. Albert S. Cook, ed., *Judith: An Old English Epic Fragment* (Boston: D.C. Heath, 1888), pp. xxiv–xxv.

39. Byrne, *The Tradition of the Nun,* pp. 51–52.

40. *Ibid.,* p.60.

41. *Idem.*

42. Hrotswitha of Gandersheim, "The Prefaces of Roswitha," in *The Plays of Roswitha,* trans. Christopher St. John (New York: B. Blom, 1966), p. xxvi.

43. *Ibid.,* p. xxvii.

44. Count de Montalembert, *The Monks of the West from St. Benedict to St. Bernard* (New York: Longman's, Green, 1896) 4: 372.

45. Tacitus, *The Agricola and the Germania,* trans. H. Mattingly, rev. S. A. Handford (Harmondsworth: Penguin, 1970), pp. 117–18. See also *The Letters of Saint Boniface,* trans. Ephraim Emerton (New York: Norton, 1976), pp. 127–28. "In Old Saxony, if a virgin disgraces her father's house by adultery or if a married woman breaks the bond of wedlock and commits adultery, they sometimes compel her to hang herself with her own hand and then hang the seducer above the pyre on which she has been burned. Sometimes a troop of women get together and flog her through the towns, beating her with rods and stripping her to the waist, cutting her whole body with knives, pricking her with wounds, and sending her on bleeding and torn from town to town; . . . until finally they leave

her dead or almost dead, that other women may be made to fear adultery and evil conduct." *The Burgundian Code* prescribes the following deterrent: "If the daughter of any native Burgundian before she is given in marriage unites herself secretly and disgracefully in adultery with either barbarian or Roman, and if afterward she brings a complaint, and the act is established as charged, let him who has been accused of her corruption, and as has been said, is convicted with certain proof, suffer no defamation of character *(calumnia)* upon payment of fifteen solidi. She indeed, defeated in her purpose by the vileness of her conduct, shall sustain the disgrace of lost chastity." *The Burgundian Code,* trans. Katherine Fischer Drew (Philadelphia: University of Pennsylvania Press, 1972), ch. 44, p. 51. Also many of the reparations in the Germanic law codes are based on actions which threatened the chastity or virtue of Germanic women.

46. This *exemplum* is used by Giovanni Boccaccio in *Concerning Famous Women,* trans. Guido A. Guarino (New Brunswick: Rutgers University Press 1963), pp. 177–78.

47. *Vitae Caesarii episcopi Arelatensis libri duo,* in *Monumenta Germaniae Historica, Scriptorum rerum merovingicarum* (Hanover, 1896) 3: 470—hereafter cited *MGH, Script. rer. mer.*

48. Maria Caritas McCarthy, *The Rule for Nuns of St. Caesarius of Arles: A Translation with a Critical Introduction* (Washington, D. C.: Catholic University of America Press, 1960), p. 171.

49. According to Caesarius' saint's life, he had originally constructed his convent outside the city walls of Arles, perhaps at Alischamps. However, even before his work was completed, the monastery was totally destroyed by barbarian armies which attacked Arles. Thus, after this experience he rebuilt his new monastery within the safety of the city walls. McCarthy, *The Rule for Nuns,* pp. 13–14; *MGH, Script. rer. mer.* 3:467.

50. McCarthy, *The Rule for Nuns,* p. 171.

51. St. Jerome, *Regula monacharum, P.L.* 30: 414–15. I would like to express my thanks to Sara Richards for her translation of this section of the *Regula.* The preoccupation with enclosure for women in monasticism can also be noted in the legislation of the councils of the period. See Schulenburg, "Strict Active Enclosure and Its Effects on the Female Monastic Experience (500–1100)," in *Distant Echoes: Medieval Religious Women,* ed. John Nichols and Sr. Lillian Thomas Shank (Kalamazoo: Cistercian Publications, 1984) 1: 51–86.

52. Gregory of Tours, *The History of the Franks,* trans. Lewis Thorpe (Harmondsworth: Penguin, 1974) 4: 47, 244.

53. *The Letters of St. Boniface,* pp. 126, 129.

54. William of Malmesbury,*Chronicle of the Kings of England,*ed. J. A. Giles (London: George Bell and Sons, 1904), pp. 159–61.

55. *The Anglo-Saxon Chronicle,* trans. G.N. Garmonsway (London: J. M. Dent, 1975), p. 164.

56. Hincmar of Reims, *Ad Regem, De coercendo et exstirpando raptu viduarum, puellarum ac sanctimonialium, P.L.* 125: 1017–36.

57. A few examples of legislation concerning the violation and abduction

of female religious include: *Concilium Parisiense* (556–73), *MGH, Legum Sectio III: Concilia* (Hanover, 1893) 1:144, no. 5—hereafter cited *Conc.; Capitularia Merowingica Chlotherii II, Edictum* (614), *MGH, Legum Sectio II: Capitularia regum francorum* (Hanover, 1883) 1:23, no. 18—hereafter cited *Capit.; Concilium Clippiacense* (626–27), *MGH, Conc.* 1:200, no. 26; *Ansegisi Capitularium, MGH, Capit.* 1:408, no. 100; *Additamenta ad capit. Reg. Franciae Occident* (845), *MGH, Capit.* (Hanover, 1897) 2:414, no. 67; *Synodus Papiensis* (850), *MGH, Capit.* 2:119–20, no. 10; *Capitulare missorum Silvacense* (853), *MGH, Capit.* 2:271–72, no. 2; "The Laws of King Liutprand," in *The Lombard Laws,* trans. Katherine Fischer Drew (Philadelphia: University of Pennsylvania Press, 1973), ch. 95.XII, p. 185. "Laws of Alfred" (885–99) in *English Historical Documents, c.500–1042,* ed. Dorothy Whitelock (New York: Oxford University Press, 1955) 1:375, nos. 8, 8.1, 8.2, 8.3; and the "Laws of Cnut" (1020–23) in Whitelock, *English Historical Documents,* 1:426, no. 50.1.

58. "The Laws of King Liutprand," in Drew, *The Lombard Laws,* ch. 30.I, pp. 159–60.

59. *Laws of the Alamans and Bavarians,* trans. Theodore John Rivers (Philadelphia: University of Pennsylvania Press, 1977) I, ch. 11, p. 122.

60. "Laws of Alfred," in Whitelock, *English Historical Documents* 1:376, no. 18.

61. In regard to Caesarius' monastery at Arles see McCarthy, *The Rule for Nuns,* pp. 13–14; *MGH, Script. rer. mer.* 3:467; or for the moving of St. Salaberga's house from a site outside of the city of Langres to within the walls of Laon, see *Vita Sadalbergae, MGH, Script. rer. mer.* (Hanover, 1905) 5: 56–57. Also a similar shift in sites can be noted in an early convent for women originally built by Ebroin and his wife Leutradis outside the walls of Soissons, only later to be moved within the walls of the city. See Jean Verdon, "Recherches sur les monastères féminins dans la France du Nord aux IX^e—XI^e siècles," *Revue Mabillon* 59 (1976): 55.

62. David Knowles and R. Neville Hadcock, *Medieval Religious Houses: England and Wales* (London: Longman, 1971), pp. 78 (Tynemouth), 486 (Wytham).

63. Thomas Perkins, *The Abbey Churches of Bath and Malmesbury and the Church of Saint Laurence, Bradford-on-Avon* (London: G. Bell and Sons, 1901), p. 106. See also a charter for the monastery of Lyminge (804), which provided "a small piece of land in the city of Canterbury as a refuge in necessity." Whitelock, *English Historical Documents,* pp. 473–74.

64. David Herlihy, ed., *The History of Feudalism* (New York: Harper and Row, 1970), p. 8.

65. *Sigeberti Chronica* (882–93), *MGH, Script.* 6:343.

66. Knowles and Hadcock, *Medieval Religious Houses,* pp. 78 (Tynemouth), 80 (Whitby).

67. Y. Chaussy, et al., *L'Abbaye royale Notre-Dame de Jouarre* (Paris: G. Victor, 1961) 1:81.

68. *De S. Gudila Virgine, Acta Sanctorum,* Joannes Bollandus, et al., edit. novissima (Paris: V. Palmé, 1845–1940), Januarius, 1, no. 37, p. 523 and no. 26, p. 528 (Jan. 8)—henceforth cited as *A A.SS.* See also Albert d'Haenens, *Les*

invasions normandes en Belgique au IX^e siècle (Louvain: Publications Universitaires de Louvain, 1967), pp. 235–36, 279–80.

69. David Knowles, *The Monastic Order in England* (Cambridge: Cambridge University Press, 1940), p. 101.

70. Knowles and Hadcock, *Medieval Religious Houses,* p. 261 (Minster). See also *The Victoria History of the Counties of England: Kent* (London: St. Catherine Press, 1926) 2:149.

71. *Bibliotheca Sanctorum (Istituto Giovanni XXIII della Pontificia Università Lateranense)* (Roma: Città Nuova Editrice, 1961–71) 9:1281–83—henceforth cited as *B. S.; De S. Ositha vel Osgitha Virg. Mart., AA. SS.,* Octobris, 3, pp. 942–43 (Oct. 7).

72. For St. Reyneld, see Agnes B. C. Dunbar, *A Dictionary of Saintly Women* (London: G. Bell and Sons, 1905), 2:185; for St. Viborada, see *B.S.,* 12:1072–73.

73. Knowles and Hadcock, *Medieval Religious Houses,* p. 256 (Barking).

74. William Dugdale, *Monasticon Anglicanum* (London: James Bohn, 1846) 1:458.

75. Knowles and Hadcock, *Medieval Religious Houses,* p. 70 (Minster in Thanet). There are several examples of abbesses taken as captives by the invaders: Abbess Leofrun at Canterbury (1010), Abbess Edgiva of Leominster (1046), etc., *Anglo-Saxon Chronicle,* pp. 141, 164. The *Vita Rumoldi* describes the brutality of the Vikings toward the nun Gerlendis whom they took captive. *De Sancto Rumoldo, AA.SS,* Julii, 1, no. 212, p. 219 (Jul. 1). See also d'Haenens, *Les invasions normandes,* p. 255, no. 292; p. 257.

76. See Michael Goodich, *Vita Perfecta: The Ideal of Sainthood in the Thirteenth Century, Monographien zur Geschichte des Mittelalters,* vol. 25 (Stuttgart: Anton Hiersemann, 1982), pp. 1–20; Donald Weinstein and Rudolph M. Bell, *Saints and Society: The Two Worlds of Western Christendom, 1000–1700* (Chicago: University of Chicago Press, 1982), esp. pp. 8–9. See also Joseph-Claude Poulin, *L'idéal de sainteté dans l'Aquitaine Carolingienne d'après les sources hagiographiques (750–950)* (Quebec: Presses de l'Université Laval, 1975), pp. 1–30, 119–31.

77. Jacques Le Goff, "Les mentalités: une histoire ambigue," *Faire de l'histoire,* eds. Jacques Le Goff and Pierre Nora (Paris: Gallimard, 1974) 3:86.

78. For an exhaustive study of St. Cyr and the heroics of Eusebia and her nuns see Simon Verne, *Sainte Eusébie, abbesse, et ses quarante compagnes martyres à Marseille* (Marseille: Imprimerie Marseillaise, 1891). See also Gonzague de Rey, *Les saints de l'église de Marseille* (Marseille: Société anonyme de l'imprimerie Marseillaise, 1885), pp. 225–38. *De SS. Eusebia Abbatissa, AA.SS.,* Octobris, 4, 292–95 (Oct. 8). H. Leclercq, *DACL,* 10:2239–41.

79. De Rey, *Les saints,* pp. 227–28.

80. Roger of Wendover, *Flowers of History: Comprising the History of England from the Descent of the Saxons to A. D. 1235,* trans. J. A. Giles (London: H. G. Bohn, 1849) 1:191. See also *De S. Aurelio Augustino, AA.SS.,* Augusti, 6, 265–69 (August 28).

81. Roger of Wendover, *Flowers of History,* pp. 191–92.

82. Fray Antonio de Yepes, *Crónica general de la Orden de San Benito*

(Madrid: Ediciones Atlas, 1959) 1:137–38. I wish to express my thanks to Heath Dillard for bringing this reference to my attention. I would also like to thank Victoria J. Meyer for her kindness in translating this episode.

83. de Yepes, *Crónica general de la Orden de San Benito*, p. 138. A number of long-lived local traditions perpetuated this event of martyrdom: the road from the main church of S. Cruz to the monastery of Ecija was called the "Road of the Virgins" or the "Road of the Howling"; there was also a "Bridge of the Virgins" with Stations of the Cross; stones splashed with the blood of the virgins were kept at Old Palma, and a sixteenth-century vision of a procession of virgins with lighted candles was witnessed by Maria de la Cruz. *Ibid.*, p. 138.

Heath Dillard has noted the use of self-inflictd facial lacerations by women mourners and victims of assault in Castilian society (1100–1300). In pressing charges against the assailant, the self-inflicted scratches on women's cheeks served as evidence that they had been assaulted. "Clawing her cheeks, a rape victim made the customary sign of a woman in mourning, but now she grieved for the loss of her chastity and her honour." See pp. 183–84 in Dillard's *Daughters of the Reconquest, Women in Castilian Town Society, 1100–1300* (Cambridge: Cambridge University Press, 1984). See also pp. 96–97.

84. *De Venerabili Oda, AA.SS.*, Aprilis, 2:770–78 (April 20). The venerable Oda's *vita* was written by a contemporary, Philip Harveng, Abbot of Bonne-Esperance, p. 771.

85. *Ibid.*, pp. 774–75.

86. *De B. Margarita Hungarica, AA.SS.*, Januarius, 3:518 (Jan. 28). I would like to thank Professor Michael Goodich for his kindness in giving me this reference.

87. Drew, "Rothair's Edict," nos. 49, 50, 54, 82, 84, 106 and 108. Rivers, *Laws of the Alamans and Bavarians*, pp. 86–87, Section 57, nos. 15–19. There are a great many other examples of this common type of mutilation in the law codes. For a summary see: "Denasatus"/"Nasi abscissio" in Charles Du Fresne Du Cange, *Glossarium mediae et infimae Latinitatis* (Paris: Librairie des sciences et des arts, 1938) 3:63.

88. Whitelock, *English Historical Documents*, 1:426, I would like to thank Gerda Lerner for pointing out to me that this punishment already existed in the Ancient Near East in the Assyrian Code. Here the law stipulates that a man may cut off the nose of his wife if he catches her in adultery, but he must also turn the adulterer into a eunuch and disfigure his face. However, if he spares his wife, he shall also acquit the man. MAL no. 15. "Middle Assyrian Laws," in *Ancient Near Eastern Texts Relating to the Old Testament*, ed. James Bennett Pritchard (Princeton: Princeton University Press, 1955). Similar provisions can be found in fourteenth-century Spain. Here a Jewish widow was charged with having sexual relations with a gentile. Thus the Jewish court ordered that her nose be cut off so as to disfigure her and make her no longer acceptable to her lover. Louis M. Epstein, *Sex Laws and Customs in Judaism* (New York: Ktav Publishing House, 1967), p. 173. Guido Ruggiero notes that in early Renaissance Venice mutilation for crimes involving sexuality was very rare. He writes, "It is significant that facial

mutilation by the commune was commonly used for serious crimes committed by females when a similar penalty for a man would be the loss of a hand. Apparently a woman's worth in this male-oriented society was seen in her beauty while a man's was seen in his working ability." See footnote 13, p. 205, in Ruggiero's *Violence in Early Renaissance Venice* (New Brunswick: Rutgers University Press, 1980). See especially his chapter on rape, pp. 156–70.

89. *Lex Pacis Castrensis* (1158) in *MGH, Legum Sectio IV: Constitutiones et acta publica imperatorum et regum* (Hanover 1893) 1:240, no. 7. I would like to thank Sarah Blanshei for the following disfigurement citation from the Statutes of Bologna, ca. 1250, where prostitutes were punished by having their noses cut off: "Statuimus et ordinamus quod publice meretrices et earum receptores seu receptrices non sinantur stare iuxta dictam ecclesiam sancti petri vel in illa contrata, et ad minus per xx domos iuxta ipsam ecclesiam ex omni parte vie et ex omni parte ipsius ecclesie stare non debeant; et si quis concesserit eis domum suam ad standum aliquo modo solvat nomine banni quociens invente fuerint 1. libras bononenorum et plus arbitrio potestatis; et ganee seu meretrices capiantur et in prima vice fustigentur per Civitatem, et *in secunda incidatur ei aliquantulum de naso*" Luigi Frati, ed., *Statuti di Bologna dall'anno 1245 all'anno 1267* (Bologna: R. Tipografia, 1869) 1: 452–53 (emphasis added). The same punishment was reserved for prostitutes from Augsburg and Naples in the late Middle Ages. Iwan Bloch, *Die Prostitution* (Berlin: L. Marcus, 1912) 1: 813.

90. Wace, *Arthurian Chronicles*, trans. Eugene Mason (New York: Dutton, 1962), p. 210.

91. *Vita I S. Brigidae, AA.SS.*, Februarius, 1: 120 (Feb. 1). Among other female saints in this tradition are Sts. Lucy, Alexandrina, and Odilia.

92. *De S. Enimia Virgine, AA.SS.*, Octobris, 3: 406 (Oct. 6).

93. *De S. Licinio, AA.SS.*, Februarius, 2: 679 (Feb. 13).

94. *Vitae Columbani abbatis discipulorumque eius libri duo auctore Iona, MGH, Script. rer. mer.* (Hanover, 1802) 4: 120–21.

95. *Vita Ansberti episcopi Rotomagensis, MGH, Script. rer. mer.* 5: 620–21.

96. *De S. Itisberga Virgine, AA.SS.*, Maii, 5: 46b (May 21).

97. *De S. Ulphia, AA.SS.*, Januarius, 3: 738 (Jan. 31). The early Christian "bearded saints"—perhaps more in the realm of *topos* than reflections of historical reality—should also be noted here. In their attempts to avoid forced marriages these saints also prayed for some disfiguration; and according to their saints' lives, in answer to their prayers, Christ enabled them to "grow beards." These so-called "bearded saints" include: Saints Galla, Avila, and the especially popular Wilgeforte. A number of other early Christian virgin saints escaped unwanted marriages by fleeing their homes dressed in masculine clothing. Several of these women then lived out their saintly lives disguised as monks. Some of these saints include Sts. Margarita, Eugenia, Apollinaria, Euphrosyne, and the Matrona de Pergé. See Marie Delcourt, "Le complexe de Diane dans l'hagiographie chrétienne," *Revue de l'histoire des religions* 153 (1958): 1–33. Also see my forthcoming book, *Forgetful of Their Sex: Female Sanctity and "Deviancy,"* ca. 500–1100 which discusses in some detail the ideology and practice of religious women assuming

male identity and dress.

98. Drew, "Rothair's Edict," no. 180, pp. 84–85.

99. I. M. Lewis, *Ecstatic Religion: An Anthropological Study of Spirit Posses-sion and Shamanism* (Harmondsworth: Penguin Books, 1971), especially pp. 186, 191, 200. The findings of the anthropologist I. M. Lewis further corroborate the validity of this behavior. From a cross-cultural perspective he discusses certain types of marginal possession cults as forms of indirect protest used particularly by women. I would like to thank Susan Friedman for calling my attention to this work.

100. *Ibid.*, pp. 31–32, 77, 147.

101. *Vita sanctae Geretrudis, MGH, Script. rer mer.* (Hanover, 1888) 2: 456.

102. *Eadmer's History of Recent Events in England (Historia Novorum in An-glia)*, trans. Geoffrey Bosanquet (London: Cresset Press, 1964), Bk. 3, p. 127.

103. *Ibid.*, p. 129.

104. *Ibid.*, pp. 128–30. See also Richard William Southern, *Saint Anselm and His Biographer: A Study of Monastic Life and Thought 1059–c. 1130* (Cambridge: Cambridge University Press, 1963), p. 189.

105. Paul the Deacon, *History of the Langobards*, trans. William Dudley Foulke (Philadelphia: Department of History, University of Pennsylvania, 1907), Bk. 4, ch. 37, 180–81.

106. *Ibid.*, pp. 183–84.

107. Christine de Pisan, *Here begynneth the boke of the Cyte of Ladyes*, trans. Brian Anslay (London: H. Pepwell, 1521), pt. II, cap. 46; or Christine de Pizan, *The Book of the City of Ladies*, trans. Earl Jeffrey Richards (New York: Persea Books, 1982), p. 164.

108. François de Billon, *Le Fort inexpugnable de l'honneur du sexe Femenin*, ed. M. A. Screech (New York: Johnson Reprint Corporation, 1970), pp. 65–66. The continuity in these rather unusual tactics adopted to ward off rapists can be noted in a modern product which has only recently been marketed. It is called "Skunk oil" and is advertised to repel rapists. "The product is a tiny plastic vial of synthetic skunk oil to be pinned to a woman's undergarments. The vial can be crushed between two fingers with about the same force it takes to break a pencil. The resulting odor is so offensive and unexpected that in most cases the attacker will flee . . ."—an uncanny counterpart to the early medieval "rotten chicken parts" repellent! "World of Women," *Milwaukee Sentinel*, March 3, 1980, p. 8. I would like to thank Willa Schmidt and Louise Coates of UW Memorial Library Reference Department and Annamarie Weis of the *Milwaukee Journal* for their help in locating this reference.

109. In comparison to the female examples of disfigurement/mutilation predicated on this inordinate preoccupation with virginity and fear of its loss is a rather isolated, notorious male example, that of Origen. According to Eusebius of Caesaria's *Ecclesiastical History* (based on hearsay evidence), Origen castrated himself to ensure chastity. Reference to this potential response can be found in Matthew 9: 12, "There are some who have made themselves eunuchs for the kingdom of heaven's sake." Chadwick, in his work on the early Church, notes

that this act could definitely be true, "since a few cases of such extreme acts of asceticism certainly occurred in the early Church." Henry Chadwick, *The Early Church* (Harmondsworth: Penguin, 1967), p. 109. However it is interesting to note the Church's response to this male mutilation: Origen was condemned for this "unnatural act"; it was an extreme embarrassment to the Church and definitely not to be recommended as a behavioral model for ascetics.

110. See note 78 for sources on St. Cyr.

111. Hippolyte Delehaye, *Les légends hagiographiques,* 2nd ed. (Brussels: Bureaux de la Société des Bollandistes, 1906), pp. 52–53.

112. de Rey, *Les saints,* p. 228. Verne, *Sainte Eusébie,* p. 411.

113. Verne, *Sainte Eusébie,* pp. 403–83.

114. See for example, Bede, *A History of the English Church and People,* trans. Leo Sherley-Price (Harmondsworth: Penguin, 1968), Bk 4, ch. 19, p. 241.

115. Verne, *Sainte Eusébie,* pp. 33–53; 676–87.

116. *Ibid.,* pp. 346–49; 611–13; 623–34.

117. Peter of Blois, *P.L.* 207: 1059. Vallerie, *Garin le Loheren,* p. 240. See also Ducange, *Glossarium Latinitatis,* 3:63.

118. *Vitae Caesarii episcopi Arelatensis libri duo, MGH, Script. rer. mer.* 3: 494; Joan Evans, *Monastic Life at Cluny, 910–1157* (London: Oxford University Press, 1931), pp. 29–30; Schulenburg, "Strict Active Enclosure," pp. 64–65.

119. LeRoy G. Schultz, ed., *Rape Victimology* (Springfield, Ill.: Thomas, 1975), p. 381.

120. See especially Cyprian, *Saint Cyprian, Treatises: The Dress of Virgins,* ed. Roy J. Deferrari, trans. Angela Elizabeth Keenan (New York: Fathers of the Church, 1958), ch. 5, pp. 35–36.

121. *De Vita Sanctae Radegundis libri duo, MGH, Script. rer. mer.* 2: 372–73, Lib. 1, nos. 25–26. According to Fortunatus, one year during Lent Radegund wore three iron bands around her neck and arms. She also wore three chains which she pulled so tightly that her skin actually grew over or enveloped the hard metal. When Lent was over, she no longer was able to take off this belt and it had to be removed by making an incision all around her body. In the process she lost a great deal of blood and her weakened body seemed to be approaching its end. Another time the saint fashioned in brass a monogram of Christ. She then heated the plate up in her cell and applied it in two places to her body. She pressed it so deeply with the end result that she burned her skin. Another Lent Radegund had brought to her a bronze vase filled with burning coals. She put her body in contact with this vase and again burned her skin, leaving gaping wounds. In accomplishing this last act of martyrdom, Fortunatus specifically notes: "Hinc discedentibus reliquis, membris trepidantibus, animus armatur ad poenam, tractans, *quia non essent persecutionis tempora, a se ut fieret martyra*" (no. 26, p. 373) (emphasis mine).

122. Jerome, *The Letters of St. Jerome,* no. 29, p. 164.

123. *Ibid.,* nos. 39–40, pp. 176–78.

124. These saints, plus many others, were mutilated or lost in one way or the other their beauty, only to be cured or to have their "features" miraculously

restored. Sts. Rodena and Euphemia are two little-known, early Christian saints who cut off their noses and lips (Rodena also cut off her ears) to avoid forced marriages. And in the hagiographic tradition, their features were appropriately restored after their marriages were called off. St. Rodena, *De SS. Silvano et Silvestro Conf. ac Rodena Virg.*, *AA.SS.*, Septembris 6:405 (Sept. 22). St. Euphemia in Agnes B. C.Dunbar, *A Dictionary of Saintly Women* (London: G. Bell and Sons, 1904) 1: 291.

125. *De SS. Eusebia Abbatissa*, *AA.SS.*, Octobris, 4: 294.

126. Matthew of Westminster (based on Matthew of Paris), *The Flowers of History*, trans. C. D. Yonge (London: H. G. Bohn, 1853) 1:410.

127. While women in modern times, faced with similar threats of sexual assault, have not followed the models of these virgin/martyrs to the letter, there is a fascinating resemblance in their responses. In *Against Our Will* Brownmiller notes a number of examples which follow in this tradition. During WWII, thousands of women were raped by the invading armies. And with this there also emerged another new generation of virgin martyrs (p. 332). "Some women of Berlin committed suicide, either in fear of rape or in shame after the act" (p. 68). Pertinent to the virgin/martyr tradition is a suicide poem which appeared in an American Jewish magazine in 1943. This work was "supposedly the last testament from ninety-three girls of the Beth Jakob Seminary in Krakow who took their own lives after being informed that the Nazis intended to turn their seminary into a brothel" (p. 332). There are other instances of calculated avoidance of sexual assault, again with an uncanny resemblance to that of the medieval saints: "Some avoided assault by making themselves appear diseased or as unattractive as possible with the aid of coal dust, iodine and bandages" (p. 68). One woman avoided being raped by claiming that she had tuberculosis (p. 68). It is perhaps rather unnerving to note that despite the more than one thousand years which separate these responses, there remains an essential sameness in some of the "successful" defenses against sexual assault adopted by these traumatized women. Susan Brownmiller, *Against Our Will* (New York: Simon and Schuster, 1975).

128. Lewis, *Ecstatic Religion*, p. 33.

129. Jerome, *The Letters of St. Jerome*, no. 41, p. 179; Aldhelm, *P.L.* 89:108, no. 7.

3

Women and the Italian Inquisitions

WILLIAM MONTER

*R*ECENTLY there has been a renaissance of studies on the Spanish Inquisition, which has just begun to extend to its younger Mediterranean cousins, the Roman Inquisition and the Portuguese Inquisition. As is evident in the tables accompanying this essay, this renaissance has a statistical (even a computerized) dimension typical of 1970s-vintage social history; it also possesses that other hallmark of recent social history, a psychological/anthropological dimension. But this recent flurry of inquisitorial scholarship—the first real breakthrough in this important area of Early Modern European history in about eighty years—has not yet encountered the problem of gender-based history, which, after all, has been another major gain during the last dozen years. My purpose, therefore, is to begin scratching the surface of what promises to be a large and interesting topic. This is a preliminary reconnaissance, with the appropriate assets and liabilities of such enterprises; I risk being superficial and incorrect, but I cannot avoid being novel to some extent.

First, a bit of background on what we have recently learned about these institutions and their mostly-male clientele during the sixteenth, seventeenth, and eighteenth centuries. The Spanish Inquisition, endowed with centralized record-keeping and requiring annual reports from each of its twenty component tribunals, has generated a kind of "data bank" comprised of about fifty thousand cases judged between 1550 and 1700, which have been sorted into eight major categories by a team consisting of a Danish ethnographer and a Spanish historian.[1] The Roman Inquisition, whose central records were scattered by Napoleon and whose Vatican remnants are jealously guarded by the Papacy, will never yield such a data bank; the statistics offered here have been compiled from the three or four

Girls and old women dancing to the witches' orchestra. By Jan
Ziarnko for Pierre de Lancre's *Tableau de l'inconstance*, Paris, 1613.
Reproduced with the permission of the University of Illinois Board of
Trustees.

TABLE A
Sicilian *Autos-da-Fé*, 1540–72

	Total	Women	As %	Executed
Judaizers (1540–49)	95	47	50	1 woman
Moriscos	113	25	22	4 men
Protestants	177	7	4	17 men
Offense				
Blasphemy	29	0	—	
Bigamy	31	12	39	none
Illicit magic	24	7	29	
All other crimes	107	14	13	

Italian branch Inquisitions whose records have been preserved and indexed by modern scholars.[2] Portugal is an in-between case: it has excellent central records for its national Inquisition between 1540 and 1760, but lacks any satisfactory index to them, so that no computers will be able to process its data for several years.[3] Portugal contains about thirty thousand cases, compared to about eleven thousand now available from Italy.

This investigation is thus drawn from the smallest and most fragmentary data base from among these three Inquisitions. In fact, one important "Italian" Inquisition in this sample, Sicily, actually belonged to the Spanish rather than the Roman system. The island was ruled by Spanish viceroys; however, other parts of present-day Italy which also had Spanish viceroys (Naples and Milan) belonged to the Roman Inquisition. The information from Sicily survives in Spain rather than Italy; it has been withdrawn from the Spanish data bank for geographical and comparative reasons.

Let us now turn to the first group of statistics, drawn from this Italian branch of the Spanish Holy Office during the heyday of its sixteenth-century heresy hunt. Close to six hundred people were sentenced in the nineteen Sicilian *autos-da-fé* reported to Spain between 1540 and 1572.[4] The vast majority of them were accused of one of the three heresies which preoccupied mid-sixteenth-century Spanish officials: Judaism, Mohammedanism, or "Lutheranism" (a generic term for all Protestants in Spain). (See Table A.) As soon as these accusations are broken down by gender, a fascinating picture emer-

ges. The relapsed Jewish converts (*neofiti*, in Sicily) who dominated the *autos-da-fé* during the 1540s but disappeared after 1550, were half female. The only martyr among them was a Jewish widow who was burned at the stake in 1549. Afterwards, Moriscos and Protestants shared center stage. More martyrs emerged, all male. Women receded from view, accounting for a respectable share of relapsed Moslem converts but becoming almost invisible among Sicily's "Lutherans." Over a hundred men were sentenced for this crime in Sicily before the first woman joined them in 1568. The difference between half of accused Judaizers and under 5 per cent of accused Protestants is enormous. Two questions immediately arise: was this situation unique to Sicily? And if not, why not?

A glance at the second set of data is enough to answer the first question with a resounding "no." Throughout Italy—in the far northeast where Protestantism was a deeply-rooted, major menace for the Roman Holy Office throughout the sixteenth century, or at Naples where "Lutheranism" was insignificant after 1542—everywhere, women comprised fewer than 5 per cent of suspected Protestants. (See Table B.) They were more likely to be charged with minor doctrinal errors, even with blasphemy, than with Protestant heresies. Among the entire gamut of inquisitorial offenses in Italy, I could locate only two categories where women never appeared at all. There were no women among the fifty-six defendants charged with atheism or materialism (believing that the soul died with the body), and there were none among the thirty who were charged with selling bogus indulgences. More to the point, in only one large category were women proportionately scarcer than among "Lutherans," and that was among people charged with owning or reading prohibited books: seven women among 181 defendants (4 per cent) at Venice, only one among 150 defendants in Friuli. (Note that these *libri prohibiti* were not necessarily heretical books; they could just as easily be magical books, as was apparently the case with Giordano Bruno when he was first arrested, as well as with many less famous people). The important point is of course the connection between Protestantism and literacy, partially but imperfectly reflected in book ownership. Women were underrepresented among bibliophiles, even in such a highly literate place as Venice, and thus they tended to be underrepresented among Protestants.

One may well object, however, that the argument from literacy—or rather, from illiteracy—cannot even begin to explain why

TABLE B
Protestantism and Italian Inquisitions

Place (dates)	Protestants	Women	As %	Executed
Venice (1547–85)	767	28	4	14 men
Friuli (1557–95)	201	8	4	5 men
Sicily (1540–72)	177	7	4	17 men
Naples (1564–1620)	37	1	3	none

women formed half of all accused Judaizers in Sicily or elsewhere (52 per cent at Naples, for instance, and about half in Portugal, where Judaism always remained the overwhelming preoccupation of the Holy Office). It is ludicrous to suppose that Jewish women were significantly more literate than Christian women of comparable social rank in Italy or Portugal. The search for a more convincing explanation for this Protestant-Jewish gender dichotomy needs a little more refining. By 1540, the Spanish Inquisition had long since learned that women were often the most stubborn defenders of traditional customs. Its fight against Jewish atavisms among baptized converts (who by 1540 were often third-generation Christians) frequently focused on the wives and mothers who led their families into observing Jewish rituals clandestinely: dietary laws, baths and clean clothes on Friday nights, use of a few Hebrew phrases—habits most likely to be maintained within a family setting and under the instigation of the senior woman in a household. Given the extent of Holy Office informants and of intrafamilial bickering, the relative privacy of such acts sometimes proved insufficient to avoid detection and punishment.

Protestantism, on the other hand, was not a familial religion and certainly had no traditional customs in sixteenth-century Italy. Without such domestic supports, its attractions to Italian women did indeed depend on such things as Bible-reading in the vernacular or a willingness to express novel opinions about religious topics openly. In Italy, Protestantism appealed to clerics and to unmarried men more than to other parts of the population: monks but not nuns were attracted, unmarried artisans but not single women.[5]

Mohammedanism forms a middle ground between the extremes of Judaism and Protestantism. In Sicily, most baptized Moslems were ex-slaves and domestic servants of both sexes, so the family nexus

was much weaker than among Jewish *neofiti*. Still, the cake of Islamic custom remained important among Mediterranean women: the use of Arabic, suspiciously frequent bathing, and abstinence from pork brought these women (and men) into the nets of the Sicilian Inquisition. In Spain itself, where the *morisco* problem retained a stronger familial dimension than in Italy, the Inquisitors began by arresting only men but finally learned the importance of women in preserving Moorish customs; by the 1590s they were imprisoning almost as many women as men on this charge.[6]

Apart from Judaizers and a few other special categories, women usually comprised only a very modest share of the Italian Inquisitors' clientele. If we look for a moment at the first table, the Sicilian *autos-da-fé*, we can see that women formed only 13 per cent of the "miscellaneous" defendants sentenced between 1540 and 1572. Indeed, if we add blasphemy cases to this group, women's share falls to about one-tenth. This is fairly close to other evidence from the Neapolitan, Venetian, and Friulian branches of the Roman Inquisition throughout the whole span of their existences. For example, women comprised 5 per cent of blasphemy defendants at Venice, 8 per cent in the Friuli, and 9 per cent at Naples. In the large group of minor religious deviations labelled by Holy Office clerks as "heretical propositions," women made up 8 per cent of the defendants at Naples, 9 per cent at Venice, and 8 per cent in the Friuli. Such examples could be multiplied. Across the broad range of incorrect beliefs censured by the Inquisition, women had only token representation, usually under 10 per cent.

There are a few exceptions. One is bigamy, a crime which was subject to both inquisitorial *and* secular jurisdiction in Italy. At Naples, where the greatest number of such cases was tried by the Holy Office, women comprised about three-eighths of almost three hundred accused bigamists (1564–1744). Bigamy was not a gender-specific crime, although it was somewhat easier for men to commit, given their greater physical mobility. What seems most interesting is less the crime itself than its punishment by the Inquisitors. Considering that bigamy was theologically identical for men and women, it seems noteworthy that both sexes were not punished for it symmetrically. Men convicted of bigamy by the Roman or Spanish Inquisition were usually sentenced to do "unpaid penance at the oar," that is, to serve upwards of five years in the nearest state galleys. But neither governments nor Inquisitors were tempted to introduce

women to galley seats. Instead, these women bigamists usually got lashings—one hundred blows was customary in Spain—and a sentence of lengthy exile (secular judges were probably even harsher on both male and female bigamists than were the Inquisitors, although the evidence is sketchy).

There is another important area of Italian inquisitorial activity, another crime divided between secular and inquisitorial jurisdiction, where women ordinarily seemed to play a predominant role: black magic. However, in the 1540–72 Sicilian *autos-da-fé,* women formed less than a third of defendants charged with illicit magic. Except for a group of six witches brought to trial at Palermo in 1556, we find only one woman among eighteen people accused of divination or necromancy. Again, our first question must be, was Sicily abnormal? Did the Roman Inquisition act differently in this matter than the Spanish Inquisition? Or were later periods different from the mid-sixteenth century?

The answer to the second question is yes. Later periods were different because everywhere in Italy (including Sicily) the Holy Office became increasingly preoccupied with this type of offense by the 1580s and 1590s. In fact, illicit magic accounted for almost 40 per cent of all inquisitorial business at Naples, Venice, and the Friuli during the seventeenth century. In Sicily it comprised only about 25 per cent of all seventeenth-century cases; but magic provided the single largest category of accusations there after 1600, and the island led all twenty Spanish tribunals in numbers of magicians prosecuted. Therefore the seventeenth-century Roman Inquisition's concentration on illicit magic was far greater than anywhere else in Mediterranean Catholicism.

But in terms of gender history, was sixteenth-century Sicily's emphasis on male magicians unusual? Apparently not. In the first place, Sicily resembles the three mainland Italian Inquisitions insofar as magic formed a very small share of their early sixteenth-century cases, and especially insofar as men outnumbered women among these early defendants, who can be split into three roughly equal-sized groups: women, men, and clerics. Perhaps it becomes a little less surprising to find clerics so well represented here if we recall a scene from Benvenuto Cellini's autobiography, where he tried to raise the devil in the Roman Colosseum in order to discover where his current sweetheart had gone. The expert Cellini hired—presumably one of the best men in Rome for the job—was a Sicilian priest.[7]

TABLE C
Illicit Magic at Naples

	1564–90	1591–1620	1621–1700	1701–40	Total
Total cases	735	1022	1086	196	3039
Annual average	27	34	14	5	
Illicit magic	178	498	387	64	1127
Women	47	177	150	9	383 (34%)
Clerics	51	128	102	23	304 (27%)

Naples, like northern Italy, was preoccupied with illicit magic during the 1600s: almost nine hundred people were tried on such charges by its Holy Office between 1590 and 1700, or over 40 per cent of all defendants at this time (a ratio which can be duplicated in northern Italy). But what is most remarkable about Naples is the relatively low participation of women in this offense. (See Table C.) Throughout the whole history of the Neapolitan Inquisition, women comprised little more than a third of all defendants for illicit magic. This is the lowest percentage known to me anywhere in Christendom. When secular courts tried witches, either in southwestern Germany or in the French-Swiss borderlands, women usually comprised about 80 per cent of all defendants.[8] Men were never in a majority, let alone the overwhelming majority that they constituted at Naples. Moreover, the Cellini example holds up insofar as clergymen continued to provide a sizable share of such defendants at all times in Naples (over one-fourth in each of the four epochs). But even excluding clergymen, more men than women were accused of illicit magic at Naples. How unusual was this situation? In the city of Venice, women formed just over 60 per cent of all defendants for illicit magic, while clerics accounted for about 10 per cent. In the Friuli men and women were equally divided, again with clerics playing a relatively minor role.

The available index to the Friuli Inquisition provides by far the most detailed information about the precise nature of the charges brought against people accused of illicit magic. (See Table D.) This mountainous area in the northeastern corner of Italy was rural, remote, and rugged. It was the most rustic part of the Venetian Republic; it bordered on Protestant-infested Austrian lands; it was Alpine; last but not least, it has been in recent years the happy hunting

TABLE D
Illicit Magic in the Friuli

Offense	1596–1610 Men	1596–1610 Women	1611–70 Men	1611–70 Women	1671–85 Men	1671–85 Women
"Magic" in general	10	16	12	7	18	7
Divination-Necromancy	5	6	3	1	4	0
Love Magic & *Tamiso*	18	26	40	23	44	7
Various spells	5	9	11	23	16	2
Spells to get rich	0	0	0	0	34	1
Therapeutic magic	50	60	39	48	0	2
Benandanti	5	5	26	8	6	0
Maleficio & witchcraft	8	39	12	72	20	29
Totals	101	161	143	182	142	48

ground for a brilliant young Italian historian, Carlo Ginzburg, who has discovered an agrarian fertility cult of "good witches," or *benandanti,* there in the 1600s.[9] Unlike Naples or even Venice, it contained bona fide witches in its mountains, as well as *benandanti* and a wide variety of other practitioners of magical arts, all forbidden by the Church. In the Friuli, women comprised half of all defendants for illicit magic, although the sex ratio varied considerably among different categories of magic and even more among different time periods. When such practices first began to preoccupy the Friuli Holy Office, from 1596 to 1610, women formed over 60 per cent of the defendants and outnumbered men in every single category of forbidden magic. But by the eighteenth century, while magic remained a major concern to Friuli's Inquisitors, men comprised three-quarters of these defendants. In the first phase, magical healers were the principal target, accounting for over 40 per cent of all cases, while by the final phase love magic (including the spell of *tamiso* which was generally used to create illicit passion) had taken over first place.

Within the sphere of illicit magic, the final category—witchcraft and harmful spells *(maleficio)*—played a special role. More than anything else, it was preeminently women's domain. If we combine figures from the first two phases, extending from 1596 to 1670, we find 131 defendants who were 85 per cent female. This is very close to witchcraft statistics from secular courts during the same period. But there still remains one startling difference between the Friuli Inquisi-

tion and secular courts: none of these 131 witches was put to death. Indeed, we know of witches executed in the 1640s by Austrian authorities in parts of the dioceses of Aquileia and Concordia (which formed the territory of the Friuli Inquisition), witches who accused women living in the Venetian parts of the diocese. The latter were arrested by the Inquisitors, questioned, and then released with various penances.[10] No evidence has yet come to light of witches executed anywhere in Italy by a branch of the Roman Inquisition; for that matter, fewer than a dozen witches were ever executed by the Spanish Inquisition in over four thousand cases between 1550 and 1700. By the seventeenth century the secular courts of Christendom had stopped burning heretics at the stake but were feverishly executing thousands of witches; in Italy, and in other places where Inquisitions had at least partial control over this offense, the situation was reversed.

Men comprised 40 per cent of all witches after 1670, thanks partly to a group of Freemasons arrested in a small Friuli town in the 1760s and charged with witchcraft. Most male magicians wanted either love or money, in about equal numbers, while a few wanted immunity from bullet wounds; one lucky group of four young men concluded a pact with the Devil in 1754 in exchange for all three. As the woman who has investigated the subject observed, "Men declared, without difficulty, that they had tried to give their soul to the Devil in exchange for money; but the Devil, although frequently invoked, never appeared, and so they gave up, more from ineffective magic and lack of confidence than from respect for the faith. . . . The characters were a disillusioned witch, a reluctant Devil, and an indifferent inquisitor."[11] The world of the Enlightenment had truly arrived, even in this remote spot.

But the dominant impression that emerges from inspecting either female witches or male magicians is that the Inquisition took neither of them very seriously. It classified such deviations as "superstitious" rather than diabolical and dangerous. Even people who claimed to have sold their souls to the Devil were not treated as apostates. Given this evidence, one may well ask why the Italian Inquisitors spent so much time and effort investigating those thousands of cases of illicit magic, which after all formed the bulk of their seventeenth-century caseloads. The example of the male magicians is significant because it rules out the easy explanation that witches' claims were not taken seriously because they were made by women.

Ginzburg has demonstrated that the claims of the *benandanti* or good witches of the Friuli were also not taken seriously, and these people were mostly men (74 per cent). Obviously, these Italian Inquisitors had other priorities. But what were they, and how did they affect women in particular? After all, the lands of the Mediterranean Inquisitions (Italy, Spain, Portugal) are the natural home of *machismo,* both the word and the thing itself. How can the proverbial oppression of Mediterranean women be harmonized with our pieces of evidence about Italian inquisitorial attitudes toward Judaism, Protestantism, forbidden magic, bigamy, and lesser crimes?

I will approach my answer by a detour. One of the most sensitive areas of inquisitorial control concerned the proper functioning of the confessional. The Holy Office supervised both the faults of penitents and those of confessors (although in principle it could not use evidence from the confessional, whose inviolability remained absolute). The faults of confessors were straightforward and numerous: the Italian Inquisitors interrogated and punished several hundred clerics for *solicitazione in confessione,* that is, for attempted seduction of women during the process of confession, a peculiarly clerical form of rape. Undoubtedly only some of the worst offenders were ever caught—sometimes five or six women denounced an offender for words and deeds extending over several years.[12] Still, over a hundred priests were arrested (and rather mildly punished) for this reason in Sicily, at Venice, or in the Friuli, mainly during the seventeenth-century apogee of the Counter-Reformation.

The faults of the female penitent were far fewer but far more interesting psychologically. The handful of cases for *affetata santità* or pseudo-sainthood (perhaps four or five per tribunal in seventeenth- and eighteenth-century Italy) tell a great deal about inquisitorial attitudes toward women. Such pseudo-saints were nearly always women but rarely nuns. Their crimes were spiritual, because their visions, revelations, special graces and other quasi-miraculous behavior were judged bogus; but their punishments depended on non-theological criteria. Consider the example of one such pseudo-saint, Angela Mellini, tried by the Bologna Inquisition in 1698.[13] An illiterate seamstress in her mid-thirties, she had joined the Ursulines, the lay sisterhood which taught reading to poor girls. More to the point, Mellini was an autonomous woman who kept changing confessors until she found one to her liking and subsequently enjoyed a symbiotic relationship with him. After a few years, she had managed her

spiritual exercise of prolonged meditation well enough to have numerous visions, including one at Christmas time, in which the Virgin handed her the newborn Christ-child and Mellini began to nurse him, feeling considerable physical sensations. She had also avowed her sexual desires toward her confessor; he answered by describing his own sexual desires toward other women and begged her to pray for him to keep him continent. After about a year he taught her to write, so that she could keep a spiritual diary (which survives). Whenever she confessed, which was often, because she took communion several times a week, they would bless each other, in Latin. He had taken to calling her *madre,* even *mama,* and of course he brought all his convent's clothes to her to be mended. This was clearly not "spiritual guidance" as the Council of Trent understood it. One of Mellini's friends and co-workers finally denounced her to the Inquisition.

The investigation was rapid and the sentence benign. Angela Mellini received some mild reprimands privately and was released; her confessor was permanently banished from Bologna, principally for sharing his sexual problems with a woman. What seems important about the whole business is the way a female penitent could seize the initiative away from her confessor, typically by means of visions and ecstasies. What made this Bologna sentence unusually mild was that the whole affair was never widely publicized; perhaps six or eight people at most knew about it. In every case of *affetata santità* the female visionary was in close touch with a spiritual director, her mentor and manager. Women visionaries who were subsequently canonized always operated through carefully-chosen spiritual directors, and nearly all of them were confronted with ecclesiastical skepticism about the genuineness of their mystical experiences. In the Mediterranean world, this meant an investigation by the Holy Office. Loyola and St. Teresa, among others, passed the test, but most candidates failed in sainthood or even beatification. The decisions of post-Tridentine Inquisitors depended on two factors: the notoriety of the visionary, and her obedience to a reliable spiritual director. Disobedient visionaries were not canonized; they were punished. Even obedient visionaries, together with their confessors, risked the serious but vague charge of "Molinism." In the context of *affetata santità,* "Molinism" meant an overly-hasty acceptance of miraculous visions by both parties, usually accompanied by hints of sexual complicity. Such charges were more common in Spain or Portugal than in Italy; several dozen visionary *beatas* were tried by each Iberian Holy Office in the seventeenth and eighteenth centuries. They and

their "Molinist" spiritual directors might get severe punishment. A woman who had been a village celebrity could get a hundred lashes and several years of exile in Africa from the Portuguese; in Spain some of them were judged insane and put into madhouses, with lesser offenders placed in convents.[14] Their clerical mentors were banished, the most compromised among them serving time in the galleys. Mellini and her Italian sisters were comparatively lucky.

Where was the common ground between these female pseudo-saints and the female witches who were treated so leniently by all of the Mediterranean Inquisitions? Many historians claim that the last witch was executed by the Spanish Inquisition in 1781. But in fact Maria de las Dolores Lopez, alias *la beata Dolores,* hanged and then burned at Seville that year, was not a sorceress but a visionary and pseudo-saint. She was a blind woman who had learned to read and write through divine inspiration; she often talked to the Virgin Mary and imposed flagellations on herself which delivered souls from Purgatory. She was finally denounced by her confessor. During her two years in prison she was questioned by many theologians, but she remained totally impenitent and unaffected by their arguments. Her unusual stubbornness, her complete impermeability to clerical control, and her notoriety in Seville earned her the distinction of becoming the only known pseudo-saint to be killed by any of the Mediterranean Inquisitions. Yet to many who saw her die she was a "witch."

The Inquisition treated its witches as a variety of female *ilusa:* not powerful and feared, but stupid and misled, out of clerical control. The Italian Inquisitions and their Castilian cousins were in fact truly macho institutions, operating on the basis of shame more often than violence, but sternly determined to control autonomous priestesses as well as sorceresses. One kind of woman was misled by the "Father of lies," the Devil; the other was misled (or not led) by her spiritual director. In this context, both were regarded as pawns of male figures and thus need not be punished with undue severity.

NOTES

1. See Gustav Henningsen, "El 'Banco de datos' del Santo Oficio. Las relaciones de causas de la inquisición española, 1550–1700," *Boletín de la Real academia de la historia* 74 (1977): 547–70.

2. See John A. Tedeschi, "La dispersione degli archivi della inquisizione romana," *Rivista di storia e letteratura religiosa* 9 (1973): 298–312. Guides to the available local archives include *L'archivo storico diocesano di Napoli*, ed. Giuseppe Galasso and Carla Russo, 2 vols. (Naples: Guida, 1978, 1979) 2: 627–914; Luigi de Biasio, *1000 processi dell'Inquisizione in Friuli (1551–1647)* (Udine: Regione Autonoma Friuli-Venezia Giulia, 1976); idem., *I processi dell'Inquisizione in Friuli dal 1648 al 1798* (Udine: Regione Autonoma Friuli-Venezia Giulia, 1978); and *Archivio di Stato*, Venice, Indice N 303. Statistical information from them has been compiled and analyzed in an article by John Tedeschi and William Monter, "Towards a Statistical Profile of the Italian Inquisitions," in eds. John Tedeschi and Gustav Henningsen, *The Inquisition in Early Modern Europe* (DeKalb: Northern Illinois University Press, 1985).

3. See Charles Amiel, "Les Archives de l'inquisition portugaise," in *Arquivos do Centro Cultural Portuges de Paris* 14 (1979): 7–29.

4. Published by Carlo Alberto Garufi, *Fatti e personaggi dell'Inquisizione in Sicilia* (Palermo: Sellerio Editore Palermo, 1978), a reprinting of articles originally published in the *Archivio storico siciliano* in 1914–17.

5. The only breakdown on clerics/laymen, monks/priests and occupational ranges among "Lutheran" suspects anywhere in Italy is in Garufi (*supra*, n. 4).

6. The best discussion of this point is in Mercedes García-Arenal, *Inquisición y moriscos: Los procesos del Tribunal de Cuenca* (Madrid: Siglo Veintiuno Editores, 1978), pp. 25–29.

7. Benvenuto Cellini, *Autobiography*, trans. G. Bull (Harmondsworth: Penguin Books, 1956), pp. 120–24.

8. In other places, such as Alan Macfarlane's county of Essex, women comprised over 90 percent of accused witches. In only one place did men comprise close to half of all known defendants—Alfred Soman's investigation of the Parlement of Paris from 1560–1640—but this was a prestigious *appellate* court; and appellate courts, like the Inquisition in Aragon (see *infra*, n. 10) were rarely used by women, especially the poor women ordinarily accused of this crime.

9. Ginzburg's monograph on *I benandanti* (Torino: G. Einaudi, 1966) is now available in English translation as *The Night Battles: Witchcraft and Agrarian Cults in the Sixteenth and Seventeenth Centuries*, trans. John and Anne Tedeschi (Baltimore: Johns Hopkins University Press, 1983).

10. The only attempt I am aware of to compare inquisitorial with secular justice in Mediterranean witchcraft cases is A. Gari Lacruz, "Variedad de competencias en el delito de brujería (1600–1650) en Aragon," in *La Inquisición Española: Nueva visión, nuevos horizontes*, ed. J. Pérez Villanueva (Madrid: Siglo Veintiuno Editores, 1980), pp. 319–28. The results are highly instructive: among two dozen Holy Office cases, including six transferred from secular courts, one finds eighteen men and only four women as defendants; but these same cases reveal traces of sixty-four women and only two men tried and executed for witchcraft by secular courts in Aragon.

11. Luisa Accati, "Lo spirito della fornicazione: virtù dell'anima e virtù del corpo in Friuli fra '600 e '700," in *Quaderni storici* 41 (1979): 669.

12. To the best of my knowledge, the record for solicitation is held by a Mexican Jesuit who was denounced for this offense by no fewer than ninety-seven women in 1620: Solange Alberro, *La actividad del Santo Officio de la Inquisición en Nueva España 1571–1700* (Mexico: Instituto Nacional de Antropología e Historia, 1981), p. 142.

13. Account drawn from Luisa Ciammitti, "Una santa di meno. Storia di Angela Mellini, cucitrice bolognese (1667–17 . .)," in *Quaderni storici* 41 (1979): 603–39.

14. See the excellent account by Claire Guilhem, "L'Inquisition et la dé-valuation des discours feminins," in *L'Inquisition espagnole (XVe–XIXe siècle)*, ed. Bartolomé Benassar (Paris: Librairie Hachette, 1979), pp. 197–240.

4

Annihilating Intimacy in *Coriolanus*

MADELON SPRENGNETHER

*W*HATEVER ELSE they are about, Shakespeare's tragedies demon-
strate, with a terrible consistency, the ways in which love kills.
My argument here concerns the structures of homoerotic and hetero-
erotic bonding that constitute the primary forms of relationship in the
tragedies, the assumptions regarding femininity they entail, and the
manner in which they combine, with particular deadliness, in the late
tragedy *Coriolanus*. In this play, which reveals a deep fantasy of
maternal destructiveness, one can see elements of a preoedipal plot
that underlies the other plays, though less explicitly articulated in
them. In this plot, the hero both desires and fears the annihilation of
his identity that intimacy with a woman either threatens or requires.
This is, in effect, a matriarchal plot, in which union with the body of
a mother/lover is fatal to the hero. In order to demonstrate the
relevance of this argument to *Coriolanus* I will first discuss preoedipal
object-relations theory as it illuminates the gender structures of pa-
triarchal culture; next I will review the patterns that gender rela-
tionships assume in Shakespearean tragedy, emphasizing the unique
ways in which these patterns combine in *Coriolanus;* and I will con-
clude by considering some implications of these structures for both
psychoanalytic and Shakespearean discourse.

Object-relations theory, on which several recent studies of Shake-
speare rely, proposes a modern psychoanalytic myth: that the infant
must undergo a process of separation and individuation from its
mother with whom its first experience is one of union.[1] Robert
Stoller articulates most clearly the assumptions concerning the de-

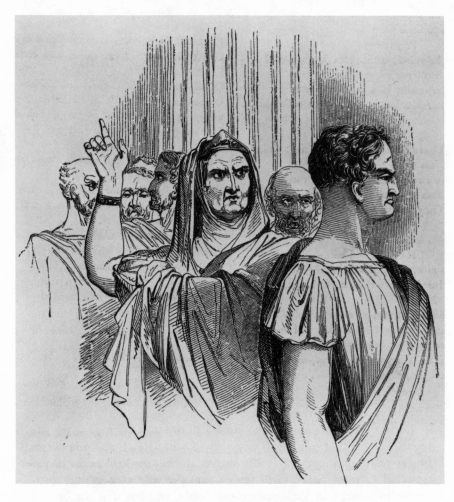

Volumnia talking to Coriolanus. By Kenny Meadows. From Corn-
wall, ed., *The Complete Works of Shakespeare,* London, the London
Printing and Publishing Company, Ltd., 1858. *Courtesy of the New-
berry Library, Chicago.*

velopment of masculinity contained in the idea of mother–infant
symbiosis. He states that in

> the whole process of becoming masculine in the little boy from the
> day of birth on, his still-to-be-created masculinity is endangered by

the primary, profound, primeval oneness with mother, a blissful experience that serves, buried but active in the core of one's identity, as a focus which, throughout life, can attract one to regress back to that primitive oneness. That is the threat lying latent in masculinity, and I suggest that the need to fight it off is what energizes some of what we are familiar with when we call a piece of behavior "masculine." So—something I never quite articulated before—in one sense, the process of the development of core gender identity is not the same in males as in females. There is a conflict that females are spared; core gender identity in males is not, as I have mistakenly said, quite so immutable. It carries in it the urge to regress to an original oneness with mother.[2]

This hypothesis seems at once to undermine and to revise classical oedipal theory, with its focus on male rivalry and female castration. Femininity, from the point of view of Stoller (and object-relations theory generally) is primary, while masculine identity is something achieved rather than given and always at risk of becoming lost or diffused back into the original feminine matrix.[3] On another level, one could say that preoedipal theory supplements oedipal theory, making explicit the competing set of assumptions concerning the representatives of masculinity (the father) and femininity (the mother) that inform and motivate patriarchal culture. In this view, the structure of patriarchal control manifest in Freud's description of the son's accession to the position of the father (through successful negotiation of the oedipal and castration complexes) is continually threatened with subversion by an equally powerful matriarchal influence. Looked at this way, as aspects of one another, which, taken together, provide a working description of the psychological underpinnings of patriarchal culture, oedipal and preoedipal theory may be seen to illuminate the gender conflicts typical of such a social structure. More specifically, these two theories, locked in tension with one another, pose rival claims of authority embodied respectively in the figures of father and mother. It is Shakespeare's engagement with this latter figure, and with the undertow of femininity she represents that I propose to explore in *Coriolanus*.[4] First, however, I want to summarize some of the developments in Shakespeare's other tragedies that cast light on the particular horror of Coriolanus' death. In my conclusion, I shall return to the questions raised in this study concerning the figure of the mother as she is represented in oedipal/preoedipal theory.

Femininity in Shakespeare's tragedies, as I have argued elsewhere, provides the ground against which the tragic action is dramatized.[5] Ambivalence on the part of the hero towards that which he considers feminine (whether in the context of homoerotic or heterosexual bonding) structures his relationships, just as it necessitates his death. The manner of the hero's death varies, however, according to his desire either for merger with a woman, as Richard Wheeler describes it, or for a form of homoerotic bonding that occurs in the context of a pursuit of heroic masculinity.[6] While the former finds its characteristic expression in the love-death of the romantic tragedies, the latter focuses on the exaggerated violence of relationships among men based on the exclusion of femininity. The desire for merger with a woman, which predominates in *Romeo and Juliet, Othello, Antony and Cleopatra,* and in variant form in *King Lear,* can only be accomplished through the destruction of both partners.[7] The flight from women, on the other hand, and the pursuit of heroic masculinity in the form of erotically charged male rivalries, which structure the history plays as well as the tragedies *Julius Caesar, Hamlet,* and *Macbeth,* lead to the spectacle of male competitors locked in fatal combat.

The tragic hero oscillates between heterosexual and homoerotic impulses, as does his counterpart in the comedies, with the difference that the violence so often threatened or symbolically enacted in the plays culminating in heterosexual marriage erupts in the tragedies in the context of both heterosexual and homoerotic embrace. In both instances the position feared by the hero is that which he considers to be feminine, and the tragic irony proceeds from the fact that it is this position that opens to him the full range of his own emotions and commands his ultimate surrender.

The heroes of *Romeo and Juliet, Othello,* and *Antony and Cleopatra* retreat from their initial gestures towards heterosexual union to a world of masculine loyalties embodied in a companion who disdains or avoids the love of women and who bases his identity on his definition of himself as a fighter or a soldier. Mercutio challenges Romeo's allegiance to Juliet by seducing him into the feud, thereby spoiling the potentially comic movement of the play. With Mercutio's taunt of "vile submission" in his ears, Romeo chooses to set aside his love for Juliet in order to avenge the death of his friend. At this crucial moment, he perceives heterosexual love as dangerously effeminate, corroborating the estimation of Mercutio, who understands Romeo's passion as a defection. Ironically, Romeo's choice of the "manly" role

of avenger leads to the ruin of his love, placing him more securely in the position of victim of passion that he seeks momentarily to avoid. An act of violence not only precedes the moment of sexual consummation in this play, but it also becomes its prevailing metaphor, as the rhetoric of death as love and love as death indicates. Romeo's fears regarding heterosexual encounter are finally realized literally in the double suicide with which the play concludes.

Othello provides a more complex instance of this pattern. Here, the hero's swerve away from the pursuit of heterosexual love takes place through the intervention of Iago, a character who disparages women and whose ruinous designs seem motivated in part by his anger at having been displaced in the affections of his master. This play presents two patterns of erotic destructiveness neatly intertwined, one involving the relationship between Iago and Othello, the other between Othello and Desdemona. As I have argued elsewhere, the form taken by Iago's disappointed love for Othello binds him to his master, as witnessed in the exchange of vows in the middle of the play, at the same time that it relentlessly destroys Othello.[8] This structure exhibits some of the features of erotically charged male rivalry that appear with varying degrees of intensity in other plays. In particular, it reveals the hierarchical ordering characteristic of these relationships, the fundamental assumption that in each pair one must dominate, the other submit, and in extreme cases that one at least must die.

For Othello, in whom heterosexual passion has awakened a terrifying sense of dependence ("and when I love thee not/Chaos is come again" III. iii. 91–92), the retreat from union with Desdemona into the world of doubt and suspicion created by Iago offers a paradoxical security in the midst of his anguish.[9] Unable to accept the position of emotional risk in which he has placed himself by his marriage to Desdemona, he falls prey to the misogynist inventions of Iago, whose honesty he steadfastly upholds over that of his wife. In attempting to defend himself against a fantasied betrayal, Othello reveals the extent to which he fears and mistrusts Desdemona and perhaps women in general.[10] Othello's ambivalence regarding heterosexual passion, while more intricately portrayed than that of Romeo, similarly engenders a tragic conclusion. The fusion of love and violence that characterizes both the action and the rhetoric of the end of the play serves as an apt expression of Othello's divided impulses.

In *Antony and Cleopatra,* the hero's movement away from

Cleopatra and toward Octavius and the world of male alliance in the beginning of the play, though justified by external events, is also fueled by his ambivalence. Antony's alternating views of Cleopatra as vile seductress and enchanting queen reflect his alternating impulses of fear and desire. The specific danger felt by Antony in Egypt—the danger expressed in the Roman censure of Antony's relationship with Cleopatra, hinted at in the playful exchange of garments described by Cleopatra, and explicitly detailed by Enobarbus in his disapproval of Cleopatra's participation in battle—is loss of military identity, which he equates with feminization.

In the beginning of the play, Antony leaves Egypt altogether in order to recover his masculine sense of himself. Later, having returned to Egypt and lost his first battle with Octavius, he attempts to recover his identity through repeated military encounters. This strategy fails when, in his moment of deepest despair, he, like the poet of the sonnets, believes himself to have been doubly betrayed by a dark lady and a boy in one another's arms: "Triple-turn'd whore! 'tis thou/ Hast sold me to this novice, and my heart/ Makes only wars on thee" (IV. xii. 13–15). In the end, the anxiety and rage occasioned in him by Cleopatra's behavior give way, as they do for Othello, to a desire for union with his lover in death. Antony's suicide enacts both aspects of his relation to Cleopatra: his wish to submit to her and his conviction that she will destroy him.

King Lear, which ends in another kind of love-death, reveals a variation on this pattern. While the romantic tragedies focus specifically on the heterosexual love relationship, *King Lear*, in which the hero's passionate love for his daughter Cordelia engenders a desire for a role reversal in which he would take the position of a son toward a nurturing mother, touches another and perhaps stronger chord. Lear's rage and pain at being denied protection suggest the helplessness of an infant in relation to an all-powerful mother. For Lear to acknowledge his feelings, moreover, in the beginning of the play, threatens his sense of manhood. Anger, curses, and threats of banishment serve Lear as a means of repressing the grief, hysteria and eventual madness that he associates with a feminine loss of control. In these early strategies of denial he more nearly resembles the inflexible Coriolanus than the heroes of the romantic tragedies. In the manner of his breakdown, however, he resembles Romeo, Othello, and Antony, all of whom undergo an emotional transformation through their experience of vulnerability in relation to a woman. For Lear this

transformation involves first a recognition of his dependence on his non-nurturing daughters, which leads to his misogynist vision of all women as centaurs, then to a submission to his helpless love for his one nurturing daughter. This submission, like that of Romeo, Othello, and Antony, effectively requires his death. Realizing that he is indirectly responsible for the death of Cordelia, he cannot then bear to be separate from her. Here, as in the romantic tragedies, love kills: through his fear and resistance, the hero ironically engages the very forces that bring about his destruction.

The assumption shared by the plays *Romeo and Juliet*, *Othello*, *Antony and Cleopatra*, and *Lear* may be stated in the following way: the hero experiences intense feeling for a woman as feminizing, an awareness that he attempts to escape or repress, and that in turn creates the condition of union in destruction that comprises both the conclusion of the play and the actualization of a basic fantasy about heterosexual relations. In these plays, a literal loss of self is the price the hero pays for his union with a woman.

In the other significant group of plays, including *Hamlet*, *Julius Caesar*, and *Macbeth*, the hero's recoil from heterosexual passion and his corresponding repudiation of femininity engage him in a pursuit of heroic masculinity through the defeat of one or more male rivals. In this structure of encounter (homoerotic rather than heterosexually oriented), it is the submissive or feminine posture that the hero seeks to avoid but ultimately embraces, as does his counterpart in the romantic tragedies.

For Hamlet, the confirmation of manhood involves the killing of a rival, a condition imposed by his father. The task of avenging his father's death, however, sets him directly in opposition to his mother, and by extension, to Ophelia. Hamlet's rage against what he considers the deceptiveness of women resembles that of Othello, Antony, and Lear in their moments of greatest anxiety about betrayal. His impulses, however, more evenly divided than theirs between the desire for feminine protection and for the refuge of masculine solidarity, more effectively paralyze him for most of the play. Finally, laboring under his father's injunction, he will choose the honesty of Horatio over that of Ophelia, displacing his passion for her into an intimate rivalry with her brother, which kills them both.

While Hamlet oscillates between conflicting allegiances to women and to men, tipping the balance finally on the side of paternal authority, Brutus and Macbeth pursue a more rigidly defined ideal of

masculinity in which male rivalries predominate. These plays, struc-
tured by the assumption that masculine identity consists primarily in
inflicting wounds on one's rival, inevitably turn the sword, in a
castrating or self-castrating gesture, against the hero himself. *Julius
Caesar* and *Macbeth,* like *Coriolanus,* exhibit a terrible logic in which
the roles of wounder and wounded and their corresponding relations
of dominance and submission are reversed.

In *Julius Caesar* it is a woman who, oddly enough, articulates the
fundamental masculine ethic of the play by voluntarily wounding
herself to demonstrate her capacity for stoic endurance and to win her
husband's confidence. In a play obsessed with wounds—with the
spectacle of Caesar's hacked and bleeding body and the ritually self-
inflicted wounds of the conspirators Cassius and Brutus—Portia's
gesture is far from gratuitous. In her zeal to prove her masculine
trustworthiness, she reveals the underlying paradox of the play,
which equates manliness with injury, so that the sign of masculinity
becomes the wound.

There is, moreover, an inverse relationship in *Julius Caesar,* as in
Macbeth and *Coriolanus,* between the degree of anxiety concerning
femininity and the amount of surface violence. Caesar's death results,
in an immediate sense, from his fear of appearing foolish or womanly
by attending seriously to Calpurnia's dream. Similarly, Brutus' split-
ting of consciousness in his rational consideration of murder blinds
him to its emotional consequences, causing him, like Macbeth, to fall
victim to hallucinations where he more nearly confronts the truth of
his experience. In denying or suppressing the kind of non-rational
awareness expressed in superstition, dream, or simply in tender con-
sideration, the protagonists initiate a cycle of violence, extraordinary
in its emphasis on physical mutilation, which ultimately consumes
them.

Both Brutus and Cassius, who choose a manner of death con-
sistent with their sense of honor and masculinity, die in the arms of
friends in a parody of erotic embrace, turning the sword used against
Caesar against themselves. While Cassius instructs Pindarus "with
this good sword / That ran through Caesar's bowels, search this
bosom" (V. iii. 41–42), Brutus in his own death invokes the spirit of
the man he both loved and murdered: "Caesar, now be still, / I kill'd
not thee with half so good a will" (V. v. 50–51). The relationships
among men in *Julius Caesar,* based in part on a repudiation of femi-

ninity, reveal a pattern of erotic destructiveness.[11] The attempt to construct an ideal masculinity, to demonstrate absolute sexual difference, collapses into an odd parody of femininity in which it is men, not women, who bleed.

In *Macbeth,* the flight from femininity is at once more obvious and more gruesome in its particular manifestations and conclusion. As many readers have observed, the idea proposed by Lady Macbeth and embraced by her husband in his relentless eradication of his enemies is based on the exclusion of reactions and emotions considered feminine and hence weak. Not to be all male in this distorted formulation is to become vulnerable, even disturbingly female, as Lady Macbeth implies in her attempts to shake Macbeth from his distraction at the banquet: "Are you a man?" (III. iv. 57); "What? quite unmann'd in folly?" (III. iv. 73); "O, these flaws and starts / (Impostors to a true fear) would well become / A woman's story at a winter's fire" (III. iv. 62–65). The dissociation of sensibility necessitated by Macbeth's course of action, one which requires a divorce between eye and hand, between consciousness and deed, is both more severe than that of Brutus and more deadening. It feeds, moreover, on a fantasy of total invulnerability, of a condition of perfect maleness, in which only a man similarly uncontaminated by femininity—"not of woman born"—can harm the hero.

Macbeth's fantasy of invulnerability coincides with an actual diminishment of stature and an increasing subjection to feminine powers, which appear in the guise of the witches. This terrible femininity, the nightmare counterpart of Macbeth's rapacious masculinity, ultimately claims him, though true to his violent course he dies at the hands of a male rival. In a final humiliation, moreover, he is beheaded, an act of physical mutilation (read psychoanalytically as castration) that emphasizes the vulnerability he has desperately sought to deny.

Both structures of action I have so briefly outlined portray the tragic consequences of the hero's ambivalences regarding femininity. If heterosexual passion does not actually feminize him, it makes him vulnerable to the woman's power to abandon or betray him, a position in which he loses mastery. On the other hand, seeking confirmation of his masculinity in more or less exclusive relationships with men, the hero finds only an illusion of selfhood that easily fragments in the high-pressured sphere of male competition. Both

strategies of relationship place him in the posture of submission that he resists and fears. Both incite him to violence, and both implicate or unite him in death with the object of his violence.

Coriolanus, as a late tragedy, not only repeats the major preoccupations of the preceding plays, it also combines the two competing structures of relationship I have described in a particularly excruciating way. While Coriolanus, like Hamlet, Brutus, and Macbeth, dies as a soldier, the manner of his death, like that of Romeo, Othello, and Antony, involves submission to a woman. The conjunction of these two structures, as in a deadlock or stalemate, seems to deprive each of its distinctive gratification. Coriolanus dies with neither the dignity of a warrior nor with the luxury of the illusion of union in death. Instead he is mutilated by his enemy Aufidius and survived by his mother, the woman who has most compelled his love. This play portrays the futility of both tragic structures at the same time that it exposes the inexorable logic behind them. The hero's flight from femininity, the undertow of which he feels most critically in relation to his mother, implicates him in cycles of eroticized violence that shatter his body as well as his identity. In the deep fantasy of this play, femininity, as represented by the figure of the mother, is both powerful and primary, and hence (as in Stoller's view) subversive of masculine identity. [12] More disturbingly, Shakespeare explores in this play a fantasy that underlies the other tragedies though less clearly articulated in them—a fantasy of maternal omnipotence in which a mother seeks the death of her son.[13] What *Coriolanus* demonstrates, I believe, is that the barriers to intimacy in Shakespeare's tragedies stem from the hero's anxieties regarding the figure of a mother/lover who threatens the annihilation of his identity, a condition he both desires and fears.

Volumnia, who maintains, like Portia, the paradoxical equation of wounds with masculinity, seems to thrust her son towards death. Claiming that "blood becomes a man," she states:

> The breasts of Hecuba,
> When she did suckle Hector, look'd not lovelier
> Than Hector's forehead when it spit forth blood
> At Grecian sword, [contemning]. (I. iii. 40–43)

On hearing of her son's exploits at Corioli, she exclaims, "O, he is wounded, I thank the gods for't," (II. i. 121). She later delights in dwelling on his wounds. When asked by Menenius how he has been hurt, she replies:

> I' th' shoulder and i' th' left arm. There will be large cicatrices to show the people, when he shall stand for his place. He receiv'd in the repulse of Tarquin seven hurts i' th' body. (II. i. 147–50)

In another complex and revealing statement, Volumnia explains to Virgilia why men should make war not love:

> If my son were my husband, I should freelier rejoice in that absence wherein he won honor than in the embracements of his bed where he would show most love. When yet he was but tender-bodied and the only son of my womb; when youth with comeliness pluck'd all gaze his way; when for a day of kings' entreaties a mother should not sell him an hour from her beholding; I, considering how honor would become such a person, that it was no better than picture-like to hang by th'wall, if renown made it not stir, was pleas'd to let him seek danger where he was like to find fame. To a cruel war I sent him, from whence he return'd, his brows bound with oak. I tell thee, daughter, I sprang not more in joy at first hearing he was a man-child than now in first seeing he had prov'd himself a man. (I. iii. 2–17)

Love and war are so intertwined in Volumnia's imagination that eroticized violence becomes the mark of her relationship with her son. To be a man and to love his mother, Coriolanus must be wounded, a condition he more than fulfills in the course of the play, until his mutilated body becomes the visible emblem of his destiny.

Coriolanus himself eroticizes violence, though this is most evident in his relationship with Aufidius, which seems initially to confirm rather than to undermine his manliness. Like other Shakespearean heroes, Coriolanus associates fighting and the kind of male bonding offered in battle with manhood, so that he fully endorses the equation of wounds with masculinity offered by his mother. The appeal of the battlefield, as Cominius describes it, seems to reside in its function as a place of ritual disidentification from femininity.[14] Cominius suggests, in the following passage, that until he proved

himself a man Coriolanus was more like a girl, or, like the young man
of the sonnets, "for a woman first created":

> Our then dictator,
> Whom with all praise I point at, saw him fight,
> When with his Amazonian [chin] he drove
> The bristled lips before him. . . .
> In that day's feats,
> When he might act the woman in the scene,
> He prov'd best man i' th' field, and for his meed
> Was brow-bound with the oak. His pupil age
> Man-ent'red thus, he waxed like a sea,
> And in the brunt of seventeen battles since
> He lurch'd all swords of the garland. (II. ii. 89–101)

In battle, Coriolanus defines himself as separate from his powerful
mother—as not female.

Displaying a notable lack of interest in his marriage and the
affairs of women, Coriolanus pursues instead a male rival whom he
can love on the battlefield. Only in this context, which provides a
superficial support for his masculine self-definition, can he express
vulnerability. Exhausted and bleeding from his conquest of Corioli,
for instance, he insists on revealing himself to Aufidius:

> The blood I drop is rather physical
> Than dangerous to me. To Aufidius thus
> I will appear, and fight. (I. v. 18–20)

The intensity of Coriolanus' attachment to his rival expresses itself
through opposition:

> Were half to half the world by th' ears, and he
> Upon my party, I'd revolt, to make
> Only my wars with him. He is a lion
> That I am proud to hunt. (I. i. 233–35)

That Coriolanus reserves his language of tenderness for situations of
mortal danger involving men is indicated by the following passage
addressed to Cominius:

> O! let me clip ye
> In my arms as sound as when I woo'd, in heart
> As merry as when our nuptial day was done
> And tapers burnt to bedward! (I. vi. 29–32)

This passage, of course, anticipates Aufidius' greeting of Coriolanus late in the play:

> Know thou first,
> I lov'd the maid I married; never man
> Sigh'd truer breath; but that I see thee here,
> Thou noble thing, more dances my rapt heart
> Than when I first my wedded mistress saw
> Bestride my threshold. (IV. v. 113–18)

Both men use the rhetoric of heterosexual passion to express intensity of feeling for another man. Because Coriolanus, in the beginning of the play, assumes mastery on the battlefield, whether in relation to Cominius or Aufidius, such a rhetoric does not threaten his masculinity. By the time he joins forces with Aufidius, however, his situation has become significantly more complex.

While Coriolanus can accept his mother's demand that he be wounded on the battlefield, he cannot accept her request that he reveal his wounds in public. While the former supports his fragile self-definition, the latter subverts it by revealing the contradiction at its heart. For Coriolanus to show his wounds is to expose his incompleteness, his implicitly castrated condition. Hoping to avoid this humiliation, he first pleads,

> Let me o'erleap that custom; for I cannot
> Put on the gown, stand naked, and entreat them
> For my wounds' sake to give their suffrage. (II. ii. 136–38)

When he actually appears before the people, he only alludes to his wounds, promising to show them in private. He takes refuge from the indignity of his position, moreover, in his rigid concept of verbal integrity.[15] Words, for Coriolanus, appear to be as subversive as wounds. Like Othello, who prides himself on his rudeness of speech as confirmation of his honesty, Coriolanus claims, "When blows have

made me stay, I fled from words" (II. ii. 72). Menenius, not without criticism, later describes the basis of Coriolanus' relationship to language.

> He would not flatter Neptune for his trident,
> Or Jove for's power to thunder. His heart's his mouth;
> What his breast forges, that his tongue must vent,
> And, being angry, does forget that ever
> He heard the name of death. (III. i. 255–59)

Anything less than an absolute correspondence between words and feelings (in this case any emotion other than anger) undermines Coriolanus' sense of himself. Specifically, he cannot tolerate any evidence of a split between seeming and being. Sensing his mother's disapproval of his contemptuous dismissal of the demands of the plebeians, he justifies himself saying, "Would you have me/ False to my nature? Rather say, I play/ The man I am" (III. ii. 14–16). When, on the contrary, Volumnia urges him to dissemble, Coriolanus responds,

> Must I
> With my base tongue give to my noble heart
> A lie that it must bear? Well, I will do't;
> Yet, were there but this single plot to lose,
> This mould of Martius, they to dust should grind it
> And throw't against the wind. To th' market-place!
> You have put me now to such a part which never
> I shall discharge to th' life. (III. ii. 99–106)

Here Coriolanus imagines total physical disintegration as preferable to acting, the threat of which he characterizes more explicitly in the following passage:

> Away, my disposition, and possess me
> Some harlot's spirit! My throat of war be turn'd,
> Which quier'd with my drum, into a pipe
> Small as an eunuch, or the virgin voice
> That babies lulls asleep! The smiles of knaves
> Tent in my cheeks, and schoolboys' tears take up
> The glasses of my sight! (III. ii. 111–17)

The ultimate humiliation for Coriolanus, and the one from which he flees into the arms of Aufidius, is to be female. What is most interesting about this passage, however, is the way it reverberates throughout Shakespeare's plays, touching as it does on the sensitive issue of language in relation to acting. Coriolanus' association of acting with harlots, eunuchs, virgins, and schoolboys evokes a complex figure that appears throughout Shakespeare's plays and is central to his art—that of the boy actor, the vehicle of an extraordinary range of verbal ingenuity and at the same time a figure of ambiguous sexual identity.

Generally speaking, the characters in Shakespeare's plays with the most complex kinds of awareness are the ones who are most at home with the possibilities of multiple meaning generated by lies, puns, riddles, and the condition of disguise.[16] What these features of language and identity share is a kind of split between appearance and reality which itself resembles the art of acting. The discrepancy between appearance and reality is made explicit in the figure of the boy actor who plays the part of a woman, and becomes self-consciously artful when the heroine he is portraying in turn disguises herself as a boy. While the comedies playfully exploit the possibilities of this convention, the tragedies on the whole, in their references to acting, reveal a more anxious relation to it. The heroes of the tragedies who associate deception and betrayal with women also regard verbal facility as dangerously feminine. The more they distrust language, the more rigid they become in their self-awareness and the more brittle in their masculine identity. Coriolanus' professed inability to play a part is directly related to his anxieties concerning his maleness; the inflexibility of his language is a reaction against the image of blurred sexual identity represented by the figure of the boy actor in a woman's role.[17]

Rejecting the ambiguous sexual identity of the boy actor who would "act the woman in the scene," Coriolanus becomes instead a "thing of blood." Turning towards Aufidius, after his banishment, he attempts to recover himself through his earlier strategy of making war on the object of his affections—this time Rome. "My birthplace [hate] I, and my love's upon / This enemy town" (IV. iv. 23–24). Whereas making war in the beginning of the play provides Coriolanus with a gratifying form of self-definition, here he merely situates himself precariously between two enemies, between his old rival Aufidius and his new rival Rome, the two forces that combine to

destroy him. Coriolanus' awareness of the danger of his position in relation to Aufidius appears in the casual reference to his death which accompanies his decision ("If he slay me,/ He does fair justice" [IV. iv. 24–25]) and in the suicidal challenge he offers to his enemy:

> I also am
> Longer to live most weary, and present
> My throat to thee and to thy ancient malice;
> Which not to cut would show thee but a fool,
> Since I have ever followed thee with hate,
> Drawn tuns of blood out of thy country's breast,
> And cannot live but to thy shame, unless
> It be to do thee service. (IV. v. 94–101)

Even though war in this instance deprives Coriolanus of the position of dominance so necessary to his self-esteem, he finds it preferable to the kind of exposure (and threat of feminization) recommended by his mother for political gain. By offering to serve Aufidius, moreover, Coriolanus achieves another end—that of severing himself from his mother, "as if a man were author of himself"—at the same time that he turns in matricidal fury against her:

> Making the mother, wife, and child to see
> The son, the husband, and the father tearing
> His country's bowels out. (V. iii. 101–3)

The futility of Coriolanus' situation manifests itself long before the end of the play. If Rome doesn't kill him, Aufidius will. Movement in either direction for Coriolanus is deadly. By embodying so explicitly the structures of eroticized violence in homoerotic and heterosexual bonding that alternately predominate in the other tragedies, and by locating himself at the intersection of these two structures, Coriolanus reveals the tragic paradox that animates them both. In his anxieties about femininity (either in relations with women where he fears a loss of masculinity, or in relations with men where he wounds himself to prove his manhood) the hero can seek only his own destruction.

The play in one sense concludes with Coriolanus' realization that he "cannot make true wars," that both his mother's injunctions (that

he be wounded and that he expose his wounds) involve him in contradictions that undermine the simple military identity he has sought and prized. He dies the unhappy victim of this truth. Having yielded to the "woman's tenderness" he has discovered within himself, he nevertheless becomes so enraged by Aufidius' taunt, "thou boy of tears," that, in defiance, he invites his own dismemberment:[18] "Cut me to pieces, Volsces, men and lads,/ Stain all your edges on me" (V. vi. 111–12). At the end, Coriolanus is metaphorically unmanned and literally mutilated, making his death singularly brutal and devoid of emotional gratification.[19]

Though Volumnia's role in Coriolanus' downfall has generated much negative commentary, the lessons to be drawn from it do not concern bad mothering *per se*.[20] Volumnia and Coriolanus are complementary partners in a fantasy structure that circulates, in less explicit form, through Shakespeare's tragedies. What is unusual about *Coriolanus* is the specific asymmetry of its conclusion: the two characters most responsible for the hero's death outlive him. This play is unique among the tragedies, moreover, in allowing a central female figure to survive. While Gertrude, Desdemona, Emilia, Goneril, Regan, Cordelia, and even Lady Macbeth all die within moments of the hero, Volumnia does not. Even Juliet and Cleopatra choose to join their lovers in death. If the image of a mother mourning the death of her son recalls that of the Pietà (in a Christian context), it also evokes that of the mother goddesses of the older fertility cults.[21] In the pagan rituals and myths the lover of the goddess is also sometimes regarded as a son. What characterizes all of these stories is the primacy of the mother and the inevitable death of her son/lover.[22] For Coriolanus, the moment of his submission to his mother signals his death.

> O my mother, mother! O!
> You have won a happy victory to Rome;
> But, for your son, believe it—O, believe it—
> Most dangerously you have with him prevail'd,
> If not most mortal to him. But let it come.
> (V. iii. 185–89)

In the deep fantasy of this play, a son is sacrificed to his mother in a perverse fertility rite that benefits no one.[23] At the same time, there is no escape in the logic of Shakespeare's tragedies from such a conclusion. Union with a woman throughout this sequence of plays is

dangerous, if not fatal, while those who flee women to pursue a counter-fantasy of ideal masculinity succumb to the contradiction inherent in the attempt to author oneself. The best death is reserved for the hero who accepts what Freud describes in *Beyond the Pleasure Principle* as the impulse ultimately to return to an undifferentiated (maternal) source.[24]

The reading I have just offered poses some theoretical questions I want to discuss (if not to resolve) that transcend the study of Shakespeare's plays. Most critics who read Shakespeare through the medium of psychoanalytic theory regard the theory itself (whether oedipal or preoedipal) as a fairly accurate model of human psychology. Volumnia, in such a reading, must appear as a terrible mother, a perversion of an implicit maternal norm of care and protectiveness. If, however, as I suspect, the figure of the mother as she is represented in preoedipal theory is a product of the oedipally organized patriarchal imagination, then other possibilities of interpretation emerge.

Freud's emphasis on the boy's oedipal struggle toward maturity, accompanied by his insistence on female castration, desubjectifies the mother (as the object of the boy's desire) at the same time that it confers on her the power and the fascination of an undifferentiated subjectivity—the power of Nature as opposed to Culture traditionally ascribed to women. Preoedipal theory, which entails a shift of focus from the father to the mother, in other ways supplements this view. The mother, still portrayed from the child's perspective as lacking subjectivity, appears as the matrix out of which his or her individuality is formed. In the ideal version of such a process, the mother, or her body, offers a paradisal state of oneness or plenitude from which the child suffers a gentle, though inevitable, Fall. This figure finds expression in countless variations on the theme of the Virgin Mother. Such an image of maternity, however, ideally nurturant and nonsexual, engenders its own dark twin. The sexual mother (sometimes termed "phallic") is as threatening in aspect as her counterpart is benign. She appears as a witch or whore. The inseparability of the two figures (good mother/bad mother) becomes apparent, however, if one considers the full implications of the concept of mother/infant symbiosis. In this concept the mother's body becomes the locus of fantasies of both union and separation, the mother herself the repre-

sentative of both plenitude and loss. Stated thus, preoedipal theory constitutes the most recent attempt to locate the origins of human consciousness and history with the agency of a woman and her transgression—Eve.

If, as I am suggesting, preoedipal theory in its construction of the figure of mother complements oedipal theory by offering a rival, though suppressed claim to authority, it also reveals the ambivalences encoded in patriarchal culture towards the figure who embodies this authority. That she should appear then in the guise of Volumnia is not surprising. That the shape of Shakespeare's tragedies should be defined by the male hero's responses to such a figure and the subversion of his masculinity that she represents is occasion for pity as well as terror.

NOTES

This essay was presented, in earlier drafts, at the Humanities Institute, Stanford University, 1982, the annual meeting of the Shakespeare Association of America, 1983, and at The Newberry Library conference on Changing Perspectives on Women in the Renaissance, 1983.

1. See Coppélia Kahn, *Man's Estate* (Berkeley: University of California Press, 1981), and Richard Wheeler, *Shakespeare's Development and the Problem Comedies* (Berkeley: University of California Press, 1981). Many of the essays in *Representing Shakespeare: New Psychoanalytic Essays,* eds. Murray M. Schwartz and Coppélia Kahn (Baltimore: Johns Hopkins Press, 1980) are also informed by this point of view. See in particular Janet Adelman's brilliant essay " 'Anger's My Meat': Feeding, Dependency, and Aggression in *Coriolanus,*" pp. 129–49. My own reading of femininity in Shakespeare, though different in important respects from the views of these critics, owes much to their work.

2. Robert Stoller, "Facts and Fancies: An Examination of Freud's Concept of Bisexuality," in *Women and Analysis,* ed. Jean Strouse (New York: Grossman Publishers, 1974), p. 358.

3. For Robert Stroller, there is no question that femininity (for both boys and girls), based on the infant's first identification with its mother, is primary. See "The Sense of Femaleness," and "The 'Bedrock' of Masculinity and Femininity: Bisexuality" in *Psychoanalysis and Women,* ed. Jean Baker Miller (Baltimore: Penguin Books, 1973), pp. 260–72 and 273–84. In his article "Facts and Fancies: An Examination of Freud's Concept of Bisexuality," Stoller also refers to biological evidence that "human tissue starts as female in fetal life, regardless of the chromosomal sex," so that "contrary to what Freud found psychologically and

then extrapolated as if it were a biological fact, a clitoris is not a little penis; rather, anatomically, a penis is an androgenized clitoris," *Women and Analysis*, p. 345. Leaving the question of fetal development aside, the assumption of an original mother-infant symbiosis would seem logically to support the notion of a primary femininity. Nancy Chodorow, in *The Reproduction of Mothering: Psychoanalysis and the Sociology of Gender* (Berkeley: University of California Press, 1978) explores in detail the implications of mother-infant symbiosis for masculine and feminine development.

4. Of all the readings of *Coriolanus* I have encountered, Janet Adelman's is surely the most compelling. She sees "the image of the mother who has not fed her children enough" at the center of the play, interpreting Coriolanus' rigid masculinity as a "defense against acknowledgement of his neediness." See *Representing Shakespeare*, pp. 129–49, pp. 130, 132.

5. See " 'I wooed thee with my sword:' Shakespeare's Tragic Paradigms," in *Representing Shakespeare*, pp. 170–87; " 'All that is spoke is marred:' Language and Consciousness in *Othello*," in *Women's Studies*, eds. Gayle Greene and Carolyn Ruth Swift 9 (1982): 157–76; and·" 'And when I love thee not:' Women and the Psychic Integrity of the Tragic Hero," *Hebrew University Studies in Literature* (Spring 1980): 44–65. These articles were published under the name Madelon Gohlke.

6. Richard Wheeler divides the tragedies into two groups, each of which exhibits a characteristic movement: towards trust/merger or towards autonomy/isolation. In the first group he includes *Hamlet, Othello, King Lear,* and *Antony and Cleopatra*, while the second consists of *Troilus and Cressida, Macbeth, Timon of Athens,* and *Coriolanus*. While these polar categories are instructive in describing the dominant movements of the plays, they obscure to some extent the shared ground in the hero's anxious relation to femininity and the extent to which homoerotic bonding appears both as an alternative to the more obvious danger of heterosexual passion and as an affirmation of the hero's heroic masculinity. See " 'Since first we were dissevered:' Trust and Autonomy in Shakespearean Tragedy and Romance," in *Representing Shakespeare*, pp. 150–69.

7. Charles Forker points out that "stories of disastrous love could explore the ambivalent relations between attraction and repulsion, commitment and doubt, freedom and bondage, elation and despair; they could address the contradictory needs for intimacy and separateness, for self-discovery and self-annihilation," "The Love-Death Nexus in Elizabethan Renaissance Tragedy," *Shakespeare Studies* 8 (1975): 211–30.

8. See " 'All that is spoke is marred': Language and Consciousness in *Othello*," *Women's Studies* 9: 157–76.

9. *Othello*, III., iii., 91–92, *The Riverside Shakespeare*, ed. G. Blakemore Evans (Boston: Houghton Mifflin, 1974). References to Shakespeare's plays throughout this essay are to this edition.

10. Edgar Snow analyzes with particular acuteness the sexual pathology of the patriarchal order as manifest in *Othello* in "Sexual Anxiety and the Male Order of Things in *Othello*," *English Literary Renaissance* 10 (Autumn 1980): 384–412.

11. Hélène Cixous, who emphasizes the ritualistic and sacrificial aspects of the play comments: "César aimait Brutus, et Brutus César. Et Brutus a tué César au moment même où il l'aimait le plus. Il a tué César par double et ironique amour," *Les Langues Modernes* 61 (1967): 53–55.

12. Joel Fineman argues that in Shakespeare's universe, sex differences are supported by violence. His understanding of the Shakespearean hero's difficulty establishing his masculinity is based on a concept of primary femininity: "For if the male's first sense of self is implicated in femininity, his masculinity is then conditional upon establishing a self distanced from its first sense of self. Women, on the other hand, because their gender is founded on a bedrock identification with maternality, have a kind of immediate gender reference to which they can refer their sense of self. In contrast to Freud, then, alienation from the object of desire is the preliminary condition both for male self-consciousness and for masculine desire." See "Fratricide and Cuckoldry: Shakespeare's Doubles," in *Representing Shakespeare*, pp. 70–109, especially p. 103.

13. Various critics have seen Volumnia's power over her son as darkly destructive. Janet Adelman states that "the cannibalistic mother who denies food and yet feeds on the victories of her sweet son stands at the darkest center of the play, where Coriolanus' oral vulnerability is fully defined." See "Anger's My Meat," p. 140. Richard Wheeler refers to the "deep maternal antagonism toward the son who becomes the man such a mother longs to be herself," in "Since first we were dissevered," p. 159. Robert Stoller is more explicit in his portrayal of Volumnia as demanding the death of her son: "He knows his master's voice, and for the last time obeys, as always, her command, this time that he be killed." See "Shakespearean Tragedy: *Coriolanus*," *Psychoanalytic Quarterly* 35 (1966): 263–74, esp. p. 273. Finally, D. W. Harding, in "Women's Fantasy of Manhood: A Shakespearean Theme," states: "the proud Roman matron passes on triumphantly while the son, having performed his last act to the greater glory of his mother, goes to the death which she herself has made inevitable" *Shakespeare Quarterly* 20 (1969): 253.

14. I am taking the phrase "disidentification" from Ralph Greenson, who, like Robert Stoller, assumes an original symbiotic relationship between mother and infant, necessitating on the part of the boy a "disidentification" from the mother in order to achieve a sense of maleness. See "Dis-Identifying from Mother: Its Special Importance for the Boy," *International Journal of Psycho-Analysis* 49 (1968): 370–73.

15. Coriolanus' uneasy relationship to rhetoric has drawn much commentary. Leonard Tennenhouse sees "his abhorrence of public speech and his distrust of words" as "functions of his obsessive quest for personal integrity which can only be correctly realized in physical action," quoted from "Coriolanus: History and the Crisis of Semantic Order," *Comparative Drama* 10 (1976): 334. James Calderwood, in "*Coriolanus*: Wordless Meanings and Meaningless Words," sees the inflexibility of Coriolanus' speech as an index of "a general insensitivity of feeling and a lack of discrimination in matters of human worth," *Studies in English Literature* 6 (1966): 216. In Stanley Fish's speech-act analysis, Coriolanus is "always doing things (with words) to set himself apart," "Speech-Act Theory, Literary

Criticism and *Coriolanus,*" *Centrum* 3 (1975): 107. For Lawrence Danson, "Coriolanus is not only the least eloquent of Shakespeare's tragic figures but one who (as we shall see) specifically rejects that humanizing speech sought by Titus or Hamlet." See *Tragic Alphabet: Shakespeare's Drama of Language* (New Haven: Yale University Press, 1974), p. 142. For all of these critics, Coriolanus' distrust of words diminishes him in stature.

16. I have argued this point more extensively in "'All that is spoke is marred:' Language and Consciousness in *Othello.*" My understanding is that complex speech, as manifest in the use of lies, riddles, puns, and the condition of disguise, is largely attributed to women in the comedies. As the issue of feminine betrayal becomes more prominent in the tragedies, ambiguous or complex speech also becomes more suspect. Like Othello who says that he is rude in speech, or Macbeth, who tries to subvert speech altogether by collapsing thoughts into actions, the hero in his attempt to establish his "honest" masculinity also expresses uneasiness about the instability of language.

17. One of the chief objections to the stage expressed in the anti-theatrical tracts of Shakespeare's time concerns the practice of cross-dressing, which is seen as dangerously effeminate, subversive of both heterosexuality and male dominance. See in particular Stephen Gosson, *The School of Abuse* (London: for Thomas Woodcocke, 1579); William Prynne, *Histrio-Mastix* (London: E. A. and W. J. for Michael Sparke, 1633); John Rainoldes, *The Overthrow of Stage-Playes* (Middleburg: R. Schilders, 1599); and Phillip Stubbes, *Anatomy of Abuses in England* (1593), ed. Frederick J. Furnivall, *New Shakespeare Society* (London: N. Trubner and Co., 1877). For a discussion of Elizabethan reactions to transvestism on the stage see J. W. Binns "Women as Transvestites on the Elizabethan Stage?: An Oxford Controversy," *Sixteenth Century Journal* 5 (1974): 95–120. For commentary on Stephen Gosson's objections to the stage, in particular his assumption of the prurient appeal of plays see Stephen Hilliard, "Stephen Gosson and the Elizabethan Distrust of the Effects of Drama," *English Literary Renaissance* 9 (1979): 225–39. For a comprehensive discussion of the anti-theatrical tracts see Jonas Barish, *The Antitheatrical Prejudice* (Berkeley: University of California Press, 1981). Though not strictly contemporary, William Prynne's association between the practise of cross-dressing (for men) and the pagan worship of Venus is suggestive. Transvestism, in his words, "is not only an imitation of effeminate idolatrous Priests and Pagans, who arrayed themselves in woman's apparell when they sacrificed to their idols, and their Venus, and celebrated Playes unto them . . . but a manifest approbation and renewall of this their idolatrous practice." See *Histrio-Mastix,* p. 207. Recently, Lisa Jardine has argued for the specifically homoerotic appeal of Shakespeare's use of boy actors. See *Still Harping on Daughters* (Totowa, New Jersey: Barnes and Nobles Books, 1983).

18. Charles Hofling and Ralph Berry both comment on the connotations of effeminacy contained in the word "boy." See Hofling's, "An Interpretation of Shakespeare's *Coriolanus,*" *American Imago* 14 (1957): 407–35, and Berry's "Sexual Imagery in *Coriolanus,*" *Studies in English Literature* 13 (1973): 301–16.

19. Janet Adelman says succinctly "there is no one here to love." See

"Anger's My Meat," p. 144.

20. It is easy to dislike Volumnia, who draws severe criticism from many readers of the play. Charles Hofling, for instance, sees her as "an extremely unfeminine, non-maternal person" ("An Interpretation of Shakespeare's *Coriolanus*," p. 415). For D. W. Harding, she "provides Shakespeare's most blood-chilling study of the destructive consequences of a woman's living out at someone else's expense her fantasy of what manhood should be" ("Woman's Fantasy of Manhood," p. 252). In Rufus Putney's words she is "a most repulsive mother" ("Coriolanus and his Mother," *Psychoanalytic Quarterly* 31 (1962): 364–81, 377).

21. C. L. Barber sees in the image of Lear with the dead Cordelia in his arms a "pieta with the roles reversed, not Holy Mother with her dead Son, but father with his dead daughter." See "The Family in Shakespeare's Development: Tragedy and Sacredness," *Representing Shakespeare,* p. 200.

22. For an overview of the archeological evidence concerning the prevalence of goddess worship in prehistoric and early historic periods see Merlin Stone *When God Was A Woman* (New York: Dial Press, 1976). Stone summarizes the work of writers such as J. J. Bachofen, Sir James Frazer, Robert Graves, and others concerning myths of goddess worship and relates it to the contemporary scholarship that grounds such speculation in archeological investigation.

23. Stanley Cavel, in an extremely interesting reading of this play, argues that *Coriolanus* fails to achieve the condition of tragedy because its hero fails to attain the status of the kind of sacrificial victim (like Christ) who could renew his society. " 'Who does the wolf love?' Reading *Coriolanus*," *Representations* 3 (1983): 1–20. In focussing on the drama of Christian ritual, however, Cavel misses the intimations of pre-Christian ritual in the image of a mother mourning the death of her son. Part of the disturbing power of this image, I believe, derives from its seeming subversion of patriarchal order.

24. *The Standard Edition of the Complete Psychological Works of Sigmund Freud,* trans. James Strachey, vol. 18 (London: Hogarth Press, 1955). The death instinct, for Freud, represents "the most universal endeavor of all living substance—namely to return to the quiescence of the inorganic world" p. 62.

5

John Foxe and the
Responsibilities of Queenship

CAROLE LEVIN

*I*N HIS *Acts and Monuments* John Foxe played a critical role in shaping perceptions of history in Elizabethan England.[1] First published in 1563, the book was republished and greatly expanded in 1570 and went through three more editions in the sixteenth century. Though much of the interest in Foxe's book centered on his account of the Protestant martyrs, *Acts and Monuments* is far more than a recitation of the trials of the godly; it is also a history of England written from the perspective of the true reformed Church. Foxe expanded his book to include this history for a purpose. He wanted to instruct both the Queen and the people about their mutual duties and obligations. Dedicating his work to Elizabeth, Foxe was both praising her and warning her of the need to establish the true Church.[2] Foxe wrote, then, both to "honour the dead victims, and [to] warn and encourage the living."[3] A humanist whose earlier work was published in Latin, Foxe chose to present *Acts and Monuments* in the less prestigious vernacular, seeking to inform the British people of what had happened and could happen again without a godly ruler. Above all, the person Foxe wanted to warn and encourage was his Queen.

Like many of the other returned Marian exiles, Foxe was unsatisfied with the Anglican Church settlement, which he considered incomplete and inadequate. Coming out of the tradition of William Tyndale and John Bale, he believed in an active God who directly intervenes in the human world. In *Acts and Monuments* he presented the history of the Church of England from the Lutheran perspective of the operation of Providence: God had saved Elizabeth from the perils of her sister's reign to rule the nation He had chosen to usher in the new age of faith.[4] Elizabeth had a duty to defend the true Church against the Church of Rome and to insist upon a complete reforma-

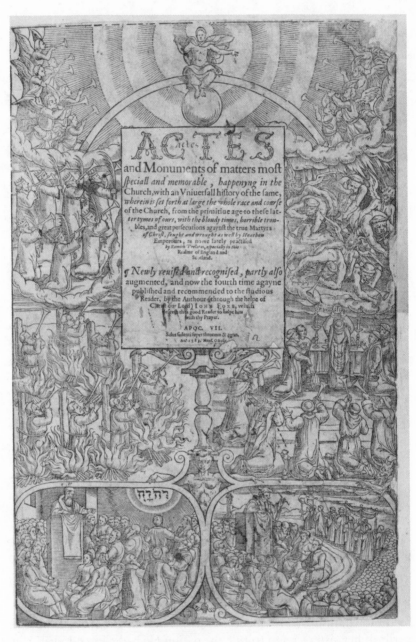

Title page of John Foxe's *Actes and Monuments*, London, 1583. Courtesy of the Newberry Library, Chicago.

tion. When apprising Elizabeth of her duty, Foxe did not want to attack her openly; he was all too aware of the dangers that could come to Protestant England if the Queen's position were weakened. Instead he sought to demonstrate to Elizabeth the nature of her true duty by presenting examples from earlier times of rulers and their fates.

Among rulers Elizabeth was special, of course, since she was not only a monarch, but a woman. As a result, Foxe's representation of earlier powerful women became crucial as a message to the reigning Queen. This essay will examine Foxe's portrayal of medieval queens, such as Matilda, Eleanor of Aquitaine, Isabel, wife of Edward II, and Margaret of Anjou, as well as such Tudor queens as Anne Boleyn, Catherine Parr, and Lady Jane Grey. Such an exploration not only reveals Foxe's important view of Elizabeth in particular; it also illuminates the influential role played by *Acts and Monuments* in the ardent debate about women's capacities as rulers that had been going on throughout the sixteenth century.

In both his work and his life, Foxe exhibited an ambiguity and subtlety that give his work a depth and significance in adding to our understanding of Elizabethan England.[5] While Foxe's sense of complexity is not confined to his attitude toward women, it is discernible in the ambivalence he expressed about female rule. His ambivalence arises directly from the conflict he perceived between a woman's power and her femininity. If a queen were to demonstrate the strong attributes of kingship, she would not be acting in a womanly manner; yet, approved womanly behavior would ill-fit her for the rigors of rule. This was a problem with which both Mary and Elizabeth had to come to terms. One solution, of course, was for the queen to marry. Though Mary's marriage to Philip of Spain had been a disaster, many people hoped Elizabeth would also relieve herself of responsibility in just that manner. Elizabeth's refusal made the concern over women's rule all the more significant.

Neither the issues involved nor the equivocation about them were original with Foxe. The discussion about whether women were suited to play a role in government had been going on in English since 1540, with the publication of Richard Hyrde's translation of Juan Vives' *Instruction of a christen woman* and Thomas Elyot's *The defence of good women*. Though arguing different sides of the question, both

Vives and Elyot betray the ambivalence that will later mark Foxe's work.[6]

Even though Vives wrote in favor of a humanist education for women, he also condemned women for playing a role in public life. Vives perceived significant differences between men's and women's natures. He argued that a woman would not be a suitable ruler because she "is a fraile thynge, and of weake discretion, and thay maye lightly be disceyved."[7] Vives gave the example of Eve as proof of this assertion. Using the early Church fathers to support his contention, Vives instructed women to stay home and "nat medle with matters of realmes or cities. Your own house is a cite great inough for you."[8]

In the same year Thomas Elyot published *The defence of good women,* in which he argued that the virtues necessary for public life could be as well exemplified by women as by men. Written as a dialogue taking place in classical times, the *Defence* presents Candidus, who supports the idea that women are fit to participate in civic affairs, and Caninius, who is a detractor of women. Candidus' friend, the captive queen Zenobia, who appears at the end of the dialogue, serves as an example of Candidus' point of view, and her obvious virtues and ability convince Caninius that he is wrong. Yet Zenobia, this virtuous model, is, after all, a captive, and as Constance Jordan suggests, "One is tempted to think that Elyot, who had nothing to say about courageous and intelligent women in any of his other works, wrote the *Defence* somewhat half-heartedly and perhaps to fulfill an obligation."[9]

The defence of good women was published in 1540, when the question of women's rule was still theoretical. Due to the presence of Scottish Regent Mary of Guise and Mary I of England, the argument over women's capabilities as monarchs became more intense and immediate in the 1550s, with the writings of such Protestants as David Lindsay, Thomas Becon, and Christopher Goodman, and, especially, John Knox, all of whom presented hostile arguments against women's rule.[10] Knox proclaimed, "I am assured, that God hath reveled to some in this our age, that it is more then a monstre in nature that a Woman shall reigne and have empire above Man."[11] While specifically critical because Mary I and Mary of Guise were Catholic, Knox and these other authors were horrified by the idea of *any* woman ruling. In the "apology" Knox sent to Elizabeth after she became queen, he stated:

I can not deny the wreiting of a booke aganis the usurped Authoritie, and injust Regement of Women; neither [yit] am I myndit to retract or call back any principall point, or propositioun of the same, till treuth and verritie do farder appeir.[12]

Though the disagreement did not end their friendship, Foxe wrote to remonstrate with Knox over the extremity of his language in *The first blast of the trumpet against the monstruous regiment of women* (1558).[13]

John Aylmer's *An harborowe for faithfull and trewe subjects* (1559) and John Jewel's *A defence of the Apologie of the Churche of Englande* (1567) both refuted Knox with examples of virtuous women and argued that while women were not naturally prepared to govern, they might become rulers as part of God's own plan.[14] This was John Foxe's perspective. Elizabeth, he wrote, "after so long restrainment, so great dangers escaped . . . by the mighty protection of our merciful God, to our no small comfort and commodity, hath been exalted and erected out of thrall to liberty."[15]

Yet despite his celebration of Elizabeth, Foxe's descriptions of earlier powerful women betray some of the ambivalence that he felt about the concept of a woman ruler. Although he praised Elizabeth's rule as God's plan, he also showed God's role in punishing other strong women rulers. Examining the depictions of earlier queens in *Acts and Monuments* is useful in gaining an understanding of Foxe's expectations for Elizabeth and in demonstrating how unique he thought she was as a woman who was also God's instrument. A number of the powerful women Foxe discusses are queen consorts. Though Elizabeth was queen regnant, Foxe clearly saw these examples as useful guides for her. The English very much hoped that Elizabeth would marry, and examples of married women became appropriate models as well. Indeed, since she was a woman ruler, these examples were considered more appropriate than those of kings.

Foxe's presentation of queens fits into his broader perspective on women's behavior in general. Didactic literature of the sixteenth century advised women to be models of chaste, passive obedience. Pearl Hogrefe and Ruth Kelso both suggest that the ideals for women of the Renaissance were the passive Christian virtues.[16] Sermons and courtesy books emphasized such qualities as modesty, humility, sweetness, and piety. Yet it is the more active Christian virtues, such

as learning, proficiency at arms, ability to command, and provision of justice that would be most suitable for a ruler; these latter were seen as the traditional kingly virtues. Foxe, in his examples of women rulers, both reinforces and modifies the concern for appropriate feminine behavior.

Some of the presentations Foxe makes of women rulers are simply negligible. Other historians of the period have made much more of their activities.[17] For example, in the case of Henry I's daughter Matilda, Foxe points out that barons and churchmen swore to uphold her claim, but they foreswore themselves and supported her cousin Stephen. Foxe, whose view of history contains an active God who punishes wrongdoing, demonstrates the horrors that befell those who broke their just oath. Yet, though Foxe refers to Matilda making "strong war" on her cousin Stephen, and Stephen's wrongs are clearly enunciated, Matilda herself plays a rather small role in the proceedings, mostly making sure of the claim of her son Henry II, whom Foxe treats at great length when he comes to Henry's reign.[18]

Foxe also pays rather less attention than his contemporaries to Henry's wife, Eleanor of Aquitaine. For the most part, Eleanor's reputation was a very bad one in sixteenth-century history and drama.[19] Foxe, however, drew only minimally on this tradition. He mentions the problems between Eleanor and Henry that lead to Eleanor's imprisonment, but he is careful about ascribing a cause. Henry imprisoned Eleanor "as some think, for the love of Rosamund." Foxe does not, however, refer to the oft-cited legend that Eleanor murdered her rival. Rather, he uses Henry's imprisonment of Eleanor as a reason for God to stir their sons to rebel against Henry. Despite the rebellion, Foxe reports inaccurately that Eleanor was soon reconciled with Henry. In fact, except for brief ceremonial visits, Henry kept Eleanor in prison for the rest of his reign.[20]

Perhaps Foxe is less interested in Eleanor because of his greater interest in Henry. His concerns about the king, for the most part, center on two conflicts. The first is with Becket; not surprisingly, Foxe treats Henry sympathetically and does all he can to strip away from Becket the saint's and martyr's image. He presents Becket as a rebel against his king and a supporter of the corrupt Catholic Church. The other conflict Foxe describes is that between Henry and his sons. Foxe is more ambivalent about this latter conflict. He cites actions on Henry's part, such as the imprisonment of Eleanor, that would lead to God's punishment.[21] But though Henry may deserve the rebellion as

a punishment for his unjust acts, his sons are still wrong to rebel against him, and Foxe also emphasizes their culpability. In depicting this complex web of relationships and retribution, Foxe pays little attention to Eleanor.

When recounting the reign of Eleanor's son Richard, Foxe makes other comments about her that are brief but positive. He pictures Eleanor bringing Berengaria to be espoused to Richard and then journeying on to Rome in search of preferment for her other son Geoffrey.[22] Here again Foxe was inaccurate historically. The Geoffrey who was consecrated Archbishop of York was *not* Eleanor's son Geoffrey, but rather Henry's illegitimate son, who had the same name. Though Eleanor did go to Rome at Richard's request to convince Pope Celestine to elect Geoffrey as Archbishop, the reason was to remove any possibility of his reaching for the crown.[23] With this action Eleanor moves out of the narrative, never to return.

We can see in his treatment of Matilda and Eleanor that Foxe is not hostile, but neither is he devoting much space to presenting them as examples of powerful female rulers. Isabel of France and Margaret of Anjou receive much more attention from Foxe, and both came to far more tragic, if also, according to Foxe, well-deserved ends.

For most of his account of her, Foxe presents Edward II's wife Isabel in a fairly sympathetic manner. It is only at the end, when her actions have transgressed conceptions of appropriate behavior that Foxe condemns her. Part of his sympathy is occasioned by his attitude toward her husband Edward and his homosexual relationship with Piers Gaveston, who "brought the king, by means of his wanton conditions, to manifold vices, as adultery, and the like . . . so much was the king's heart infatuated by this wicked person." Edward's passion for Gaveston was so intense that he impoverished his wife's estate by giving Gaveston her possessions. Isabel's problems with Edward allied her interests with those of the kingdom. "If [Gaveston] were still suffered . . . the queen could not enjoy the love of the king, neither could there be any quietness in the realm."[24]

Foxe reports that when the nobles tried to separate Gaveston and the king, Edward responded by abandoning his pregnant wife to flee with Gaveston. Even though the nobels thought they had settled the problem by executing Gaveston, Edward continued his "evil living" by raising the Hugh Spensers, father and son, to be his favorites.[25]

Edward was not only having problems with his own barons but also with Isabel's brother, the King of France, over the allegiance he

(Edward) owed for his French possessions. To negotiate a settlement, Edward sent Isabel to the French court, and she soon convinced him to allow their son and heir Edward to join her. When Edward summoned her home, however, she refused to return. Foxe suggests several possible reasons for this refusal. First, the king had confiscated her lands and possessions. Another possibility was her hatred of the Spensers, while a third was "for love and familiarity of Sir Roger Mortimer." In mentioning this potential adulterous motivation, Foxe begins to shift his sympathy away from Isabel.[26] Isabel refused to return to England unless Edward granted a safe conduct to all the nobels who fled his reign. Not only did Edward reject this ultimatum, but Foxe reports that, encouraged by the Spensers, Edward contemplated having his wife and son murdered.

With the support of many of the English people outraged by Edward's rule, Isabel finally returned to England, bringing an army with her. At this point in Foxe's narrative Isabel is depicted as a powerful, strong woman who has the concern of the country at heart. Because Edward is a tyrant, the situation is extraordinary, and to combat it, she must move out of her accustomed female sphere to deal with the crisis. It is only later that her love for Mortimer contaminates her. People flocked to the returning Isabel, while almost no one could be hired at any wages to fight on Edward's behalf against her. Isabel was very concerned about her people. Foxe reports that she threatened her army with severe penalties if they hurt either person or property.

Because of Edward's tyranny, Parliament proclaimed him deposed. His son Edward was crowned in his place. Had Isabel allowed her young son to rule at that point, she might well have been described as a good example of a woman who acts only when there is need and then returns to her accustomed subordinate position. But Isabel did not do that. No longer considered as powerful herself, she handed her power to her lover Mortimer, who used it corruptly.

The next year Sir Roger Mortimer ordered the deposed Edward II to be murdered. Even worse, Mortimer used his position with Isabel to convince the young Edward that his uncle, the Earl of Kent, was trying to have him poisoned. Because of this false information, the innocent Earl was executed. "But the just judgement of God," Foxe proclaims, does not permit "such odious crimes to be unpunished or undetected." Soon Mortimer was destroyed, and Isabel with him. The fall of Mortimer began when Isabel was found to be

carrying his child. When the young king received word of this, he also began an investigation into Mortimer's role in the deaths of Edward II and the Earl of Kent. In Foxe's world, sexual misconduct for women is always severely condemned. It indicates total ethical lapse. Mortimer was executed, but Isabel was also punished, being "restrained of her liberty." Foxe does not mention whatever became of the child that proclaimed her guilt, and, in fact, there is no such record of pregnancy for Isabel at that time. But to demonstrate Foxe's vision of the world, the tale of Isabel's pregnancy worked well.[27]

Foxe is not the only Elizabethan to equate sexual impropriety with female immorality in general. As Lawrence Stone points out, Early Modern English society stressed honor but had very different conceptions of what constituted male and female honor.[28] While male honor depended on the integrity of one's word and courage, sexual chastity was the sole determinant of female honor. One of the ways in which people denigrated Elizabeth as queen was to accuse her of illicit sexual behavior and to suggest that she had illegitimate children. For example, in 1563 Edmund Baxter stated "that Lord Robert [Dudley] kept her Majesty, and that she was a naughty woman, and could not rule her realm, and that justice was not being administered." His wife added that when she saw the Queen at Ipswich, "she looks like one lately come out of child-bed."[29] For Elizabeth, one way she could continue to command the love and respect of her people was *not* to engage in inappropriate sexual behavior, and, even when she did not, the rumors continued.

In much the same manner, Foxe portrays Isabel as both powerful and good until she becomes involved with Mortimer. Once that happens she becomes powerless; we do not hear of anything else she herself accomplishes. And for her transgressions she is punished. Yet both Isabel's crimes and the just punishment that follows are mild compared to those that befall another powerful queen, Margaret of Anjou, wife of Henry VI.

Foxe's portrayal of Margaret is hostile from the beginning. The marriage arranged between her and Henry VI was, Foxe states, "unprofitable and unhonourable." In narrating Henry VI's reign, he portrays Humphrey, Duke of Gloucester, as one of the heroes of the period. Margaret is presented in contrast as a "sore enemy and mortal plague to this duke."[30]

Foxe described Margaret as "being of haughty stomach, and all set upon glory, of wit and wilines lacking nothing, and perceiving her

husband to be simple of wit, and easy to be ruled, took upon her to rule and govern both the king and his kingdom."[31] In Isabel's situation, her husband was depraved, and at a crucial moment she was the best person to rescue England from his tyranny. With Margaret, her husband is not evil but only simple, and there are more appropriate people than she to help him rule.

In an observation characteristic of sixteenth-century accounts of powerful women, Foxe refers to Margaret as this "manly woman and courageous queen." The word "manly" others also used at times to praise women's brave deeds. For example, an Italian residing in England during Mary's reign described Lady Jane Grey at her death as "submitting the neck to the axe with more than manly courage." Given Foxe's condemnation of Margaret's treatment of Gloucester, however, one suspects that in Foxe's view, for a woman to be manly and courageous is immoral.[32] Interestingly Foxe is manipulating historical fact in his interpretation by exaggerating Margaret's role in Gloucester's downfall. Since Gloucester's power would act as a check to Margaret's ambition, Foxe claims that she worked "by all imaginations and practices possible" to achieve his destruction. Because Gloucester was "so dear to the people and to all men so beloved," Margaret was afraid to move against him openly. She had him arrested and secretly murdered, hoping by this crime to make herself more powerful. In fact, Gloucester died of natural causes after his arrest. Margaret's hope for power failed, as Foxe is quick to point out, because of "the marvelous works of God's judgement." Ironically, in this action "the queen thought most to preserve her husband in honour and herself in state, thereby both she lost her husband, her husband lost his realm, the realm lost Anjou, Normandy, and the duchy of Aquitaine."[33]

The death of the good Duke led to such strife that eventually England was plunged into civil war. Foxe again shows Margaret as courageous and powerful during the war, but he also blames her for much of the sorrow of the realm. Finally the Duke of York's son was crowned Edward IV, and Margaret and her son were forced to flee to France. Her husband was eventually captured and lodged in the Tower. When her erstwhile enemy the Earl of Warwick turned against Edward IV, he joined Margaret in exile, thus giving her another chance to wreak havoc on England. The two prepared for another invasion.

What Foxe condemns most in Margaret is her blindness in not

realizing how her own actions led to the destruction of her hopes. When Edward IV triumphed over the Lancastrians, she "was so dismayed, disquieted, and pierced with sorrow . . . that she feard and took on with herself . . . crying out of fortune, as though blind fortune were she that governeth times and tides . . and not the secret power and terrible justice of Almighty God." Margaret finishes her role in Foxe's history by once again going to battle. Captured when she was "almost dead for sorrow," she was eventually ransomed by her father. By this time both her husband and her son were dead.[34]

For the most part, Foxe's view of medieval queens who exercise power is negative. Matilda and Eleanor do not come to terrible ends, but neither does Foxe give them much attention. Isabel, and even more, Margaret, show courage and resolution but are destroyed, one through her inappropriate sexual behavior, the other because of her ambition. In his depiction of medieval queens, Foxe does not really present Elizabeth with appropriate models, though he is certainly providing cautionary tales on the misuse of power.

This perspective partially shifts when Foxe discusses Protestant queens in the sixteenth century. In these cases religion seems to be a more significant determinant than gender. Anne Boleyn, Catherine Parr, and Lady Jane Grey are all queens who are virtuous women concerned with fostering the true Church. Yet even here the model is not completely positive, since two of these women died at the executioner's hand, and the third, Catherine Parr, only narrowly escaped this fate.

Following Foxe's treatment of earlier queens, Anne Boleyn's life appears well-suited to embody the laws of his moral universe. Rising to become queen of England, Anne died on the executioner's block, a fate she shared with the men accused of being her lovers. How much more of an object lesson Anne's fate could have provided than either Isabel's or Margaret's! Foxe, however, had certain problems in presenting Anne Boleyn, since he was writing about the ruling sovereign's mother, who had been executed on the order of Elizabeth's father. Though Foxe discusses Anne's death, he is vague about the cause; he simply states that she was sent to the Tower with her brother and certain others and was beheaded a few weeks later. Foxe begins his commentary on Anne Boleyn's character by calling her "godly." He does admit that this description may cause some objections, but he then goes on to demolish them.

Although historians may question the veracity of Foxe's portrait

of Anne Boleyn, his emphases in it suggest the values that he believes comprise a positive model for queenly behavior. Given Foxe's concerns, it is not surprising that he first praises Anne's "sincere faith and trust in Christ"; he is also impressed with "her quiet modesty . . . [the] gentleness, modesty, and pity toward all men . . . the quiet moderation of her mild nature." As queen, according to Foxe, Anne Boleyn kept her ladies occupied sewing garments for the poor.[35] Of course Anne was the mother of the reigning Queen Elizabeth, and, for Foxe, this fact is the best proof of her virtue: "Furthermore, to all other sinister judgements and opinions, whatsoever can be conceived of man against that virtuous queen, I object and oppose again (as instead of answer) the evident demonstration of God's favour, in maintaining, preserving, and advancing the offspring of her body, the lady Elizabeth, now queen." Gentleness, modesty, piety, and moderation, then, are obviously characteristics Foxe approved of in a woman ruler. Yet none of these qualities was sufficient to preserve Anne so that she might continue her support of the true Church.[36]

Unlike Anne Boleyn, Henry's last queen, Catherine Parr, did manage to survive during her husband's reign. Foxe's description of her is useful in the lessons it suggests for the survival of an intelligent, forceful woman who is also virtuous and pious.[37] Because of her intense faith, Catherine, with "reverent terms and humble talk" would discuss the Scriptures with the King. But even reverence and humility were not enough to placate Henry once he was in an ill humor. Their discussions appeared amicable enough until "by reason of his sore leg . . . he waxed sickly, and therewithal forward, and difficult to be pleased." Catherine left the room after one such discourse with Henry; the King then turned to Stephen Gardiner, Bishop of Winchester, and muttered, "A good hearing . . . it is, when women become such clerks; and a thing much to my comfort, to come in mine old days to be taught by my wife." Gardiner's calculated response only stirred up Henry's anger and displeasure. As a result, Gardiner left the King's presence with a warrant to draw up articles against the Queen. He began to gather information secretly about Catherine's religious practices to be used in a heresy trial.[38]

According to Foxe, in an extravagant coincidence, the bill of articles drawn up against Catherine, which Henry himself had signed, was mislaid. Some "godly person" found it and immediately brought it to Catherine. The Queen was at once sick with fright; she "fell incontinent into a great melancholy and agony," but she was still able

to conceive of a strategy to resolve the situation. Catherine had the presence of mind to tell her ladies to dispose of all their illegal religious books. Then she went to Henry, who immediately began to argue with her over religion. Catherine, with "mild and reverent countenance," told Henry:

> Since . . . God hath appointed such a natural difference between man and woman, and your majesty being so excellent in gifts and ornaments of wisdom, and I a silly poor woman, so much inferior in all respects of nature unto you, how then cometh it now to pass that your majesty, in such diffuse causes of religion, will seem to require my judgement? . . . I refer my judgment in this, and in all other cases to your majesty's wisdom, as my only anchor . . . as under God, to lean unto.

One would certainly expect such a submission to be enough, but Henry was still not appeased. He accused Catherine of wanting to be a doctor and to instruct him, rather than to be instructed. Catherine protested that she was simply trying to learn and take Henry's mind off his troublesome leg. At last HeNry was delighted: "And is it even so sweet heart! . . . Then perfect friends we are now again." Henry kissed and embraced Catherine, and told her that words out of her own mouth had done him more good than a present of £100,000—but he did not cancel the arrest order. Meanwhile, Gardiner and his colleagues—unaware of the reconciliation—continued their plans, and Henry deliberately did nothing to stop them. Instead, the next day he sat in the garden with Catherine and allowed the men to come forward and start to arrest her. Only then did he berate their chief as "arrant knave! beast! and fool!"[39]

Although Catherine Parr survived, she did so by hiding her intelligence, posing as a "silly, poor woman," and manipulating Henry. Elizabeth as queen also learned to be manipulative, to give "answerless answers" when asked by Parliament or her advisors to do what she wished to avoid. Yet one wonders if Foxe perceived this evasiveness as the best method of behavior for his queen, however much he might admire it in Catherine Parr. Elizabeth also used the technique of manipulation in her dealings with Parliament to avoid further reformation of the Church.

Both Catherine Parr and Anne Boleyn, as well as the medieval queens Eleanor, Isabel, and Margaret, were queens by virtue of the

fact that they were married to kings. Foxe presents one sixteenth-century example of a woman whose reign would have perpetuated the true Church had she been allowed to rule, and that was Lady Jane Grey, queen for only nine days. Foxe has great admiration for Lady Jane Grey, and yet he depicts her position as ambiguous, since she was the center of a plot that, had it succeeded, would have eliminated not only Mary's succession but also Elizabeth's.

Foxe solves this problem by presenting Jane Grey's virtue as a Protestant, while, accurately enough, demonstrating that she had no volition in the conspiracy. He calls her and her husband Guilford "two innocents in comparison of them that sat upon them. For they did but ignorantly accept that which the others had willingly devised." But while Lady Jane Grey was an innocent pawn in the conspiracy, she was an ardent and steadfast Protestant whose faith did not waver even in the face of death.[40]

In portraying Jane Grey as a Protestant heroine, Foxe describes two incidents that occurred late in Edward VI's reign. These events emphasize not only her piety, but her willingness to speak out for her beliefs. Both incidents involved her cousin the Lady Mary, the future queen. One occurred when she was visiting Mary. In defiance of the law, Mary had mass said in her household. While passing the chapel, Lady Jane saw Anne Wharton make a low curtsy to the sacrament on the altar. Jane asked Lady Wharton why she had curtsied. Was the Lady Mary in there? Lady Wharton replied no, "that she made her curtsy to Him that made us all." "Why how can He be there, that made us all, and the baker make him?" Mary was insulted when this conversation was reported to her and she "did never love Jane after," Foxe reports. Lady Jane demonstrated the same want of tact in another confrontation with Mary, this time over the issue of simple dress. Mary had sent her cousin a richly elaborate dress as a gift. Jane refused to wear it: "Nay, that were a shame to follow my Lady Mary against God's word, and leave my Lady Elizabeth which followed God's word."[41] (Ironically, given her later performance, Elizabeth dressed with great simplicity during her brother's reign.) Hester Chapman suggests that while today people might censure Jane Grey's behavior for its rudeness, in her own time, Protestants used such remarks as examples of her high principles and courage in speaking out for her beliefs.[42]

Examples of high education and steadfast religion are in general the lessons John Foxe taught when writing about Lady Jane Grey. He praises her as being "in learning and knowledge of the tongues"

superior to her cousin Edward. She used her learning to defend her religious beliefs. Foxe gives a full transcript of the religious debate between Lady Jane and Master Feckham, whom Queen Mary had sent to attempt to convert Jane before her death. Naturally Foxe presents their discussion so that Lady Jane Grey appears not only able to best Feckham at theological argument, but also to do so with tranquillity, even as she approaches her own death. [43]

Foxe describes in great detail Lady Jane's behavior on the scaffold. Her serene courage especially impresses him. To the very last minutes of her life she stayed true to the Protestant precepts which had brought her such comfort: "I pray you all, good christian people, to bear me witness that I die a true christian woman, and that I do look to be saved by no other means, but only by the mercy of God, in the blood of his only Son Jesus Christ." Since, as a Protestant, she did not believe in purgatory and thus saw only blasphemy in prayers for the dead, she asked the people to pray for her only while she lived: "And now, good people, while I am alive, I pray you assist me with your prayers." [44]

To this decorous, probably well-rehearsed speech, Foxe adds a description of Lady Jane Grey's last moments. After requesting the executioner to "dispatch me quickly," she tied a handkerchief around her eyes. She misjudged the space, however, and could not then find the block, saying, "What shall I do? Where is it? Where is it?" Finally one of the standersby guided her. She "laid her head down upon the block . . . and said, 'Lord into thy hands I commend my spirit,' and finished her life." [45]

Lady Jane Grey did not survive to ensure a godly reformation, and Mary I's reign was a tragedy for England:

> From the first beginning of queen Mary's reign, wherein so many men, women, and children were burnt, many imprisoned, and in prison starved, divers exiled, some spoiled of goods . . . a great number driven from house and home, so many weeping eyes, so many sobbing hearts, so many children made fatherless . . . so many vexed in conscience . . . and in conclusion, ever a good man almost in all the realm but suffered something during all the time of this bloody persecution. [46]

Foxe was convinced that Elizabeth survived her sister's reign through God's direct intervention: "We have to consider again . . . how strangely, or rather miraculously, she was delivered from danger,

what favour and grace she found with the Almighty; who, when all help of man and hope of delivery was past, stretched out his mighty protection." God had his plan for England, and this plan was embodied in Elizabeth. It was her duty to bring to England the godly reformation the country needed.[47] Yet though Foxe was convinced that Elizabeth was part of God's plan, one can still sense his ambivalence about women's rule from his treatment of earlier queens, and this treatment demonstrates the unresolved contradictions in his advice.

Elizabeth was as well aware of the contradictions between being a woman and being a ruler as anyone. Much of her reign was spent as a balancing act: "I know I have the body of a weak and feeble woman, but I have the heart and stomach of a king," she proclaimed at a moment of national crisis.[48] But Elizabeth's solutions to the problems of her reign were far different from those suggested by John Foxe.

One can see how different their approaches were when one examines the actions for which Foxe celebrated his queen. Several times in the *Acts and Monuments,* Foxe's praises of Elizabeth have an ironic overtone; he is acclaiming her for actions that he wishes she would take, rather than deeds she has actually done. The use of praise to effect change in a prince is a typical rhetorical device of the Renaissance, and Foxe was following Erasmus' advice in employing it.[49] But we can feel the disparity between Foxe's desires and Elizabeth's behavior when, for example, Foxe commends Elizabeth who, during her sister's reign, took "little delight in . . . gay apparel, rich attire, and precious jewels." At the time Foxe was writing this passage, Elizabeth, to the dismay of some Protestants, was dressing with regal splendor.[50] Similarly, in his dedication Foxe praises Elizabeth for her "provident zeal, full of solicitude, you have, minding (speedily I trust) to furnish all quarters and countries of this your realm with the voice of Christ's gospel and faithful preaching of his word."[51] But, as noted earlier, many of the returned Marian exiles (including Foxe) were not satisfied with the Anglican Settlement, although it was already more Protestant in doctrine than Elizabeth had originally wanted. And once the Acts of Supremacy and Uniformity and the Thirty-Nine Articles were in place, Elizabeth considered the matter closed. There would be no further discussion of reforming the Church. As the reign progressed, the Puritans became more and more vociferous in their arguments, and Elizabeth responded by pushing them out of the established Church. This struggle between ruler and

Puritans was eventually to lead to armed conflict in the seventeenth century.

Unlike the Puritans, Foxe was never openly willing to criticize his queen.[52] Instead, he hoped that examples of ecclesiastical history would urge Elizabeth to further the reformation. Foxe's own ambivalence, however, in some ways blunted the message he was attempting to promote. Lyndsay, Becon, Goodman, and Knox had all condemned women's rule. Vives, despite his encouragement of women's education, condemned it also. The discomfort implicit in Vives' attitude toward women's capabilities is very much evident in the writings of those, such as Elyot and Aylmer, who favored women's participation in public affairs. By the middle of the sixteenth century, queenship was no longer a theoretical issue. Women were ruling as regents or queen regnants in much of Europe. Like the others who wrote on queenship in the sixteenth century, Foxe was never able to reconcile completely the conflict over how a female ruler could act in both a womanly and a regal fashion. The qualities needed for strong rule were antithetical to the expectations of appropriate female behavior. If a queen followed the expectations, she could be condemned for not ruling well, but if she ignored the expectations, she was perceived as unwomanly. Though this paradox was one Foxe was never able completely to reconcile, his perception of Elizabeth as God's chosen instrument was the best method available to him.

John Foxe's *Acts and Monuments* is in some sense circular; dedicated to Elizabeth, it ends with praising her at the beginning of her reign for what her rule will mean to England. The examples of earlier women rulers show how perilous Foxe considered Elizabeth's situation to be. Isabel and Margaret had been destroyed by lust and ambition. The examples of Anne Boleyn, Catherine Parr, and Lady Jane Grey demonstrated that even the godly were not exempt from the dangers of the world. The reform of the church had been left to Elizabeth. Foxe's lessons of earlier queens worked both as cautionary tales and as celebrations of godly acts. Elizabeth had survived to become queen for a purpose. Foxe gave her these examples in the hope that she would carry that purpose forward.

NOTES

I would like to express my appreciation to Professors Dennis Moore, Elaine Kruse, and John N. Wall, Jr. for their helpful suggestions. A shorter version of this paper was presented at the Southern Conference on British Studies, Charleston, South Carolina, 1983. Professor Warren W. Wooden organized the session of which this paper was a part. He was a fine scholar and a caring and generous colleague, and I would like to dedicate this essay to his memory.

1. For the significance of Foxe's work, see especially, William Haller, *The Elect Nation: The Meaning and Relevance of Foxe's Book of Martyrs* (New York: Harper and Row, 1963); James Frederick Mozley, *John Foxe and His Book* (reprint ed., New York: Octagon Books, 1970); and Neville Williams, *John Foxe the Martyrologist: His Life and Times* (London: Dr. Williams's Trust, 1975). Warren W. Wooden, "Recent Studies in Foxe," *English Literary Renaissance* 11, 2 (Spring 1981): 224–32, is also extremely useful.

2. In his dedication Foxe deprecated his work because he had chosen to publish the book in English, and he told Elizabeth that as a result, it "serveth not so greatly for your own peculiar reading." *Acts and Monuments,* ed. by Stephen Cattley (London: R. B. Seeley and W. Burnside, 1839) 1: 504. Historians such as William Haller and Alistair Fox, however, argue convincingly that his statement should not be accepted without reservation. Haller, *The Elect Nation,* p. 140; Alistair Fox, "John Foxe's *Actes and Monuments* as Polemical History," *Parergon* 14 (1976): 43–51.

3. Mozley, *John Foxe,* p. 156.

4. Fox, "John Foxe's *Actes and Monuments,*" p. 45; Williams, *John Foxe,* p. 15.

5. Another example of Foxe's ambiguity is his attitude toward persecution. Foxe, the influential author of the book of martyrs, wrote to Elizabeth's government to plead not only for Anabaptists, but also for Jesuits. Williams, *John Foxe,* p. 22; John T. McNeill, "John Foxe: Historiographer, Disciplinarian, Tolerationist," *Church History* 43, no. 2 (June 1974): 216–29.

6. There is some question about the dating of these works, but scholars generally agree on 1540. Hyrde must have completed the translation between 1524, when Vives published *De institutione foeminae Christianae,* and his death in 1528. Hyrde's translation appears in *Vives and the Renascence Education of Women,* ed. Foster Watson (New York: Longmans, 1912); it was originally published as *A very frutefull and pleasant boke called the instruction of a christen woman, turned out of Laten into Englysshe by R. Hyrd* (London: T. Berthelet, 1531) STC 24857; Sir Thomas Elyot, *The defence of good women* (London: T. Bertheleti, 1545) STC 7658. Useful on these two works are James E. Phillips, Jr., "The Background of Spenser's Attitude Toward Women Rulers," *The Huntington Library Quarterly* 5, no. 1 (October 1941): 5–32; Paula Louise Scalingi, "The Scepter or the Distaff: The Question of Female Sovereignty, 1516–1607," *The Historian* 41, no. 1 (November 1978): 59–75; Diane Valeri Bayne, "*The Instruction of a Christian Woman:*

Richard Hyrde and the Thomas More Circle," *Moreana* 12, no. 45 (February 1975): 5–15; Gloria Kaufman, "Juan Luis Vives on the Education of Women," *Signs* 3, no. 4 (Summer 1978): 891–96; and Constance Jordan, "Feminism and the Humanists: The Case of Sir Thomas Elyot's *Defence of Good Women,*" *Renaissance Quarterly* 36, no. 2 (Summer 1983): 181–201.

7. *The instruction of a christen woman,* sig. E$_2$.

8. Cited in Jordan, "Feminism and the Humanists," p. 193.

9. Jordan, "Feminism and the Humanists," p. 196.

10. David Lindsay, *The Monarche, or Ane Dialogue betuix Experience and ane Courteour, off the Miserabyll Estait of the Warld* (1552) in *The warkis of the famous and worthie knicht Schir David Lyndesay* (Edinburgh: T. Bassandyne, 1574) STC 15660; Thomas Becon, *An humble supplicacion unto God* (London: H. Singleton, 1544) STC 1730; Christopher Goodman, *How superior powers oght to be obeyd of their subjects* (Geneva: J. Crispin, 1558) STC 12020; John Knox, *The first blast of the trumpet against the monstruous regiment of women* (Geneva: F. Poullain a. A. Rebul, 1558) STC 15070. For a discussion of these authors, see Scalingi, "The Sceptor or the Distaff," pp. 64–67.

11. John Knox, *Works,* ed. David Laing (Edinburg: James Thin, 1895) 4:366–67.

12. *Ibid.,* 2: 28.

13. McNeill, "John Foxe: Historiographer, Disciplinarian, Tolerationist," n. 5, p. 218; Knox, *Works* 4: 352.

14. John Aylmer, *An harborowe for faithfull and trewe subjects* (London: J. Daye, 1559) STC 1005; John Jewel, *A defence of the Apologie of the Churche of Englande* (London: H. Wykes, 1567) STC 14600. See also Scalingi, "The Scepter or the Distaff," pp. 69–71.

15. Foxe, *Acts and Monuments* 8: 624.

16. Pearl Hogrefe, *Tudor Women: Commoners and Queens* (Ames: Iowa State University Press, 1975), p. 3; Ruth Kelso, *Doctrine for the Lady of the Renaissance* (Urbana: University of Illinois Press, 1956), pp. 23–25.

17. About Matilda (or Maud) in other Elizabethan histories, see, for example, *Holinshed's Chronicles of England, Scotland, and Ireland,* ed. by Henry Ellis (London: J. Johnson, 1807) 2: 78, 82, 87, 91, 100, 104, 105, 108. Holinshed describes Matilda as "a woman in stoutnesse of stomach and warlike attempts more famous than commonlie any of that sex," p. 128. See also Richard Grafton, *Chronicle,* ed. by Henry Ellis (London: J. Johnson, 1809) 1: 186, 189, 190, 192.

18. Foxe, *Acts and Monuments* 2: 185.

19. See Virgil B. Heltzel, *Fair Rosamond: A Study of the Development of a Literary Theme* (Evanston: Northwestern University Studies, 1947). Holinshed describes Eleanor as a "fierbrand" for encouraging her sons to rebel against their father, and argues that Henry was right to commit her "to close prison" as a result, *Holinshed's Chronicles* 2: 159. Eleanor is also the villain of the Elizabethan play, *Look About You* (Issued for Subscribers by the Editor of The Tudor Facsimile Texts, 1912).

20. Foxe, *Acts and Monuments* 2: 272–73.

21. Foxe also mentions Henry's refusal to become king of Jerusalem, adding that, as a result, some historians suggest God brought plagues upon Henry. "If it be true, it may be a lesson to good princes, not to deny their necessary help to their distressed neighbors, especially the cause appertaining unto God," 2: 258.

22. Foxe, Acts and Monuments 2: 304.

23. Amy Kelly, Eleanor of Aquitaine and the Four Kings (Cambridge: Harvard University Press, 1950), p. 265.

24. Foxe, Acts and Monuments 2: 644, 646.

25. Ibid., p. 649.

26. Ibid., p. 655–56.

27. Ibid., p. 670.

28. Lawrence Stone, The Family, Sex and Marriage in England, 1550–1800 (New York: Harper and Row, 1977), pp. 503–4.

29. Calendar of State Papers, Domestic Series, of the reigns of Edward VI, Mary, and Elizabeth, ed. by Robert Lemon and Mary Anne Everett Green (London: Longman, Brown, Green, Longmans and Roberts, 1856–72) 11: 543.

30. Foxe, Acts and Monuments 3: 714.

31. Foxe, Acts and Monuments 3: 715. In the sixteenth century, stomach could mean, variously, "spirit, courage, valour, bravery," or "pride, haughtiness; obstinacy, stubbornness," The Oxford English Dictionary (Oxford: Clarendon Press, 1933) 10: 1004–6.

32. Foxe, Acts and Monuments 3: 715; The Accession, Coronation and Marriage of Mary Tudor as Related in Four Manuscripts of the Escorial, trans. C. V. Malfatti (Barcelona: C. V. Malfatti, 1956), p. 72.

33. Foxe, Acts and Monuments 3: 715–16. For an account of Gloucester's death, see Peter Saccio, Shakespeare's English Kings: History, Chronicle, and Drama (London: Oxford University Press, 1977), p. 122.

34. Ibid., pp. 750–52.

35. Ibid., 5, p. 135. It is hard to imagine a portrait of Anne Boleyn that is less accurate than this one by Foxe. For more modern accounts, see Paul Friedmann, Anne Boleyn (London: Macmillan, 1884); Marie Louise Bruce, Anne Boleyn (New York: Coward, McCann and Geoghegan, 1972); Hester W. Chapman, Anne Boleyn (London: Jonathan Cape, 1974); Maria Dowling, "Anne Boleyn and Reform," The Journal of Ecclesiastical History 35, no. 1 (January 1984): 30–46; and Retha Warnicke, "The Childhood and Adolescence of Anne Boleyn," Historical Journal, forthcoming, and "The Fall of Anne Boleyn: A Reassessment," History, forthcoming.

36. Foxe, Acts and Monuments 5: 136.

37. For a further discussion of Foxe's representation of Catherine Parr and the lessons it taught Elizabethan women about appropriate behavior, see Carole Levin, "Women in The Book of Martyrs as Models of Behavior in Tudor England," International Journal of Women's Studies 4, no. 2 (1981): 197–99.

38. Foxe, Acts and Monuments 5: 554.

39. Ibid., pp. 558–60.

40. *Ibid.* 6: 425. For a further discussion of Lady Jane Grey, see Carole Levin, "Lady Jane Grey: Protestant Queen and Martyr," in *Silent But for the Word: Tudor Women as Patrons, Translators, and Writers of Religious Works,* ed. Margaret P. Hannay (Kent: Kent State University Press, forthcoming).

41. Foxe, *Acts and Monuments* 8: 700, 603–04.

42. Hester Chapman, *Lady Jane Grey* (London: Jonathan Cape, 1962), p. 73.

43. Foxe, *Acts and Monuments* 6: 384, 415–17.

44. *Ibid.,* p. 424.

45. *Ibid.*

46. *Ibid.* 8: 624.

47. *Ibid.,* p. 605.

48. Quoted in Joel Hurstfield, *Elizabeth I and the Unity of England* (New York: Harper and Row, 1960), p. 157.

49. In a letter to Jean Desmarez of 1504, Erasmus wrote, "And what method of exhortation is more effective, or rather, what other method has in fact become habitual to men of wisdom, than to credit people with possessing already in large measure the attractive qualities they urge them to cultivate? Surely 'virtue, when praised, grows great; and boundless is the spur of fame,'" Desiderius Erasmus, *The Correspondence of Erasmus,* trans. R. A. B. Mynors and D. F. S. Thomson, annotated by Wallace K. Ferguson (Toronto: University of Toronto Press, 1975) 2: 81. I am indebted to Prof. John N. Wall, Jr., for this reference.

50. Foxe, *Acts and Monuments* 8: 603. Elizabeth, as queen, hated to be preached at on the subject of a simple dress. For example, when Bishop John Aylmer, in a sermon before Elizabeth, discussed "the vanity of decking the body too finely," Elizabeth turned to one of her ladies-in-waiting and said loudly that if she heard more on that subject from the bishop, "she would fit him for Heaven—but he would walk thither without a staff and leave his mantle behind him." Lacey Baldwin Smith, *Elizabeth Tudor* (Boston: Little, Brown and Co., 1975), p. 72.

51. Foxe, *Acts and Monuments* 1:504.

52. On the question of Foxe's Puritan sympathies, see Haller, *Elect Nation,* p. 139 and Williams, *John Foxe,* p. 20.

6

Shakespeare's Comic Heroines, Elizabeth I, and the Political Uses of Androgyny

LEAH S. MARCUS

"For the Lord hath created a new thing in the earth,
A woman shall compass a man." Jeremiah 31:22

WOMEN IN Shakespeare's plays are, for the most part, utterly credible as women: we can talk about them, analyze their motives as though they were actual people. But what are we to make of the fact that in the Elizabethan theatre these utterly credible women were brought to life by actors who were young boys? Perhaps nothing at all. The battle over Shakespearean acting conventions is still simmering, and whichever side we take, we can argue that the sexual identity of the actors playing female parts was of no particular importance to sixteenth-century audiences. If the performance style was naturalistic and the boy actors were skilled, they could certainly be relied upon to create convincing female roles. Ben Jonson lamented that the boy Solomon Pavy played "old men so duly" that the Parcae themselves were deceived and carried him off by mistake—if old men, why not women as well?[1] On the other hand, if we assume a high level of stylization in performance, then it is easy enough to suppose that the sex of those playing female parts would be accepted as part of a system of conventional devices and would not have called particular attention to itself.

But a number of Shakespearean plays do seem to call attention to the latent maleness of at least their central female characters, to play with questions of sexual identity in ways that set the male actor apart from his female role. We encounter the greatest concentration of these plays near the end of Queen Elizabeth's reign and near the end of Shakespeare's period of high comedies. In three of them, *As You Like It, Merchant of Venice,* and *Twelfth Night,* the heroine adopts male

135

The Armada portrait of Queen Elizabeth I (1588). Attributed to George Gower. *By kind permission of the Marquess of Tavistock, the Trustees of the Bedford Estates, and the Paul Mellon Centre for Studies in British Art.*

disguise; in a fourth, *Much Ado,* she adopts no disguise, but is observed to be "much like her honorable father"; she brings up the subject of cross-dressing in a series of crusty observations. At the end of *As You Like It* the actor playing Rosalind actually steps outside her female role and confesses her maleness: "If I were a woman I would kiss as many of you as had beards that pleased me." Robert Kimbrough has argued that this revelation would have come as a shock, that the dramatic power of the work depends on the sustained illusion of Rosalind's womanhood until that final moment of un-masking. But on a deeper level, he suggests, the heroine's unmasking would bring to the surface a process which had underlain the dra-

matic action all along—an "ungendering" of human identity by which socially imposed sexual stereotypes are so jostled and teased and transmuted one into the other as to lose some of their power.[2] I should like to examine one specific way in which this "ungendering" process may have functioned for Elizabethan audiences.

There are remarkable correlations between the sexual multivalence of Shakespeare's heroines and an important strain in the political rhetoric of Queen Elizabeth I. Like the women in the plays, Elizabeth I was wont to clothe herself in the "disguise" of male identity in order to further her goals. Her strategies with language are mirrored in the dramatic action of the comedies so that the two forms reinforce one another: the "ungendering" of Shakespeare's heroines recapitulates royal rhetoric in various subtle ways, helping to lend credibility to the queen's androgynous language while at the same time commenting upon it, placing it within reassuring limits, and thereby enhancing its power.

There has been tremendous interest lately in the mythicized self representations which Queen Elizabeth either created for herself or allowed her subjects to confer upon her. She was the divine Astraea returned or, in place of the Holy Virgin banished from Protestant spirituality, a secularized Virgin Mother to the nation. She was a Queen of Shepherds, a new Deborah, a Cynthia or Diana, the unreachable object of male desire and worship. All of these are clearly feminine roles, familiar to us from the language of sixteenth-century poets and courtiers. But alongside such womanly identifications, which she certainly did nothing to discourage, the queen possessed a set of symbolic male identities which are much less familiar to students of literature, in part because they surface most frequently in her speeches and public pronouncements and in part, I suspect, because her rhetoric confounds our own preconceived notions about gender. Queen Elizabeth presented herself to the nation as both man and woman, queen and king, mother and firstborn son. Especially in years of particular crisis and at the end of her reign, we can observe her building the myth of her own androgyny in order to palliate the political anxieties aroused by her presence as a "frail" woman on the throne, by her perennial refusal to marry and beget children or even to name a successor. The closest historial analogue to the sexually composite nature of Shakespeare's comic heroines, who at least for the space of the play float free of the usual gender distinctions and are privileged to step in and out of male and female identities at will—

indeed perhaps the only genuine historical analogue—was Queen Elizabeth herself.

As a virgin queen, Elizabeth I was anomalous, unprecedented in England. Her virginity exempted her from most of the recognized categories of female experience, allowing her to preserve her independence while simultaneously tapping into the emotional power behind the images of wife and mother through fictionalized versions of herself. But the identity which lay behind all the others and lent them much of their authority was her identity as ruler. Elizabeth envisioned this primary public identity in clearly male terms. Like the earlier Tudors, she relied heavily on the medieval concept of the king's two bodies: the monarch is at once a frail earthly being, subject to death and disease, and an immortal being, the incarnation of a sacred principle of kingship which exists along with the merely mortal body from the monarch's first annointing as king. The Boy King Edward VI's advisors had insisted that the transcendental powers of his office resided in him despite the childish weakness of his person; so Queen Elizabeth frequently appealed to her composite nature as Queen: her "body natural" was the body of a frail woman; her "body politic" was the body of a king, carrying the strength and masculine spirit of the best of her male forebears.[3] In her famous Armada speech before the troops massed at Tilbury in 1588, for example, she offered herself as a model of kingly courage: "I have the body of a weak and feeble woman, but I have the heart and stomach of a king, and of a king of England too." On this martial occasion, her costume gave visual embodiment to her verbal appeal. She carried a truncheon as she rode between the ranks and wore upon her breast a "silver cuirass"— appropriate covering for the heart and stomach of a king. Poets commemorating the occasion praised her "tough manliness," her *"mascula vis,"* and likened her to her father, Henry VIII, "Whose valour wanne this *Island* great renowne."[4]

The urgency of the Spanish threat and the Queen's Amazonian attire made her Tilbury performance atypical. But the basic rhetorical strategy she employed on that occasion was not. She appealed very frequently to her "male" authority as the embodiment of sacred monarchy and gave the ideal special emphasis when she needed to enforce her will upon a group of recalcitrant men. As early as 1563, for example, when she began to encounter Parliamentary opposition, she argued, "The weight and greatness of this matter might cause in me, being a woman wanting both wit and memory, some fear to

speak and bashfulness besides, a thing appropriate to my sex. But yet, the princely seat and kingly throne wherein God (though unworthy) hath constituted me, maketh these two causes to seem little in mine eyes, though grievous perhaps to your ears."[5] Or to take a more elaborate example from 1566, in response to a petition that she marry and declare a successor:

> As for my own part, I care not for death; for all men are mortal. And though I be a woman, yet I have as good a courage, answerable to my place, as ever my father had. I am your anointed Queen. I will never be by violence constrained to do anything. I thank God I am endued with such qualities that if I were turned out of the realm in my petticoat, I were able to live in any place in Christendom.
>
> Your petition is to deal in the limitation of the succession. At this present it is not convenient; . . . But as soon as there may be a convenient time, and that it may be done with least peril unto you— although never without great danger unto me—I will deal therein for your safety, and offer it unto you as your Prince and head, without request; for it is monstrous that the feet should direct the head.[6]

These passages adapt the theory of the king's two bodies to a rhetorical formula which Elizabeth I was to use successfully throughout her reign. She concedes to male discomfort at being commanded by a woman through her open acknowledgment of her weakness. But that disarming confession of the visible truth disables her audience's resistance to the invisible truth that follows. As monarch she exceeds them all; her participation in the undying principle of kingship outranks their masculinity. Small chance that she would be turned out of the nation in her petticoat! That belated reference to her femininity in the 1566 speech, appearing after the appeal to her father's authority and her continuation of his "place," takes on almost the quality of self-inflicted sacrilege. Her self-deprecation corners the market on that potential strategy and renders it unavailable to her subjects.

We could argue that such appeals to kingship do not amount to the construction of a second, male identity. But Elizabeth I used a number of other strategies which reinforce the sense of her "body politic" as male. For one thing, she took great care with the vocabulary used to describe her position on the throne. She had no objection to the term *queen* and used it herself throughout her reign. But much more habitually, she referred to herself as *prince*. The word's most

basic sixteenth-century meaning was ruler, especially male ruler; it was also applied to the eldest son of a reigning monarch. The equivalent female term was *princess*. But although Queen Elizabeth was frequently called "princess" in the early years of her reign and used the word of herself, with the passing of time that feminine epithet tended to disappear in favor of the more masculine *prince*. *Princess* was, in the Queen's own later usage, a term of disparagement applied to discredited female monarchs like Mary Queen of Scots. In her policy statements weighing the fate of the Scottish "princess" Mary, Elizabeth calls herself "prince."

We can trace the gradual masculinization of Queen Elizabeth's epithets quite clearly in the formulaic openings to her proclamations. Mary Tudor's proclamations had, as often as not, begun "The Queen our sovereign Lady," with explicit reference to her sex. That formula is also quite common at the very beginning of Elizabeth's reign, but tends gradually to be replaced by more sexually ambiguous formulas: first "The Queen's majesty," then more elaborate formulas like "the Queen's most excellent majesty in her princely nature considering" or "Monarch and prince sovereign" substituting for the earlier "sovereign lady." In the early years proclamations frequently refer to her as "princess," in the later years, almost never. The formula "The Queen our sovereign Lady" lingers on in contexts for which an evocation of her feminine nature is particularly appropriate: in plague-time, when the measures she has taken assume the aura of maternal concern for her stricken people, or in famine in connection with feeding the hungry.[7] But otherwise she was always a "prince." In parliamentary speeches or court audiences, it was quite common for the Queen to be addressed as "princess"; in her response, she would deftly underline her own authority by referring to herself as "prince." Subtly, perhaps not always consciously, she constructed a vocabulary of rule which was predominantly male. Gradually, perhaps not consciously, her subjects yielded to the symbolic truths she sought to convey through her precision with vocabulary and modelled their language upon her own.

At the very end of her life, as her "mortal body" became older and frailer, she insisted more strongly upon the male component of her regal identity and began to refer to herself with increasing frequency as "king." In her famous "Golden Speech" of 1601, which was printed and disseminated throughout England, she protested, in a

variation of the rhetorical formula which had served her well for forty years:

> I know the title of a King is a glorious title; but assure yourself that the shining glory of princely authority hath not so dazzled the eyes of our understanding, but that we well know and remember that we also are to yield an account of our actions before the great Judge. To be a King and wear a crown is a thing more glorious to them that see it, than it is pleasant to them that bear it. For myself, I was never so much enticed with the glorious name of a King or royal authority of a Queen, as delighted that God hath made me His instrument to maintain His truth and glory Shall I ascribe anything to myself and my sexly weakness? I were not worthy to live then; and, of all, most unworthy of the mercies I have had from God, who hath given me a heart that yet never feared any foreign or home enemy.

In a message to Parliament that same year, the Speaker noted, "She said her kingly prerogative (for so she termed it) was tender."[8] "For so she termed it": the Queen's contemporaries were aware of something distinctly anomalous in her adoption of male epithets for her "body politic." But they also grasped what she was trying to convey, commenting that in her "Stately and Majestick comportment" she carried "more of her Father than Mother," and that she had "too stately a stomach to suffer a commander"; she was "king and queen both."[9]

As king and queen both, how could she accommodate a husband? It is almost comical to note how, during the early years of her reign when she at least appeared to entertain the possibility of marriage, she used her chosen epithet "prince" to cool potential suitors. We might suppose that being wooed would bring out her feminine side as it did in the symbolic, half-playful courtship of admirers like Sir Walter Ralegh. But when she was wooed in earnest, she tended to insist on her status as a prince: the subtle masculine identification of her language repulsed the potential lover even as she seemed in other ways to encourage him. One of her usual ploys when Parliament or her advisors pleaded with her to marry was to insist that she was already married to her kingdom. On one such occasion early in her reign she held up the hand bearing her coronation ring, seeming to portray herself symbolically as the nation's wife. But as time went on,

she more and more frequently placed herself in the role of husband. In 1596, for example, she claimed, "Betweene Princes and their Subiects there is a most straight tye of affections. As chaste women ought not to cast their eye upon any other than their husbands, so neither ought subiects to cast their eyes upon any other Prince, than him whom *God* hath given them. I would not have my sheepe branded with another mans marke; I would not they should follow the whistle of a strange Shepheard."[10]

One of Queen Elizabeth's most clearly womanly self-portrayals was as virgin mother to her people. She used this role throughout her reign but particularly when the matter of the succession reared its ugly head: how, she would protest, could her people demand that she marry and produce an heir when she was already mother to them all? In an interesting recent paper, Carole Levin has shown how versions of the unsolved problem of the succession would surface to plague her at moments of political vulnerability. There were persistent rumors that the Boy King Edward VI was still alive and ready to claim his throne; several imposters claimed to be the long-lost king; there were rumors that she had given birth to illegitimate children; a particularly impudent rebel protested "that the land had been happy if Her Majesty had been cut off twenty years since, so that some noble prince might have reigned in her stead"—that prince, of course, being male.[11]

The longing for a male successor to Elizabeth was unquestionably intense, even among the Queen's most adoring subjects. One of the ways she tried to assuage that longing was by depicting herself, on a subliminal, symbolic level, as a son, her own son. Her favored term "prince" conveys this to some degree: even though it was a generic term for monarch, its more specific use was for a male heir apparent. Her perpetual status as young virgin or "virgin Prince" even as she passed far beyond the childbearing years may have fostered the idea of her sonship since in the sixteenth century, women were commonly regarded, like boys, as immature men.[12] Costume emphasized the connection. As anyone who has viewed the portrait of the Sidney children at Penshurst has noted, young Tudor boys wore skirts just like their mother and sisters, with only a sword at their sides to suggest their sexual differentiation. So long as Elizabeth I's identity continued to allow the symbolic potential of growth into manhood, however irrational that hope was, given the fact of her womanhood, she was able to alleviate at least some of the longing for an heir.

Occasionally, her political rhetoric seems to deploy language in ways that foster the fantasy. When Mary Queen of Scots gave birth to a prince, Prince James, the English still hoped for the like from Elizabeth. The issue became particularly delicate when James was hailed by the Scots as "Prince of Scotland, England, France and Ireland." Queen Elizabeth issued a proclamation denying reports on the Scottish succession, rumors that Prince James was to "be delivered into her majesty's hands, to be nourished in England as she should think good" and that Elizabeth meant to control the Scottish succession "after the decease of the young Prince or King without bairns." In this context, the word "Prince" is used to mean male heir to the throne. But the language that follows seems subtly to suggest that the English have no need of such a prince and such rumors. Elizabeth herself is their prince: she "is (and by God's grace intendeth during her life to be) a prince of honor and a maintainer of truth."[13] Like the emblematic phoenix, a device closely associated with the Queen, she embodies her own succession.

How many members of the general public would have encountered the Queen's various strategies for instilling an image of her dual identity? Probably more than would have encountered Shakespeare's plays. Elizabeth's proclamations were usually both printed and read with fanfare in towns and villages throughout the kingdom; her most important speeches were printed and others circulated widely in manuscript versions through alehouses and other gathering places. She herself appeared frequently in public in London and the counties. Nearly everyone living in southeast and central England would have seen her in person at one time or another and she may have used elements of her rhetoric of masculinity in extemporaneous speeches on many such occasions.[14] In sermons and public entertainments, she was associated with male heroes along with the more familiar female ones. As she was a Belphoebe or Astraea, so she was often portrayed as a St. George or a David, Moses or Solomon, an Alexander, an Aeneas who (symbolically) had sacrificed the Dido of her own femininity out of duty to the future of the nation. Then too, for the most educated segment of the public, the notion of the monarch as androgyne may have had a certain familiarity; it was not uncommonly claimed as an attribute even by male rulers like François Premier, who had himself painted with the head of a Virago emerging from his breast.[15] But despite their acquaintance with the Queen's rhetoric, particularly in the final years of her reign when her adoption of male

epithets became particularly prominent, Elizabethans were not neces-
sarily comfortable with her strategies. It is with that thought in mind
that we turn now to a brief consideration of how such ambivalences
may have been played out in the drama.

We modern readers have for the most part been cautious about
interpreting Elizabethan drama as political satire or allegory, but
sixteenth-century playgoers were nowhere near so hesitant. Political
lockpicking was endemic. The Queen herself seems to have assumed
a direct application of the plays she saw to her own person and
circumstances. Even the commonest of theatrical conventions took
on political specificity. In the 1560s she offered the Spanish ambas-
sador several explications of comedies performed at court. In each
recorded case she took the inevitable marriage of the heroine at the
end of the play as an implied criticism of her own single state; she
expressed with some vehemence "her dislike of the woman's part."
This almost paranoid application of the drama to herself and her
political situation continued throughout her reign, as in her famous
remark at the time of the Essex rebellion that *she* was Shakespeare's
deposed King Richard II.[16] That comment is interesting because it
suggests that Queen Elizabeth considered plays performed in the
public theater to be as charged with political intensity as the plays
performed in her presence. Her explications were in part politically
motivated: what she saw (or claimed to see) in a given performance
would depend on her own situation and whom she was addressing.
But her unwillingness to separate dramatic texts from the political
milieu of their performance suggests how strongly she perceived the
drama as a figuration of public life. We do not know what Queen
Elizabeth thought of Shakespeare's festive comedies, though she must
certainly have seen at least some of them performed at court. By the
time he wrote them, the marriage question was moot since she was
long past childbearing. But she was as inclined as ever to view plays as
political commentary upon herself. What would she have made of
Rosalind or Beatrice?

Given the sixteenth-century passion for reading the drama polit-
ically, we can offer a number of facile answers to that question or to
the kindred one of how her subjects, many of them as agile as the
Queen herself in the art of political lockpicking, may have seen
Shakespeare's comic heroines as reflecting upon the Queen. Parallels
are easy to discover. Portia offers a becoming speech of womanly
submission to Bassanio, then heads off in male garb to do justice in a

high court of law—she enacts over time Queen Elizabeth's standard rhetorical ploy of declaring her weakness as a woman, then successfully asserting her masculine prerogative over a resisting body of men. Rosalind exerts almost complete control over the world of Arden, playing many parts male and female, using her disguise as Ganymede to get what she cannot as a woman, pairing couples off to suit her purposes as Elizabeth was notorious for doing. Beatrice's protests against marriage, her strong identification with her father, very closely resemble the Queen's. And so we could continue. But the trouble with such an approach is that it is as dubious and protean as Elizabeth's: nearly anything that happens anywhere in Shakespeare can be likened to some aspect of her reign and the likenesses we find usually raise more troublesome issues than they settle. If Portia seems to carry justice too far against Shylock, does that mean Shakespeare is accusing Queen Elizabeth of a similar deficiency—in the Lopez case of a few years earlier or more generally? What I would like to suggest is a different level of analysis, equally speculative, but more amenable to coherent formulation. Setting aside the obvious surface similarities, what more stable underlying correlations can we find between the androgynous rhetoric of the Queen and the sexual ambiguity of Shakespeare's comic heroines?

The most basic correlation would seem to be in the layering of sexual identities. The dramatic construct of a boy clothed as a woman, an altogether credible woman, who then expands her identity through male disguise in such a way as to mirror the activities which would be appropriate to her actual, hidden male identity—that construct precisely replicates visually the composite self-image the Queen created through language. She was clearly a woman on the stage of public life—and she liked to call it that—but with a male identity, her princehood, underlying her obvious femininity and lending her authority, offering the subliminal promise of growth into kingship as a boy actor would grow into a man. She did not, except on highly unusual occasions like Tilbury, dress herself as a man, but performed so effectively the "male" responsibilities of government that in that sphere her subjects were invited to forget she was female. She was, in her own formulation, a "woman who acted as a man."[17] She called much more attention to her male "immortal body" than Shakespeare's heroines do to their latent maleness, but her emphasis was necessary to achieve the same effect. She had to create a new convention, build a conceptual model which seemed to belie the

visual data offered by the "frail" female body that her subjects saw; the sexual identity of those playing female parts on stage was, by contrast, understood from the outset, a familiar theatrical device. What is distinctive about the four Shakespearean comedies we are considering is not their use of boy actors to play female parts, as all plays before the 1620s in England did, but the fact that they call attention to the convention by acting it out in reverse in the person of the central character through a disguise which replicates the actor's sexual identity. As they watched Shakespeare's heroines move in and out of their manhood, the Elizabethan audience actually witnessed the creation of sexual composites which resembled the "man and woman both" that Queen Elizabeth claimed to be. And her public rhetoric appears to supply the only historical analogue. Shakespeare's comedies helped to validate the Queen's anomalous identity by presenting the construct visually through witty and attractive characters who were easy to admire, full of charm and charisma. Elizabethans tended to think of the theater as a microcosm of the vaster life of England; they likened its ceremonial patterns to the pageants and ritual observances which helped to structure the political life of the nation with Queen Elizabeth I, consummate actress that she was, always implied or physically present as their center. In the festive comedies, the heroine performs a similar function, her sexual multivalence embodying and strengthening the myth of sexual duality which Elizabeth herself deployed so skillfully to keep her subjects' allegiance.

But if Shakespeare's comedies embody the myth, they also set limits upon it. Quite unlike the Virgin Queen, Shakespeare's heroines all marry at the end; they all end up playing the part which the Queen professed to dislike. The fundamental ambivalence of a boy actor playing a woman's part remains at the end of the play, but the audience is left with the unspoken assurance that the heroine will no longer act it out through the donning of male garb and the playing of masculine roles. She will, instead, settle down into wifehood and fertility: do the things which Elizabethans yearned for their Queen to do in the interest of stability and continuity. Shakespeare normalizes the aberrant status of his heroines while Elizabeth clung obdurately to her singularity, but his comedies nevertheless seem to reinforce the subliminal fantasies that Elizabeth nurtured in her subjects to palliate anxieties over the succession. She portrayed herself as husband and wife, mother and first-born son—tried to encompass within herself

the separate beings required for a genuine succession. Shakespeare's plays separate out the component beings—the heroine cannot marry herself, but must go out and get a husband—but in such a way as to enmesh the heroine's temporary masculinity inextricably with the search and testing of an appropriate partner. Rosalind and Viola use their male disguise at least in part to be near the men they love and interact with them in a freedom which would be impossible otherwise. Their playing out of masculine roles furthers their marriage and the creation of a succession—one of the very fantasies Queen Elizabeth sought to perpetuate about her own "body politic" through her assimilation of husband and prince into her own identity.

I have stated that the rhetoric of Queen Elizabeth represents the only real contemporary analogue to the sexually composite nature of Shakespeare's comic heroines. But there is another partial analogue, a rather alarming one—the "disorderly woman," often a man in disguise, associated with popular festivals and their inversion of normal hierarchies. For the space of the festival, a woman could be placed on top: a Maid Marion or a Robin Hood disguised as an old hag, or "Lady Skimmington," the central figure in the English version of the *charivari*, who was impersonated by men dressed as women and led a raucous procession which very commonly boiled over into riot.[18] The image of a woman in power carried strong associations with anarchy in sixteenth-century England and Queen Elizabeth's predecessor "Bloody Mary" Tudor had done little to dispell the connection. Despite the genuine violence which erupted during her reign, we may wonder to what extent her sinister epithet "Bloody" may have stuck to her because she was an "unruly" woman on the throne. None of the male rulers of the previous centuries of near constant warfare and slaughter, not even the "bloody dog" Richard III, had been given such a persistent sobriquet. John Knox had written a bitter and highly influential diatribe against the monstrous irregularity of women on the throne, though he belatedly exempted Elizabeth, and Catherine de' Medici's part in the St. Bartholomew Massacre had reinforced the fear in the minds of English Protestants. Queen Elizabeth's self portrayal as both man and woman, a ruler dressed as a woman but acting with the force and leadership of a man, perpetuated a complex of attributes associated with misrule and disorder.

The Queen well understood the power of public festivities, both for good and for evil: she even created a new one to replace those suppressed under Protestantism—her Accession Day, which was a

celebration of hierarchy and degree centering upon herself and her royal authority.[19] Her habit of appearing in person as the orderly and ordering center of pageants and ceremonials, her insistence on degree and proper subordination, helped to tame the image of the "unruly woman" even as it moderated the effect of her own bisexual rhetoric. Her role in pageantry and the heroines' roles in the comedies are very much alike. Shakespeare's comedies evoke an atmosphere of holiday misrule, with the donning of male attire and male roles an element of the general "folly of the time" and of the festival inversion of hierarchy. But they never explode into anarchy—the "disorderly woman" never threatens the social order itself, only its abuses. The overthrow and discarding of accepted gender roles helps to undo injustice, promote renewal and rebirth; the "disorderly woman" transforms herself into a heroine who helps to lead the progression back to order, harmony and fertility. Through their positive reworking of the menacing festival motif of the "woman on top" Shakespeare's comedies work along with and help to reinforce Elizabeth's own attempts to link her androgynous nature with ideals of stability and renewal. Non-western cultures offer frequent analogues: a woman, either a young virgin or an aging woman past menopause, who is set apart from the usual female functions and allowed access to otherwise exclusively male activities, who is perceived as androgynous and given hieratic status.[20] Shakespeare's heroines may appear to bear little resemblance to such icons of power. They are far from unapproachable, and interact with their fellow beings rather than setting themselves apart. Even while Rosalind seems to work magic upon the forest of Arden, she herself remains reassuringly human. But that was also true of Queen Elizabeth herself, at least until the very end of her life. Recent studies of the Cult of Elizabeth have emphasized the hieratic side of her impact upon her subjects, frozen her into the ceremonial stasis of an object of worship.[21] We have tended to lose sight of her more vibrant and personal side, her approachability, her talent for creating an effect of immediate personal rapport with subjects at every social level. She was turned into an icon by anxious, adoring poets and artists; yet, for all her emphasis on the divinity of her "immortal body," she never conducted herself for long as a remote being apart.

Living icons are vulnerable. They fade more quickly than painted ones usually do. Shakespeare's androgynous heroines were created at an interesting point in English history, a time when many

considered the nation to have declined from its brilliance of a decade or two before. The grave old courtiers and advisors were gone, and the young were more impatient, more volatile; the moral tone of the court was perceived as more degenerate than before; the Queen's financial problems were more serious. And she herself was unmistakably aging, withdrawing from the close interaction with her subjects that had marked most of her reign. The old, ugly rumors and anxieties about the succession again became very prominent in the late 1590s. It is perhaps not mere happenstance that the end of Shakespeare's period of festive comedy roughly coincided with the end of Elizabeth's rule. In her final years, the Queen still dressed like a young virgin despite her black teeth and wrinkled breast, still clung tenaciously to the sustaining myths of her reign. But there was an increasing sense of strain, increasing distance between the sublime immortality of her "body politic" and her evident mortality as a "frail woman." When viewed in terms of the increased tensions that surrounded the Queen's image in the late 1590s, Shakespeare's comedies become especially poignant. They present an earlier stage of the androgyne in the form of a young woman, radiant, vivacious, approachable, with much of her life yet before her, not the old woman Queen Elizabeth had become beneath her show of perpetual youth. Perhaps that is the most important way in which Shakespeare's plays enhanced the image of the Queen: they helped to sustain the fading vision of Elizabeth as a self-contained, endlessly self-perpetuating composite of male and female identity by recasting that image in an earlier form, infusing it with an earlier vitality. Of course, all such endeavors of art are finally futile: they cannot undo mortality. Perhaps a recognition of that futility helps to account for the slight patina of melancholy many readers have seen as burnishing and softening the mirth of the final comedies. Certainly, the specific dramatic model of androgyny we have identified here, with its joyous interplay among gender roles, its expansive optimism about the male-female heroine's capacity to revive and renew, died along with Queen Elizabeth I.

In the Jacobean theater, the figure of the androgynous woman reemerges, but with significant variations. The most fascinating of these is the comic Roaring Girl in Dekker and Middleton's play by that name: Moll Frith in many ways perpetuates the myth of Elizabeth, but several rungs down the social ladder. She is unruly, yet virginal, dressed in male clothing, an affront to male authority, yet for the most part salutary in her impact, associated with social restructur-

ing rather than the maintenance of a pre-existing equilibrium.[22] She is therefore less conservative than Elizabeth had been, but functions in some of the ways the image of the Queen did for disgruntled Jacobeans. As reformers tended to hark back to the glorious reign of Elizabeth in their impatience with the autocracy and ineptitude of her successor James I, so Dekker and Middleton seem deliberately to have constructed an ambivalent, lowlife variant upon her androgynous image, a self-sufficient yet isolated figure whose virtue shows up the corruption of the times. The other significant Jacobean transmutation of the Elizabethan androgyne as heroine merges her back into the monstrous "unruly woman." Lady Macbeth is a "woman on top" whose sexual ambivalence and dominance are allied with the demonic, and mirror the obscure gender identification of the bearded witches. And her "unnatural" dominance unleashes a series of catastrophes which nearly destroy a kingdom. As we know, Shakespeare designed *Macbeth* on one level to praise King James I, one of the monarchs reflected in the magic "glass." In the tragedy, the positive vision of androgyny associated with the comedies and with Queen Elizabeth, who had demonstrated her superior political skills to James's humiliation on many occasions, is symbolically cancelled out. The glorious figure of Elizabeth I was remembered throughout the Stuart period, for the most part with affection, as she still is remembered today. But she is remembered as a woman, not as "man and woman both." Her anomalous rhetoric of masculinity, when separated from its magnetic center in her person and from the sophisticated ritual and dramatic mechanisms which had helped to exalt and maintain it, was too unsettling to dwell upon, and has gradually been expunged or forgotten.

NOTES

1. Ben Jonson, *Poems,* ed. Ian Donaldson (London: Oxford University Press, 1975), pp. 69–70, "Epitaph on Salomon Pavy, a Child of Queen Elizabeth's Chapel."

2. Robert Kimbrough, "Androgyny Seen through Shakespeare's Disguise," *SQ:* 33 (1982), 17–33. I am also indebted to the study of disguise and the boy actors in Juliet Dusinberre, *Shakespeare and the Nature of Woman* (New York: Barnes & Noble, 1975), pp. 231–71; Carolyn Lenz *et al.,* eds., *The Woman's Part:*

Feminist Criticism of Shakespeare (Urbana: University of Illinois Press, 1980), esp. pp. 19 ff. and Clara Claiborne Park's essay, "As We Like It: How a Girl Can Be Smart and Still Popular," pp. 100–16; and, more generally, to C. L. Barber, *Shakespeare's Festive Comedy* (1959; rpt. New York: Meridian, 1963). As Dusinberre has noted, Imogen in *Cymbeline* doesn't follow the same pattern: she never really sees herself as a man, doesn't relish her disguise or use it much to expand her possibilities. For an altogether different view of theatrical androgyny, see Lisa Jardine, *Still Harping on Daughters: Women and Drama in the Age of Shakespeare* (Sussex: Harvester Press, 1983), pp. 9–36.

3. See Ernst Kantorowicz, *The King's Two Bodies: A Study in Mediaeval Political Theology* (Princeton: Princeton University Press, 1957), esp. pp. 7–14; and Marie Axton, *The Queen's Two Bodies: Drama and the Elizabethan Succession* (London: Royal Historical Society, 1977), esp. Chaps. 2 and 3 and p. 38.

4. See Winfried Schleiner's important article, *"Divina Virago:* Queen Elizabeth as an Amazon," *SP* 75 (1978): 163–80. For other references to the Queen's androgynous image and related strategies, see Jonathan Goldberg, *Endlesse a Worke: Spenser and the Structure of Discourse* (Baltimore: Johns Hopkins University Press, 1981), esp. pp. 150–53; and Louis Adrian Montrose, " 'Shaping Fantasies': Figurations of Gender and Power in Elizabethan Culture," *Representations* 1, No. 2 (1983): 61–94. I am also indebted to Leonard Tennenhouse, "Arcadian Play: The Poetics of Shakespeare's Romantic Comedy," a talk presented at the Modern Language Association, Los Angeles, 1982 which Mr. Tennenhouse has been kind enough to let me see in manuscript; and, for a general sense of the theatricality of Elizabeth's style of rule, Stephen Greenblatt, *Sir Walter Ralegh: The Renaissance Man and His Roles* (New Haven: Yale University Press, 1973), esp. pp. 52–65.

Joan La Pucelle, the amazonian warrier in *I Henry VI,* also uses Queen Elizabeth's rhetoric of power and virginity in interesting ways, but I will reserve investigation of how that character may relate to Elizabeth's "amazonian" image at Tilbury for separate study as part of a book to be entitled "Shakespeare and the Unease of Topicality."

5. Quoted in J. E. Neale, *Elizabeth I and Her Parliaments, 1559–1581* (London: Jonathan Cape, 1953), pp. 107–08. I am also indebted to Allison Heisch's study, "Queen Elizabeth I: Parliamentary Rhetoric and the Exercise of Power," *Signs* 1 (1975): 31–55; Heisch gives excerpts from many of Elizabeth's speeches in their original manuscript forms.

6. Neale, *1559–1581,* pp. 149–50. At least some of her contemporaries noted the skill with which she used the strategy. See Neale, *Elizabeth I and Her Parliaments, 1584–1601* (London: Jonathan Cape, 1957), pp. 248–49.

7. See Paul L. Hughes and James F. Larkin, eds., *Tudor Royal Proclamations,* vols. 2 and 3 (New Haven: Yale University Press, 1969). For illustrations of the masculinization of epithets, see, for example, vol. 2, 100, 103, 144, 210, 258, 273; 3, 119, 121, 125, 185, 193, 198, 236, 242, 245, 256; for proclamations issued in plaguetime, vol. 2, 236, 317, 321, 345, 420, 430, and for the later more masculine plaguetime proclamations, vol. 3, 121; for feeding the hungry, vol. 3, 193–94.

Another place where she kept the feminine forms was in contexts which also mentioned her father, but even that vestige dropped out in time. See vol. 2, 364, 435, and vol 3, 97.

For examples of the use of "princess" to imply demeaned status, see Neale, *1584–1601*, p. 127; George P. Rice, Jr., ed., *The Public Speaking of Queen Elizabeth* (1951; rpt. New York: AMS Press, 1966), pp. 89–91; and G. B. Harrison, ed., *The Letters of Queen Elizabeth I* (1935; rpt. New York: Funk & Wagnalls, 1968), pp. 180 and 219.

8. Neale, *1584–1601*, pp. 385, 388–92, 432.

9. See Paul Johnson, *Elizabeth I* (New York: Holt, Rinehart & Winston, 1974), p. 111; and Sir Robert Naunton, *Fragmenta Regalia*, ed. Edward Arber (1870; rpt. New York: AMS Press, 1966), p. 15.

10. William Camden, *Annales*, tr. R. N[orton], 3rd. ed. (London, for Benjamin Fisher, 1635), p. 469. Louis Montrose notes her "paradoxical analogy" in his fine study "'Eliza, Queene of shepheardes,' and the Pastoral of Power," *ELR* 10 (1980): 153–82, but doesn't attempt to explicate it. For the use of "prince" in her "love letters" to the Duke of Anjou, see *Letters*, p. 145. Her parliamentary speeches often seem deliberately to befuddle her meaning. See Neale, *1559–1581*, p. 127.

11. Carole Levin, "Queens and Claimants: Political Insecurity in Sixteenth-Century England," forthcoming in Janet Sharistanian, ed., *Women's Public Lives* (Greenwood Press), esp. pp. 23–30. My thanks to Ms. Levin for generously allowing me to use her work in manuscript form. See also Martin Hume, *The Courtships of Queen Elizabeth*, rev. ed. (London: E. Nash, 1904), pp. 334–61. Examples of the Queen presented as the nation's mother are easy to come by. See Neale, *1584–1601*, p. 74; Montrose, "Shaping Fantasies"; and Heisch, p. 54.

12. Dusinberre, *Shakespeare and the Nature of Women*, p. 95.

13. *Proclamations*, vol. 2, 308. Of course, the issue of her princehood may have had important personal dimensions for her. To say that all those involved in her birth and upbringing had hoped for a boy would be to understate the matter.

14. Johnson, *Elizabeth I*, pp. 323–24; Neale, *1584–1601*, p. 392; Montrose, "Eliza," p. 169.

15. On the ruler as hermaphrodite see Edgar Wind, *Pagan Mysteries in the Renaissance*, 2nd ed. (London: Faber & Faber, 1968), p. 214; and for Elizabeth's male analogues, Roy Strong, *The Cult of Elizabeth* (Wallop, Hampshire: Thames & Hudson, 1977), esp. pp. 122–24; and his *Portraits of Queen Elizabeth I* (Oxford: Clarendon, 1963), pp. 68, 156–57; David Bevington, *Tudor Drama and Politics: A Critical Approach to Topical Meaning* (Cambridge, Mass.: Harvard University Press, 1968), p. 6; and Frances A. Yates, *Astraea* (London: Routledge & K. Paul, 1975), pp. 42–51.

16. See Bevington's splendid introduction, pp. 1–26, esp. p. 8. Marie Axton has argued that many entertainments performed before the queen were frankly intended as political advice on the succession question: see esp. pp. 39–87. If she is right, then paranoia is obviously too strong a term for the queen's perpetual tendency to see herself in works performed at court.

17. Hume, *The Courtships of Queen Elizabeth*, pp. 59–60. Hume does not quote Elizabeth directly, but presents the phrase as the queen's own language.

18. See Natalie Zemon Davis, "Women on Top: Symbolic Sexual Inversion and Political Disorder in Early Modern Europe," in *The Reversible World*, ed. Barbara A. Babcock (Ithaca: Cornell University Press, 1978); Buchanan Sharp, *In Contempt of All Authority: Rural Artisans and Riot in the West of England, 1586–1660* (Berkeley: University of California Press, 1980), which describes numerous "Skimmingtons" that erupted into riots; and for Robin Hood and female disguise, Peter Stallybrass, " 'Drunk with the Cup of Liberty': Robin Hood, the Carnivalesque, and the Rhetoric of Violence in Early Modern England," an essay to be incorporated into a larger study of carnival which Mr. Stallybrass was kind enough to send me in manuscript. The hic-mulier, the masculinely clad woman of the late sixteenth and earlier seventeenth century familiar to us from the controversy by that name, has been suggested as another analogue. But that fashion in apparel, I would suggest, may itself derive from emulation of the self-presentation of the Queen. In any case, it involves two rather than three layers of sexual identity: the woman dressed as a man, unlike Queen Elizabeth as she presented herself, remains fundamentally a woman. On the controversy, see Jardine, *Still Harping on Daughters*, pp. 158–62; and Linda Woodbridge, *Women and the English Renaissance: Literature and the Nature of Womankind, 1540–1620* (Urbana: University of Illinois Press, 1984), pp. 139–51.

19. The service for the day was drawn up by Elizabeth herself. See Johnson, *Elizabeth I*, p. 194.

20. See Sherry B. Ortner and Harriet Whitehead, eds., *Sexual Meanings: The Cultural Construction of Gender and Sexuality* (Cambridge: Cambridge University Press, 1981), esp. the essays by FitzJohn Porter Poole, pp. 116–65, and Ortner, pp. 359–409; Shirley Ardener, ed., *Defining Females: The Nature of Women in Society* (New York: John Wiley, 1978), intro., esp. pp. 41 and 47; and Kirsten Hastrup's essay, pp. 49–65, esp. 59–60. I am indebted to Judith Kegan Gardiner for suggesting both these references. Of course, a familiar if partial western analogue is the Virgin Mary. See Geoffrey Ashe, *The Virgin* (London: Routledge & Paul, 1976).

21. I am referring in particular to the use which has been made of Strong and Yates's studies of the iconography of Elizabeth, n. 15 above.

22. See Mary Beth Rose's fine essay, "Women in Men's Clothing: Apparel and Social Stability in *The Roaring Girl*," *ELR* 14 (1984): 367–91; and Dusinberre, *Shakespeare and the Nature of Women*, pp. 303–07. Marston's Queen Sophonisba, whom Dusinberre mentions, also uses familiar rhetorical strategies associated with Queen Elizabeth I.

Autobiography of a New "Creatur"

Female Spirituality, Selfhood, and Authorship in The Book of Margery Kempe

JANEL M. MUELLER

S INCE ITS DISCOVERY in manuscript in 1934, *The Book of Margery Kempe* has variously engaged the interest of students of late medieval literature and spirituality. But this interest has tended, until recently, to obscure the narrative and thematic coherence of the *Book's* autobiographical design. It is remarkable enough that the work is the first autobiography in English, and the autobiography of a woman. But it emerges as a still more remarkable creation from the sidelights afforded on Margery's authorial struggles. In the preface and in the reflections linking Book 1 with Book 2, we learn that Margery, an illiterate lay woman of over sixty, had nearly completed an account of twenty-five years or so of her experience when, in 1436, the man who had been writing at her dictation and reading back to her for checking suddenly died. After this scribe's handwriting proved undecipherable to others, Margery obtained another man's help. He made a new, somewhat fuller transcript for her in 1438; this is the version of her *Book* that survives.[1]

More secular currents of interest in Margery have mainly run in two channels. In that of social history, her robust self-esteem and broad travel experience invite comparison with a literary antecedent, Chaucer's Wife of Bath. In the channel of language history her *Book* contributes to documenting the widespread resumption of English as a written medium in the fifteenth century.[2] For their part, students of late medieval spirituality have worked at identifying affinities between *The Book of Margery Kempe* and other mystical works, especially those of two close female contemporaries: Julian of Norwich's *Showings of Divine Love* and St. Birgitta's *Revelations*. Margery herself indicates that possible female affinities are not exhaustive, for she refers to works by St. Bonaventure, Richard Rolle,

The Prioress. From *The Workes of Geoffrey Chaucer*, London, 1532. *Courtesy of the Newberry Library, Chicago.*

and Walter Hilton which a priest read aloud to her.[3] Nonetheless, Margery's firsthand experience gives special pertinence and strength to the links with Julian and Birgitta. Margery's spirituality, like that of Julian whom she tells of having visited to obtain spiritual counsel (Book 1, chapter 18), centered on the Sacred Manhood and the Passion of Christ—a dominant strain in popular devotion of the period. Also, like Birgitta, whose canonization was confirmed in ceremonies at Rome which she witnessed (1.39), Margery was called to become a bride of God—even though she, unlike Birgitta, was no widow at the time and did not proceed to formal religious vows.

Margery parts company with others, men and women, in the controlling and apparently distinctive feature of her spiritual life: her calling to a mystical spousal while remaining in the world and, indeed, remaining bound to a living husband in certain evolving ways. These, we shall see, are vital to the autobiographical design of her *Book*. But before we examine the peculiar nature and implications

of Margery's calling, we must take some notice of the difficulty experienced by her first amanuensis with regard to another aspect of her spirituality. In a rare obtrusion of his own voice (1.62), he interrupts a series of anecdotes illustrating the hostility and ostracism to which Margery was subjected because of her violent "wepyng & sobbyng" in public places. He confesses that he at first had "fled & enchewyd" her under the influence of a censorious friar and that he had begun writing down Margery's story for her before he had a "ryth cler mende of the sayd mater" of her tears. "Therfor he wrot the lesse therof" and "les seryowslech & expressiowslech" then he eventually came to do.[4] This scribe explains that he sought to understand Margery better by reading in Bonaventure's *Stimulus amoris* and in Rolle's *Incendium amoris* how these two mystics report themselves to have run in the streets, crying out and calling upon the Lord. But he remained disturbed about the lack of fit he found between Margery's weeping and Bonaventure's and Rolle's crying—a lack we can partially ascribe to the influence of a potent (and male) Scriptural precedent, David the king and psalmist, upon the behavior of the latter (Psalms 17:1,5; 22:2,6–7; 27:6–11; cf. 2 Samuel 6:14–16). In further searching, the scribe tells us, he could find only one relevant analogue for "terys of pyte & compassyon" as a whole "maner of levyng" in "plentyuows grace." This was the biography of the saintly Marie d'Oignies (1177–1213) written by her spiritual director, the Augustinian canon Jacques de Vitry. Through reflecting on Marie's *Life,* Margery's first amanuensis came to *bona fide* acceptance of the two women's shared mystical "gift of tears" and thence to willing cooperation with Margery in setting down an account of her life and spirituality in her own words.[5]

It would be hard to overrate the importance of Margery's "gift of tears"—a trait manifested copiously every day for ten years, and at less frequent intervals over an additional fifteen (1.27, 82, 85). The prominence of her devout fits of weeping as a compositional element in her *Book* stems directly from their indispensability to her: they validate her personal witness to God's unfailingly tenderhearted love for the whole of humankind. Thus any examination of the autobiographical design of Margery's *Book* must begin with the vital equivalence between her tears, on the one hand, and the truth of feeling and being a "creatur" of God, on the other, which she everywhere reaffirms. As the associative, loosely sequential progression of her story establishes itself, no fewer than three early chapters rehearse

assurances from Jesus, Our Lady, and Julian of Norwich that Margery's tears mark her as a special recipient of divine love and favor. First Jesus tells Margery "in hir mende" that "terys of compunccyon, devocyon, & compassyon arn the heyest & sekerest ʒyftys that I ʒeve in erde" (1.14). Almost immediately thereafter, Julian urges upon Margery this view of her tears: "Whan God visyteth a creatur wyth terys of contrisyon, devosyon, er compassyon, he may & owth to levyn that the Holy Gost is in hys sowle" (1.18; *BMK*, pp. 31, 42–43; B-B, pp. 23, 34). Next, after Our Lady assures Margery that her tears attest the flowings of Jesus' grace, to make the world wonder at her and love the Son for Margery's sake (1.29), the *Book* attains a level of confidence which never recedes, despite intermittent doubts and challenges. Margery identifies her very life and selfhood with what she calls her "welle of teerys" (1.32, 41, 57; II, concluding prayers). So complete is this identification that when she finds herself "bareyn fro teerys," her consciousness goes numb with anguish. She cannot function religiously or socially (1.82) until her capacity to weep is restored (*BMK*, pp. 81, 99, 141, 199, 249; B-B, pp. 70, 86, 129, 182, 227). In alleging a singular spiritual counterpart for the weeping Margery in Marie d'Oignies, the *Book*'s first scribe points to an external of social behavior as the sign of a characteristic sensibility—a mode of expression and a way of life—which appears to be female; his search turned up no male analogues. However, this scribe's preoccupation with the likenesses between Marie and Margery keeps him from remarking what to us is an equally essential difference. Margery's female spirituality impelled her, as it did not impel Marie, to the joint self-awareness and self-realization demonstrated in compiling an autobiography. Not only did the interworkings of female spirituality, selfhood, and authorship issue in the transmissible record known as *The Book of Margery Kempe*; they also etched that record with its unique autobiographical design.[6]

One major aspect in which female spirituality, selfhood, and authorship come together is in the formation of blocks or sequences of narrative that address the question of giving credence to Margery, to what she says and does. The authorial imperative she faces at the outset of her *Book*—in rhetorical terms, the necessity to use *ethos* effectively in self-presentation—is exactly the challenge Margery represents herself as having to face in life. Certainly it was anomalous, not to say scandalous, that she experienced her calling to become a bride of God when she had a living husband and had recently borne a

child. The precedent of the virginal Marie d'Oignies could in no way cover the latter circumstance. St. Birgitta, too, had received her calling to mystical spousal only after she was widowed. The utter incongruity of Margery's situation with her newly announced calling causes the otherwise well-disposed Richard Caister, vicar of St. Stephen's, Norwich, to exclaim in sheer bemusement: "What cowd a woman ocupyn an owyr er tweyn owyrs in the lofe of owyr Lord?" (1.17; *BMK*, p. 38; B-B, p. 30).

Inevitably, the first steps in the spiritual reorientation that Margery seeks for her life entail breaking with various settled conceptions and demands to which she as a woman is subject—those of her husband most immediately, later those of religious and civil authorities as well as society at large. Having to strain toward her new identity against these settled conceptions and demands creates the constitutive narrative tension of several important sequences of chapters set in England, where Margery is a known entity, and also commands her native tongue for use in self-definition and self-defense. In the first such sequence, chapters 9 through 25 of Book 1, Margery's prime objective is to secure her husband's consent to her newly spiritualized understanding of her wifehood in the form of a mutual vow of sexual continence.[7] After almost three years she wins his cooperation and support, demonstrated in his accompanying her on a less successful quest—a quest for permission from ecclesiastical superiors in York, Canterbury, Lincoln, and Norwich that Margery be allowed to wear the white garments of a bride of God. The long withholding of this permission figures prominently in the design of her *Book*. In the second relevant sequence, chapters 43 through 55 of Book 1, the narrative tension rises as Margery, now attempting to negotiate official recognition of her special spiritual identity without her husband's help, is arraigned for questioning at Worcester and then actually prosecuted for heresy (Lollardy) at Leicester, York, and Beverley.

As author, Margery works deftly to shape and sustain these blocks of narrative which convey the notion that she had no selfhood, no existence worthy of naming, before her protracted struggle to clarify and confirm her religious calling both to herself and others. Thus she introduces herself in the most minimal terms at the opening of her *Book* by leaving anonymous the two male figures, father and then husband, whose dependent she successively was. Her husband is cited only as "a worschepful burgeys" and her father as "sum-tyme

meyr of the town N. and sythyn . . . alderman of the hey Gylde of the Trinyte in N." (1.1, 2; *BMK*, pp. 6, 9; B-B, pp, 1, 3), while she consistently styles herself, here and throughout, as "this creatur"—a locution which encapsulates her sense of radical dependency on God for her ongoing creation. In the ensuing blocks of narrative which detail society's grudging acknowledgement of the claims of Margery's spirituality, the calculated unspecificity of the style raises one question—namely, Who is this woman?—and the tension of social dealings transmutes it into another question: What possible place or meaning can her life have? The purposiveness of autobiographical design in *The Book of Margery Kempe* emerges in the answers it offers to these questions.

Although Margery's first steps toward reorienting herself and her sexual and social roles under the imperative of divine love take disjunctive form—the new as a break with the old—she is soon instructed that true female spirituality proceeds otherwise. Its nature consists in an embrace of non-exclusive, co-existing relations and functions which may well strike us readers as cognate with the most enduring historical role of females as characterized by Elise Boulding.[8] To Margery, however, the lesson in the comprehensiveness which her spirituality must attain comes as the will of her Lord, and her initial advance in such consciousness provides the crux of the first sequence of chapters in her *Book*. Near its end (1.21, 22), Margery voices perplexity and abashment at being singled out as a special recipient of her Lord's love, since she does not belong to either privileged category—maiden or widow. Her Lord reassures her that he finds her "a synguler lover" and beloved in a range of roles; he calls her "a mayden in thi sowle," "dowtyr," "myn owyn derworthy derlyng," "myn owyn blyssed spowse" (*BMK*, pp. 52–53; B-B, p. 42). The initial insight to be gained by the spiritually instructed Margery and communicated to her husband is this: there is no inherent incompatibility between becoming a bride of God and being acknowledged as the wife of John Kempe, burgess of Lynn, and the mother of his fourteen children (cf. 1.15).

Society at large, however, clings to either/or thinking with respect to Margery, especially in England where, if anywhere, she has her place. The crux of the second extended narrative sequence is Margery's pertinacity in seeking the public confirmation of her special spiritual status which would come with permission to wear white wool clothing and a gold ring engraved *Jesu est amor meus;* in this

regard she must persuade males other than her husband who have authority over her. Hence the issue of her clothing is more complicated in the sense of being more social than the vow of continence was. Margery is also as intensely concerned with her clothes as she is with her tears; she treats both as an extension of herself, a measure of the recognition accorded her in the public domain. Perhaps her concern with her clothes indicates an emergent feature of female authorial consciousness.[9] Yet it is well to be cautious about any such inferences, for Rolle had set a famous precedent in English mysticism by devising a new dress for his religious calling from his sister's garments; and, nearer in time to Margery, a general mindfulness of sumptuary considerations marks other, quite disparate vernacular works in fifteenth-century England.[10] At any rate, it is indicative of the strength of her difficulties at home that Margery first reports wearing her white clothes and gold ring in a discontinuous group of chapters on her travels to Zurich, Constance, Bologna, Venice, Jerusalem, and Rome which intervenes between the first and the second narrative sequences dealing with England.

When Margery is abroad, her weeping creates as much disturbance and antipathy as it does at home. But otherwise, when she is abroad, she emerges in her text as a far more tenuous and peripheral presence—a woman remarked at best in passing, for the most part slighted and disregarded, isolated too by her inability to speak any language but English. It is against this desultory and disorienting backdrop that Margery strikes a bargain with her Lord: if she is brought safely to Rome, she will fulfill His longstanding injunction that she wear white clothes (1.30). She keeps her bargain (1.31) and has the self-possession to defy an English priest in Rome who commands her to shed her hypocritical holiness (1.33). Next, however, she obeys a German priest who tells her to resume wearing her black clothes (1.34). Yet what looks like vacillation proves to be the last shedding of Margery's diffidence regarding the rightness of a mystical spousal for one in her marital state. In direct succession follows one of the most arresting chapters in the *Book* (1.35): Margery's account of her wedding to the Godhead in the Church of the Holy Apostles in Rome on the feastday of St. John Lateran. This experience, in which God the Father plights to Margery's soul the bridegroom's "for richer or for poorer" troth before the other Persons of the Trinity and a large company of saints and angels, reconfirms dramatically the lesson of non-exclusivity in her roles and relations which she had earlier been

taught as a precept. This experience also climaxes the pilgrimage of nearly two years on which Margery had embarked just after she and John had together vowed sexual continence. Quite simply, it makes her able to return home.

A rapid narrative transition signals that any further development of the ramifications of Margery's status, selfhood, and spirituality, as externalized in the issue of her clothing, must await her arrival in England. The development begins as soon as she disembarks in Norwich and regains the use of her tongue in her native speech community (1.43). To a monk who confronts her with the rumor that she had borne an illegitimate child abroad, she declares "how it was owr Lordys wyl that sche xulde be clad in white clothyng." This declaration seems to be vindicated forthwith; "a worshepful man in Norwich" makes her a present of a white gown, kirtle, hood, and cloak, and John, her husband, arrives to conduct her back to Lynn (1.44; *BMK*, pp. 103, 104; B-B, pp. 90, 91). Before she can go her way, however, Margery has to answer to the bishop of Worcester for calling some of his retainers "the Develys men" because they wore slashed and pointed clothes (1.45; *BMK*, p. 109; B-B, p. 96) much like those she describes herself as having worn in her unregenerate youth (cf. 1.2). To her surprise, the bishop receives Margery hospitably, white clothes and all, insisting that she dine with him because he recognizes her as John of Brunham's daughter, from Lynn. In this solitary instance social identification promotes rather than hinders acceptance of Margery's singular spirituality.

Much more typical and much more highlighted in the narrative design of the *Book* are the negative reactions to her spirituality and selfhood which Margery proceeds to encounter at Leicester, York, and Beverley. In the next sequence of chapters, every interrogation ends by pitting the power of society against Margery's dual spousal, the operative assumption of the authorities being that once they determine who she is, they will know what she cannot be. Thus the mayor of Leicester reviles Margery as "a fals strumpet, a fals loller, & a fals deceyver of the pepyl" when she lays claim to the identity of a bride of God. Indeed, she makes matters worse and seems more outrageous when she offers on behalf of her claim the credentials of her present male connections:

"Syr," sche seyd, "I am of Lynne in Norfolke, a good mannys dowtyr of the same Lynne, whech hath ben meyr fyve tymes of that

worshepful burwgh and aldyrman also many ȝerys, & I have a good
man, also a burgeys of the seyd town, Lynne, to myn husbond"
(1.46; *BMK*, pp. 111–12; B-B, p. 98).

By contrast, the steward of Leicester refuses to believe Margery's
protestations that she is "a mannys wife" because she is unaccom-
panied. When she resists his sexual advances by laying claim to the
protection of divine love, the steward's bafflement erupts in this
disjunction: "Eythyr thu art a ryth good woman er ellys a ryth
wikked woman" (1.47; *BMK*, p. 113; B-B, p. 100). Later, as events in
Leicester build to a hearing on heresy charges before the abbot and
dean, Margery struggles to articulate her understanding of the em-
bracing consciousness enjoined on her as her proper spirituality.
Confessing herself, on the one hand, "bowndyn" to the husband by
whom she has "born xiiij childeryn," she asserts, on the other, that
"there is no man in this worlde that I lofe so meche as God, for I lofe
hym a-bovyn al thynge." She then phrases the inclusiveness of her
feeling in her state of dual spousal in this way: "Ser, I telle ȝow trewly
I lofe al men in God & for God." The only response she records from
Leicester officialdom to all this comes from a man who frankly sees
her example as a threat to the social order: "I wil wetyn why thow
gost in white clothys, for I trowe thow art comyn hedyr to han a-way
owr wyvys fro us & ledyn hem wyth the" (1.48; *BMK*, pp.115, 116; B-
B, pp. 102, 103).

The pattern of incomprehension and recoil which unfolds in
such detail at Leicester continues at York. There Margery, clad in
white, circulates like a preaching friar among the people, reprehend-
ing vice in folk fables—for example, that of the bear and the flower-
ing pear tree—which she herself devises (1.50, 52). Although she is
branded a "wolf" in her white wool clothing and warned by the
archbishop not to "techyn ne chalengyn the pepil in my diocyse" any
longer, she refuses to swear an oath to this effect; for, she says, Christ
in the Gospel gave women warrant to witness of Him (*BMK*, pp. 120,
125–26; B-B, pp. 107,113). At Beverley, questions about Margery's
identity predominate. First she is accused of being Lord Cobham's
daughter and a member of an outlawed communications ring (1.53);
later she is taken for the woman who counseled Lady Greystoke, John
of Gaunt's granddaughter, to forsake her husband (1.54). Finally, the
disruptive force which she is perceived as being finds recognition
even in the friendly advice given to Margery by countrymen of the

Beverley region: "Forsake this lyfe that thu hast, & go spynne & carde as other women don, & suffyr not so meche schame & so meche wo" (*BMK*, p. 129; B-B, p. 117).

Throughout the narrative of her experiences at Leicester, York, and Beverley, Margery's mounting confidence regarding her spirituality, selfhood, and authorship takes shape in a distinct, if complex design. To some extent the sequence reads typologically, for it utilizes the familiar conventions of female and male saints' lives: it develops Margery's identity through identification with her Lord, a prophet without honor in his own country (Matthew 13:57; Mark 6:4; John 4:44) who was repeatedly called to account by the civil and religious authorities of his time. Nevertheless, the dominant overlay in the design of the narrative sequences of Margery's *Book* remains circumstantial, experiential, autobiographical. We are repeatedly reminded that the selfhood and the spirituality in question are a woman's, and that it is she, rather than a third party, who stands to vouch to the authorities for what she has learned about divine love: its embrace transcends all human compartmentalizations. Thus a deep thematic resonance emits from the narrative resolution (1.55) in which Margery finally obtains permission to dress in public as a bride of God after her husband has accompanied her to Lambeth palace and made appeal with her to the archbishop of Canterbury.

Just how constitutive this autobiographical design is in the composition of *The Book of Margery Kempe* can be traced likewise in the shaping of the materials of its second book, a comparatively brief addition made in 1436, at a four-year remove from the original account. Margery may have been motivated to resume her life story by a revelation from her Lord that her authorial efforts pleased Him (1.89). In the second book the aging Margery continues to learn how she is to accommodate her human involvements as a mother and mother-in-law to her Lord's spiritual imperatives. Since the issue of her selfhood is cast once again as a quest fraught with opposition and misgivings, it is a noteworthy advance that "this creatur" is able, for the first and only time in her *Book,* to make a full reference to herself as "Mar. Kempe of Lynne" (2.9) in a context where she is being maligned and misreported. From start to finish, we find her tirelessly absorbed in what she conceives as setting the record straight about herself.[11]

Beyond its function as a catalyst in the narrative, Margery's apprehension of specific imperatives of divine love for her as a female

contributes vitally to the emotional and thematic substance of her story. This apprehension has a continuing referent in the mode of behavior enjoined upon Margery when she acts the role of Our Lady's maidservant in her revelations; the mode is summed up in the set phraseology of the wordpairs *mekenes & pacyens, mekely & paciently*.[12] Although these wordpairs are reserved for the characterization of Margery's role as maidservant, they obviously have no exclusive bearing on female comportment. Another phrase, however, develops more and more exclusively female associations as Margery learns through conversations with her Lord that divine love must manifest itself in her life by familiarity, intimacy, openness of the self to another, especially in acts of tendance and nurture. The locution for such love in Margery's *Book* is one shared with Julian's *Showings:* "to be homly."[13] But in Margery's *Book,* unlike Julian's *Showings,* the homeliness of divine love becomes a direct function of mystical spousal. Her Lord tells Margery: "For it is convenyent the wyf to be homly wyth hir husbond. . . . Ryght so mot it be twyx the & me, for I take non hed what thu hast be but what thu woldist be. . . . Therfore most I nedys be homly wyth the." In turn, the homeliness of divine love, ranging through the reaches of the hus-band–wife relationship, is to activate simultaneously in Margery the entire spectrum of female responses and roles. Thus her Lord exhorts her:

> "Take me to the as for thi weddyd husbond, as thy derworthy derlyng, & as for thy swete sone, for I wyl be lovyd as a sone schuld be lovyd wyth the modyr & wil that thu love me, dowtyr, as a good wife owyth to love hir husbonde" (1.36; *BMK*, p. 90; B-B, p. 77).

Such exhortations embolden Margery, in a remarkable continuation of this passage, to invite the reader's reflection on all the reasons a woman might have to open her arms or to share her bed with another in the course of her experience. By these homely images of her own, she evokes the manifold responsiveness which divine love demands of her soul.

As Margery progresses on the contemplative plane, she finds herself able to empathize equally with the love felt for Jesus by his mother Mary, by the passionately devoted Mary Magdalene, and by the bereaved disciples—all personages with whom she has vivid and

prolonged visionary contact. What is more, she learns to integrate her visions with her experiences in the world, at first simply as an observer who has as ready a devotional response to mothers with their boy babies, or to seemly youths, or to a beating in the street as she has to a consecrated Host, images of Our Lady and Christ, or the sacred places of Jerusalem.[14] But a still more significant stage in Margery's maturing sense of self as loving and beloved of God involves putting her tenderheartedness to the test in day-to-day conduct. A priest in Rome inducts her in this vein by assigning her, as a penance, the care of a destitute old woman for six weeks (1.34); immediately thereafter, she is brought to recognize her creaturehood as wedded to the Godhead of the Father, and His will and purposes, not simply engrossed in love and affection for the Manhood of Christ (1.35). The consequent redirecting of Margery's energies into difficult and even repellent tasks becomes a measure of her growth in understanding and responding to the absoluteness of divine love. The measure is at its fullest late in Book 1, where a series of chapters carry the ramifications of spirituality and selfhood to the greatest experiential extremities and autobiographical insights in Margery's *Book*.

Margery describes her ministrations to various sick persons in Lynn, particularly the affectionate care which she—like Marie d'Oignies—gave to street lepers whom others reviled and refused to touch, as she, too, formerly had done (1.72, 74, 75). Then, by one of the associative, loosely temporal transitions so characteristic of her *Book*,[15] Margery proceeds to relate the most taxing but finally illuminating imperative laid upon her by divine love: her six years spent in nursing her senile, incontinent husband after a near-fatal fall (1.76). With extraordinary candor she rehearses her Lord's injunction—"I bydde the take hym hom & kepe hym for my lofe"—and her objection to doing what she considered a severe hindrance to her mystical spousal. "Nay, good Lord," Margery rejoins, "for I xal than not tendyn to the as I do now." But her Lord insists that she fix her thoughts on the all-embracingness of spirituality which is her peculiar lesson and the overarching theme of her *Book*:

> "ʒys, dowtyr," seyd owr Lord, "thu xalt have as meche mede for to kepyn hym & helpyn hym in hys nede at hom as ʒyf thu wer in chirche to makyn thi preyerys. And thu hast seyd many tymys that thu woldist fawyn kepyn me. I prey the now kepe hym for the lofe of

me, for he hath sumtyme fulfillyd thi wil & my wil bothe, and he
hath mad thi body fre to me that thu xuldist servyn me & levyn chast
& clene, and therfor I wil that thu be fre to helpyn hym at hys nede in
my name" (*BMK*, p. 180; B-B, p. 165).

In the event, as she describes it, Margery draws heavily upon the
range of female roles she has acted in life to persevere in caring for her
husband. Her candor and authorial self-consciousness come to the
fore again in her remarkable admission that, only by making herself
remember the "many delectabyl thowtys, fleschly lustys, & inordinat
lovys to hys persone" that she had entertained "in hir ʒong age,"
could she steel herself to the endless washing and wringing entailed
when John "in hys last days . . . turnyd childisch a-ʒen" and "as a
childe voydyd his natural digestyon in hys lynyn clothys ther he sat
be the fyre er at the tabil, whethyr it wer, he wolde sparyn no place"
(*BMK*, p. 181; B-B, pp. 165–66). Clearly, the implicit typology of this
episode derives from the parable in Matthew 25:31–46; its moral is
that any ministering done to the least of one's fellow human beings is
done to Christ. And yet this moral translates literally in Margery's life
as a resumption of earlier diapering and laundering to keep pace with
John's lapse into second childhood. But the both enjoined and volun-
tary character of the resumption makes all the difference: Margery
undertakes it on her Lord's assurance that such service will not
separate her from her devotion to Him; rather, it will confirm her
devotion all the more.

The third from last chapter (1.86) in the original ending of
Margery's *Book* is particularly conclusive for understanding the
meaning and purpose of her life as she represents them. Here her Lord
emphasizes that she did not repudiate her earlier sexual and social
roles through mystical spousal, but, instead, was granted a means to
their more encompassing exercise. He interprets the pattern of her
marital experience for her as follows:

Dowtyr, ʒyf thu knew how many wifys ther arn in this worlde that
wolde lovyn me & servyn me ryth wel & dewly, ʒyf thei myght be as
frely fro her husbondys as thu art fro thyn, thu woldist seyn that thu
wer ryght meche beheldyn on-to me. . . . And for the gret
homlynes that I schewe to the . . . thu art mekyl the boldar to askyn
me grace for thi-selfe, for thin husbond, & for thi childryn & thu

makyst every Cristen man & woman thi childe in thi sowle for the tyme & woldist han as meche grace for hem as for thin owyn childeryn (*BMK*, p. 212; B-B, p. 192).

In reporting her Lord's words thus, Margery signals the fulfillment of her spirituality and selfhood through an expansion of her wifely and maternal concerns to encompass all the souls of Christendom in homely love. Such a transvaluation of the sexual and social roles into which she was born made an autobiographer of her as well, for she resolved that the implications she perceived in her experience should be preserved in the *Book* that keeps alive for us her name and her story.

NOTES

1. Margery's reflections on her authorial role, both on her inward sense (shared with Julian of Norwich) that she should await understanding before recording her experience and on the time and effort that authorship took away from her life of devotion, are to be found in the latter part of the preface and in Book 1, chapters 87 and 88. See *The Book of Margery Kempe,* ed. Sanford B. Meech, with annotation by Hope Emily Allen, EETS orig. ser. 212 (London: Humphrey Milford, 1940), pp. 3–6, 214–16, 219–20; cited hereafter as *BMK*. For discussion of aspects of the cooperative process by which Margery's *Book* came into being, see M. C. Seymour, "A Fifteenth-Century East Anglian Scribe," *Medium Aevum* 37 (1968): 166–73; and John C. Hirsh, "Author and Scribe in *The Book of Margery Kempe,* " *Medium Aevum* 44 (1975): 145–50.

2. See, in the former connection, H. S. Bennett's essay on Margery in his *Six Medieval Men and Women* (Cambridge, Eng.: Cambridge University Press, 1955), pp. 124–50; and Joseph Crawford, "Independent Women in a Medieval World," *Spritual Life* 20 (1973): 199–203. In the latter connection, see especially Shōzō Shibath, "Notes on the Vocabulary of *The Book of Margery Kempe,*" in *Studies in English Grammar and Linguistics: A Miscellany in Honor of Takanobu Otsuka,* ed. Kazuo Araki (Tokyo: Kenkyusha, 1958), pp. 209–220; Alfred Reszkiewicz, *Main Sentence Elements in 'The Book of Margery Kempe': A Study in Major Syntax* (Wroclaw: Polskiej Akademii Nauk, 1962); and Robert Karl Stone, *Middle English Prose Style: Margery Kempe and Julian of Norwich* (The Hague: Mouton, 1970). For listings of other studies, see the "Margery Kempe" section in *A Bibliographical Index of Five English Mystics,* comp. and ann. by Michael E. Sawyer (Pittsburgh: The Clifford E. Barbour Library of Pittsburgh Theological Seminary, 1978), pp. 97–103.

3. See *BMK*, 1, chaps. 17, 58, 62. For discussions of Margery's spirituality,

see W. A. Pantin, *The English Church in the Fourteenth Century* (Cambridge, Eng.: Cambridge University Press, 1955), pp. 256–63; Edmund Colledge, "Margery Kempe," in *Pre-Reformation English Spirituality*, ed. James Walsh (New York: Fordham University Press, 1965), pp. 210–23; Wolfgang Riehle, *The Middle English Mystics*, trans. B. Standring (London: Routledge, 1981); and Hope Phyllis Weissman, "Margery Kempe in Jerusalem: *Hysterica Compassio* in the Late Middle Ages," in *Acts of Interpretation: The Text in Its Contexts*, ed. Mary J. Carruthers and Elizabeth D. Kirk (Norman, Okla.: Pilgrim Books, 1982), pp. 201–17. On the emergence of the affective tradition of devotion to the Sacred Manhood and Passion of Christ, see André Wilmart, *Auteurs spirituels et textes dévots du moyen âge latin: Etudes d'histoire littéraire* (Paris: Bloud et Gay, 1932; rpt. Etudes augustiniennes, 1971), pp. 62–63, 126–37, 476–82; Simone Roisin, *L'Hagiographie cistercienne dans le diocèse de Liège au XIIIᵉ siècle*, Université de Louvain: Recueil de travaux d'histoire et de philologie, series 3, no. 27 (Louvain: Bibliothèque de l'Université, 1947); Michael Goodich, "The Contours of Female Piety in Later Medieval Hagiography," *Church History* 50 (1981): 20–32, esp. 23–25; Brant Pelphrey, *Love Was His Meaning: The Theology and Mysticism of Julian of Norwich*, Salzburg Studies in English Literature, no. 92 (Salzburg, 1982); and Caroline W. Bynum, "Women Mystics and Eucharistic Devotion in the Thirteenth Century," in *Medieval Women*, ed. Hope Phyllis Weissman (forthcoming).

4. *BMK*, p. 153. In quoting, I have substituted *th* for the 'thorn' letter and *v* and *j* for consonantal *u* and *i*, respectively. For the convenience of those wishing to consult the modernized transcript made by the owner of the unique manuscript, I include correlated page references to W. Butler-Bowdon, *The Book of Margery Kempe: A Modern Version* (New York: The Devin-Adair Co., 1944), p. 140; hereafter cited as B-B.

5. To date, the most precise attempt to delineate the singularities and the common features in Margery's spirituality as viewed against a continental and then a specifically English backdrop has been made by Susan Dickman, "Margery Kempe and the Continental Tradition of the Pious Woman," in *The Medieval Mystical Tradition in England*, ed. Marion Glasscoe (Cambridge, Eng.: Boydell and Brewer, Ltd., 1984), pp. 150–68. Dickman's account of the new socioreligious developments which Jacques de Vitry recognized in emergent *mulieres sanctae* like Marie d'Oignies and her followers (pp. 155–57) highlights two apparently distinctive features of Margery's spirituality: (1) her eschewal of community in favor of a strongly individualistic life style and (2) her public, social enactment of her mystical marriage which pits her understanding against male authority, clerical as well as lay (pp. 161–66). For other discussions of the increased activity and self-assertion of women in late medieval religious life, see Ernest W. McDonnell, *The Beguines and Beghards in Medieval Culture* (New Brunswick: Rutgers University Press, 1954), pp. 219–319; Richard William Southern, *Western Society and the Church in the Middle Ages* (Harmondsworth: Penguin, 1970), pp. 318–31; Brenda M. Bolton, *"Mulieres Sanctae,"* in *Sanctity and Secularity: The Church and the World*, ed. Derek Baker, Studies in Church History, no. 10 (Oxford: Basil Blackwell, 1973), pp. 77–95; Bolton, *"Vitae Matrum: A Further Aspect of the Frauenfrage,"* in

Medieval Women: Essays Presented to Professor Rosalind M. T. Hill, ed. Derek Baker, Studies in Church History, Subsidia no. 1 (Oxford: Basil Blackwell, 1978), pp. 253–73; and Caroline W. Bynum, *Jesus as Mother* (Berkeley and Los Angeles: University of California Press, 1982), pp. 170–262.

6. The identifiably female cast of *The Book of Margery Kempe* has been discussed generally but very suggestively in a four-way comparative study by Mary G. Mason, "The Other Voice: Autobiographies of Women Writers," in *Autobiography: Essays Theoretical and Critical,* ed. James Olney (Princeton: Princeton University Press, 1980), pp. 207–35; esp. pp. 211, 217–21, 231. Mason's other texts are Julian of Norwich's *A Shewing of God's Love* (ca. 1373); *A True Relation of My Birth, Breeding and Life* (1656) by Margaret Cavendish, Duchess of Newcastle; and Anne Bradstreet's "To My Dear Children" (1657).

7. Dickman, "Margery Kempe and the Continental Tradition of the Pious Woman," pp. 159–60, remarks sensitively on the tension between sexuality and spirituality which Margery handles in a gentler fashion than do other medieval women mystics. For a less sympathetic view of Margery's spirituality as a means of resisting and evading the conditions of marriage, see Anthony Goodman, "The Piety of John Brunham's Daughter, of Lynn," in *Medieval Women,* ed. Baker, pp. 347–58.

8. See Elise Boulding, *The Underside of History: A View of Women through Time* (Boulder, Colo.: Westview Press, 1976), pp. 132–33, 146–47, 170, on the persistence of "women's tendency not to specialize" but, instead, to play a wide gamut of roles in culture.

9. Valuable sidelights on clothing as an adjunct of sexual identity are offered in Sandra M. Gilbert's "Costumes of the Mind: Transvestism as Metaphor in Modern Literature," *Critical Inquiry* 7 (Winter 1980): 391–417.

10. See, for example, the specifications regarding apparel in *A Booke of Precedence of all estates and playcinge to ther degrees,* ed. Frederick J. Furnivall, EETS ext. ser. 8 (London: N. Trübner and Co., 1869). Relevant period studies include Frances E. Baldwin, *Sumptuary Legislation and Personal Regulation in England* (Baltimore: The Johns Hopkins University Press, 1926), esp. pp. 73–95 on Lancastrian England; and Françoise Piponnier, *Costume et vie sociale: la cour d'Anjou (XIVe-XVe siècle)* (The Hague and Paris: Mouton, 1970), esp. pp. 261–88 on the class nuances of female dress.

11. As an appreciable body of theory and criticism dealing with first-person writing continues to make clear, there is never an equation to be drawn between an author as an actual historical person and the "I" of that author's text, even—or especially—when the text insists on just such an equation. Hence Jean Starobinski, in "The Style of Autobiography," *Literary Style: A Symposium,* ed. Seymour Chatman (New York: Oxford University Press, 1971), pp. 285–96, distinguishes the historical and discursive subjects in first-person narrations, extending a distinction between "énunciation historique" and "discours" made by Emile Benveniste, *Problèmes de linguistique générale* (Paris: Gallimard, 1966), 1:242. With interesting implications for texts like *The Book of Margery Kempe* Starobinski observes that the tension between being and self-knowing is usually resolved by

some radical change which the autobiographer experiences, most frequently in the form of conversion to a new life. Other suggestive leads in interpreting texts like Margery's *Book* can be found in Joan Webber's *The Eloquent 'I': Style and Self in Seventeenth-Century Prose* (Madison: University of Wisconsin Press, 1968) and in the essays in Olney's collection, cited n. 6 above.

12. For example, 1:68, 69, 74 (*BMK*, pp. 166, 167, 177; B-B, pp. 152, 153, 162). For other listings of wordpairs and discussion of this stylistic staple, see Stone, *Middle English Prose Style*, pp. 121–33.

13. See 1.31, 36, 86 (*BMK*, pp.79, 90–91, 210; B-B, pp. 67, 77, 192). Cf. Dickman (p. 37): "Where Julian means the phrase to describe a kind of physical intimacy equally manifest in Christ's assumption of humanity in the Incarnation, in the suffering of the Passion, and in his willing to 'show' himself to a 'creature living in sinful flesh,' in Margery's *Book* the homeliness of divine love is most often manifest in a kind of domestic intimacy."

14. See, in this connection, 1.29, 30, 35, 39, 57, 60, 72, 78, 82, and 83.

15. See, in this regard, the beginnings of chaps. 21 and 25 in Book 1 and the endings of chaps. 36, 67, and 85 in Book 1. Mason, "The Other Voice," pp. 210–12, notes that a flexible, highly psychologized handling of temporal sequence recurs in female autobiography.

8

Spiritual Fun

A Study of Sixteenth-Century Tuscan Convent Theater

ELISSA WEAVER

*A*MONG sixteenth-century Italian women writers, the nuns have been the most neglected by scholars. They were indeed rarely recognized in their own time beyond their convent walls, for their writings were usually composed for the benefit of the sisters themselves and seldom reached an outside audience. The literary manuscripts they left, mostly religious works, were dispersed, many lost during the monastic suppressions of the eighteenth and nineteenth centuries. Among the nuns only the saints have been remembered.

Yet nuns comprise perhaps the largest group of Italian sixteenth-century women writers, and this is not surprising, since, in the cities at least, they generally came from the upper classes; and their convents, which were well-endowed, provided the women with a comfortable life and some form of education.[1]

Convent education was surely not the same in all the houses nor for all the women; however, its aims probably were. It was meant to prepare the novices, nuns, and the school girls (who would return to secular society) for their domestic and spiritual lives. When a young girl of the Medici family was sent to the convent of San Giovannino in Florence for an education in 1615, she was given two teachers, one for her religious training ("le virtù") and needlework ("i lavori"), another for writing; and, while she got more attention than most (a nun served as her hairdresser and another looked after her food and clothing), her studies seem to be standard and to be the same as those of the preceding century.[2]

In the convents women were taught the virtues of a Christian life and the tenets of their faith. They learned to read, and the regular nuns were taught to write, in the vernacular, if they didn't already know how, though what competence they were to achieve remains a

Frontispiece of Suor Beatrice del Sera's *Amor di virtù* (1555). Codice Riccardiana 2932. *Courtesy of Biblioteca Riccardiana e Moreniana, Firenze.*

question. Some Latin was necessary so the regular nuns could read their breviary and follow the liturgy.[3] A good knowledge of the vernacular language probably sufficed for reading the Scriptures, the Church Fathers, and the lives of the saints—the standard convent texts, all translated into Italian by the sixteenth century.[4] The curriculum often included music and the rudiments of arithmetic and probably always stressed the "feminine arts" of sewing and fancy needlework. Convents that participated actively in the economic life of the community, providing the townspeople with artifacts and themselves with revenues, taught their young women, along with needlework, other special skills, such as weaving, painting, sculpture, manuscript production and illumination, printing, and even pharmacy.[5]

In sixteenth-century Italy a majority of the unmarried women of the patriciate were in nunneries. Fifteen to sixteen percent of the women of Florence in 1552 were nuns, and this figure doesn't include the many Florentine women in the convents of neighboring cities, especially Prato, whose ten convents had a predominantly Florentine population.[6] With such a large number of upper-class women, some could be expected to have intellectual interests.

As was fitting, nuns wrote saints' lives, meditations, accounts of mystical experiences, chronicles of their convents, biographies of their abbesses, founders, and saints, and they translated Scriptures.[7] They have left many letters, some poetry, and religious and moral plays. These convent genres have not been studied by literary critics and historians, and all merit attention, if only as specific varieties of popular literature and historiography. The plays, moreover, add to our knowledge of an aspect of convent life as old perhaps as convent life itself and still alive today—that of the festivities, the special convent occasions for recreation and celebration.

Plays were part of holiday entertainment—for Carnival, Christmas, the convent's or the city's patron saint's day, and the novices' special feasts.[8] The practice was evidently widespread in Europe and had existed for a long time, as the famous case of the tenth-century dramatist and nun Hrotswitha of Gandersheim would suggest.[9]And there are some other note-worthy examples. In the twelfth century the Benedictine nun and scholar, Hildegard von Bingen, wrote a Latin morality play entitled the *Ordo Virtutum*; she set it to music as well and performed in it together with other nuns of her convent.[10] A *Ludus Paschalis*, which survives in a late thirteenth-early fourteenth-

century manuscript, is known to have been written in the convent of Origny-Saint Benoît in France and performed by the nuns.[11] In the late fourteenth century, between 1363 and 1376, Katherine of Sutton, the abbess of Barking Nunnery in England (Essex), wrote a Latin liturgical drama for Easter services, and nuns performed in it together with male clerics.[12] By the end of the fifteenth century theatrical performances were a common practice, especially at Carnival time, in the female convents of Central Italy.[13] This study will concentrate on the Italian case and specifically the Tuscan tradition for which there is an abundance of manuscript documentation. Giovan Maria Cecchi, a sixteenth-century Florentine playwright, in the prologue to a play written for convent production, justifies the tradition:[14]

> ogni cosa insomma, vuole i suoi riposi. Da questo, mi credo io, fûr mossi quelli che fêro i monasteri, a consentire che le suore facessero, ne' tempi che siamo adesso, le presentazioni e le commedie, avendo sempre l'occhio che le fussero oneste e da cavarne spasso spirituale e documento.
>
> (*L'Acquisto di Giacobbe,*Prologo, lines 69–77)

> [everything, in fine, needs to rest. For this reason, I believe, those who established the convents saw fit to allow the nuns to put on *sacre rappresentazioni* and comedies in this season, making sure they were always above reproach and apt to produce spiritual fun and learning.]

Young boys of lay confraternities, such as the Company of the Evangelist or that of St. Sebastian, who were known for their theatrical productions, were often invited to perform in convents and monasteries.[15] This practice began in the fifteenth century, but exactly how long it continued and precisely where has not yet been studied. The nuns also staged plays themselves and must have done so with increasing frequency in the course of the sixteenth century, for, as their cloistering was pursued with greater determination by the Church, the admission of young men, especially actors, into the convent could scarcely have been permitted.[16] In fact, a chronicle of the convent of San Giovannino delle Cavalieresse di Malta reports an order from their governor as early as 1534 forbidding lay actors from entering the house:[17]

> Non sia lecito per tempo alcuno di far commedie ed intervenire persone secolari: ed a questo sia vigilante la commendatrice e pro-

hibischiamo e comandiamo di dare tal licenza eccetto che fra di loro,
con quei vestimenti che saranno nel monastero, e non si accattino
abiti di fuori.

[Let it not be permitted at any time to put on comedies with the
participation of lay persons: and let the superior be vigilant in this
matter; and we forbid giving permission (to put on comedies) unless
they (the nuns) put them on among themselves, with costumes
belonging to the convent and not to be gotten from the outside.]

The young women of the convent—novices, school girls, and
other young boarders—were the actresses, playing male and female
roles, without a lot of preparation it seems, for they typically apolo-
gize in advance for the shortcomings of the performance. Take, for
example, the "Argument" of the *Commedia di San Raimondo Vescovo di
Canturia*:[18]

> Et se a queste nostre giovanette
> qualche lecito spasso si concede
> si fa perché diventin più perfette;
>
> ma, non faccendo ben quanto richiede
> questo degno collegio et excellente,
> perdono a tutte si domanda et chiede.
>
> Pensate che le sono incipiënte
> et, s'alcuna non fusti così destra
> nel dire e' versi, egli è conveniënte
>
> discepola esser prima che maestra

> [And if we allow our young women
> some legitimate recreation, we do it
> so they will become more perfect;
>
> but, if this worthy, excellent group
> is unable to do well what is required of them,
> we ask that you forgive them all.
>
> If one of them, reciting her lines,
> were not so good, remember that they are
> beginners, and it is appropriate to be
>
> a student first and then a teacher.]

Many, if not most of the comedies refer to the novices' productions, and some of the manuscripts include lists of the nuns, novices, and school girls who were members of the cast.[19]

The authors of the plays were laymen as well as clergymen and nuns. It is known that Giovan Battista Cecchi wrote the *Tobia* (1580) and the *Sant'Agnese* (1582) for the convent of Santa Caterina da Siena in Florence and that Domenico di Gismondo Tregiani, a member of the Congrega degli Insipidi, wrote for Sienese convents.[20] Fra Andrea di Chimenti wrote a play, *Ottaviano imperadore quando si voleva far adorare*, to be performed at Christmastime in a Tuscan convent, probably Domenican, of which he was the spiritual director.[21] The teachers of the novices are frequently cited as authors of the plays. A manuscript containing five comedies of the nuns of Santa Chiara in Pistoia says the plays were composed by Suor Annalena for her novices when she was their teacher ("quando l'era maestra per le suo novitie").[22] The brief biography of Sister Plautilla della Casa, contained in a chronicle of her convent, San Jacopo di Ripoli, says that when she was novice mistress she began to compose comedies which, to the great surprise of the priests, were very elegant and learned, and that she continued this activity until near the end of her life.[23]

Giovan Battista Gelli in his play *La sporta*, first published in 1543, attests to the flurry of activity that went into each convent production:[24]

> Egli è testé lor tocco la fregola di far una comedia; otto dì prima e otto dì poi si durerà a portar cose in qua e in là.
>
> [Now they're hot to do a comedy; eight days before and eight days afterward they'll be carrying things here and there.]

The elaborateness of the productions depended on the convent's size and means, and upon the occasion. Some houses may have had a permanent theater room, as Francesco Trucchi thought.[25] In others a room was transformed for the event: an announcement of the performance of the anonymous *Commedia di Judit* included in the manuscript invites the prospective audience to the room where the stage has been set up ("stanza dove è il proscenio parato").[26] The sets varied; some replicated standard medieval forms, others the contemporary secular stage. The same *Commedia di Judit* describes six en-

trances and eight areas of the stage designated by Latin rubrics which hang over them: "Palatium Ozie," for example, "Domus Judith," "Forum," "Castra Assiricorum," "Talamus Holofernis."[27] The stage for the *Persecutione di David,* probably performed in 1568 in Florence in the convent of the Angiolini, is described only in terms of four areas of the stage ("fori") which function throughout the play: they indicate the city, the house of Saul and the areas next to the city and next to the house.[28] Other plays had more complicated and modern sets. In the *Amor di virtù* by Sister Beatrice del Sera, dated 1555, the stage directions designate many different places, for the action moves in and out of doors and all around the Mediterranean. Only one passage tells how this might have been represented. It reads:[29]

Quando si partono dalla fonte per ire a Roma, due ninfe cantino questa o altre canzone mentre si tira la tenda alla torre e scuopresi la chiesa.

[As they (the protagonists) leave the fountain to go to Rome, two nymphs should sing this or other songs while the curtain is being pulled up at the tower and the church is being uncovered.]

Constructions or painted scenery on stage were hidden and revealed by curtains. I've seen no documents more detailed with regard to the stage, but many also mention costumes and props.[30]

For the most part the audience was the convent community. The prologues and epilogues address a feminine plural audience, some-times specifically designated as nuns, novices, lay sisters and school girls, for example: "Di Cristo spose belle/chiare madre e sorelle . . . tutte voi/verginelle et novitie . . ." ("Brides of Christ, illustrious mothers and sisters . . . all of you young virgins and novices").[31] Other manuscripts specifically mention the "converse," the lay sis-ters.[32] Some exceptions to the usual formula indicate that there were occasional outside visitors. In 1575 Cecchi's *Acab* was performed by the nuns of the Florentine convent of the Spirito Santo in the presence of Giovanna of Austria, the wife of the grand duke Francesco I, and she is specifically addressed.[33] A few plays begin with a masculine plural form of address, which would indicate the presence of at least one man. Perhaps the overseers or confessors of the nuns were present, or some "noble" guest.[34] It is almost certain that towns-women—relatives, friends, and benefactresses of the convents—at-

tended in the 1540s. This practice is explicitly mentioned in Cecchi's play the *Assiuolo* of 1549, in which two Pisan noblewomen have recently been to the performance of a comedy in a local convent and plan to attend another.[35] Cecchi makes it clear that townsmen were excluded. In the following passage, a maidservant explains that her mistress was accompanied only as far as the courtyard by her husband and his friend, and that the men had to wait for her outside:[36]

> e la condussono infino nella corte del munistero e se dentro fussino possuti entrare, dentro entravano; ma non possendo, perchè e' non v'entra uomini, feciono mula di medico insino che la festa fu finita.
>
> (*Assiuolo*, I, ii)

> [and they took her as far as the courtyard of the convent, and, if they could have gone in, they would have, but, not being able to, since men are not allowed, they played the part of the doctor's mule till the party was over.]

The attendance of the laity and the performances themselves must have been restricted from time to time, and certainly the practices were different in different dioceses. For example, it is unlikely that this theater flourished in Milan at the time of Carlo Borromeo, an energetic opponent of all theater, secular and religious, who specifically banned performances on religious holidays.[37] In Florence, on the contrary, according to Cecchi, the Church was in favor of the performances, indeed thought them beneficial to convent life, though it feared the intrusion of outsiders in the convent and prohibited their attendance with growing frequency in the course of the century.[38]

Scholars of religious theater in Medieval Europe find its beginnings in the dramatic character of the liturgy of the Mass. Liturgical dramas, first staged in churches, later often moved out of the sanctuary and into the streets, piazzas, courtyards, and oratories. In fifteenth-century Italy *sacre rappresentazioni*, plays in the vernacular language, longer and more varied than their predecessors, became a popular form of public entertainment, and, especially in Florence, a quite polished and lively literary genre.[39] Their plots were simple hagiographical, Biblical, and symbolic stories. Narrations rather than actions, they were often dominated by long declamations of the characters, yet always enlivened by elements of popular secular literature and the details and preoccupations of everyday life. The per-

formances became increasingly elaborate spectacles, which included music and stage machinery. In Florence by the late fifteenth century, this tradition began to lose its general appeal, largely due to the new passion for classical theater, yet *sacre rappresentazioni* continued into the sixteenth century on a more modest scale, especially in convents and monasteries.[40]

Contemporaneously, in the early sixteenth century, there began to appear *commedie sacre* or *spirituali,* religious plays of a new and more complex form, which like contemporary secular theater, borrowed from classical theater and from the vernacular narrative tradition, but which were specifically destined for monastic audiences and for organizations of lay piety. The *commedia sacra* had act and scene divisions and employed prose and a variety of verse forms. It opened with a classically inspired "prologue," while closing with a "licenza," a simple epilogue or afterword like that of the *rappresentazioni.* It typically presented sacred and profane elements in a separable main and subplot structure. Musical *intermezzi* were common, but not much is known about other aspects of the spectacle. Cecchi thought the productions should be more grandiose than those of regular comedy, as befitted their heroic characters and exceptional actions.[41]

Most of the *commedia sacra* tradition that can be dated belongs to the last half of the century. The earliest dated plays are Sister Beatrice del Sera's *Amor di virtù* of 1555 and Cecchi's *Morte del re Acab,* which was first performed in 1559.[42] Yet there are indications that this theatrical genre developed in the 1540s or shortly before. Some of the anonymous manuscripts seem to belong to the early sixteenth century, but they cannot be dated with certainty; what is more persuasive is the treatment of the subject of convent theater in secular Florentine literature of those years.

Two secular plays, Cecchi's *Assiuolo* and Gelli's *La sporta,* the first published in 1549, the second performed in 1543, refer to convent theater in a way that suggests a lively and new tradition, different from its predecessors for its emphasis on the secular. Characters in the two plays argue about the appropriateness for nuns to dress up like men in tights, short breeches and velvet hats and to carry swords. Male characters object. A steward of a convent explains (*La sporta,* III, sc. 4):

Io vorrei che voi le vedessi. . . . Elle si veston da'uomo con quelle calze tirate, con la brachetta, e con ogni cosa, ch'elle paion proprio soldati.

[I wish you could see them. They dress like men with those tights and short pants and everything so that they look just like soldiers.]

A gentleman, on seeing costumes the nuns would borrow, objects (*Assiuolo,* III, sc. 4):

e' ci sono fino alle calze chiuse frappate. Guarda qua, che braghet-tacce intirizzate! E portate voi anco queste ne' munisteri!

[and there are even tights with fringe. Look at this—short stiff breeches! And you take these things to the convents!]

Women in both plays respond, defending the right of the nuns to some fun: "Non hann'ellen aver mai spasso ignun le poverine, che stanno sempre mai dentro serrate?" [*La Sporta,* III, sc.4, Aren't the poor women to have any fun—they're always locked up?] and "le poverette sono pur di carne e d'ossa come noi, e l'hanno pur a aver qualche spasso; che volete voi che le faccino?" [*Assiuolo,* III, sc. 4, The poor dears are flesh and blood like us, and they too need to have some fun; what would you have them do?]. In the *Assiuolo* the question is answered with the conventional "stick to their spinning," but also with an exclamation that suggests that convent theatrical productions were frequent:

Che tante commedie e non commedie? Che ci avete stracco voi e loro; se l'avessino bisogno, come le dicono, ell'attenderebbono ad altro che a commedie. Son temporali da commedie questi, eh? Lascino fare le commedie al Duca, e alla compagnia dei Cardinali, e attendino a filare.

[What is it with all these comedies? You and they have worn us out; if they had the needs they say they do, they'd tend to something besides comedies. Do they think they are worldly types suited for comedies? Let them leave comedies to the Duke and to the Confraternity of the Cardinals and stick to their spinning.]

Antonfrancesco Grazzini, also in the 1540s, attests to this controversy in the introduction to his short story collection the *Cene,* where he

says it is permissible on the special occasions of holiday plays for the nuns to wear men's clothes—velvet berets and tights—and to carry swords.[43] And the 1534 order, cited above, to the nuns of San Giovannino delle Cavalieresse di Malta, forbidding them to get costumes outside the convent, is evidence that the practice predates its literary treatment. Sixteenth-century theater and short stories were attentive to the details of contemporary life. The polemics in Florentine literature indicate the novelty in the 1540s of a convent theater which was not primarily religious and the reaction of the Florentine public to the intrusion of worldly elements in female convent life. They were probably referring to early productions of *commedia sacra*.

A distinguishing feature of the new theatrical genre, and that which seems to have caused the controversy, is its interweaving of sacred and profane elements with nearly equal stress and in the forms and modes of classical theater. The *commedia sacra*'s typical double plot, generally comic in secular scenes and serious in religious ones, portrays a morally edifying story, whose characters are saintly, noble, and heroic, which it combines with a humorous, or at least so-intended, secondary plot, of jokes and pranks, by and among servants and peasants. The subplot is sometimes of such length and emphasis that it vies with the main story for central importance. Occasionally it supports through negative example the lessons of the play; sometimes it merely provides comic relief.

Sister Maria Grazia Centelli, when she was mother superior of the Domenican convent of San Vincenzo in Prato in the late 1570s and early 1580s (she was superior twice, in 1578–80 and 1584–86), wrote a play entitled the *Tragedia di Eleazzaro ebreo* [the *Tragedy of Eleazar the Jew*, cod. Ricc. 2974, n. 2], which takes its title and main plot from the second and fourth *Maccabbes*'s account of the martyrdom of the old scribe Eleazar under the persecutions of Antiochus IV (ca. 215–165 B.C.).[44] It is a prose play in five acts, which tells the following story. The ninety-year old Eleazar refuses to deny his faith to avoid torture and death. It would mean giving up for one day's release from suffering the fruit of his lifetime's devotion to God. There is a parallel secondary action in which Fenena, a seventy-eight year old slave woman freed by Eleazar as he prepares for death, foolishly demands the dowry her former master has offered the "fanciulle," the young women of his household; this part of the story is not in the Biblical account. Fenena is duped by other servants who promise her a husband, only to trick her, take her money, and beat her up. The

subplot is a *beffa,* a practical joke with physically painful consequences, typical of the Italian short story *(novella)* tradition. Fenena's beating parallels Eleazar's, and the message of his sacrifice, the victory of reason and faith over the senses, is enacted simultaneously by negative example in her story. Eleazar has chosen to deny himself the comfort of his old age; Fenena would procure it. He sacrifices himself for what is right; she dramatizes her egotistical desire for what is inappropriate.

The humor and other plebeian elements of this play are not, however, limited to the subplot. In the Biblical story, for example, a peasant named Stanberga, who brings Eleazar word of the desecration of the Temple and worship of false idols, mispronounces, uses malapropisms and vulgarities. He calls Eleazar, in Italian, *Eleazzaro,* Mr. Zanzara, a distortion of his name which means mosquito. *Focaccia,* a kind of bread, is pronounced *cofaccia* and *dedicazione,* dedication, becomes *decacatione,* defecation. In moments of high seriousness, such as the episode of Eleazar's torture, the pagan persecutor calls in the Jewish butcher Farfuglia and asks if he has any pork. The butcher has *only* pork, and, proud of his fare, lists a dozen varieties of contemporary Italian specialties. He says:

> voletela lessa o arrostita, fegatelli, salsiccia, fegato fritto, migliacci, sanguinacci, zambrognini, prosciutto, polpette, cervellati, salsicioni, gelatina o di altra sorta?
>
> > (cod. Ricc. 2974, n. 2, p. 35v)

> [do you want it boiled or roasted (here follows a list of the possibilities, some of which are sausages without a close English equivalent and are therefore left in Italian), little livers, sausage, fried liver, *migliacci,*blood sausage, *zambrognini,* ham, meat balls, *cervellati, salsicioni,* gelatin or some other kind?]

The pagan orders something that will be easy for the old man to eat, and it is immediately delivered and described with the detail and self-satisfaction of a gourmet chef:

> Io ho portato quatro fegatelletti, arostiti tra le foglie dello alloro, salvia e ramerino tratti hora dello stidione caldi, caldi con una mel[ar]ancietta brusca premuta sopra che ne mangerebbe un morto e uno bichieretto di trebbiano da bervi che parla con gli agnoli.
>
> > (same as above)

[I've brought a dish of four little livers roasted with bay, sage and rosemary leaves, just now off the spit, steaming hot, with a bit of bitter orange juice sprinkled on it, so good it would make a dead man eat, and to drink with it, a little glass of Trebbiano wine which speaks to the angels.]

The humorous moments outweigh the serious ones, but they always alternate with them and never undermine the spiritual message introduced in the prologue, repeated in the afterword, embodied in the plots, and declaimed by Eleazar throughout the play. The comic subplot presents not only the spiritual lesson of renunciation of the world, but also directs it specifically to the female audience through its call for the renunciation of marriage when marriage is inappropriate.

The Chronicle of the convent of San Vincenzo in Prato shows that Maria Centelli entered at the age of twelve or thirteen, as was then customary, and that during her life she held all of the important offices of her convent and conducted them with singular intelligence and to the great satisfaction of the community.[45] Little else is known about this nun, apart from the date of her death in 1602, but we can learn something about her education and her mind from the play she wrote. It above all reveals an unusual command of the vernacular literary language and a good sense of the comic. If the long speeches on the virtue of renunciation, usually delivered by Eleazar, do not bespeak a keen sense of measure, at least to the modern reader, they were perhaps necessary to justify all the fun in the rest of the play. Sister Maria Grazia seems to have had a more than casual acquaintance with secular literature—the antics and language of servants and peasants are reminiscent of the comedies of Plautus and the Italian short story tradition. It would be interesting to know whether that knowledge was direct or indirect. A convent record explains that San Vincenzo was forced to be cloistered in precisely the years that Maria Centelli was prioress;[46] until that time she could rather easily have had contacts with the secular literary world and read or at least known of books that were not available in the convent.

The play by Sister Maria Grazia, while it is more entertaining than most spiritual comedies, is typical of the genre in the way it combines plot and subplot, seriousness and humor. Atypical, instead, for its artistry and its particular combination of sacred and profane is the *Amor di virtù* or *Virtù di amore [Love of Virtue* or *Virtue of Love]* by

Sister Beatrice del Sera, a Florentine nun in the Domenican convent of San Niccolò, also in Prato.[47]

Beatrice del Sera was born in 1515, and when she had just turned two years old she was placed in the convent where she lived until her death in 1586, except for one brief period in 1530 when she took refuge in Pistoia from Imperial troops that it was feared would again sack Prato as they had in 1512.[48] Like Maria Centelli she was once prioress of her convent (1562) and a playwright. We know from the afterword of her one surviving play that she was an avid reader of the few books that came into her hands. Among those she mentions were two by Boccaccio, the *Genealogy of the Gods* and the *Filocolo*; her copy of Petrarca's *Canzoniere* and *Trionfi* with autograph marginalia is today in the library of the University of Pavia.[49] Her play, the *Amor di virtù (Love of Virtue)*, which she also calls *Virtù di Amore (Virtue of Love)*, cod. Ricc. 2932, is a *commedia sacra* in five acts, written for the most part in unrhymed hendecasyllabic verse, with a variety of other verse forms in the *intermezzi*, in other accompanying songs, and occasionally in the text itself. The manuscript indicates that it was composed between 1548 and January, 1555. (See note 42).

The plot of *Love of Virtue* is taken from Boccaccio's version of the love story of Florio and Biancifiore in his early romance the *Filocolo*.[50] The story is read as an allegory in which the lover's quest for his beloved is said to signify the soul's search for God. This spiritual reading is authorized by the Boccaccian model, which begins with a vow, a miracle, and a pilgrimage to Galizia and which ends with the conversion of a pagan country to Christianity, elements which all reappear in the new version.[51] Taking her cue from Boccaccio, and following the ancient Judeo-Christian tradition, Sister Beatrice uses erotic love to symbolize love of God. As is true of this tradition, however, the literal love story sometimes must strain to produce its spiritual message, and, to do so, must be considered only along its general lines. Nevertheless, this reading should have created no problem for the play's audience—most, if not all of whom were nuns, who considered themselves brides of Christ.

The play takes from Boccaccio only the plot of the love story and the attendant allegory, skipping over all of the embellishments, the accessory and digressive episodes; it adds new elements, some required or suggested by the change in genre, others revealing the playwright's particular interests. The story is an old familiar one that goes back at least to Greek romance and Longus' *Daphnis and Chloe:* two children are raised together, though not brother and sister; they

fall in love at a very tender age reading, in this case, Ovid; his parents, in this version the King and Queen of Spain, try to keep them apart, unaware or unwilling to believe that she too is of noble blood; after separations and peregrinations, the lovers are united when he frees her from a tower prison; they marry, go to Rome to discover her origins, convert to Christianity and return bringing their new faith to Spain. There are new characters, all secondary. Some perform narrative functions lost in the transformation from romance to comedy; others, for example, two gypsies and a buffoon, are introduced for comic effect, and their brief action, confined to Act I, is a concession to the typical subplot of the *commedia sacra* tradition.

This *commedia sacra* is unusual since the sacred and profane elements, for the most part, are not separately developed but rather are bound together by the allegory. The story of the lovers' separation, trials and adventures, and their reunion and marriage represents the Christian's difficult pursuit of Christ; adventure and knowledge of the world lead to knowledge of God and to salvation. And there is a non-religious allegory as well. Like Boccaccio, Sister Beatrice puts her personal and artistic experiences into the play, but unlike Boccaccio whose allegories are various and discontinuous, she reads both spiritual and autobiographical allegories simultaneously as meanings of the literal love story.[52] The coherence of her multiple readings is facilitated by her reduction of the story to its main plot line and elimination of accessory and digressive material.

The allegorical readings of the play are imposed on the love story in two ways: first, through explicit interpretations that are given in the metatextual passages of the work, that is, in the title, the *intermezzi* and other songs, in poems that precede and follow the text, and in the prose afterword; and, secondly, changes are made in the presentation of the story itself which refer the audience or reader to a meaning beyond the literal one.

The long version of the title of the work can serve to exemplify the metatextual pronouncements. It reads as follows:

AMOR DI VIRTÙ/opera fatta da una donna fiorentina sopra/il Filocolo, nella consi-/derazione d'uno animo va-/loroso nelle virtuose im-/prese; il quale deliberata-/mente cercando il fine del-/aurata beatitudine, per-/viene alla cognizione di Dio. (p. 1r)

[LOVE OF VIRTUE, a work written by a Florentine woman based on the Filocolo, understanding it as a valorous soul in virtuous

endeavors who determinedly, seeking the goal of heavenly beatitude
(lit., golden beatitude, playing on the name "Aurabeatrice" of the
heroine), comes to the knowledge of God.]

Alongside the metatextual interpretations, there are indicators
within the comedy that guide the spiritual reading of the story. For
example, moral qualities are attributed to the characters through the
substitution of transparent names for many of the classical names of
the tradition. The king Felice becomes Costante and glosses his own
name saying that it is fulfilled by the constancy of his perseverance
("Costante il mio gran nome èadempiuto/con la costanza del per-
severare," p. 15v, "my great name Constant is fulfilled by the con-
stancy of my perseverance"). The courageous Roman Quinto Lelio
Africano becomes Valerio, and his wife Giulia Topazia is renamed
Beatrice. More significant, however, are the new names of the pro-
tagonists. Florio and Biancifiore become Florido Febo and Au-
rabeatrice. This change is a key to multiple readings of the text. The
play's characters tell us that the couple is named Febo and Aura
because of the time of their birth: he was born at the hour when
Apollo, "Febo," first brings the sun's rays, and she, when he conceals
them at the time of the gentle evening breeze, "l'aura." He is also
called "Florido," first to describe his healthful color, but then the
name sticks, and he becomes Florido Febo, no doubt to counter-
balance her double name, for she is also called Beatrice, after her
mother. But this is just the literal story—the names are signifiers of
something else. Aurabeatrice has some very obvious connotations,
literary and otherwise. The protagonist is clearly a Dantean Beatrice,
an intermediary between man and God—as we have seen in the long
version of the title of the comedy. Beatrice is, of course, also the name
of the author Beatrice del Sera, and it designates this character as a
figure for the author in the play. "Aura" and "Febo" too function in
the autobiographical allegory to which I shall return shortly. But first
a word about eroticism and the part it plays in the spiritual allegory.

In religious literature of the mystical tradition the love between
God and the soul is frequently represented by a sensual love story,
following the model of the biblical *Song of Songs*. Such allegorical
works were widely produced and read in monastic circles, and nuns
in fact imagined themselves as brides of Christ.[53] *Love of Virtue*
belongs to this tradition, and that explains its author's acceptance of
some of the erotic episodes of the *Filocolo* and rejection of others.

Erotic elements of Boccaccio's story remain in the play, but only those necessary for the allegory. The prurient details of the description of two temptresses are eliminated, and the hero's erotic overtures to them are attenuated. He leans his head on one of the two beautiful, nearly naked women, says something about warming her body with his, and then quickly comes back to his senses and sends them away. The scene is kept because it is an important step in the hero's spiritual progress, representing the temptation of lust and infidelity overcome. It also obviously has entertainment value and, in fact, this is enhanced in the play with the addition of two songs the temptresses sing, to which the *Filocolo* merely alluded. The love-making of the couple upon their reunion in the tower is not described, merely suggested, and it is justified by Florido's declaration of love, promise of marriage, and, finally by two practical considerations added by the playwright: first, that Aurabeatrice will no longer be desirable to the Sultan for whom she was being held prisoner, and secondly, that she will receive more respect, since she now belongs to Florido—one of a number of indications in the play of the high regard in which the playwright holds the married state.

If in general, non-functional erotic details are eliminated, there are instances in which, on the contrary, we find a suffused eroticism in the text which is not in the *Filocolo*.[54] This occurs generally in soliloquies where the lovers lament their separation; in Boccaccio's youthful work, instead, emotions are expressed in conventional literary formulas. To discuss this aspect of Sister Beatrice's portrayal of human emotions only under the rubric of eroticism, however, is to misrepresent it. The depiction of the lovers' passions is part of the author's attempt to represent feelings and responses convincingly and to motivate actions, and it is one of the most persuasive aspects of her dramaturgy. Some passages echo the Boccaccian literary model: Aurabeatrice's "limbs are afire . . . burning often with enkindled desires" ("l'infiammate membra . . . ardon sovente d'accesi desiri," p. 42v). In another passage Ovidian transformations, only alluded to in Boccaccio's text, are developed, and their expression conveys the sensual and sentimental longings of the heroine:

> E se per lacrimare io fussi fonte
> da Giove convertita, forse almeno
> in me si bagnerebbe il mio signore;
> s'i' fussi un cane in grembo gli starei

e se mirto fussi io, o fior di Prato[46f]
s'appoggerebbe a me o iacerebbe
quando da' suoi desiri afflitto posa.
O carte più felici d'una donna
deh! fammi libro diventar, o Giove,
ch'io senta la sua voce che mi parli,
che posi sopra me talora il capo
e che mi tratti come più gli piace,
o Florido, signore et mio padrone.
(p. 38r)

[And if for all my tears I were
Transformed by Jove into a fountain,
Perhaps my lord would bathe in me;
Were I become a dog, I'd stay on his lap
And were I a myrtle or a field flower
He'd lean on me or lie down there
When, overwrought by his desires, he rests.
Oh pages happier than a woman!
Change me into a book, oh Jove,
That I may hear his voice speak to me
And he may sometime rest his head on me
And treat me as he pleases,
Oh Florido, my lord and master.]

The apostrophe to pages happier than a woman and the final desired metamorphosis, to become a book in order to be near her beloved, to hear his voice, to be touched by him and treated as he wishes convey affection and intimacy. This is also one of the many places in the text where the stories of the protagonist and the poet come together. And, indeed, alongside the love story of the play, there are allusions in the accompanying songs to a love story of the poet, which, like the play, can be read on two levels—a love that is human and one that is divine. The story of the protagonist is compared to that of the poet, and the two examples serve to generalize the message of the play, saying, I think, that we can read all love stories this way.

Along with the religious messages conveyed by the allegory, the love story allows the author to treat themes that are important to her and to her female audience. First, the theme of matrimony, not an innovation in the work, but a subject that reappears with new stress;

and this theme, as one might expect, plays a large part in most convent theater.

The theme of matrimony is dramatized principally through the relationships of the Queen of Spain, Beatrice, and Aurabeatrice, and their respective spouses. The wives are portrayed as caring and willingly subservient; Beatrice, the mother of the protagonist, is presented in the opening scene of the play, and she is shown to be a model wife: loving, chaste, and contemptuous of luxury. When the King of Spain returns from battle, he receives in the *Filocolo* the "chaste embraces of his waiting spouse" ("e ricevuti i casti abbracciamenti dell'aspettante sposa," I.33.1, p. 114); in the comedy, instead, the scene is expanded. The king wants to recount his adventures, but the queen interrupts, asking instead, how he is, if he has been hurt: "Hor come state voi della persona,/havete voi ferite o alcun male?" (p. 23v, "But how are you physically, have you wounds or any pain?"). Aurabeatrice adds to this picture of the perfect wife by declaring time and again her subservience to her husband. The conjugal devotion presented by the play would seem to be a lesson for the lay women of the audience; and for the nuns, apart from the religious allegory of their relationship to Christ, it must have represented the ideal version of a state many of them envied and offered the attraction of the unknown and the forbidden.

The play's scenes of domestic life also reflect the author's interest in portraying simple human emotions. One of the play's most appealing features is its rendering of familiar life experiences in everyday language. In the schoolroom scene, when the two children have been ogling one another instead of reading their lesson, the teacher walks in and exclaims: "Questi son gli studi che voi fate/ . . . m'aveggo chiaro/ ch' e' libri stanno chiusi . . ." (p. 31r, "so this is how you study . . . it is quite clear that your books are closed . . ."). The young girl very plausibly tries to cover up with a lie: "Quella pistola d'Hero rivedevo" ("I was looking over the letter of Hero"). Boccaccio's romance of heroic adventures and sublime passions is transcribed in the domestic key of quotidian banalities and simple sentiments.

The most moving and humanly interesting of the profane elements of the comedy is the autobiographical component. Through the protagonist Aurabeatrice, Beatrice del Sera, the author, dramatizes aspects of her life and of her art and invites the women of the audience to see themselves and their experiences in the play as well.

This autobiographical component is so central to the play that it is worth careful consideration of its many aspects and implications. The reading, like that of the spiritual allegory, is produced in two ways——through changes made in the story, alterations and additions, and through the commentary.

The poet clearly draws a parallel between herself and the protagonist in the poems and songs that accompany the play. A sonnet which precedes the text of the play (*Quant'Amor fusse mai costant' e forte*, p. 4v) contrasts the heroine, who is liberated from her tower prison by her lover, with the speaker, who remains imprisoned in the rock and whose happiness will come in the next life: "Whence I, poor and alone in the rock, put my hopes in the good of my future life" ("Ond'io che pover son sol dentr' al sasso/spero nel ben della vita futura"). The *intermezzo* between Acts II and III expresses a poetics of vicarious enjoyment of the love experiences of the play which are otherwise denied: the poem says "he feigns a feast who paints before his eyes . . ." ("le vivande finge,/chi innanzi a sé dipinge . . . ," p. 6v). The last verse is an explicit invitation to the audience to participate as well:

Chi sente 'l dolce fuoco
d'amor, meco sospiri
che 'l cielo a mia desiri
ha chiuso il passo e loco
e pur la sorte
c'invita per amare insino a morte.

[He who feels the gentle fire
of Love, sigh with me
for heaven has denied
entry and place for my desires
and yet fate
would have us love until we die.]

Within the play the "rock" ("sasso"), "wall" ("muro"), and "tower" ("torre") are always seen as prisons for women and as metaphors for the confinement of the cloister. Female characters repeatedly protest being locked up. Beatrice, the mother of Aurabeatrice, says that if she were shut up at home with only bread and water and her beloved husband, it would be Paradise, to which her sister re-

sponds that if she had ever experienced being walled up she wouldn't
call it Paradise ("Se tu provassi quel che è star murata/non gli poresti
nome paradiso," p. 12v). Another woman, imprisoned in the tower
with Aurabeatrice, tells her they were not born to be happy, but to be
prisoners, slaves, subject to others ("Noi non nascemo per haver
contenti,/la nostra sorte ci ha fatte prigione, schiave e suggette,"
p. 73v). Aurabeatrice says she finds consolation only in her thoughts
and her dreams, and this statement must also be a key to reading the
play as its author's consolation for a life of confinement which she did
not choose for herself. In one scene men are accused of keeping
women locked up and forcing them to find remedies of their own to
alleviate their suffering. The admiral, who was Aurabeatrice's jailor in
her tower prison, complains of her escape:

> Io l'ho trattata come una regina
> per la sua gran bellezza, et ho errato
> che quanto me' si fa, peggio ti fanno.
>
> [I treated her like a queen
> for her great beauty, and I was wrong.
> The better you treat them, the worse they treat you.]
> p. 81r.

A captain named Mario speaks for women, arguing that they follow
the dictates of their hearts and should not be blamed if they flee from
those who treat them badly and keep them alone; but the admiral
does not seem to understand and says, "She isn't the first, there have
been many!" ("Elle non è la prima, le son tante," p. 81v). Mario
makes a long and eloquent reply, defending Helen, Clytemnestra, and
all women, and he concludes accusing all men who treat women as if
they were "pictures to hang on the wall" ("pitture/d'appicarle ad un
muro," p. 81v). It is obvious in this exchange and elsewhere in the
play that the references go beyond the comedy and that the play-
wright is protesting her society's mistreatment of women; moreover,
giving this explicit defense of women to a male character in the play
may well indicate that Beatrice del Sera's audience included some men
whom she sought to persuade with her rhetoric. It may also mean
that she believed women should defer to male authority in important
matters.

Beatrice del Sera's play presents a polemic, an appeal for free-

dom of choice. When the admiral suggests that, if women want to be free to choose the company they like, they should get a husband, Mario responds, "you lock them up when they could get one," that is, when they're young. The polemic does not, however, go beyond this appeal. The play's female characters happily accept the authority of their husbands: when Aurabeatrice and Florido are married she tells him he is her lord and master ("O car maestro mio, come ver padre/vi voglio aver e sempre al mio governo," Act IV, sc. ii, p. 83v); her mother, Beatrice, as you'll remember, thought it would be Paradise to be locked up at home with her husband. Beatrice is here repeating her Church's and her society's views of a woman's subservient role in marriage and, at the same time, idealizing the married state which she was denied. Throughout the play the author suggests that she has come to terms with her vocation: it is not what she would have chosen for herself, but since she was not given the choice, she awaits her reward in the next life ("spero nel ben della vita futura," p. 4v).

Through Aurabeatrice, her alterego in the play, the author experiences the world and its pleasures, and through the play she turns her own life into art. This transformation is symbolized in the well-worn, by her time, Petrarchan device of *aequivocatio, l'aura-Laura-lauro*. It is certain that she knew Petrarch's poetry, not only because she echoes it, but also because her copy of the *Rime* and *Trionfi* has survived. Like Laura for the poet, Aura in her love adventure with Florido Febo is a figure for the poetic achievement, and Febo, Apollo, of course, also symbolizes poetry. Two shepherds, innovations in the play, sing a song full of Petrarchan language, which is a lovers' lament become poetry. The idea is clear in the following lines from the second stanza:

> e del mio lungo pianto
> compagna veggo la tortola sola,
> che mesta e scompagnata intorno vola,
> e nel più secco dume
> la vita mena, e nel concavo sasso
> ove io, piangendo ancora, sfogo il cor lasso.
>
> (p. 7r)

> [and my long lament
> finds its companion in the lone dove
> who, sad and unaccompanied, flies around
> and leads her life in the driest, lonely place

and in the hollowed rock where I,
still crying, express the sadness in my heart.]

Shepherds are symbolic of poets in the Western tradition, and the shepherd speaker of this poem calls his singing crying and his words the expression of the sadness in his heart, just as Petrarch in the opening sonnet of the *Canzoniere* calls his poetry "the sound of those sighs" with which he "nourished his heart" and of "the varied style" in which he cries and discourses at the same time (*Rime,* I). It is clear too that the author alludes to her own poetic career in the comparison, also inspired by the *Song of Solomon,* to the "lone dove" that "leads her life in a lonely place," in a "hollowed rock" ("concavo sasso"); [55] the envoy of the poem makes the reference to herself more explicit, saying, "I will go on singing my song, far from the world, while I shepherd my sheep," and the word here used for sheep is "agnelle," the specifically feminine plural form, not the general masculine term one would expect. This flock is female, and the autobiographical allusion to Beatrice del Sera's religious and artistic life and to her female charges and audience is effectively and convincingly drawn.

While the play in many ways speaks of confinement, the *intermezzi* of renunciation, there is also an optimistic message. The heroine is saved from her prison, characters in the play speak against the enforced solitude of women, the speaker of the *intermezzi* and other accompanying sonnets and songs, while she awaits salvation and happiness in the life to come, enjoys vicariously the experiences she has been denied, and all of the personae of the author dramatize aspects of Beatrice del Sera's accomplishment. Sister Beatrice's work gives her what life has denied her: her sympathetic portrayal of experiences, she says, is a participation in them, and the play, her poetic act, written for a convent audience reaches an audience beyond the confines of the cloister.

In the afterword to her play the author says that she is surprised that learned men have noticed her work (c. 101v). [56] She responds to their surprise that a woman who has been cloistered all of her life and who has never seen or experienced the world could depict it so well, saying

that her talent is a gift from God. She likens her portrayal of places and emotions she has never seen or experienced to her ability to embroider lifelike flowers in silk without ever having had lessons, and she closes that argument with indisputable mercantile class logic: the proof that her needlework is good is that it brings a good price. [57] In a sonnet, *Altro volar di penna, altro valore, A Different Flight of Pen, A Different Value* (c. 8), intended to precede her play and to serve as apologia, Sister Beatrice sees her work as part of a literary tradition that goes beyond the convent. She compares her efforts and those of her literary sisters to the battle of the Amazons against nobles and kings. This is not her best poem, nor her best analogy, but it is useful in telling us something about how she imagined her work. Her comparison suggests a heroic competition of equals; however, in her lines of explanation she is humble and asks for no great victory, only for understanding and notice. She speaks in her other poetry of reasons which led her to write this play: to please the honest and loving Fiammetta, to ingratiate herself to her public, to flee the boredom of her "closed cloister" ("chiusi chiostri"), and, in this sonnet, with due humility and declarations of inadequacy, she expresses as well, a desire for fame. The tercets say:

> E se l'armate donne ebbon per vanto
> di far battaglia contro ai grandi e regi
> e questi e quelle ancor ne portono fama,
>
> non si sdegnino i saggi se donna ama
> giucar cosí di penna, ornando in fregi
> non già di sangue, ma di pace un canto.
> (p. 8)

> [If armed women dared
> to do battle with nobles and kings
> and if their deeds are still sung,
>
> then wise men should not marvel that a woman would
> compete with her pen, praising
> not war, but peace with her song.]
> (transl. John Hill)

Amor di virtù is a truly unusual statement for its time, exceptionally well-written in a variety of verse forms, with sophisticated handling

of figurative speech, especially of allegory, and a convincing portrayal of sentiment. It is the expression of a natural, untutored talent, a moving and audacious dramatization of self. All of the convent plays written by the nuns are fascinating documents of convent life, and their linguistic competence is witness to the effects of the education of women. The mixture of sacred and profane, which is central to the Tuscan convent tradition, signals the close ties that existed between religious and lay cultures, certainly through the sixteenth and the early seventeenth centuries. The plays were produced by a female subculture that united convent women at least for a time with their relatives and friends on the outside. While this subculture had little resonance in the circles of the dominant Florentine culture, it provided education, relaxation, and an artistic arena in which women could learn and find expression for their feelings and talents.

NOTES

1. For studies of female convents in sixteenth-century Italy see: Pio Paschini, "I monasteri femminili in Italia nel'500," in *Problemi di vita religiosa in Italia nel Cinquecento* (Atti del Convegno di Storia della Chiesa in Italia, Bologna, 2–6 September 1958), (Padua: Antenore, 1960), pp. 31–60; Enrica Viviani Della Robbia, *Nei monasteri fiorentini* (Florence: Sansoni, 1946); Richard C. Trexler, "Le célebat à la fin du Moyen Age: Les religieuses de Florence," *Annales* 27 (1972): 1329–50; and Gabriella Zarri, "I monasteri femminili a Bologna tra il XIII e il XVII secolo," *Atti e Memorie della Deputazione di storia patria per le province di Romagna*, n.s., 24 (1973): 133–224 and "I monasteri femminili benedettini nella diocesi di Bologna (secoli XIII–XVII)," *Ravennatensia* 9 (1981): 333–71.

2. Florence, Archivio di Stato (hereafter ASF), *Conventi Soppressi,133,* filza 60, p. 296; the document in which the story of Maria Maddalena de'Medici is recounted is a book of *Memorie del monastero di S. Giovannino di Via S. Gallo* compiled in the eighteenth century by Sister Esaltata Ridolfi and based on earlier documents which seem to have disappeared. The picture of convent education in sixteenth-century Italy is still unclear. The general aims are known, but specific details of the pedagogical materials and methods are wanting. Much information bearing on the subject has been collected by G. Ludovico Masetti Zannini in *Motivi storici dell'educazione femminile (1500–1650): I. morale, religione, lettere, arte, musica* (Bari: Editorialebari, 1980) and *[II.] scienza, lavoro, giuochi* (Naples: M. D'Auria Editore, 1981). See also Emmanuel Rodocanachi, *La Femme italienne Avant, Pendant et Après La Renaissance* (Paris: Hachette, 1922), pp. 23–29. On the education in general see Ruth Kelso, *Doctrine for the Lady of the Renaissance* (Urbana, Ill.: University of Illinois Press, 1956), especially the chapters "Training" and "Studies," pp. 38–77 and the recent anthology compiled by Maria

Ludovica Lenzi, *Donne e madonne; L'ducazione femminile nel primo Rinascimento italiano* (Turin: Loescher, 1982).

3. Only the *corali,* the regular nuns of the community, necessarily read the breviary. The *servigiali* or servant nuns, the *converse,* lay nuns and *commesse,* women, often widows who lived celibate lives in the convents, did not need and may indeed have been sometimes forbidden to learn to read. Carla Russo in her study of seventeenth-century Neapolitan convents (*I monasteri femminili di clausura a Napoli nel secolo XVII* [Naples: University of Naples, Istituto di Storia Medioevale e Moderna, 1970], p. 63) points out that the teacher of lay sisters (the *maestra delle converse*) was to instruct her charges to be humble and never seek to be the equals of the regular nuns and that the Constitutions of some convents specified that women who knew how to read ought not to be admitted as lay sisters, but, if they were, that they not be allowed to sing the office in choir with the nuns.

The regular nuns in important convents in Tuscany were literate, and very likely many read Church Latin with good understanding. One piece of evidence is the *Commedia sulla vita di S. Raimondo Vescovo di Canturia* (codice Riccardiana 1413, pp. III–136v), addressed to an audience of nuns and performed by young convent women, in which St. Raimondo's university lessons, which occupy a large part of the play, are in Latin. The chronicle of the Florentine convent of San Jacopo di Ripoli (ASF, *S. Jacopo di Ripoli, 23*), in the brief biographies that accompany the death registrations, specifies from time to time that the nun knew Latin well (for example, p. 150v, "intendeva bene gramaticha," which is to say that this was not always, nor even generally the case.)

4. See Anne Jacobson Schutte, *Printed Italian Vernacular Religious Books 1465–1550: A Finding List* (Geneva: Librairie Droz, 1983).

5. See Viviani Della Robbia, *Nei monasteri fiorentini,* pp. 17–21, 195–96 and *passim.* On the printing press at San Jacopo di Ripoli see Emilia Nesi, *Il diario della Stamperia di Ripoli* (Florence: Seeber, 1903). Trexler ("Les religieuses de Florence," p. 1331) points out the importance of convents in the development of the Florentine wool industry, although he maintains that their economic importance declined at the end of the Middle Ages, and they became greater consumers than producers. On Dominican nuns who were painters, sculptors, and manuscript illuminators in sixteenth-century Italy see Raymond Creytens, O. P., *Cultural and Intellectual Heritage of the Italian Dominican Nuns* (Summit, N. J.: Published by the Dominican Nuns, Monastery of Our Lady of the Rosary, 1977), pp. 18–24, and Vincenzo Marchese, O. P., *Memorie dei più insigni pittori, scultori e architetti domenicani 2* (Firenze: Parenti, 1846) 2: 286–94.

6. Trexler, "Les religieuses de Florence," pp. 1337–38, and Domenico di Agresti, O. P., who says (in *Aspetti di vita pratese del Cinquecento* (Florence: Olschki, 1976, p. 38) that in the sixteenth century two thirds of the over one thousand nuns in Prato's ten convents were Florentines whose families chose to send them there because the monastic dowries were lower.

7. Creytens, *Cultural and Intellectual Heritage, passim.* See also the nuns listed in Maria Bandini Buti, *Poetesse e scrittrice,* 2 vols., series 6 of the *Enciclopedia*

biografica e bibliografica italiana (Milano: E.B.B.I. Istituto Editoriale Italiano Bernardo Carlo Tosi, 1941–42).

8. The following references to holiday performances at Carnevale time, Christmas, certain saints' days, and at the novices' special feasts are found in the manuscripts of the plays, convent chronicles, and pastoral reports: for example, cod. Ricc. 1413, p. 172, "Una commedia di Ottaviano imperadore quando si voleva far adorare composta da frate Andrea di Chimenti nostro padre spirituale per la vera della *Natività del Signore;*" cod. Ricc. 2931, p. 175, "Recreatione facta per *el dì S. Agnese* . . . ;" cod. Ricc. 2976, vol. 4, p. 92v, "per far favore al giovinato et adornar *lor festa;*"ASF, *Conventi Soppressi,* 133, filza 60, p. 350, "era questa religiosa una buona serva di Dio e molto penitenziera: quando l'altre sorelle facevano qualche commedia nel *carnevale* ella durava tutto quel tempo a disciplinarsi" (italics mine).

9. Hrotswitha of Gandersheim wrote six plays in Latin, *Gallicanus, Dulcitius, Callimachus, Abraham, Paphnutius,* and *Sapientia,*which were discovered by the humanist Conrad Celtes in the late fifteenth century and first published in 1501. See *The Plays of Roswitha,* translated by Christopher St. John [Christabell Marshall] (New York: Cooper Square Publishers, Inc., 1966).

10. The *Ordo Virtutum: Sequentia* has recently been recorded in Germany (1982) on the Harmonia Mundi label using the text edited by Peter Dronke (Oxford: Oxford University Press, 1970); see the introduction "Hildegard von Bingen (1098–1179)" by Barbara Thompson.

11. A discussion and the text of the *Ludus Paschalis* of Origny-Saint Benoît was published by Karl Young in *The Drama of the Mediaeval Church* (Oxford: Clarendon Press, 1933) 1:411–50, 684–87; excerpts are cited in Federico Doglio, *Teatro in Europa* (Milan: Garzanti, 1982)1:147–51.

12. See Nancy Cotton, *Women Playwrights in England 1363–1750* (Lewisburg, Pa.: Bucknell University Press and London-Toronto: Associated University Presses, 1980), pp. 27–28. The plays were first published by Karl Young in "The Harrowing of Hell in Liturgical Drama," *Transactions of the Wisconsin Academy of Sciences, Arts, and Letters* 16 (1910):888–947 and again in his *Drama of the Mediaeval Church,* 1:164–67, 381–85. The entire *Barking Ordinarium* to which the plays belong has been edited by J. B. L. Tolhurst and published in two volumes by the Henry Bradshaw Society Publications, 1927–28.

13. Richard Trexler, in "Florentine Theatre, 1280–1500. A Checklist of Performances and Institutions," *Forum Italicum* 14 (1980):471, mentions theatrical performances at the nunnery of San Gaggio near Florence during Carnevale 1496–98.

14. Giovan Maria Cecchi (1518–1587). The *Acquisto di Giacobbe* (written between 1580 and 1587) is published in *Drammi spirituali,* vol. I, ed. Raffaello Rocchi (Florence: Successori Le Monnier, 1899–1900); the prologue is on pp. 95–98.

This and all translations in this paper are mine unless otherwise indicated.

15. See Alessandro D'Ancona, *Origini del teatro italiano,* (Turin: Loescher, 1891–2), 1:405–25. On the lay confraternities in general, Ronald Weissman, *Ritual*

Brotherhood in Renaissance Florence (New York: Academic Press, 1982).

16. For a carefully documented discussion of the Church's efforts to cloister nuns, especially following the Council of Trent, see Raimondo [Raymond] Creytens, O.P., "La Riforma dei monasteri femminili dopo i Decreti Tridentini," in *Il Concilio di Trento e la riforma tridentina* (Proceedings of the Convengo Storico Internazionale, Trent, 2-6 September 1963 [Rome: Herder, 1965]), 1:45–84.

17. ASF, *Conventi Soppressi,* 133, filza 60, p. 47. This passage is quoted in Viviani Della Robbia, *Nei monasteri fiorentini,* pp. 118–19 with unacknowledged omissions and an error in transcription.

18. Cod. Ricc. 1413, p. 111.

19. The *Persecutione di David,* cod. Ricc. 2977, vol. 3, either written or simply owned by Sister Laura di Candeli, belonging to the convent of Santa Maria degli Angeli in Via della Colonna (called the "Angiolini"), has names of the members of the cast written throughout the MS alongside the speeches of the characters; only four of the twenty-one parts are attributed to nuns, the others are indicated only by women's given names, no title, and therefore probably refer to school girls or novices. The *Sposalizio d'Iparchia filosofa,* by Sister Clemenza Ninci of the convent of San Michele in Prato (written in the early seventeenth century), cod. Ricc. 2975, vol. 3, has a cast list written alongside the list of characters; they are all nuns except for one "ragazza" (girl).

20. R. Rocchi, preface to G. M. Cecchi, *Drammi spirituali,* I, p. 28. Curzio Mazzi, *La congrega dei rozzi di Siena nel secolo XVI* (Florence: Successori Le Monnier, 1882), 1:329–30.

21. See n. 8.

22. Cod. Ricc. 2976, vol. 6, p. 1.

23. ASF, San Jacopo di Ripoli, 23, pp. 150v–51. Sister Plautilla di messer Ruggieri della Casa (1529 or 1530-1613). Her brief biography reports, "quando fu maestra di novities cominciò a comporre comedie con stile elegantissimo et con tanta dottrina che alcuni de' nostri padri ne restavano maravigliati che mostrassi tanta praticha delle sacre e divine scritture et nel detto esercitio si affatichò assai fino che era all'ultima età sua."

24. Giovan Battista Gelli, *Opere* (Naples: Fulvio Rossi, 1970–72), *La sporta,* Act III, sc. 3, p. 448.

25. Francesco Trucchi, ed., *Poesie italiane inedite di dugento autori dall'origine della lingua infino al secolo decimosettimo* (Prato: Ranieri Guasti, 1846-1847), 3:307–8.

26. cod. Ricc. 2976, vol. 4, p. 85. See also the *Sant'Agnese,* cod. Ricc. 2931, p. 176: "Ora le suore vanno dove è preparato la recreatione . . ." (Now the nuns go to where the recreation is prepared).

27. P. 84v.

28. "foro della ciptà," "foro allato alla ciptà," "foro della casa," "foro allato alla casa," cod. Ricc. 2977, vol. 3.

29. Cod. Ricc. 2932, p. 102v.

30. The *Commedia di Judit,* cod. Ricc. 2974, vol. 4, pp. 85v–87, lists and

describes props: a bloody head and silk drape to cover it, a dagger, a basket, a bag full of food and a flask of wine, a large knife, a rope, and a water pitcher. Costumes too are described in detail: Judith is to wear her widow's weeds over a richly ornate gown so that she can make her costume change quickly; a parasite is to put pillows under his clothes to make him look fat and to offer protection when the cook beats him; etc.

31. *Commedia della Purificatione*, cod. Ricc. 1413, p. 183. The *Commedia sulla vita di San Raimondo vescovo di Canturia*, cod. Ricc. 1413, p. 136, addresses "sorelle et madre et voi più giovanette" and the *Commedia di Judit*, p. 83v, for example, "venerande madri e gratissime sorelle."

32. In the *Commedia di Judit*, pp. 84v–85, there are texts of three formal invitations to the play, the first to "tutte le madri e professe e giovani," the second to "tutte le sorelle novitie e loro madre maestra," and the third to "tutte le converse del nostro monastero."

33. *Morte di Acab re di Sammarea e de' suoi*, cod. Ricc. 2818, vol. 7, p. 5v: "Regina serenissima, & voi altre/signiore illustre & reverende madri."

34. For example, the *Viaggio dell'anima pastorella e sposalitio*, cod. Ricc. 2969, vol. 4, p. 235, addresses "devotissimi ascoltatori" and "auditori nobili." See also *Persecutione di David*, cod. Ricc. 2977, vol. 3, p. 2: "benigni et honorandi audienti," or the *Amor di virtù* by Sister Beatrice del Sera, cod. Ricc. 2932, p. 8v: "Nobilissimi e degni ascoltatori."

35. Giovan Maria Cecchi, *L'Assiuolo* (Bologna: Arnaldo Forni, 1974; rpt. Milan: Daelli, 1863).

36. *Assiuolo*, Act I, sc. 2, pp. 87–88.

37. Charles DeJob, *De L'influence du Concile de Trente sur la littérature et les beaux-arts chez le peuples catholiques: essai d'introduction à l'histoire littéraire du siècle de Louis XIV* (Paris: Ernest Thorin, 1884), pp. 206–26, the chapter "L'Eglise et le théâtre," esp. pp. 211–13.

38. Cecchi, *Acquisto di Giacobbe*, prologue, cited in n. 11. The provincial Council of Cologne in 1549 issued a decree which specifically banned lay actors from performing in female convents: Ch. 17, "Comoedias quatenus liceat in monasteriis ludere. Percepimus comoediarum actores quosdam, scena & theatris non contentos, transire etiam ad monasteria monialium, ubi gestibus profanis, amatoriis & saecularibus commoveant virginibus voluptatem. Quae spectacula, etiamsi de rebus sacris & piis exhiberentur, parum tamen boni, mali vero plurimum relinquere in sanctimonialium mentibus possunt, gestus externos spectantibus & mirantibus, ceterum verba non intelligentibus. Ideo vetamus, & prohibemus posthac vel comoedos admitti in virginum monasteria, vel virgines comoedias spectare," published in Philippe Labbé and Gabriel Cossart, S. J., *Sacrosancta Concilia ad regiam editionem exacta . . . curante Nicolao Coleti, tomus decimus nonus ad anno 1538 ad annum 1549* (Venice: Albrizzi and Coleti, 1732), *Concilium Coloniense II, 1549*, col. 1390 (this decree is cited by Angelo Emanuele in his monograph on the play by Beatrice del Sera, *Virtù d'amore di Suor Beatrice del Sera* (Catania: F. Tropea, 1903), in chapter 3, p. 33. The order to the nuns of San

Giovannino delle Cavalieresse di Malta from their governor in 1534, cited above, specifically forbids lay actors from entering the convent: "Non sia lecito per tempo alcuno di far commedie ed intervenire persone secolari . . ." see n. 14.

39. See entry by Nino Pirotta, "Sacra rappresentazione," in the *Enciclopedia dello spettacolo* (Rome: Casa Editrice Le Maschere, 1961) 8: cols. 1370–77.

40. D'Ancona, *Origini del teatro italiano* 1:418–19; 2:157. An example of a *sacra rappresentazione* written in monastic circles well into the sixteenth century is the *Mosé* by Sister Raffaella de' Sernigi of the convent of Santa Maria della Disciplina a Portico. She was born in 1472 or 73, died in 1557 and was mother superior of her convent (see the *Obitorio del monastero*, ASF, *Conventi Soppressi*, 207, filza 109, p. 35v). The play was first published without a date in about 1550 (Schutte, *Religious Books*, p. 355) or 1560 [Alfredo Cioni, *Bibliografia delle sacre rappresentazioni* (Florence: Sansoni, 1961), part II, entry 76].

41. See the prologues to Cecchi's *Morte del re Acab*, published in *Commedie*, (Florence: Le Monnier, 1899) 1:501–5 and his *Coronazione del re Saul* in *Drammi spirituali* (Florence: Le Monnier, 1900) 2:9–11.

42. According to dates written on the MS, pp. lv and 98, the *Amor di virtù* was composed between 1548 and January of 1554, Florentine style, that is, 1555. Cecchi's *Morte del re Acab* was first performed by the Compagnia del Vangelista in 1559, see entry "G. M. Cecchi," *Enciclopedia dello Spettacolo* 3: col. 302.

43. Anton Francesco Grazzini, *Cene*, ed. R. Bruscagli, (Rome: Salerno, 1976), p. 11: "alle monache ancora non si disdice, nel rappresentare le feste, questi giorni vestirsi da uomini, colle berette di velluto in testa, colle calze chiuse in gamba e colla spada al finaco."

44. The name on the MS is "Madre S⟨uperior⟩a Maria Grazia a San Vincenzo di Prato," and according to convent documents only one Maria Grazia has been mother superior of that convent, Maria Grazia Centelli. Information on her is contained in two documents in the Archives of the Convent of San Vincenzo, MS 22, *Cronache*, pp. 92v, 101, 102, 192r and v, and *Inventario* 168A, *Monastero di S. Vincenzo: Le nostre sorelle*, p. 30. She was born in 1518 or 1519 as Maria di Lorenzo Centelli and was raised by Giovanni Bartolini. She entered the convent at 12 or 13 years of age, took the veil on April 11, 1531. She was prioress twice, 1578–80 and 1584–86. She died May 7, 1602 while comforted by Sister Caterina de' Ricci (canonized in the eighteenth century), who assured her that she would die suddenly and go straight to Paradise (MS 22, p. 192). She is described as follows: "Fu questa benedetta madre di molto ingegno, di molta prudenza, e di molto governo, e nel temporale, e nello spirituale: onde successivamente fu costretta ad esercitare tutti gli uffizi principali del monastero. Fu maestra di lavoro, traffica maggiore, sagrestana, maestra delle novizie, soppriora, priora due volte, e sempre con gran sodisfatione, e sindaca molti, e molti anni, con singolare intelligenza" (same page). Her first term as prioress was a difficult time for it was then that Church authorities forced San Vincenzo to be cloistered (*Inv.* 168A, p. 30).

45. See n. 33.

46. See n. 33

47. In the Archivio of the Convent of San Niccolò in Prato, the *Ruolo delle religiose del monastero di S. Niccolao*, on p. 130 lists Beatrice de Sera and says only that she was the daughter of Andrea del sig. Neri del Sera of Florence, that she was brought to the convent on June 9, 1517, was prioress in 1562 and died on January 27, 1585, Florentine style, therefore 1586. More has been learned about her by two scholars who studied her works, Angelo Emanuele and Federico Ageno. Emanuele wrote a monograph on her play, *Virtù d'amore di Suor Beatrice del Sera* (cited n. 35). He found her birth record in the Archivio dell'Opera di S. Maria del Fiore in Florence, *Libro Femine, anni 1513–1522* which reads: "Beatrice et Margherita d'Andrea di Neri del Sera nata a dì 3 d'aprile (martedì) 1515. Popolo di S. Maria Novella," (Emanuele, p. 16, n. 2). Ageno wrote an article about her copy of Petrarch's *Canzoniere* and *Trionfi* which contains two autograph sonnets by Sister Beatrice and other annotations and which today is in the University of Pavia Library: "Rime autografe di Suor Beatrice del Sera in un *rarum* della biblioteca universitaria di Pavia," *Bollettino della Società Pavese di Storia Patria* 19 (1919): 1–21. Francesco Trucchi first discovered Beatrice del Sera's play and published a part of the sonnet "Al discreto lettore" and the intermezzo between Acts II and III, "Alma gentil che siete . . ." in *Poesie italiane inedite* (cit. n. 22) pp. 305–11. Trucchi also published (ivi) a passage from Sister Beatrice's prose comment that follows her play along with some undocumented misinformation regarding her death. He does not cite the manuscript he used, and his readings differ slightly from those in the Riccardiana codex, the only manuscript I have been able to find.

48. cod. Ricc. 2932, p. 101.

49. cod. Ricc. 2932, p. 101 r and v: "Accadde che l'anno 1530 per fuggire gli avversi casi che soprastavano alla terra di Prato alora cerchiata dal compo del serenissimo Imperator Carlo V, noi di numero 30 andamo nella città di Pistoia dove levandosi per discordia le parti e abbruciandosi le case, furono sgombre molte robe nel monasterio dove io ero, e di quante sorte ve ne fussi, io solo andavo a legger libri tra quali fu quello chiamato *Genealogia degli Dei,* che a me pare dichiarazione che non sono dei, ma dal volgo intitolati così per somiglianza di qualche loro virtù mostra per loro dal vero Dio, in fra questi libri, m'occorsi il *Filocolo* di M. Giovanni Boccaccio quale molto ci piacque e alla domanda d'una cortese giovane per nome Fiammetta [Fiammetta Villani, Suor Sigismonda, Archivio di S. Niccolò, *Ruolo delle religiose,* p. 138, to whom a sonnet in the MS is dedicated, "Con quella fiamma che mi scalda 'l cuore," p. 99v] io promissi di trarre il fiore in versi e opera da recitare in scena" (For the text of *Amor di virtù* I cite here and elsewhere from the edition I am preparing for publication with the Longo Press, Ravenna, Italy; I have conservatively modernized the orthography and I have used conventional modern punctuation). On her Petrarch see Ageno, "Rime autografe di Suor Beatrice del Sera."

50. Boccaccio's precise source is unknown, but he must have based his romance on a version of the story dependent on the so-called "popular version" of the French poem *Floire e Blancheflor.* See Antonio Enzo Quaglio, in the introduction, p. 48, to his edition of Boccaccio's *Filocolo,* in *Tutte le opere di*

Giovanni Boccaccio 1; (Milano: Mondadori, 1967) and Joachim Reinhold, *Floire et Blancheflor: Etude de littérature comparée* (Paris: E. Larose-P. Geuthner, 1906), ch. 3, pp. 81–118.

51. The hero Filocolo/Florio also has a vision which makes explicit the spiritual meaning of his love, showing that this love is accompanied by the theological as well as the cardinal virtues and that it leads him to God, *Filocolo, IV.* 74. 9–20, pp. 457–59.

52. The allegory of the *Filocolo* has been studied, and interpreted variously, by Victoria Kirkham, "Reckoning with Boccaccio's *questioni d'amore,*" *Modern Language Notes* 89 (1974):47–59; Janet Smarr, "Boccaccio's *Filocolo:* Romance, Epic, and Religious Allegory," *Forum Italicum* 12 (1978): 26–43; and Robert Hollander, *Boccaccio's Two Venuses* (New York: Columbia University Press, 1977), pp. 31–40, 149–58, and *passim*.

53. For the diffusion of such mystical literature in female convents see Lina Eckenstein, *Woman Under Monasticism: Chapters on Saint-Love and Convent Life Between A.D. 500 and A.D. 1500* (New York: Russell & Russell, Inc., 1963 rpt. Cambridge: Cambridge University Press, 1896), pp. 305–53.

54. There is also an instance in which Sister Beatrice clarifies an erotic joke, which is not explicit, but no doubt intended in Boccaccio's text. When the hero is hoisted up to the tower window, hidden in a basket of roses intended for the women prisoners, in the *Filocolo* the lady who first receives the basket, seeing a man's face among the flowers, is frightened and screams. When she realizes who it is, to protect him she tells those who heard her cry that a bird had flown out of the basket into her face, startling her (IV. 109, pp. 494–95). In Sister Beatrice's version there is no mention of a face in the flowers and Florido is undressed before he is hidden there, so that the bird is more clearly that figurative one that sings in so many of Boccaccio's stories (Act IV, sc. 5, p. 77r).

55. Cfr. the *Canticum canticorum salomonis,* 2, 12–14 (*Biblia Vulgata*, Madrid, EDICA, 1977):

> Vox *Turturis* audita est in terra nostra;
> Ficus protulit grossos suos;
> Vinea florentes dederunt odorem suum
> Surge, amica mia, speciosa mea, et veni:
> Columba mea, *in foraminibus petrae,*
> *In caverna maceriae.*

56. On p. 101v she says, regarding the *Amor di virtù*, that she wrote it "con rozze e poco accurate parole *senza pensare che mai da i dotti dovessi esser vista,* ma l'haver fatto poi dell'altre opere con quelle m'è uscita questa di mano e *pare che metta meraviglia a molti che una stata sempre rinchiusa senz'havere studiato o visto i paesi e maniere del mondo, facci quelle cose che di me si veggono nate,* al che io rispondo, che sono molti ammaestrati nelle scuole che non sanno quello che han udito non che dare del suo, et così è chiaro che ogni dono è dato dal ottimo Iddio . . ." (italics mine).

57. P. 101v: "Et a me così facile è l'intender e mostrare l'intenzione delle persone secondo i loro sensi come la grazia datami di sapere ritrarre e fabricare ⟨ta⟩nte sorti di lavori senza mai havergli imparati e più oltre con quella vera effigie formar in seta la moltitudine de' fiori. Quest'opere pruovono d'esser state ben fatte sendomi state ben pagate.

9

The Countess of Pembroke
and the Art of Dying

MARY ELLEN LAMB

*M*ANY WOMEN of the English aristocracy received impressive
educations during the Renaissance, and some of them—
Margaret Roper, Lady Jane Grey, the daughters of Anthony Cooke—
became well-known for their intellectual abilities. Yet the outlets for
the public expression of a woman's learning were severely limited. At
pains to protect women's chastity, influential educators like Juan Vives
confined women's reading to church fathers, Scriptures, and a few
"sad" classical authors.[1] Whether or not Vives' actual strictures were
obeyed, the motivating force behind them effectively prevented most
women from writing romances, plays, or sonnet cycles: if even
reading works in these genres was said to place a woman's reputation
at risk, what would *writing* them do?[2] The expression of women's
religious views was also restricted, for Paul's prohibition against
women speaking in church worked to prevent the publication of their
ideas on religious issues of the day.[3] Only a few unexceptionable
literary activities remained; and, at least until the end of the sixteenth
century, most women writers confined themselves to composing
letters, diaries, advice on raising children, non-controversial religious
writings such as meditations and prayers, and especially translations
of works, particularly religious works, written by males.[4]

As a writer, the Countess of Pembroke operated within the
limited arena open to her. With the exception of a few short pieces,
her work consists primarily of translations. While she has been justly
praised for her skill in translating the *Psalms,* this essay focuses on
three of the Countess's other translations, less often discussed in their
own terms: *The Discourse of Life and Death* (1590) from Philippe Du
Plessis Mornay's *Discours de la vie et de la mort,* the *Antonie* (c. 1590)
from Robert Garnier's *Marc Antoine,* and *The Triumph of Death* (c.

Mary Sidney, Countess of Pembroke. After the engraving by Simon
Pass (1618). From Young, *Mary Sidney, Countess of Pembroke*, London,
David Nutt, 1912. *Courtesy of the Newberry Library, Chicago.*

1599) from Petrarch's *Trionfo della Morte*.[5] These works, which the Countess chose to translate from a wide variety of options, all share an interest in death and dying.[6] Mornay's essay is explicitly an *ars moriendi* tract, developing its argument against the fear of death along primarily Stoic lines; the work was, in fact, eventually issued with translations from Seneca's letters.[7] And Garnier's play and Petrarch's poem each portray female protagonists who demonstrate their heroism by dying well.

In what follows, I will suggest that the Countess's translations of the works by Garnier and Petrarch reveal her struggle to apply Mornay's insights to the specific situation of women. Taken together, the three translations demonstrate the Countess's response to the *ars moriendi* literature and to the Stoic ideal as these traditions concerned women at the end of the sixteenth century. By exalting the ability to suffer without complaint, to endure any affliction with fortitude, Stoicism functioned like many models in the Renaissance that recommended silence and obedience in the face of adversity as praiseworthy female behavior. Similarly the scene of the noble death repeatedly portrayed in the *ars moriendi* tracts offered a model of heroism that women might emulate without violating the dominant sexual ideology. Thus I will argue that the Countess's translations of Mornay, Garnier, and Petrarch embody a female literary strategy through which women could be represented as heroic without challenging the beliefs of the patriarchal culture of Elizabethan England.

When the Countess chose to translate an *ars moriendi* tract, she had a variety of possibilities open to her for, according to Nancy Lee Beaty, the *ars moriendi* tradition had become rich and various by the end of the sixteenth century.[8] As Beaty describes it, many Renaissance tracts continued the practice originating in a fifteenth-century source of offering practical advice to arm Moriens, the conventionalized medieval character who embodies death and dying, against the devil's final temptations, especially the temptation to despair. This advice was developed in two basic ways. First, several Protestant tracts adapted the Catholic technique of meditation to inspire Moriens with the religious devotion fitting for an exemplary death. Second, and less satisfactorily, Calvinist tracts included expositions of dogma not always directly helpful to the act of dying itself; this strategy reflected

the strain the *ars moriendi* tradition created within the context of Calvinist theology, according to which Moriens was already elect or damned, despite deathbed behavior.[9] A third form of *ars moriendi* tract ignored the deathbed entirely to focus instead on philosophical arguments persuading the reader not to fear death. This third, humanistic form, developed a Stoic view that need not have conflicted with church doctrine; for its pervasive sense of the illusory nature of worldly fortune was thoroughly present in church teachings as well. But in practice this classical perspective drastically de-emphasized the personal relationship between man and God, the sense of sin, and the recognition of Christ as Redeemer that composed the cornerstones of both Catholic-influenced and Calvinist tracts on dying.[10]

The Catholic-influenced, the Calvinist, and the humanist versions of *ars moriendi* literature continued to exist in pure or mixed forms at least until the end of the sixteenth century. Indeed the Countess of Pembroke's interest in the *ars moriendi* tradition is consonant with her immediate familial and social context as well as with the broader cultural environment. A letter from the Countess's husband to Sir Francis Hastings, who had just lost his brother Henry, demonstrates the strength of the Earl of Pembroke's feelings on the subject of death. His self-description is striking enough to warrant quoting the passage at length:

> In the mean time I request you to take neither that nor your brother's death more to heart than Christianity and wisdom should: for as in showing some passions we seem men and no stones, so in being too sorrowful we may show ourselves turtles and no men. You are not ignorant that three hundred days lamenting the death of Moses could not recall that mild, wise and godly duke from death: and verily were ours as long, as great and as true a sorrow (wherein I with yourself will ever bear a part) yet we cannot, or (if we love him) we should not bring him again to life, or rather to another death. Might it have pleased the giver and taker of souls to have ransomed one life with a thousand, no doubt there are no fewer in England that would have stood betwixt him and the arrow: since whose death I may truly write thus much of myself, I dream of nothing but death, I hear of little but death, and (were it not for others' farther good) I desire nothing but death. The departure of Sir Roger Williams did much trouble me, more the irrecoverable sickness of Sir Thomas Morgan: but never any more, or so much, as the wanting of him for this little time of my pilgrimage, with whom I hope to live ever. I mean your most honourable deceased brother, whom now we want, but here-

after shall want indeed. Thus desiring God to comfort you and us all
with His holy spirit, I rest your assured loving friend.[11]

While the Earl's grief over the death of Henry Hastings, third
Earl of Huntingdon, to whom he was related by marriage, was no
doubt intense, his "desire for nothing but death" was probably also
affected by his own illness. His wish had apparently nearly been
granted; for, about three weeks before December 24, 1595, when this
letter was written, his brother-in-law Robert Sidney's retainer had
written of the Earl: "Truly I hard, that if my Lord of *Pembroke* shuld
die, who is very pursife and maladife, the Tribe of *Hunsdon* doe laye
Waite for the Wardship of the brave yong Lord."[12] Thus the Earl's
letter reads like more than a usual letter of condolence; it represents a
small *ars moriendi* tract in its own right, urging Hastings not to mourn
more than "Christianity and wisdom" would allow, for mourning
cannot bring his brother back, and even if it could, life is only
"another death." While the Earl himself expresses evident sorrow, he
represents death as desirable: "I dream of nothing but death, I hear of
little but death, and (were it not for others' farther good) I desire
nothing but death."

Written in 1595, five years after the Countess wrote her transla-
tion of Mornay, the Earl's feelings were perhaps influenced by the
Countess's works or, more likely, the influence was mutual, a shared
absorption. Furthermore the Countess's own mother, Mary Sidney,
was publicly praised for her excellent death. No less eminent a work
than Holinshed's *Chronicles,* published in 1587, recorded the noble
death of the mother in great detail:

During the whole course of her sicknesse, and speciallie a little
before it pleased almightie God to call her hense to his mercie, she
used such godlie speeches, earnest and effectual persuasions to all
those about hir, and unto such others as came of freendlie courtesie
to visit hir, to exhort them to repentance and amendement of life,
and dehort them from all sin and lewdness, as wounded the con-
sciences, and inwardlie pearsed the hearts of manie that heard hir.
And though before they knew hir to exceed most of hir sex in
singularitie of vertue and qualitie; as good speech, apt and readie
conceipt, excellence of wit, and notable eloquent deliverie (for none
could match hir, and few or none come neere hir, either in the good
conceipt and frame of orderlie writing, indicting, and speedie dis-

patching, or facilitie of gallent, sweet, delectable, and courtlie speaking; at least that in this time I my selfe have known, heard, or read of) yet in this hir last action and ending of hir life (as it were one speciallie at that instant called of God) she so farre surpassed hir selfe, in discreet, wise, effectual, sound, and grounded reasons, all tending to zeale and pietie, as the same almost amazed and astonished the hearers to heare and conceive such plentie of goodlie and pithie matter to come from such a creature. Who although for a time she seemed to the world to live obscurlie, yet she ended this life, and left the world most confidentlie, and to God (no doubt) most gloriouslie, to the exceeding comfort of all them (which are not few) that loved or honored hir, or the great and renowned house whereof she was descended.[13]

As Holinshed's portrait of Mary Sidney's death indicates, one feature increasingly common to the later *ars moriendi* literature is the explicit recognition of the applicability of the tradition to women. Twelve years before the Countess's translation of Mornay, a Catholic-influenced tract includes a spiritual counsel addressed to "my Daughter."[14] The next year in a (vehemently anti-Catholic) Protestant tract, a speech to be read to the dying person by a minister or friend is suffused with references to "B.S.N.," that is, "Brother, Sister, or Name."[15] Seven years after the Countess's translation of Mornay an immensely popular tract recommends itself on the title page to persons subject to unexpected deaths: mariners, soldiers, and women in childbirth.[16] Increasingly at this time and into the seventeenth century, women as well as men are praised for dying well.[17]

Along with the influence of the *ars moriendi* traditions, the Countess' attraction to translating Mornay's tract may also have been due to its heavy emphasis on Senecan Stoicism, an immensely popular philosophy that, at the end of the sixteenth century, had an obvious appeal for women.[18] Interest in Seneca was not, of course, confined to women, as Stoic heroes such as Bussy d'Ambois would demonstrate, yet there are indications of the felt applicability of the Stoic ideal to the situation of women in the Renaissance. Even the most rigid of educators encouraged women to read Seneca.[19] A 1589 portrait of the Countess of Cumberland shown holding the words of Seneca along with the Bible and a book of alchemy represents the centrality of the Stoic ideal to the presentation of a well-known Elizabethan woman.[20] And in the early seventeenth century, Eliz-

abeth Cary translated portions of Seneca, along with extensive Catholic writings.[21]

The reason for the attractiveness of Stoicism to Renaissance women is not difficult to comprehend. Perhaps more than any other philosophy, Stoicism is consonant with the sexual ideology of the time. The Stoic ideal as expressed in Mornay's *Discourse of Life and Death* is as follows: the apparent "goods" of this life—love, wealth, fame—are illusory, for they cannot bring true satisfaction. Instead, they subject one to the unpleasant emotions of hope and fear, joy and sorrow, which attend the revolutions of the wheel of Fortune. Only by disengaging from earthly desires can one gain a sense of what is real and enduring; from this detachment one achieves the equanimity of soul to endure any misfortune, even death, without complaint. Death, in fact, provides a welcome release from the miseries of life; and the calmness with which one greets one's own death measure the extent to which one has achieved a superior understanding of the illusory nature of the pleasures of this life.[22] This Senecan ideal, which emphasizes passive endurance rather than heroic action, which honors withdrawal and inner composure as positive virtues, ennobles the behavior that was expected of women anyway; to refrain from entering public life which is here devalued and to endure whatever fortune sends without resistance or discontent.

In Mornay's treatise, however, the Stoic ideal was applied to the life course led by men, not by women, a fact which is clarified when Mornay elaborates life's miseries as a series of active or public deeds: the abandonment of youth to "all libertie or rather bondage of . . . passion" (A3ᵛ), the ambitions of older men to "make a thousand voyages by sea and by lande" (A4ᵛ), to be "great about Princes," or to be one of the "commanders of Armies" (B2). It is left to the Countess of Pembroke's other two translations to develop the potential for female heroism implicit in Stoicism.

Strong evidence suggests that the Countess's translation of the *Marc Antoine* with its heroic portrait of a female protagonist, Cleopatra, is an attempt to apply Mornay's philosophy to the situation of Renaissance women. First, the Countess's translations of Mornay's treatise and Garnier's play were probably intended as a pair, for they were published in the same volume. Secondly, the content of the two works is strikingly similar. The Chorus to Act I of the *Antonie* reads like a versified *Discourse of Life and Death:*

Nature made us not free
When first she made us live:
When we began to be,
To be began our woe:
Which growing evermore
As dying life dooth growe,
Do more and more us greeve,
And trie us more and more. (G1)[23]

The Chorus to Act III recites a virtual paean to death:

Death rather healthfull succor gives,
Death rather all mishapps relieves,
 That life upon us throweth:
And ever to us doth unclose
The doore whereby from curelesse woes
 Our wearie soule out goeth.
What Goddesse else more milde then she
To burie all our paine can be,
 What remedie more pleasing? (L3ᵛ)

But it is the central figure of Cleopatra herself who most prominently embodies the Stoic ideal. From Antony's opening speech, the suspense of the play revolves around whether or not Cleopatra will betray him to Caesar to save her own kingdom and her life. Much of the middle of the play consists of debates between Cleopatra's followers, who attempt to dissuade her from her decision to die, and Cleopatra, whose contempt for life and desire for death would impress any Stoic philosopher. The play ends with Cleopatra's ringing resolution to die, as soon as she has paid the proper obsequies to Antony's corpse. In her absolute rejection of the possibility of saving her life and perhaps her crown by living subject to Caesar, Cleopatra attains the stature of a Stoic hero, transcending Fortune's wheel by her insistence on death.

But Cleopatra's desire to die is itself motivated by a passion that would not have been endorsed by Seneca or Mornay. Neither writer makes any distinction between mature love and the "tyrannical passion" felt at the height of youth. An Elizabethan explication of Seneca asserts that love is madness, although not as severe a madness as the

lust for riches.[24] Love, according to Seneca, is one of those passions that bind a human to Fortune's wheel; emotional dependence on another person's affections prevents the attainment of complete calm. For Cleopatra, however, love is the agency through which she rises above the caprices of Fortune, as she declaims to the absent Antony:

> And didst thou then suppose my royall hart
> Had hatcht, thee to ensnare, a faithles love?
> And changing minde, as Fortune changed cheare? (G4ᵛ)

For Cleopatra the prospect of loyalty to a defeated Antony, even a dead Antony, outweighs her realm, her children, her own life. And it is her love for Antony, not just her ability to face death, that motivates her bravery. Far from a beastly passion, this love is an integral part of her humanity, as she exclaims to one of her women: "Without this love I should be inhumaine" (H5).

Cleopatra's renunciation of her ability to protect the interests of her children and her realm as well as her own life understandably displeases her fellow Egyptians; and much of the central portion of the *Antonie* is composed of their attempts to dissuade her. Her exchange with Charmion is typical:

> Charmion: Live for your sonnes. Cleopatra: Nay for their father die.
> Charmion: Hardhearted mother! Cleopatra: Wife kindhearted I.
> (H5)

Diomede soliloquizes to himself the wish that the Queen would ease mourning and charm Caesar to gain back her crown, saving them all from disaster. But, despite Antony's suspicions that she is unfaithful to him, expressed in a prominent speech at the beginning of the play, Cleopatra never wavers in her resolve, and the curtain falls on her final lines, delivered over Antony's corpse:

> A thousand kisses, thousand thousand more
> Let you my mouth for honors farewell give;
> That in this office weake my limmes may growe,
> Fainting on you, and fourth my soule may flowe. (o2ᵛ)

Repeatedly calling Antony her "husband," Cleopatra is por-
trayed as a faithful wife instead of the adulteress of legend; and
through her heroism the domestic virtue of a wife's loyalty to her
husband, despite the vicissitudes of fortune, is raised to exalted
heights. Representing this usually passive attribute as heroic ennobles
a wifely response perhaps often taken for granted. Second,
Cleopatra's serene death suggests by implication a means by which
ordinary women can demonstrate their heroism. One does not have
to search for an objective correlative for this example of heroism in
the Countess's life. As noted above, the Countess's own mother was
memorialized in Holinshed's *Chronicles* for the excellence of her
deathbed sentiments. According to Holinshed, Mary Sidney's heroic
death compensated for the obscurity of her life: "Who although for a
time she seemd to the world to live obscurlie, yet she ended this life,
and left the world most confidentlie." Cleopatra's confrontation with
death represents a literary counterpart to Mary Sidney's bravery, as
recorded in Holinshed. Possibly her mother's death influenced the
Countess's evident admiration for Cleopatra's resolve; possibly dying
well was a goal many women in this age of *ars moriendi* tracts strove to
achieve, one of the few outlets for publicly-acknowledged heroism
possible in lives restricted to the private realm.

There is an important difference, however, between Cleopatra's
orientation toward death and Mary Sidney's. According to Holin-
shed, Mary Sidney's speeches demonstrated Christian virtues, as she
exhorted those standing around her deathbed to "repentance and
amendment of life," persuading them "from all sin and lewdness" and
proving herself a virtuous Christian in much the same manner as a
man would do. In contrast Cleopatra proves herself a Stoic and a
wife. By defining herself in terms of her relationship with a man,
Cleopatra represents a specifically female deviation from the Stoic
ideal as it applied to men, who died declaiming philosophical, politi-
cal, or moral sentiments, not love for their wives.

According to the dedication to the Countess of Pembroke,
Samuel Daniel's *Tragedie of Cleopatra* (1594) was written to complete
the plot line begun in the Countess's *Antonie,* for Daniel claims he
would have continued to write sonnets had not the "well grac'd
Anthony,/Requir'd his *Cleopatras* company." In fact, Daniel's play was
explicitly written at the Countess's request; it was "the worke the
which she did impose . . . who onely doth predominate my Muse."[25]
For this reason his representation of Cleopatra as "l'incarnation du

stoicisme le plus élevé"[26] is certainly a continuation of the Countess's perception of Cleopatra in her own translation, and Daniel's play in some sense completes the Countess's attempt to apply the Stoic philosophy to the situation of women. Indeed, Daniel adds a passage to other treatments of the subject that explicitly relates Cleopatra's heroic resolve to die to abstract philosophies like Seneca's, which are supposed to reconcile adherents to their deaths. In Daniel's passage, two philosophers bewail their cowardice, explicitly contrasted to Cleopatra's bravery, for they are unable to conquer their fear of death despite their learning:

> And yet what blasts of words hath Learning found,
> To blow against the feare of death and dying?
> What comforts unsicke eloquence can sound,
> And yet all failes us in the point of trying.
> .
> For when this life, pale Feare and Terrour boords,
> Where are our precepts then, where is our arte?[27]

Is this passage Cleopatra is represented as capable of embodying what even learned philosophers could not: the highest Stoic principles as adumbrated in learned tracts reasoning against the fear of death. The Countess's translation of just such a tract surely influenced this addition of Daniel's; the passage therefore further links Cleopatra's form of heroism to the perspective on death expressed in Mornay's treatise.

While Cleopatra only resolves to die in the *Antonie*, she actually accomplishes her death in Daniel's *Tragedie of Cleopatra*. With Antony already dead, Daniel's play presents a new focus. In Cleopatra's heroic resolution to die, she not only proves her love for Antony, she also thwarts Caesar. In contrast to Garnier's *Marc Antoine*, Daniel's play stresses Cleopatra's triumph over Caesar even more than her loyal love. As Cleopatra applies the asps to her body, for example, her long speech barely mentions Antony until the last lines; even then he is almost subordinate to Caesar in her thoughts:

> Witnesse my soule partes free to *Antony*,
> And now prowde Tyrant *Caesar* do thy worst. (V, 1608–9)

At the moment of her death, serene and heroic, her focus is on her resistance to Caesar's will:

And in that cheere th'impression of a smile,
Did seeme to shew she scorned Death and *Caesar,*
As glorying that she could them both beguile,
And telling Death how much her death did please her. (V, 1626–29)

In Daniel's version of the story then, Cleopatra not only proves her Stoic disregard for death and establishes her identity as a true wife; she also demonstrates her freedom from male tyranny as represented by Caesar. This pointed refusal to subject herself to Caesar suggests the pride and resentment against male domination contained in Cleopatra's self-sacrificing form of heroism.[28]

In both the Countess's translation of Garnier and in Daniel's play, the heroic representation of Cleopatra functions as an exemplification of the female virtues idealized in Renaissance England. Cleopatra becomes a mirror through which women can perceive themselves—in their self-sacrifices, in their constancy, in their love for and anger at their husbands—as heroic. If women could not fight in battle, argue in the lawcourts, intrigue in the royal court, at least they could achieve heroic stature by preserving Stoic equanimity at home. This virtue was, obviously, extremely convenient for men to promote; for this form of heroism did not challenge the *status quo.*

The achievement of heroic stature by maintaining Stoic calm in the domestic sphere is nowhere more evident than in another version of the Cleopatra story, Samuel Brandon's *The vertuous Octavia* (1598), a play clearly influenced by Daniel's *Tragedie of Cleopatra* and dedicated to Lucia Audelay, the mother of the Countess's neighbor, Mary Thinne.[29] Published four years after Daniel's play, *The vertuous Octavia* treats the Antony and Cleopatra story from the perspective of Octavia, Antony's long-suffering wife in Rome. Confronted with the infidelity of her errring husband, Octavia provides a model of how to deal with domestic affliction, and the real drama of the play lies in Octavia's attempt to keep a "vertuous minde" (I, 194).[30] When, for example, she learns of Antony's love for Cleopatra, she invokes virtue's aid in her struggle against her feelings of jealousy and her desire for revenge:

O vertue, thou that didst my good assure,
Arme now my soule against proude fortunes might:
Without thy succour I may not endure,
But this strong tempest will destroy me quite. (II, i, 682–85)

When she receives Antony's order that she leave his house, only the last of a series of indignities she endures from him, her response is almost serene:

> True fortitude doth in my soule abound,
> My honor scornes the height of fortunes pride.
> The worst that can befall me is but death:
> And O how sweete is his lives sacrifize,
> On vertues altar that expires his breath.
> .
> But those that know not, let them learne in me:
> That vertuous minds can never wretched be. (V, 1836–40; 1846–47)

Octavia's success lies in her ability to conquer the passions of anger, jealousy, and the desire for revenge through her "vertue." A true Stoic, Octavia distances her anger by the desire for death. If death is the worst catastrophe, and if death is not to be feared, then life holds nothing that can make her "wretched." The desire for death follows a consistent pattern of emotions; it is a logical extension of the denial of anger, the effacement of her own emotional needs, the submersion of her own identity in her husband's.

The vertuous Octavia shows that the Stoicism of Cleopatra's heroism was readily adaptable to an even more explicitly domestic situation commonly confronted by upper-class Renaissance women isolated on country estates while their husbands travelled freely, often spending time in the sexually-charged atmosphere at court. Brandon's play presents the inner turmoil resulting from the restrictions placed on female behavior as an opportunity for heroism, although the terms of this heroism require nothing less than absolute self-effacement.

Brandon's dedication of two letters on his theme, "Letter from Octavia to Antonius" and "From Antonius To Octavia," to Mary Thinne, the Countess of Pembroke's neighbor at Longleat, contains rare information on the feelings of a woman whose opportunities to express her learning had been denied. In the dedication to these letters, Brandon calls Mary Thinne "the mother, or (under your correction, to say better, the murtherer) if concealing may bee called a murther, of such excellent, and vertuous knowledges."[31] That is, Brandon had at first apparently tried to pay her a compliment by describing her as the "mother" of "knowledges." Her emendation of

"mother" to "murtherer" implies an anger and bitterness seldom publicly expressed on this subject in the Renaissance. Her self-description as a "murtherer" also suggests that at least some of this anger was self-directed, that she perceived herself as a "murderer" of her own "knowledges." The implication that "knowledges" are like fetuses "concealed" or never allowed to be born hovers disturbingly around the contrast of "mother" and "murtherer." Yet somehow in Brandon's dedication, the violence of this image is submerged. Thinne's emendation of the poet's compliment comes off as a playful, witty interchange between poet and friendly patron, suitably modest about her learning. But the negative feelings implied in her correction of "mother" to "murtherer" could have made her, in the poet's eyes, a patron who would profit from the letters, which provide a Stoic model for dealing with internal passions.

Perhaps the ultimate representation of female self-effacement is contained in the Countess's translation of Petrarch's *Triumph of Death,* which she was working on in 1599, but never published. The Countess of Pembroke's continuing interest in the *ars moriendi* tradition is suggested by her choice of this triumph over the five others—the *Triumph of Love, The Triumph of Chastity, The Triumph of Fame, The Triumph of Time,* and *The Triumph of Eternity,* the last of which was translated by Queen Elizabeth. *The Triumph of Death* opens with the depiction of Laura as a prominent member of a troop of women whose chastity has just won a victory over love. The description of the other members of this group in the previous triumph places Laura squarely in the tradition of women heroically willing to sacrifice even their lives for their men or for their chastity. Among others, they include Lucrece, who killed herself after being raped by Tarquin; Virginia, whose father killed her after she was raped; "the German women who chose death/ Their own barbaric honor to preserve"; "the Greek maid who plunged into the sea/ To flee an evil fate, and die unstained"; Dido, "who for a belov'd and faithful spouse/ (not for Aeneas) willed to meet her end."[32] Unlike these heroines, however, Laura does not choose death. Instead, Death comes to her, in the person of an old woman who warns her that she will die soon. Laura's heroism consists instead of her brave acceptance of the news of her own death; and her resignation probably provided a more usable model for Renaissance women readers than Cleopatra's willed suicide. But like Cleopatra, Laura defines herself even in death in terms of her relationship with a man. Even in her initial reply to Death, she tempers her welcome with the sorrow her death will cause the poet:

> To this, thow right or interrest hast none,
> Little to me, but onelie to this spoile.
> Replide then she, who in the world was one.
> This charge of woe on others will recoyle,
> I know, whose safetie on my life depends:
> For me, I thank who shall me hence assoile. (I, 49–54)[33]

 Laura's death scene itself represents a striking departure from the *ars moriendi* tradition. The conventional Moriens took an active part in his own death, battling the Devil for the fate of his soul. As we have seen, the Countess of Pembroke's mother was reported to have exhorted her friends and family to "repentance and amendment of life." Cleopatra's decision to die entails lengthy internal debates between "Life" and "Honor." But Laura's death scene, "deservedly famous for its serene beauty,"[34] is extraordinarily passive. While after her death Laura admits that "the crosse/ Preceeding death, extreemlie martireth" (II, 46, 47), her death scene conveys no sense of her coping with pain. Fading like a flame, white as snow, she takes no active part in her dying. Instead, she gains admiration through her beautiful passivity:

> Right lyke unto som lamp of cleerest light,
> Little and little wanting nutriture,
> Houlding to end a never-changing plight.
> Pale? no, but whitelie; and more whitelie pure,
> Then snow on wyndless hill, that flaking falles:
> As one, whom labor did to rest allure.
> And when that heavenlie guest those mortall walles
> Had leaft: it nought but sweetelie sleeping was
> In hir faire eyes: what follie dying calles
> Death faire did seeme to be in hir faire face.
>
> (I, 163–72)

 The depiction of Laura in the *Triumph of Death* is perfectly understandable for Petrarch. He was not writing an *ars moriendi* poem; he was not even writing about the real Laura, whose death was probably not at all like a fading flame. Even in the *Canzoniere,* Laura always represents an externality, a projected fiction by which the male poet measures his flame, his own worth, his ontology, as one critic puts it.[35] What is more disturbing is the Countess of Pembroke's apparent acceptance of Petrarch's perspective, implied in her choice to translate this *Triumph.*

But perhaps representation of Laura functions less as a model for dying well than, like Octavia, a model for living heroically. After her death in the poem, Laura returns to the poet to pledge her love for him in a way she never could in life without compromising herself. She describes how in life she had maintained an elaborate fiction to mold the poet's behavior, encouraging him when he despaired, appearing angry with him when his suit became too hot:

> A thousand times wrath in my face did flame,
> My heart meane-while with love did inlie burne,
> But never will, my reason overcame. (II, 100–2).

Her modulation of her display of emotion to respond to the poet's needs, not to her own feelings, demonstrates a control of her passions far exceeding the poet's. Ironically, she reverses the pattern presented by Octavia. Laura controls her love to make it appear as wrath, rather than controlling her wrath to emerge victoriously loving, as does Octavia. Laura's confession of her real feelings for the poet suggests another form of heroism for women to follow. Her example shows how women can fulfill the function of spiritual guide, molding their words and actions to benefit their men on their pilgrimage to heaven. Like dying well, this self-effacing form of heroism by implication becomes available to any woman living an ordinary life.

Thus the Countess of Pembroke's translations perform a complex function as models of female behavior. They hold up mirrors in which women could perceive themselves as heroic. Cleopatra's constancy to Antony raises the domestic virtue of a wife's loyalty to her husband, despite the turnings of the wheel of Fortune, to an exalted level. Through this representation of Cleopatra women could view themselves in their simultaneous love for and anger at their husbands, as worthy protagonists in the drama of their own lives. Through Laura, women could perceive themselves as spiritual authorities, bearing upon their virtuous shoulders the responsibility for their husbands' immortal souls. If women could not win public admiration for remarkable deeds in the outside world, they could at least attain heroic stature at home in their own eyes through a gentle form of Stoicism, giving of themselves, preserving their own equanimity despite incitements to rage or sorrow. And when the time came, they all had the opportunity to die gracefully. But the cost exacted by these

forms of heroism is high. Both Cleopatra and Laura are, finally, models of negation. Each defines women as important solely in terms of their relationships with men, even in the most private and solitary act of death. Each demands the suppression of the display of basic emotions, like anger, grief, and passionate love, without which no person can be whole.

The Countess of Pembroke is, finally, a translator, in the broader as well as in the literal sense, of a male perspective on women. The Cleopatra of the *Antonie* is the creation of Robert Garnier; Laura is the creation of Petrarch. Both of these female heroes bear striking resemblances to Iphigenia, Portia, Lucrece and other women who "died well" in the interests of a patriarchal culture.[36] The Countess's choice to translate these texts tempers the assumption of "feminism" often cited in relation to the impressive education of some aristocratic Renaissance women.[37] For the texts to which women had new access—Scripture, church fathers, classical poets and philosophers, contemporary writers—are, for the most part, misogynistic. But in the very act of translating these texts and, even more remarkable, publishing two of her translations without apology or subterfuge, the Countess of Pembroke, with a few other Renaissance women, created a more positive option for future literary women. Her publication of her translations presents a model if not of heroism at least of intellectual self-assertion that has nothing in common with the self-effacement and beautiful deaths of Stoic heroines.

NOTES

1. Vives' *Instruction of a Christen Woman* (London, 1557), D4ᵛ; for a survey of various educators see Ruth Kelso, *Doctrine for the Lady of the Renaissance* (Urbana, Ill.: University of Illinois Press, 1956), pp. 58–77.

2. Interestingly enough, two prominent women writers in these genres had little to lose because they were outsiders to mainstream society. Mary Wroth, author of a romance and sonnet cycle, suffered a decline in social status when she bore the Earl of Pembroke two illegitimate children; Elizabeth Cary, author of a play, was to leave her husband and position to become a Catholic recusant. See Josephine A. Roberts, "The Biographical Problem of *Pamphilia to Amphilanthus*," *Tulsa Studies in Women's Literature* 1 (1982): 47; *The Lady Falkland: Her Life, from a MS in the Imperial Archives at Lille* (London: Catholic Publishing and Bookselling Company, 1861).

3. Vives, *Instruction of a Christen Woman,* D6. Vives used Paul's prohibition to justify the prevention of the expression of women's learning outside the home.

4. Conventional as well as exceptional writings by women are catalogued in Betty Travitsky, *The Paradise of Women: Writings by Englishwomen of the Renaissance* (Westport, Conn.: Greenwood Press, 1981); for translations, see Patricia Gartenberg and Nena Thames Whittemore, "A Checklist of English Women in Print, 1475–1640," *Bulletin of Bibliography* 34 (1977): 1–13.

5. In the 1592 edition of the translations of Mornay and Garnier, "1590" is printed after each translation. The translation of Petrarch was never published during the Countess of Pembroke's lifetime; in the dedication of *The Silkwormes and their Flies* (1599), Thomas Moffett urges the Countess to "Let Petrarch rest." The *Antonie* is traditionally viewed as the Countess's contribution to a movement to reform the English stage according to her brother's precepts; her translation of Mornay's tract is usually perceived as her attempt to carry on her brother's work, for he had begun a translation of another work by Mornay; *The Triumph of Death* has been interpreted as an expression of "her own deeply idealized love for her brother." See Virginia Beauchamp, "Sidney's Sister as Translator of Garnier," *Renaissance News* 10 (1957): 12–13; Frances Young, *Mary Sidney, Countess of Pembroke* (London: Nutt, 1912), p. 140; Gary Waller, *Mary Sidney, Countess of Pembroke: A Critical Study of Her Writings and Literary Milieu* (Salzburg: Institut fur Anglistik and Amerikanistik, 1979); still, she could have chosen another work by Mornay to translate, for instance, the work begun by her brother, if the *Discours de la vie et de la mort* had not been interesting to her for its own sake. See Josephine A. Roberts, "Recent Studies in Women Writers of Tudor England, II: Mary Sidney, Countess of Pembroke," *English Literary Renaissance* 14 (1984): 426–39.

6. For a range of options of works to translate, see Gartenberg and Whittemore's "A Checklist of English Women in Print, 1475–1640."

7. Diane Bornstein, *The Countess of Pembroke's Translation of Philippe de Mornay's DISCOURSE OF LIFE AND DEATH* (Detroit, Michigan: Michigan Consortium for Medieval and Early Modern Studies, 1983), pp. 6–7.

8. Nancy Lee Beaty, *The Craft of Dying, A Study in the Literary Tradition of the ARS MORIENDI in England,* Yale Studies in English, 175 (New Haven, Conn.: Yale University Press, 1970); Louis B. Wright, *Middle-Class Culture in Elizabethan England* (Chapel Hill, N.C.: University of North Carolina Press, 1935), pp. 248–51.

9. An interesting accommodation of Calvinism to the *ars moriendi* tradition occurs in the account of the death of Katherine Stubbes, who overcomes the devil's temptation to despair and is inspired to preach Calvinist theology on issues such as predestination; see Philip Stubbes, *A christall glasse for christian women* (London, 1591).

10. Beaty, *The Craft of Dying,* pp. 54–107. esp. 106.

11. December 24, 1595 letter from Henry Herbert to Sir Francis Hastings, described and quoted in the Historical MSS Commission *Report on the MSS of the*

late Reginald Hastings, of the Manor House, Ashby-de-la-Zouche, ed. Francis Bickley (London: His Majesty's Stationery Office, 1930), 2:43–44.

12. Dec. 5, 1595 letter from Rowland Whyte to Robert Sidney, quoted in Arthur Collins, *Letters and Memorials of State . . . whereunto is added, also Memoirs of the Lives and actions of the Sydneys* (London, 1746), 1, p. 372.

13. *The Third Volume of Chronicles, beginning at duke William the Norman . . . First compiled by Raphaell Holinshed . . . Now newlie recognised, augmented, and continued (with occurrences and accidents of fresh memorie) to the year 1586* (London, 1587), L1111112.

14. W. B., *The Maner to Dye Well* (London, 1578), C5.

15. I. S., *A christian exhortation taken oute of the holy Scriptures, for the great comfort of every person being in the agonie of deathe* (London, 1579), *passim.*

16. William Perkins, *A Salve for a Sicke man* or, the right manner of dying (London, 1595), title page.

17. Besides the death of Katherine Stubbes in Philip Stubbes, *A christal glasse for christian women* (1591), see lives of Katherine Evans and Sarah Chevers (1662), Mary Simpson (1649), Elizabeth Wilkinson (1659), and others listed in Owen C. Watkins, *The Puritan Experience* (London: Routledge & Kegan Paul, 1972), pp. 241–60; central to this development is the increasing publication of funeral sermons as examples to the faithful.

18. Ralph Graham Palmer, *Seneca's "De Remediis Fortuitorum" and the Elizabethans,* Institute of Elizabethan Studies, 1 (Kendal: Titus Wilson and Son, 1953), p. 1; according to Bornstein, p. 7, Mornay's "emphasis is so much on Stoic themes . . . that when the author briefly speaks of Christian immortality, it almost strikes a jarring note."

19. Vives, *Instruction of a Christen Woman,* 4v; Kelso, *Doctrine for the Lady of the Renaissance,* pp. 70–73.

20. G. C. Williamson, *Lady Anne Clifford* (N. Y.: Kendal, 1922), p. 339.

21. *The Lady Falkland,* p. 4.

22. Bornstein, *The Countess of Pembroke's Translation,* p. 6; Palmer, *Seneca's "De Remediis Fortuitorum,"* pp. 2–6.

23. *Antonius, A Tragedie written also in French by Ro. Garnier* (London, 1592), G1. All citations will be taken from this edition, which was bound with the tract by Mornay. It is commonly referred to as the *Antonie.*

24. Guillaume du Vair, *The Moral Philosophie of the Stoicks,* trans. Thomas James, 1598, ed. Rudolf Kirk (New Brunswick, N. J.: Rutgers University Press, 1951), pp. 73–75.

25. Samuel Daniel, *Tragedie of Cleopatra* (London, 1594), A2.

26. Pierre Spriet, *Samuel Daniel (1563–1619): Sa Vie—Son Oeuvre* (Didier, 1968), p. 375.

27. III, 485–88, 495–96; all citations taken from 1599 edition available in Geoffrey Bullough, *Narrative and Dramatic Sources of Shakespeare,* vol. 5 (New York: Columbia University Press, 1964) pp. 406–49. The 1595 edition of the *Antonie* is also available in this volume.

28. In this respect, Cleopatra's heroism implies a "bitter subtext of egotism repressed," a conflict between self-assertion and self-effacement present in several seventeenth-century autobiographies by women; see Mary Beth Rose, "Gender, Genre, and History: Seventeenth-Century English Women and the Art of Autobiography," in this volume.

29. Ruth Hughey discusses parallels between *The vertuous Octavia* and Daniel's "Letter from Octavia," *The Arundel Harington Manuscript of Tudor Poetry*, vol. 2 (Columbus, Ohio: Ohio State University Press, 1960), p. 383; R. B. McKerrow, intro. to Samuel Brandon, *The virtuous Octavia* (Oxford: The Malone Society, Oxford University Press, 1909), p. v. For the relationship between Audelay and Thinne, and Thinne's residence at Longleat, twenty miles from the Countess's estate at Wilton, see Arthur Collins, *The Peerage of England*, vol. 6 (London: T. Bensley, 1812), p. 554 and *The Visitation of Wiltshire 1623*, ed. George W. Marshall (London: Bell and Sons, 1882), p. 60.

30. Ed. R. B. McKerrow; all citations will be taken from this edition.

31. *Ibid.*, F7.

32. Francis Petrarch, "The Triumph of Chastity," in *The Triumphs of Petrarch*, trans. Ernest Hatch Wilkins (Chicago: University of Chicago Press, 1962), pp. 44–45.

33. *The Triumph of Death and Other Unpublished and Uncollected Poems by Mary Sidney, Countess of Pembroke, 1561–1621*, ed. G. F. Waller (Salzburg, Institut fur Englische Sprache und Literatur, 1977), p. 68. All citations will be taken from this edition.

34. Wilkins, *The Triumphs of Petrarch*, p. v.

35. Thomas M. Greene, *The Light in Troy: Imitation and Discovery in Renaissance Poetry* (New Haven, Conn.: Yale University Press, 1982), pp. 104–26; Giuseppe Mazzotta, "The *Canzoniere* and the Language of the Self," *Studies in Philology* 75 (1978): 271–96.

36. For discussion of the role of these models, see Lisa Jardine, *Still Harping on Daughters* (New York: Barnes and Noble, 1983), pp. 169–98.

37. Louis B. Wright, *Middle-Class Culture in Elizabethan England*, p. 490; Doris Mary Stenton, *The English Woman in History* (New York: MacMillan, 1957), p. 141; Myra Reynolds, *The Learned Lady in England, 1650–1760* (Boston: Houghton Mifflin, 1964, 1st pr. 1920), pp. 4–23.

10

Inventing Authority of Origin
The Difficult Enterprise

TILDE SANKOVITCH

". . . le silence, ornement de la femme, peut couvrir les fautes de la langue et de l'entendement: je respondray qu'il peut bien empescher la honte, mais non pas accroistre l'honneur, aussi que le parler nous separe des animaux sans raison . . ."

(. . . silence, ornament of women, may cover mistakes of language and of judgment: I'll answer to that, that silence may well prevent shame, but cannot enlarge honor, and that speaking separates us from the witless beasts.)

Madeleine des Roches

*I*N FRENCH RENAISSANCE POETRY of the Pléiade period the problem of the poet-predecessor—which Harold Bloom calls "the anxiety of influence," Terence Cave, "a perpetual confrontation with alien writing,"[1] and recent critical theory, "intertextuality"—is handled with vigor and confidence. Sixteenth-century theorists treat the question at great length and with inventive gusto as that of *imitatio*. Du Bellay outlines in his *Deffence et Illustration de la langue françoise* (1549) a theory of imitation based on "concordance of identities as the basis for two discourses, parallel but necessarily and authentically different."[2] It is a process of fruitful *innutrition:* "Immitant les meilleurs aucteurs Grecz, se transformant en eux, les devorant, et apres les avoir bien digerez, les convertissant en sang et nouriture" (imitating the best Greek authors, transforming oneself into them, devouring them, and after having digested them well, converting them into blood and food), *Deffence* (I, vii, pp. 42–43).

This basically optimistic approach to the problem of intertextuality is reinforced in these poets by two factors: the humanistic belief in the possibility of fashioning oneself and the confident as-

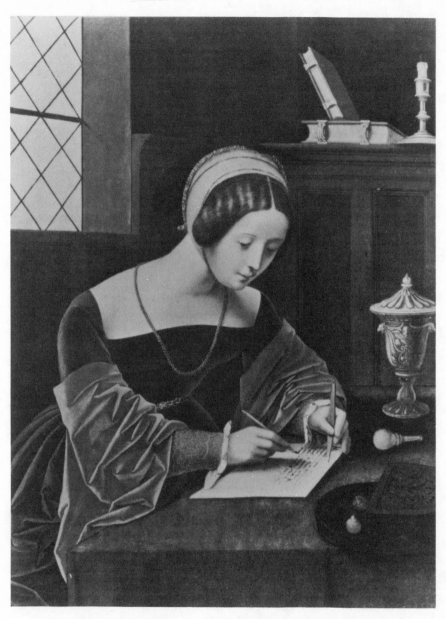

Baudonivie writing the *Vita* of St. Radegund. From the *Vita* of St. Radegund (eleventh century), Bibliothèque Municipale Classée, Ms. 250, Fol. 43ᵛᵒ. *Courtesy of the Bibliothèque Municipale, Poitiers.*

sumption that they (the poets) are the legitimate heirs and descendants of a long and exalted poetic tradition. From Phoebus Apollo and the Muses, from Orpheus and the other "Poetes divins" (Ronsard, "Ode à Michel de L'Hospital"), from the Greek and Roman poets, "ces grand Demons humains, ces Chantres et Poëtes" (these great human Demons, these Singers and Poets [Jodelle, "Epithalame de Madame Marguerite"]), the sixteenth-century poets inherit the divine lyre which turns them into "Prophetes des Dieux" (Prophets of the Gods [Ronsard, "Ode à du Bellay"]) and transforms France into the new dwelling place of poetry. Thus the poets experience no problem of origin: all the ancient mythology exists to reassure them of the divine origin of their inspiration and activity, and of their deserved place in the "mythique Chaîne platonicienne de la transmission . . . poétique" (mythical Platonic chain of poetic transmission).[3] Ronsard calls Apollo "O Pere, ô Phoebus Cynthien/O Saint Apollon . . ." (Odes I, 20), and sees that father/son relationship not in the oedipal terms of conflict and anxiety which Harold Bloom confers on the confrontation of precursor-text and descendant-text, but rather as a guarantee of constant access to an inspiration which predates all texts. Ronsard sees himself and all other poets, ancient and contemporary, as the legitimate sons of a divine father: "O vous chantres honorez,/Qui tenez en ce bas estre/Vostre naistre/D'Apollon aux crins dorez" (O you honored singers,/Who, in this base world/Owe your birth/To golden-haired Apollo). This sense of legitimacy allows the poet a great deal of confidence in his interaction with his human poetic predecessors. In them, after all, he encounters his own genealogy, which allows him to "keep everything in the family."[4]

This confidence is reinforced by the humanistic belief, proclaimed by Pico de la Mirandola and joyfully accepted by many French humanists and poets, that, as Pico says in *De Hominis Dignitate,* man is eminently capable of fashioning himself into whatever he desires to be, since God has awarded him the privilege of self-determination, "nullis angustiis coercitus." The male poet may well see himself as a descendant of the gods and a favorite son of God! Sure of his powers and his privileges, he enjoys the pleasure and energy of creativity to the full.

During this period a large number of women seem to have been poetically active, but they lack the self-assurance, as well as the reputations, of their male peers. Leon Feugère names no less than sixty-four women authors, among whom figure such eminent writ-

ers as Louise Labé, Pernette du Guillet, and Marguerite de Navarre, but most of whom are not at all known, even by *seizièmistes*. Their obscurity stems primarily from the fact that their works either have not been reprinted since the sixteenth century or have never been printed at all, which Feugère attributes to woman's becoming modesty.[5] What I would like to argue, however, is that the reticence of women poets in the French Renaissance stems not from that supposedly innate feminine modesty, but from the problems posed for women authors by their desire for poetic creativity and their need for poetic legitimacy.

In this essay I will deal with two women poets of the sixteenth century who have examined the problems of the sources of poetic authority and of the justification of poetic activity throughout their work. Madeleine (c. 1520–87) and Catherine (1542–87) des Roches, a mother and daughter from Poitiers, wrote and published a substantial body of work, consisting of poems, prose dialogues of a philosophical nature, translations of Latin texts, letters, and even a tragi-comedy. Widely known and admired in their time and circle, they are today mentioned in histories of literature because of their early role in the creation of the *salon* and of the *genre épistolaire*.[6]

As I have indicated, what interests me about these women is that they were not blind concerning the problematic aspects of female creativity, and they have dealt with these conflicts in their work. They clearly realize that, as poets, they cannot situate themselves within the sacred pedigree of their male contemporaries, and they seek to replace that tradition—which confers authority of origin, but not on them—with a genealogy of their own making, suited to the needs of their gender. In other words, they recognize that "le texte a partie liée avec la génitalité" (the text is in league with genitality),[7] and, recognizing also the dominant male genitality coded into the predecessor-texts as well as into the texts of their contemporaries, they strive to develop for themselves a female poetics, leading to a female text.

In the aforementioned Renaissance "confrontation with alien writing," the experience of alienation is fully real only for women, who feel neither the anxiety nor the security of influence experienced by male poets. As humanists, women artists feel compelled to confront and ingest the work of their male poet-predecessors and to seek nourishment from it; but as poets they feel exiled from this writing, since they are aware that the intertextual "grephe" (graft) recommended by du Bellay *(Deffence)* presents problems not only of "sau-

vegarde de l'organisme où elle [la grephe] se loge" (safekeeping of the organism in which it [the graft] lodges itself),[8] but of basic incompatibility; that the process of digestion might well mean debilitating indigestion! Even the very act of seeking nourishment may be problematic for women. As humanist poets the Dames des Roches see *sçavoir* (knowledge) and poetry as inseparable (cf. Ronsard: "Les Muses sont l'estude et le sçavoir" [The Muses are in study and knowledge] in "La Lyre"); but *sçavoir,* indispensable to creativity, is often forbidden to women, on whom society imposes limits of learning and of knowing. Madeleine writes:

> Nos parens ont de louables coustumes,
> Pour nous tollir l'usage de raison,
> De nous tenir closes dans la maison
> Et de nous donner le fuzeau pour la plume.
>
> Une femme assez sage
> Qui file et faict son mesnage,
> L'on y fait mieux son profit.[9]

> [Our parents have the laudable custom,
> In order to deprive us of the use of our wits,
> Of keeping us locked up at home
> And of handing us the spindle instead of the pen.
>
> A woman who is smart enough
> To spin and to keep house,
> That is really more profitable.]

She also laments the fact that her own youthful impulse toward poetry was curtailed in her adulthood by the needs of her "profession," that is, her social and domestic roles:

> Au temps heureux de ma saison passee
> J'avoy bien l'aile unie à mon costé:
> Mais en perdant ma jeune liberté,
> Avant le vol ma plume fut cassee.
>
> Je voudroy bien m'arester sur le livre,
> Et au papier mes peines souspirer.

Mais quelque soing m'en vient tousjours tirer,
Disant qu'il faut ma profession suivre.

[In the happy time of my past season
My wings were firmly attached to my sides:
But, in losing my young freedom,
Before flight my feather [that is, my pen] was clipped.

I'd love to sit over my books,
And, sighing, confide my sorrows to the paper,
But some occupation always comes up to pull me away,
Telling me that I must follow my profession.]

She protests against what she feels to be an injustice, and, indeed, an act of violence, inflicted upon women by a male-dominated culture:

Les hommes ont toute l'autorité
Contre raison et contre l'equité.
Il me suffit aux hommes fair voir
Combien leurs loix nous font de violence.

[Men have all the authority
Against reason and against fairness.
It is enough if I can make men see
To what point their laws commit violence upon us.]

She and her daughter yearn for what is man's birthright: the possibility of fashioning themselves. They wish to give form and shape to themselves by writing, and to gain *honneur*, that is, poetic immortality, in the process. Madeleine understands that "la lettre est l'art qui prenant la matiere/Luy peut donner la forme la plus entiere" (writing is the art which, taking matter/Can give it its most complete form), and that women, by renouncing poetry, accept that they can receive form and attain possible escape from oblivion only from male poets. Both she and Catherine express the conviction that women must, by writing, overcome this silence and conquer their mortality themselves. Madeleine says: "Vous pouvez de vous mesme/Vous venger du sort blesme/Sans mendier l'escrivain" (You can by yourselves/Take revenge on pale fate/Without begging any writer), and Catherine speaks of women who, by womanly wiles, seek approval from male

poets, "desirant qu'ils puissent devenir dignes chantres de leurs beau-
tez, encores qu'elles ayent bien la puissance de se chanter elles mes-
mes" (hoping that they will become the worthy singers of the
women's beauty, although women have fully the power to sing
themselves). Of course, it is precisely that hypothetical *puissance*
which must be grounded in a genealogy similar to, yet profoundly
different from, that of the male poets, so that it may gain in authentic
origin an authentic authority.

Madeleine and Catherine des Roches undertake the project of
establishing their poetic origin by using as a starting point the inti-
mate bond between themselves.[10] The mother/daughter relationship
of giving and receiving biological life is paralleled by a reciprocal life-
giving creative exchange. The mother continually encourages her
daughter "de faire ton devoir/Envers la Muse et le divin sçavoir" (to
do your duty/Towards the Muse and divine knowledge). She recog-
nizes her debt to Catherine as well: "ma Fille, qui par le vol de ta
plume, sans mendier l'aide d'autruy, prends peine de me tirer hors des
nuitz Cimerienes, où l'ignorance et la viellesse me tenoient ensevelie,
tu ressembles au vert rameau, qui n'oublie jamais la vielle souche qui
luy a donné un peu de matiere sans forme . . . Ta force m'encourage
de parler en public" (my daughter, you who by the flight of your pen,
without begging for anybody's help, take the trouble to free me from
the Cimmerian nights in which ignorance and old age kept me
buried, you resemble the green twig which never forgets the old
stump which has given it a little formless matter . . . Your strength
encourages me to speak in public). Catherine, talking aboout the role
played by her mother in her creative life, calls Madeleine "mon
appuy," and "la vie de ma vie" (my support, life of my life). The
analogy of life-giving/poetry-giving is clear. The two poets then
transmute that bond onto a mythological plane—for the figures of
myth remain the paradigmatic figures of desirable origin—by replac-
ing the father, Apollo, with what they construe as a mother-of-poetry
configuration, the Ceres/Proserpina unit that functions simul-
taneously as a mirror-image of their own creative bonding. Thus they
enter, legitimately, the mythological domain, so important for six-
teenth-century practitioners of poetry. François Rigolot talks about
"la fonction révélatrice du mythe en tant que signature de chaque
auteur" (the revelatory function of myth as signature of each au-
thor).[11] The Ceres/Proserpina figure, then, functions both as a guar-
antee of the intimacy between Madeleine and Catherine and as a

paradigm of poetry: that is, poetry as the giving and receiving of life: "Ceres la blonde/Qui garda tant elle sceut faire/Porte-blez et legifere/ Corps et ames de perir" (The blonde Ceres/Who, bearer of wheat and maker of laws, kept/As much as she could,/Bodies and souls from perishing [Madeleine]). Although Ceres (much more than Proserpina) figures a fair amount in the writings of the Pléiade poets, she is imagined in the one-dimensional role of a goddess of agriculture, not as the mother-of-life who is also the goddess of poetry. Demerson remarks that "toute mythologie est conservatrice, par fonction: per-pétuant des signes fixés par la tradition, ce sont les idées et les institutions du monde présent qu'elle tente de préserver contre la dégradation en leur attribuant une valeur absolue et intemporelle" (all mythology is conservative by its very function: perpetuating signs fixed by tradition, mythology attempts to preserve the ideas and values of the present world against degradation, by attributing to them an absolute and timeless value).[12] Madeleine and Catherine des Roches go much beyond that conservative *préservation:* they choose the Ceres/Proserpina myth for its possibilities, re-tell it in the images and terms of their own reality, and establish a new institution: that of women poets.

It is not surprising that Catherine chose to translate Claudian's *De Raptu Proserpinae*. In a rudimentary yet fruitful way translation is a road into positive intertextuality, and here is a text which must have spoken to Catherine with the familiarity of her own voice. Claudian's narrative poem tells the story of the abduction and rape of Proserpina by Pluto and ends with the terrifying spectacle of a desperate Ceres stalking the earth in search of her daughter. The violent separation of Ceres and Proserpina signifies the coming of the end of poetry, as life decays and wilts: "Le pudique laurier a changé de feuillage" (The chaste laurel has changed its foliage). Together with poetry's immortal laurels, now reduced to mortality, Ceres' "couronne d'epis" (crown of wheat) dies, while "la fluste de Lydie/gemit de mort" (the Lydian flute/moans of death). Thus an element of precariousness and vulnerability is built into this particular mythic structure, and the possibility of loss and disruption is menacingly present.

Another myth which Catherine uses is that of the Amazons. In the "Mascarade des Amazones" she has the Amazons say, "Nous rapportons en main les Myrtes et les Lauriers" (We carry in our hands Myrtle and Laurel), and "en toutes parts la femme ne resonne/Que du pouvoir hautain de la Roine Amazone" (everywhere all women speak

only/Of the high power of the Amazon Queen). Where the Ceres myth justifies the initial urge of female creation by tracing it to the mother/daughter exchange, the Amazons seem to perpetuate and guarantee creative strength, leading to poetic rewards. More than anything else, they embody indomitable courage and moral virtue, both guarantees of potential power: "Nous faisons la guerre/Aux Rois de la terre/Bravant les plus glorieux./Par nostre prudence/Et nostre vaillance/ . . . Nous chassons les vices,/Par les exercices/Que la vertu nous apprend" (We wage war/Against the kings of the earth/Defying the most glorious ones./By our prudence/And our valour/ . . . We chase away vices/By the practices/Which virtue teaches us ["Chanson des Amazones"]).

But the most telling myth of all is one which Catherine invents, that of *l'Agnodice*. In a long narrative poem we learn how *Envie* causes men to become "les tyrans de leurs femmes/Qui leur deffendant le livre et le sçavoir/Leur osteront aussi de vivre le pouvoir/[Et] leur ostent le plaisir où l'ame se recree" (the tyrants of their wives./By forbidding them books and knowledge/They take away their life-power/[And] also take away the pleasure in which the soul recreates itself). Thus deprived of *sçavoir,* the women fall into unremitting illness. Childbirth especially becomes an unbearable suffering: "Mais surtout la douleur de leurs enfantemens/Leur faisoit supporter incroyables tourmens" (But above all the pain of giving birth/Made them suffer incredible torments). The women, powerless, are unable even to help each other: "Les femmes (ô pitié!) n'osoient plus se mesler/De s'aider l'une l'autre, on les faisoit filer" (The women [alas!] did not dare to undertake/To help one another, they were made to spin). Wanting to help her sisters, a young woman, "belle, sage, et subtile" (beautiful, wise, and subtle), disguises herself as a man in order to be allowed to study medicine, and to "guerir les douleurs de ses pauvres voisines/D'une herbe mesmement qui fut cueillie au lieu/Où Glauque la mengeant d'homme devint un Dieu" (heal the sufferings of her poor neighbors/With an herb picked on the very spot/Where Glaucus, eating that herb, from man became a god). When she is ready "la gentille Agnodice," still dressed as a man, goes to the women, and secretly revealing her sex by her "blanches pommes rondes" (white round apples), cures them with the herb of poetic life. *Envie* alerts the men, who are ready to seize and kill Agnodice. When, however, she reveals her true identity and her purpose which "n'est point pour les tromper, mais pour authoriser/Les lettres . . ." (is not

to cheat them, but to gain/writings . . .), the men become ashamed. Converted by Agnodice's "rare excellence" (which has on them an effect similar to that of Orpheus on beasts, rocks, and rivers!), they agree to let their wives taste once again the pleasures of poetry, "sans envier la gloire/Que l'on a pour servir les filles de Memoire" (without envying the glory which one obtains by serving the daughters of memory [that is, the Muses]).

Several aspects of this myth deserve a closer look. First of all, Catherine, needing a strong mythic base and not finding it in the well-known figures of male mythology, engages in her own mythopoeic enterprise and, engendering her own origin and her own justification, extends them to all women. Yet there are connections between Catherine's creation and the Apollo myth in that both Apollo and Agnodice are healers. Ronsard calls Apollo "Poëte, et gouverneur de toute herbe" (Poet, and master of all herbs), Odes, I, 20, and implores him for "l'herbe forte qui changea/Glauce si tost qu'il la mangea, le faisant immortel" (the strong herb which changed/ Glaucus as soon as he ate it, making him immortal), the same herb which Agnodice uses to heal the women by admitting them to divine immortality. This healing aspect, important but not dominant in Apollo, is the crucial activity of Agnodice. The meaning is clear: poetry heals women's deadly alienation, both from themselves as life-givers (cf. "la douleur de leurs enfantemens"), and from other women (cf. "n'osoient plus se mesler"), and frees them from their destructive imprisonment in an imposed occupation (cf. "on les fasoit filer"). Poetic possibility is inseparable from the bond between women, but this bond may have to remain hidden. Agnodice has to disguise herself, revealing her true identity only in secret, or when her life is in danger. Her name, of course, means "the Unknown." Much has been written on the significance of the *nom propre*. E. R. Curtius points out that Dante's dictum "nomina sunt consequentia rerum" had been adopted with enthusiasm by the Renaissance.[13] Julia Kristéva remarks that "l'annonce du nom propre . . . tient lieu de tout un univers de discours" (the declaring of the proper name . . . stands for a whole universe of discourse),[14] and François Rigolot states that "en règle générale, la signification du *Nom poétique* sera perçue comme un *détour* pour saisir de biais l'idéologie du texte" (as a rule, the significance of the poetic Name may be perceived as a roundabout way of approaching, indirectly, the ideology of the text).[15] "The Unknown" is full of ideological resonances, as it evokes the idea of women deeply un-

known in their intellectual and creative needs and capacities; women condemned to un-knowing each other and themselves, and so their creativity; women's problematic and often limited access to learning and thus to knowing; the danger yet the need inherent in knowing and in being known; and the "wealth unknown of these texts," an expression used by Geoffrey Hartman to designate lost texts by women poets.[16]

By setting up a myth of un-known-ness on the one hand, and of healing on the other, "L'Agnodice" establishes for women poets an authority of origin which subsumes weakness and danger in an encompassing strength. However, there is again a threatening precariousness in the ending of the myth: men's *Envie*, which will encourage them to make women spin rather than practice poetry, is ever alive: "L'Envie cognoissant ses efforts abattus/Par les faicts d'Agnodice, et ses rares vertus/A poursuivy depuis d'une haine immortelle/Les Dames qui estoient vertueuses comme elle" (Envy, recognizing the defeat of its work/By Agnodice's action, and by her rare virtues/Has ever since persecuted, with mortal hatred/All ladies who were as virtuous as she). Thus what remains lacking is the total confidence that might assure a definite conquest of poetry. Instead we see signs of ambivalence, all centered on the semiotic area of the verb "filer" (to spin), a sign, as we have already seen in "L'Agnodice," of life-depriving, anti-poetic activity. Spinning and equivalent occupations (weaving, embroidering) as well as their appendages (spindle, distaff, needle) have long been symbols of women's appointed function and role: domesticity with all its positive and negative implications.

In the Renaissance spinning and the distaff are often evoked on both sides of the feminist debate by authors such as Erasmus, Thomas More, Agrippa von Nettesheim, Jean Bouchet, André Tiraqueau, and Charles de Sainte-Marthe, as well as by women writers. In his poem, "La Quenouille," Ronsard sees the distaff as both "maisonnière" (a sign of woman as the dispenser of comfortable erotic domesticity) and "chansonnière" (a phallic sign of his own poetic creativity). In mythology, Zeus sends Hercules to Lydia to be a slave of the Queen, Omphale, who makes him dress as a woman and spin. Together with figures like Medea, Circe, or Medusa, Omphale is viewed by French Renaissance authors as an example of women's dangerous wiles.[17] But in this story of punishment inflicted by woman upon man, there is also a mythic element of feminine self-

contempt: the worst possible fate Omphale can conceive for Hercules is to trap him in a feminine appearance, tied to the treadmill of feminine activity. Inspired by this myth Catherine des Roches writes in the "Chanson des Amazones":

> Nous tenons les hommes
> Des lieux où nous sommes
> Tous empeschez à filer:
> Leur lasche courage
> D'un plus bel ouvrage
> N'est digne de se mesler.

> [We keep the men
> In our countries
> All busily spinning:
> Their cowardly wits
> Do not deserve
> To take up more beautiful work.]

Spinning is the second-rate, the unfree activity. Plato uses the distaff to symbolize the necessity which reigns at the heart of the Universe, and woman, if she is deprived, as she often is, of the counteracting flexibility, remains dominated by nothing but necessity. Yet in François de Billon's *Le Fort inexpugnable de l'honneur du sexe Feminin* (1555) the invention of spinning and weaving is seen as the first accomplishment on a whole list of feminine achievements, which also includes "l'invention des lettres" by the nymph Carmentis.[18] Catherine des Roches herself makes a positive connection between the spindle and life:

> Achille feit tort a ses mains
> Quittant le fuseau pour l'espee:
> L'un file la vie aux humains,
> De l'autre la vie est coupee.

> [Achilles wronged his hands
> When he abandoned the spindle for the sword:
> One spins life for human beings,
> The other cuts life down.]

In "Le Ravissement de Proserpine" Proserpina is weaving a tapestry for Ceres at the time of her abduction:

Proserpine chantoit d'une mignonne grace
Et pour sa Mere absente elle tissoit en vain
D'un art laborieux et d'une docte main
Une toille admirable . . .

[Proserpina sang with delicate grace
And wove for her absent Mother
With diligent skill and knowing hand
An admirable cloth . . .]

Singing and weaving are depicted as harmonious rather than inimical
or mutually exclusive occupations; but that Utopian state is forever
disrupted by the male invader. When Ceres comes to see her daugh-
ter, "elle trouve l'ouvrage/Que sa fille tissoit/Demy rompu sus un
mestier brisé" (she finds the work/Her daughter was weaving/Half
destroyed on a broken loom).

Although spinning is depicted by such Renaissance women
authors as Hélisenne de Crenne, Louise Labé, and the Dames des
Roches as a demeaning and confining occupation,[19] there is also a
very persistent awareness that it signifies all the traditional functions
and activities which give women *droit de cité* in sixteenth-century
culture and society. Refusal of that conventional *socialité* is not, in any
way, unproblematic. Madeleine des Roches writes courageously,
"j'aime mieux escrire que filer," but Catherine expresses, in the
following sonnet, a fragmenting ambivalence:

A ma Quenoille

Quenoille mon souci, je vous promets et jure,
De vous aimer toujours, et jamais ne changer
Vostre honneur domestic pour un bien estranger,
Qui erre inconstamment et fort peu de temps dure.

Vous ayant au costé je suis beaucoup plus seure
Que si encre et papier se venoient arranger
Tout à l'entour de moy, car pour me revanger
Vous pouvez bien plustost repousser une injure.

Mais quenoille m'amie, il ne faut pas pourtant
Que pour vous estimer, et pour vous aimer tant
Je delaisse du tout cest'honneste coustume

D'escrire quelque fois; en escrivant ainsi

J'escri de voz valeurs, quenoille mon souci,
Ayant dedans la main le fuzeau et la plume.

To my Spindle

My spindle and my care, I promise you and swear,
To love you forever, and never to exchange
Your domestic honor for a good which is strange,
Which, inconstant, wanders, and tends its foolish snare.

With you at my side, dear, I feel much more secure
Than with paper and ink arrayed all around me
For, if I needed defending, there you would be
To rebuff any danger, to help me endure.

But, spindle, my dearest, I do not believe
That, much as I love you, I will come to grief
If I do not quite let that good practice dwindle

Of writing sometimes, if I give you fair share,
If I write of your merit, my friend and my care,
And hold in my hand both my pen and my spindle.

The hesitation between "quenoille" and "plume" signifies the deep split in the poet's self.

In the beginning lines of the poem Catherine addresses the distaff almost as if it were a husband, calling it her "souci" (that is, the "normal" focus of her preoccupations and occupations), and abandoning her freedom to it in quasi-legalistic terms of promise and oath, thus conferring on "spinning" the prestige and the rigidity of the legal act, and forsaking the flexibility of the self-fashioning *moi*. The "honneur domestic" is opposed to the "bien estranger," which is presented, as it were, as a lover, and is the poetic act, seductive and alien. So we have in the first stanza already a vocabulary of "souci" (promettre, jurer, aimer toujours, jamais ne changer, honneur domestic), and a vocabulary of "bien" (estranger, errer inconstamment, fort peu de temps durer): two opposed codes, one of freedom but also of danger and precariousness, the other of rigidity, but also of safety and stability. Julia Kristéva describes woman as being coded by the fetishistic code of "désir," that is her "normal" function, which Catherine calls "souci," and yet solicited by "jouissance," which

Catherine calls "bien," the experience of free, non-fetishistic, poetic creativity, called in "L'Agnodice" "le plaisir où l'ame se recree." Kristéva sees woman as always divided between "un langage qui est toujours celui des autres" (a language which is always that of the others), and the self-oriented enticements of poetry: "pour autant qu'elle se demande comment parler ce que de sa jouissance le code social—filial ne représente pas, elle prête l'oreille au rythme poétique . . . Mais pour autant que, devenue sujet d'une société productrice-reproductrice, elle est codée d'un seul désir (celui de l'enfant) . . . elle participe au fétichisme général; plus encore, par ce revirement de la jouissance au désir la femme reste le support le plus solide de la socialité" (Insofar as she [woman] wonders how to speak that what of her pleasure the social-filial code does not represent, she lends an ear to poetic rhythm . . . But insofar as, subject of a productive-reproductive society, she is coded by one single desire [that of the child] . . . she participates in the general fetishism; even more, through that switch from pleasure to desire, woman remains the most solid support of sociality).[20]

In the second stanza of the poem, Catherine names "le bien," but weakens it at the same time. The distaff-husband protects, while pen and ink, in the hands of a woman, are weak. Their presence is enveloping but ineffective. The tone changes in the third stanza when she addresses the distaff as "m'amie," that is, as a woman, as weak. It is only through this subterfuge that she dares to suggest that she be allowed to indulge in creating poetry, which is now called "cest'honneste coustume"—terms more suggestive of duty and sociality than of "bien estranger." The possibility of writing exists only through that transformation which adapts to poetry the "honnêteté" of the legal, the legitimacy of the social; even so there are reservations: "quelque fois." In the last two lines, the distaff occupies again the dominant place of the husband, as "souci," adorned with "valeurs," eliminates the possibility of *jouissance,* and usurps the substance of the text itself.

Thus, through the feminine metaphor of spinning, this deeply melancholy poem expresses with painful clarity Catherine's ambivalence toward poetic creation. Freud points out that ambivalence and melancholia are often inseparable, and he describes melancholia as a withdrawal of libido from its object, and a projection of the object, by identification, onto the ego, so that "the ego itself is then treated as though it were the abandoned object."[21] Hesitating—now

withdrawing, now consenting—torn between two objects, both of which are, tortuously, herself, Catherine must always project upon herself rejection and loss. She must always see herself as mutilated and alienated, whether she opts for her "souci" or for the "bien estranger."

The Dames des Roches' effort to create an origin and an authority for women's poetry seems flawed by the fundamental fragmentation of woman's self. The effort, nevertheless, is admirable and significant, especially when seen in the context of the great Renaissance poetic enterprise. It should be recognized and studied, together with its failure, as part of that enterprise's challenge and history.

NOTES

1. *The Cornucopian Text. Problems of Writing in the French Renaissance* (Oxford: Clarendon Press, 1979), p. 325.

2. *Ibid.*, p. 65.

3. Guy Demerson, *La Mythologie classique dans l'oeuvre lyrique de la "Pléiade"* (Genève: Droz, 1972), p. 552.

4. Jonathan Culler, *The Pursuit of Signs* (Ithaca: Cornell University Press, 1981), p. 108.

5. *Les Femmes poètes au XVIe siècle* (Paris, 1860; Genève: Slatkine, Reprints, 1969), p. 70.

6. In 1936 George Diller published his Princeton dissertation on *Les Dames des Roches. Etude sur la vie littéraire à Poitiers dans la deuxième moitié du XVIe siècle* (Paris: Droz, 1936).

7. Julia Kristéva, *La Révolution du langage poétique* (Paris: Editions du Seuil, 1974), p. 613.

8. Laurent Jenny, "La Stratégie de la forme," *Poétique* 27 (1976): 271.

9. All quotes are from *Les Oeuvres de Mes-dames des Roches de Poitiers mere et fille. Seconde edition, Corrigee et augmentee de la Tragi-comedie de Tobie et autres oeuvres poëtiques* (Paris: Pour Abel L'Angelier, 1579), and from *Les Missives de Mesdames des Roches de Poitiers mere et fille, avec le Ravissement de Proserpine prins du Latin de Clodian* (Paris: Abel L'Angelier, 1586).

10. Their extraordinarily close relationship has been widely discussed by their contemporaries, such as Etienne Pasquier: cf. his letters, 7 and 8 in *Oeuvres Complètes* (Trévoux, 1723; Genève: Slatkine, Reprints, 1971).

11. In "Mythologie et Poésie à l'époque de la Pléiade: Problèmes et méthodes," *French Literature Series III: Mythology in French Literature* (1976): 7.

12. Demerson, *La Mythologie classique*, p. 584.

13. *European Literature and the Latin Middle Ages,* trans. Willard R. Trask (New York: Harper and Row, 1953), p. 499–500.

14. Kristéva, *La Révolution du langage poétique,* p. 341.

15. In "Rhétorique du nom poétique," *Poétique* 28 (1976): 468.

16. During a talk in a Symposium on "The Challenge of Feminist Criticism" held at Northwestern University, November 5, 1981.

17. Demerson, *La Mythologie classique,* p. 252.

18. Madeleine des Roches alludes to this myth in one of her *Odes.* Carmentis is also the protectress of women during childbirth.

19. Hélisenne de Crenne in her *Epistre Invective IV* addresses a critic of women: "En parlant en general tu dis que les femmes sont de rudes et obnubilez espritz: parquoy tu concludz, que aultre occupation ne doibvent avoir que le filer" (Speaking in general, you say that women have unpolished and dim minds: therefore you conclude that they must not have any occupation but spinning). Louise Labé, in her letter to Clémence de Bourges, writes: "Je ne puis faire autre chose que prier les vertueuses dames d'eslever un peu leurs esprits dessus leurs quenoilles et fuseaux . . . " (I can only implore the virtuous ladies to lift up their minds a little above their distaffs and spindles . . .).

20. Kristéva, *La Révolution du langage poétique,* p. 614.

21. *A General Introduction to Psychoanalysis,* trans. Joan Riviere (New York: Pocket Books, 1952), p. 434.

11

Gender, Genre, and History

Seventeenth-Century English Women and the Art of Autobiography

MARY BETH ROSE

*I*N THE late seventeenth century English women began to write secular autobiography. Largely excluded from the political arena and the professions, Early Modern women had not added to the accounts men wrote of their public lives and the development of their careers. When a woman wished to assert herself as a member of the community whose experience was worth recording, she was confined to the family history—her role as daughter, wife, and mother—or to the accounts of religious experience—the visions, trances, ecstasies, and conversions which often exempted her from traditional sexual arrangements, as well as from the social and moral taboos against female self-expression.[1] But when, in the late seventeenth century, English autobiography began to depart from its diverse and complex origins in religious narrative and in accounts of the public actions of famous men, women who were neither saints, mystics, nor proselytizers, but traditional wives and mothers, began not simply to record the deeds of their male relatives, but to explore their own identities and experience in autobiographical form.

When the modern conventions of autobiography as a distinctively personal, secular, and introspective literary form began to coalesce during the British Restoration, then, traditional wives and mothers can at once be recognized among the liveliest, most imaginative contributors to the evolving genre.[2] Viewed in terms of the early development of modern autobiography, the four women whose life accounts are the subject of this essay—Margaret Cavendish, the Duchess of Newcastle (1625–1674), Anne, Lady Halkett (1623–1699), Ann, Lady Fanshawe (1625–1680), and Alice Thornton (1626/7–1706/7)—immediately sensed the literary opportunity to assert themselves as social personalities. Rather than the articulation of their

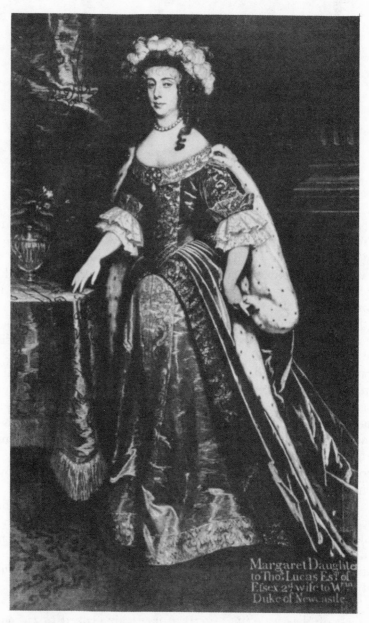

Margaret Cavendish, Duchess of Newcastle (seventeenth century).
Attributed to Abraham van Diepenbeke. *Courtesy of the Lady Anne
Bentinck.*

personal experience of the supernatural, or as passive recorders of genealogy and observers of men's deeds, what these women depict are their relations with other people and their actions within a social world of contemporary events. Although they are all pious, they do not seek to transcend what is experienced as the confinement of their bodies, but rather to embody and enact their spirituality in sexual relationships and social life.

Several reasons enabling these women to overcome the cultural injunction against female self-expression to the point of asserting the value of their individual secular experience in autobiographical form immediately suggest themselves. In general, the individual self and the private life, realms in which women could claim some authority, were beginning to be publicly valued in the seventeenth century.[3] Secondly, cut off from continental influence and freed from the stylized requirements of the conversion narrative, the conventions of English secular autobiography had yet to be formed; as feminist criticism has shown, women writers often excel when generic boundaries are construed as fluid and flexible.[4] Thirdly, as is the case with three out of the four texts under consideration, secular autobiographies by both women and men tended to remain unpublished before the eighteenth century, so that women autobiographers during the Restoration need not worry that they were asserting themselves scandalously in public.[5] Finally, and as I will argue, most importantly, all four of these women lived through the English Civil War, a period of social chaos which liberated them from many of the ordinary constrictions of sexual ideology.

Yet even the fortuitous combination of gender, genre, and history which allowed these four women to make early contributions to secular autobiography did not mitigate their expression of their social identities as problematic. Indeed, it is precisely the felt conflict between self-effacement and self-assertion, between private and public life, and between individual personality and social role that gives shape to their narratives and which they seek to resolve through the art of autobiography. In this essay I am not attempting to establish the extent to which women may be credited with influencing the development of secular autobiography.[6] Rather, by examining four texts in detail, I will explore the ways in which the early development of modern autobiography as a form of personal assessment was congenial to the expression of female sexual and social identity in late seventeenth-century England; and will demonstrate that the par-

ticular problems that women felt in constructing their identities were the very problems which the newly evolving genre was being designed to represent.

The critic Georges Gusdorf distinguishes helpfully between two types of autobiography. The first, which he calls "propaganda for posterity," comprises the attempts of the famous to commemorate and justify their public deeds; as we have seen, early modern English women were prevented from contributing to this type of life account. But as Gusdorf and many other scholars agree, autobiography finds its fertile artistic impulse and becomes a major literary genre "when the private face of existence assumes more importance" than the recording of official facts (pp. 36, 37).[7]

As Gusdorf explains, the second type of autobiographer, who is the concern of this essay, seeks above all to gain self-knowledge and to confer meaning on his or her experience through the unifying structural techniques of narrative. The author of an autobiography "strains toward a complete and coherent expression of his entire destiny . . . to reconstitute himself in the focus of his special unity and identity across time" (p. 35) by regarding the narrative as "an avowal of values and a recognition of self by the self—a choice carried out at the level of essential being" (p. 44). According to Gusdorf, the autobiographer's attempt to narrate a coherent selfhood is characterized by the apparent contradiction that arises when the self becomes both subject and object, creating "a considerable gap between the avowed plan of autobiography, which is simply to retrace the history of a life, and its deepest intentions, which are directed toward a kind of apologetics or theodicy of individual being." Because the autobiographer must assume, for example, the reliability of memory, the "impartiality of the self to itself," and the ability successfully to merge the present with the past in a single narrative framework, he or she "take(s) for granted the very thing that is in question," a gap between public and private intention that explains the puzzlement and the ambivalence of the literary genre (pp. 39, 40). The success of an autobiography therefore depends on the author's ability to reconcile these generic ambivalences by imposing on the material a narrative structure that comprises a coherent vision of him or herself as a unique, integrated human being.

Gusdorf's formulations allow us to approach autobiography as

an individual's struggle to define his or her experience by the narrative creation of a unified personality, through which the author attempts to reconcile the public and private aspects of being, often represented as conflicting. Considered as the dilemma of merging apparently contradictory levels of being into a coherent identity, the autobiographer's particular task can be equated with that of the woman writer in any form. As many scholars have shown, the attempts of woman to define herself as an integrated individual in a male-dominated society are, at worst, self-contradictory and paralyzing, and, at best, problematic.[8] In a recent essay Elaine Showalter argues that women's writing can be comprehensively assessed as a "double-voiced discourse," the product of a muted group within a dominant structure that participates both in its own unique reality and in the shared reality engendered by the more powerful elements of society: "Both muted and dominant groups generate beliefs or ordering ideas of social reality at the unconscious level, but dominant groups control the forms or structures in which consciousness can be articulated. Thus muted groups must mediate their beliefs through the allowable forms of dominant structures" (p. 30).

Showalter[9] makes clear that this "female tradition can be a positive source of strength and solidarity as well as a negative source of powerlessness; it can generate its own experiences and symbols which are not simply the obverse of the male tradition" (p. 34). As I will try to show, in female autobiography the dialogue between muted and dominant voices which Showalter describes is conjoined with the generic impulse to impose a coherent structure of selfhood on potentially contradictory aspects of identity. Because of this congeniality of impulse between gender and genre, the four texts I am about to consider become important not only as evidence of the ways in which four Early Modern women experienced the past, but also as four early, self-conscious female attempts to create the self in literary form by constituting personality as a unifying narrative principle. In each case, the success of the author's life account depends upon her ability to mediate between apparently conflicting realities by imagining herself as a socially and psychologically integrated individual.

Insofar as autobiography attempts to unite the potentially disparate materials of individual identity through the author's creation of a coherent narrative and personality structure, the Duchess of Newcas-

tle's *A True Relation of My Birth, Breeding, and Life* (1656) is an interesting and most illustrative failure.[10] Among the four female autobiographers considered here, the Duchess is in several important ways an exception. Like the other women, she is an upper-class Anglican and Royalist; the English Civil War ruptured the stable social and emotional world in which she was brought up, filling her life with chaos and a variety of experience that, in all likelihood, would otherwise have remained completely unavailable to her. Unlike the other three women, however, she never becomes a mother, nor is she a widow at the time she writes. *A True Relation* is composed while she is exiled in Antwerp with her husband, William Cavendish, the Marquis of Newcastle, who, in Virginia Woolf's words, "had led the King's forces to disaster with indomitable courage but little skill."[11] The Duchess is also the only one among these women who writes with the conscious intent of publication and, indeed, her autobiography (along with other writings of hers) was published during her lifetime. Rather than composing as the others do, with her youth, her marriage, the Civil War, and the fear of indiscretion safely behind her, the Duchess abjures the organizing principle of hindsight, choosing instead to write, as it were, from the eye of the storm. As a result, although the challenges and problems of female identity remain unresolved in her narrative, they are nevertheless articulated with an immediacy that is unusually poignant and clear.

Not surprisingly, the Duchess's unresolved narrative and personal dilemmas center on issues of independence, power, responsibility, and freedom of choice. As several critics have noted, she begins and ends her autobiography by defining herself in terms of her relations with others. Mary Mason has recently argued, for example, that the Duchess's narration presents a model of female autobiography, in which women consistently "record and dramatize self-realization . . . through the recognition of another"; and, according to Mason,[12] the Duchess establishes a "pattern of alterity–equality" in her depiction of her relationship with her husband (pp. 235, 232). But, as we will see, the Duchess's sense of attachment is in fact overwhelmed in her account by a more pressing sense of problematic uniqueness. It is true that her claim to attention as daughter and wife provides the rhetorical framework for her narrative (pp. 275, 318); yet her descriptions of her relations with others emerge not as a central, but as a subordinate element in the more compelling representation of her singularity. As an alter ego William Cavendish cuts a feeble,

shadowy figure in *A True Relation,* never coming alive as a personality and making only brief, unconvincing appearances as an idealized moral character and as a writer whose abilities supposedly exceed those of his wife (pp. 306–07). What does emerge from the account is not a personality who defines herself through relationship, but rather a troubled, complex, and indecisive shaping intelligence, whose narration can be characterized more usefully by the author's persistent attempts to subsume her individuality in her social role or her personal life.

At one point, in an erratic burst of candor, the Duchess announces both a competitive desire to excel and an independent wish to control her own destiny: "I think it no crime to wish myself the exactest of Nature's works, my thread of life the longest, my Chain of Destiny the strongest, my mind the peaceblest; my life the pleasantest, my death the easiest, and the greatest saint in heaven; also to do my endeavour, so far as honour and honesty doth allow of, to be the highest on Fortune's Wheele, and to hold the Wheel from turning, if I can. And if it be commendable to wish another's good, it were a sin not to wish my own" (p. 315).

But the natural self-regard and confident joy in singularity which this passage expresses is not sustained in *A True Relation.* Indeed the Duchess is incapable of asserting herself without beating an instant retreat. The narrative effect of her conflict between self-assertion and self-denial can best be disentangled by observing her repeated attempts to define herself not merely in terms of her personal attachments, but rather according to a Renaissance ideal of femininity, in which relations with others form a single element in a composite of prescribed character traits, including, along with subordination and obedience, modesty, chastity, shyness, gentleness, innocence, and silence.[13] These traits permeate the Duchess's idealized portrait of her mother, whom she memorializes as exquisitely beautiful, retiring, and even-tempered, a woman who, in educating her daughters, stressed the importance of moral character not as conjoined with, but at the expense of, discipline and skill (pp. 279–80). Indeed the Duchess has internalized this cultural ideal of the feminine, and she goes on to represent herself as (with the exception of beauty) the embodiment of these qualities.

Yet the Duchess proves as unable to commit herself to the self-effacement required by socially defined female behavior as she is to the more fully human challenge of individualism. Attempting to

seem modest, for example, she often assures us that she is bashful to the point of foolishness: "I durst neither look up with my eyes, nor speak, nor be any way sociable, insomuch as I was thought a natural fool," she explains, in a purportedly self-critical account of her behavior as a young lady at Court (p. 287). But her girlish modesty turns out to be foolish wisdom: "Neither do I find my bashfulness riseth so often in blushes, as contracts my spirits to a chill paleness" (p. 300), she confides later, betraying a vain, rather disintegrated preoccupation with the advantages her shyness lends to her physical appearance; indeed it is this very shyness that wins the love of the Marquis. But the Duchess does not simply disguise self-idealization as self-deprecation. She also does the opposite, namely, subverting her own claims to achievement or ambition with denial and self-contempt. Shortly after the passage quoted above, in which she exults in her uniqueness, she confesses to the reader in a moving and forthright paragraph the actual intensity of her ambition for fame which, even "if it be a vanity" (p. 317), she nevertheless desires above all things. On the same page, clearly wishing to appear more "silent, chaste and obedient,"[14] she reassures us that her deepest instinct is actually to "willingly exclude myself, so as never to see the face of any creature but my Lord as long as I live, inclosing myself like an anchorite, wearing a frieze gown, tied with a cord about my waist" (p. 317). But she had elaborated earlier her love of dressing up in fashion designs of her own invention, "for I always took delight in a singularity" (p. 312). Furthermore, despite "being addicted from my childhood to contemplation rather than conversation" (p. 307), she not only likes going "abroad," but finds exposure to public life necessary in order to gather fresh material for her writing (p. 309). In short, the Duchess's attempt to characterize herself in terms of the world's image of womanhood, to which she feels deeply attached, is nevertheless compromised everywhere by contradiction and hyperbole. Is she a moody, melancholy, contemplative genius, whose delicate modesty and innocence cannot bear the boisterous intrusion of the vulgar world? Or is she an intelligent, talented writer whose gregarious energy and productivity demand both company and fame? Is she a serious artist, whose overwhelming wealth of ideas requires nurture and expression? Or a foolish, shallow dilettante, inattentive and vain? She tells us all of these things, affirming them each with equal vehemence, denying them all with unyielding self-doubt. Are her thoughts and ideas really worth writing about? Does the world's

opinion matter, or should she disregard it? Should she assert herself, taking responsibility for her desires? She cannot decide.

How does such profound ambivalence translate itself into action? When the Duchess recounts her failed attempt to save her husband's estate during the Protectorate, she reveals the paralysis inherent in her approach to the world. Exiled in Antwerp, she learns that the wives of Royalist owners of sequestered estates could receive allowances; "necessity"—the Duchess never admits to acting by choice—forces her to return to England with her brother-in-law, harboring "hopes I should receive a benefit thereby" (p. 296). We learn from her account of this episode neither the facts of her case, nor the details of her transactions. Instead she dwells on her lady-like "absolute refusal" either to plead in her own behalf or to plan an effective course of action because "I had a firm faith, or strong opinion, that the pains was more than the gains, and being unpractised in publick employments, unlearned in their uncouth ways, ignorant of the humours and dispositions of those persons to whom I was to address my suit, and not knowing where the power lay, and being not a good flatterer, *I did not trouble myself or petition my enemies; Besides I am naturally Bashful* . . ." (pp. 299–300; italics added).

Desperately needing the money, having made the dangerous, painful journey to obtain it, the Duchess then abdicates all responsibility for her property in order to consolidate the pose of female innocence so crucial to her self-conception. Boasting of her ineptitude, she clarifies the way in which female "success" becomes equivalent to male failure, making all action on her part futile. As we will see, the Duchess's self-defeating attitude toward her practical abilities stands in vivid contrast to the more constructive approaches taken by several of the other women autobiographers under consideration, all of whom are forced by political exigency to transcend the constrictions of sexual ideology in the effort to save their property.

But the Duchess cannot adjust to emergency: naturally she loses her cause. She ends the account of her failure in a burst of misogynist rage, castigating women who seek "pre-eminence of place" by words: "words rushing against words, thwarting and crossing each other . . . it is neither words nor place that can advance them, but worth and merit" (p. 299). The Duchess does not connect this wrath against other women's attempts to excel verbally with her own prodigious literary output and acknowledged desire for fame;[15] therefore she misses, as she continually does, the opportunity for self-

knowledge. It is this failure to merge, to make connections, which pointedly fractures her self-conception and her uneven run-on narrative. Her attempts at structure are repeatedly undermined, for example, by her inability to settle on a point or commit herself to an idea. At the beginning of *A True Relation* she links the unfortunate disruption of her nuclear family with the disastrous disruption of the kingdom; but then we learn that she left home out of desire, actively wanting to go to Court where, although she describes herself as maladjusted in an attempt to seem meek, she in fact achieves a happy and brilliant marriage. So much for the connecting theme of unwanted personal and political change.

Often called incoherent, the Duchess's narrative actually imitates the psychological logic of ambivalence. Gusdorf argues that an autobiography "does not show us the individual seen from outside in his visible actions but the person in his inner privacy, not as he was, not as he is, but as he believes and wishes himself to be and to have been" (p. 45). The Duchess's disjointed narrative makes clear that she cannot begin to formulate a desired identity: she simply cannot *decide* how she "wishes [herself] to have been." Insofar as *A True Relation* reveals the urgently problematic, ambiguous nature of feminine identity, it can be considered, as scholars have argued, a model of female autobiography.

Claims for viewing *A True Relation* as an influential forerunner in this genre should not, however, be exaggerated. The other three women under consideration confront the same problems of role and individuality that the Duchess of Newcastle does, but each manages to find more coherent personal and narrative strategies for resolving them. Unlike the Duchess's equivocal, urgent self-assertion, Ann, Lady Fanshawe's autobiography is written as a recollection during her widowhood and is cast in the socially conventional form of the family history. Addressing her *Memoirs* (1676) to her son, she explains that she writes to memorialize her excellent husband for her son's benefit; publication appears never to have been her goal.[16] When we approach Lady Fanshawe's *Memoirs*, Mary Mason's argument that women define themselves in relation to others therefore becomes considerably more useful than in the case of the irrepressible narcissism of *A True Relation*. As I hope to show, Lady Fanshawe's text reveals the advantages as well as the price of such self-definition.

Unlike the Duchess of Newcastle, Ann Fanshawe succeeds remarkably in subsuming her individuality within her role. Charac-

teristically, the cultural superego through which she defines herself is not the prescribed composite of individualized female character traits with which the Duchess struggles, but rather the seventeenth-century Protestant vision of the perfect wife. Since the British Reformation in the 1530's, the essentially Pauline conception of "holy matrimony," wherein "the husband is head of the wife, even as Christ is head of the Church" (Ephesians 5:23) had been refined and reiterated in Protestant moral and religious writing.[17] At the very beginning of her narrative, Lady Fanshawe succinctly presents the image of her desired identity as a fortunate partner in such a union, the "great mystery" in which the husband and wife "shall be one flesh," the husband loving the wife as he loves himself, the wife submitting to the husband, reverencing him (Ephesians 5:21–33): "*Glory be to God* we never had but one mind through out our lives, our soules were wrapped up in each other, our aims and designs one, our loves one, and our resentments one . . . What ever was reall happiness God gave it me in him; but to commend my better half . . . methinks is to commend myself and so may bear a censure" (p. 103).

At no point in her narrative does Lady Fanshawe deviate from her loyal, loving adherence to this idealized partnership of identical emotions and goals. Indeed she recounts the one moment of matrimonial conflict in her autobiography only in order to reveal the ease with which she overcame her need for self-assertion. In this isolated instance she discusses her attempt during the height of the Civil War to extract secret information from her husband, Sir Richard, who was performing crucial services for the beleaguered King Charles: "I that was young, innocent, and to that day had never in my mouth 'What news,' begun to think there was more in inquiring into buseness of publick affaires than I thought off" (p. 115). She wheedles and cries, refuses to eat or sleep until he tells her what he knows; he condescends, kisses her, changes the subject, until finally compelled by her weeping and begging to declare that, though his life, fortune, and "every thought" are hers, yet "my honour is my own" (p. 116). It never occurs to Lady Ann to question either openly or deviously an arrangement in which her husband's knowledge and attachments are so much freer and more various than her own. Instead the unequal logic of patriarchal power relations is revealed to her through the glow of Sir Richard's undoubted affection and, as she watches him, the scales fall from her eyes: "So great was his reason and goodness, that upon consideration it made my folly appeare to me so vile that

from that day untill the day of his death I never thought fit to aske him any business, but that he communicated freely to me, in order to his estate or family" (p. 116).

The problem for this inquiry becomes: how does a self-defined silent partner manage to generate a narrative unified and enlivened by her integrated conception of her individuality? As Lady Fanshawe continually makes clear, her goal is not to act, as a subject, but to be loved, as an object of devotion. The lack of conflict with which she discards her girlish fondness for physical activity in order gladly to assume her dead mother's modest, subdued role as family caretaker indicates the potentially static quality of her life account (p. 110). Yet most of her *Memoirs* tell a lively and engaging story.

Surprisingly, in telling her story, Lady Fanshawe eschews two rhetorical strategies that female autobiographers commonly employ when confronting the contradiction between culturally enjoined silence and the need for self-assertion, or between the peaceful, cyclical orderliness assumed to comprise feminine destiny and the linear, suspenseful quest motif required for the construction of conventionally masculine narrative. The first of these strategies, devious self-assertion, takes the form either of self-idealization disguised as self-deprecation or the overt denial of anger and hostility, prominent emotions that, because they cannot really be ignored, form a subversive subtext. The Duchess of Newcastle and, as we will see, Alice Thornton, are experts at this double-edged, often self-defeating technique. At times the violence and self-hatred implicit in Lady Fanshawe's complete identification with male superiority are starkly revealed, as in her account of her son Richard's death. "Both my eldest daughters had the smallpox att the same time," she explains, underscoring the virtue of her priorities, "and though I neglected them, and day and night tended my dear son, yet it pleased God they recovered and he dyed, the grief of which made me miscary and caused a sickness of 3 weeks" (p. 139). But the inhumanity in this passage is shocking precisely because it is exceptional; furthermore, no unacknowledged emotional conflicts surface to disturb the author's untroubled identification with the sexual status quo.

A second narrative strategy which female autobiographers commonly use involves the creation of a conventional linear quest motif out of the author's romantic adventures, which culminate in her destiny-as-marriage. Lady Anne Halkett uses this strategy with great success, a point to which I will return. But, despite her genuine love

for her husband and her dramatic location of selfhood in marriage, Lady Ann Fanshawe alone among the four autobiographers under consideration fails to tell the saga of her courtship. For her, the story of self-creation begins, rather than ends, with marriage.

In Lady Fanshawe's case, it is clearly the Civil War that liberates her from the acquiescence and passivity required by the sexual ideology to which she is profoundly attached; it is therefore the War which gives her story a plot. Because Sir Richard is deeply involved in Royalist intrigue, Lady Ann must frequently act to protect him, along with their joint property interests. Unlike the Duchess of Newcastle, whose ambivalence about public self-assertion and individuality paralyzes her, Ann Fanshawe responds to the call to independent action as a challenge. In three daring episodes, for example, she not only makes dangerous, clandestine nightly trips to visit her husband in jail, but also intrigues resourcefully for his freedom (pp. 134–35); imitating romantic tradition, she disguises herself as a man and stands by her husband's side during a shipboard battle with Turkish pirates, inspiring Sir Richard to cry, "Good God, that love can make this change!" (p. 128); she plots and successfully enacts a courageous escape from Britain, forging her passport in order to join her husband when he is exiled in France (p. 138). Significantly, the perilous exigencies of Civil War in no way compel the boldly and publicly active Lady Ann to feel conflict about her feminine identity. On the contrary, the war simply lends wider meaning to her role as faithful, obedient, and loving wife. Unlike the Duchess's, her identification with her role is complete and untroubled, enabling her to perform effectively on her husband's behalf. Just as her duty as wife and mother later becomes the rationale for the act of writing her *Memoirs,* so her marriage provides her with a motive and cue for action during the Revolution without requiring her to question prevailing sexual assumptions, which she never does.

For Lady Ann Fanshawe, the female autobiographer's task of integrating potentially conflicting aspects of identity in the creation of a story and a self is thus considerably reduced in difficulty by the Civil War. The external chaos of the Revolution paradoxically releases her from internal conflict by allowing her to merge her private concerns with the larger political environment. Specifically, the exterior strangeness of the political scene enlarges the internal borders of the psychologically familiar, enabling her to act by rendering her vision of the ideal Protestant marriage more expansive and flexible. This

point becomes clear when we examine the progress of her narration, which divides neatly between accounts of the Revolution and the Restoration. In her retelling of Civil War experiences, Lady Ann structures her vision of her marriage with a coherent narrative pattern of death and resurrection, disaster and delivery. Replete with echoes from the Gospels and the Book of Acts, her story of holy matrimony plagued by war becomes a secular scripture recounting separation from and reunion with her husband who, going about "his master's business" (p. 121), becomes a type of Christ that she can follow, serve, and adore.[18] This scheme works well to propel the narrative forward but, when the two are permanently reunited at the Restoration, the successful pattern inevitably dissolves.

During peacetime, when Sir Richard serves as ambassador to Portugal and Spain, the flamboyant public drama of war, resonant with the depth of emotional life, dwindles to a shallow catalogue of ceremonies and gifts that is enlivened only by Lady Ann's sensual love for exotic and colorful objects, along with her splendid eye for concrete physical detail. Indeed the depiction of her passionate attachment to money and property alters drastically as her experience shifts from war to peace. The pattern of separation from and reunion with Sir Richard, for example, allows her to unite money with love in a blissful epiphany of bourgeois marital goals: "He with all expressions of joy received me in his arms and gave me an hundred pieces of gold, saying, 'I know that thou that keeps my heart so well will keep my fortune.'. . . And now I thought myself a qween, and my husband so glorious a crown that I more valued myself to be call'd by his name than borne a princess . . . and his soule doted on me" (p. 115). In peacetime Spain, however, this ecstatic merger of affection and property is reduced to representing the once dynamic soldier Sir Richard as a colorful, although lifeless, diplomatic artifact: "His sute was trimed with scarlet taffeta ribbon, his stockings of white silk upon long scarlett silk ones, his shoes black with scarlett shoes' strings and garters, his linnen very fine laced with very rich Flanders lace, a black beavour button on the left side, with a jewell of 1200 lb." (p. 164).

Lady Fanshawe's capacity for reverence has given way to the related but less creative capacity to be dazzled. In the second part of her narrative, her need to be loved is represented in the reiterative rendition of public honors—the banquets, gifts, and canon salutes that celebrate her and her husband by diplomatic requirement (pp. 145ff). It is a static picture of power without desire: she has

become absorbed in the institution, rather than the relationship of marriage.[19] It is not surprising that her narrative trails off inconclusively after her husband's death, although she survived him by fourteen years.

Lady Fanshawe's *Memoirs* provide an excellent example of the way in which a chaotic period of history involves a woman whose conventionality and single-minded devotion to her husband would otherwise have restricted her to silence and passivity in an engaging and dramatic story. In Elaine Showalter's terms, the Revolution releases the muted female voice to achieve creative expression within the "allowable forms" of masculine adventure and narration. Yet to read the *Memoirs* is to become increasingly aware of an inhibited, repressed story. It is not simply that Lady Fanshawe's narration dwindles from war to peace, drama to stasis, ceasing entirely with the death of her husband and her role as his wife. Rather there is an essential tale that remains untold, namely, the saga of Lady Ann's body. During the twenty-two years of her marriage, Ann Fanshawe gives birth to fourteen children, nine of whom die, and this impressive statistic does not encompass the repeated trauma of miscarriages, including one of triplets. In short, while during both war and peace she is almost constantly pregnant, miscarrying, or giving birth, Lady Ann treats these experiences peripherally, merely mentioning rather than exploring them. This astonishing omission cannot be accounted for by attributing to her an anachronistic reticence about sexuality. It is rather that, in her selection of material and her choice of narrative strategies, she assigns a secondary value to this highly individualized aspect of her experience.

Was participation in endlessly similar diplomatic ceremonies really more compelling to this sensual, erotic woman than the precarious adventure of pregnancy and childbirth in the seventeenth century? Or was there simply no "allowable form" in which to tell such a story? The *Autobiography* (c. 1670) of Mrs. Alice Thornton proves that there was.

Alice Thornton (1626–1706/7) was an Anglican and Royalist from a distinguished upper gentry family, and her father, Christopher Wandesford, became Lord Deputy of Ireland before his death forced her mother to return with her family to England during the chaos of the Irish Rebellion in 1641. Mrs. Thornton's *Autobiography* is a long, bulky account of her childhood, the political upheavals she experienced in Ireland and England, her marriage and numerous pregnan-

cies, her squabbles with relatives, friends, and neighbors, her many illnesses, and her efforts to retain her property.[20]

Upon this variety of selected material Alice Thornton imposes the same narrative pattern that Ann Fanshawe uses to organize the first half of her *Memoirs:* the scriptural sequence of death and resurrection, affliction and delivery. As we have seen, Lady Fanshawe creates this structure to convey her love for her husband and to define herself by dramatizing her relationship with him, an imaginative feat made feasible by the intervention of the Civil War in her emotional life. Further, her location of meaning in her relationship to her husband causes her virtually to ignore her frequent pregnancies and childbearing, experiences which he could not directly share. In stark contrast, Alice Thornton uses the same narrative pattern precisely to convey her struggles with her body, and, in so doing, she seeks to dramatize herself not as a partner, a secondary ally, but as a hero, a primary object of God's love.

In Mrs. Thornton's *Autobiography,* her body becomes the symbol for the questing, surviving, even the competing self. Delivered from fire (pp. 7, 11), revolution (pp. 28–32), smallpox (pp. 6, 32), drowning (p. 9), and rape (pp. 44–47), her body also endures the heroic adventure of childbirth. Indeed Mrs. Thornton's narrative shows itself most vivid and interesting when, for example, she describes in full physical detail the sometimes delightful, often hazardous process of nursing one of her babies (p. 124), the painful phenomenon of a breech birth (pp. 95–97), or the grotesque details of the illnesses she suffers as a result of childbirth: "The haire on my head came off, my nailes of my fingers and toze came of, my teeth did shake, and ready to come out and grew blacke" (pp. 87–88). In a characteristic passage worth quoting at length, she relates the death of her baby son, providing in the process an intimate and detailed account of the frequent experience of infant mortality in Early Modern life:

> . . . and my pretty babe was in good health, suckeing his poore mother, to whom my good God had given the blessing of the breast as well as the wombe, of that childe to whome it was no little satisfaction, while I injoyed his life; and the joy of it maked me recrute faster, for his sake, that I might doe my duty to him as a mother. But it so pleased God to shorten this joy, least I should be too much transported . . . for on the Friday senitt affter, he began to

be very angery and froward . . . his face when he awaked was full of
red round spotts like the smale pox, being of the compasse of a
halfpeny, and all whealed white all over . . . and, about nine a'clocke
on Satterday morning he sweetely departed this life, to the great
discomfort of his weake mother, whoes only comfort is that the
Lord, I hope, has receaved him . . . And that my soule may be
bettered by all these chastisements He pleaseth to lay upon me, His
vilde worme and unprofitable servant . . . Whereby He has cor-
rected me, but not given me over to death and destruction, for which
I humbly magnifie His glorious name for ever. (pp. 124–25)[21]

The above passage should help to clarify the way in which Mrs.
Thornton's recognition of the importance of her body allows her to
generate a coherent story and a self. But in presenting the components
of her claim to attention as piety, humility, affliction, and rescue, this
passage, like many others in the book, also reveals the extent to which
her location of individuality and heroism in her body depends upon
pain and loss. Again and again she falls ill or loses a loved relation,
suffering outrageously; yet repeated sorrows only appear as further
"signes of His love to me" (p. 111). In short, Mrs. Thornton's is the
self-sacrificing heroism of the martyr, for whom endurance is the
highest form of activity. In the spiritual pattern to which she adheres,
affliction becomes a badge of moral prestige. Disaster and recovery
illuminate the individuality of the sufferer by marking her as one of
God's chosen, for whom He personally demonstrates both potential
destruction and promised delivery from death. Dame Julian of Nor-
wich "prayed for an illness that would both confirm and deepen her
vocation," writes a recent critic, "that illness [was] the gift and sign of
her grace."[22] By choosing the state of prestigious affliction as a
projection of her desired self, Mrs. Thornton thus adapts a con-
ventional Early Modern form of piety which was available to both
sexes. More interesting for these purposes, however, is the fact that,
with repetitive intensity, she applies this religious configuration to
her specifically secular, feminine experiences of marriage and child-
birth. As a result, her *Autobiography* very clearly dramatizes the
morality of female self-sacrifice by revealing its spiritual and psycho-
logical dynamics at work in secular life.

Alice Thornton's narrative makes clear that the religious config-
uration of prestigious affliction, with its psychological purpose of
self-sacrifice meeting a deferred reward, achieves only limited success

as a pattern of adjusting to reality when transferred to the realm of female secular experience. I have suggested the ways in which Mrs. Thornton's conscious identification with her body endows her with individual integrity and provides a detailed and revealing account of the monumental physical hardships that a traditional wife and mother faced and surmounted in seventeenth-century England, all of which lends great conviction to her *Autobiography*. Like the Duchess of Newcastle's, Mrs. Thornton's internal drama centers on issues of independence, power, and choice. We can recall that the Duchess oscillates wildly between professions of inner weakness and inner strength, often confusing the two and creating as a result a bewildering, run-on narrative structure in which conflicting psychological claims exist side by side unmediated, demanding equally to be heard. Subtext is not subordinated to primary text: her ego cannot settle on a pose. Lacking the Duchess's undisciplined, aristocratic arrogance, as well as her sensitivity and grace, Alice Thornton also lacks her ambivalence. Consequently she achieves a more coherent identity by recognizing that her physical weakness *is* her moral strength and finding an appropriate narrative form for this paradoxical self-conception in the scriptural sequence of delivery from death. Despite the greater firmness and coherence of her narrative self-conception, however, Alice Thornton shares with the Duchess of Newcastle the unresolved problems of moral responsibility that result from attempting to quell the individual ego within a culturally defined, often internally conflicting conception of femininity. Much longer and more consistent than the Duchess's, Mrs. Thornton's narrative allows us to observe more closely the effects of these moral and psychological tensions on the author's own consciousness, her text, and her relations with others.

Like the texts of the Duchess and Ann Fanshawe, Mrs. Thornton's *Autobiography* contains an untold tale, a submerged story which, in Alice Thornton's case, calls into question the integrity of her account. Here "integrity" should not be confused with accuracy or literal truth. As Gusdorf makes clear, the significance of autobiography exists beyond truth and falsity: "the truth of facts is subordinate to the truth of the man . . . the narrative offers us the testimony of a man about himself, the contest of a being . . . seeking its innermost fidelity" (p. 43). To acquire reader sympathy, then, the autobiographer must meet the demands of unflinching self-scrutiny, in order faithfully to reproduce the image not of the "actual," but of the

desired self. Yet throughout Mrs. Thornton's account it becomes clear
that her introspection has not been heroic and is therefore not ade-
quate to the autobiographer's task. A bitter subtext of egotism re-
pressed and turned resentful distracts the reader with increasing
frequency, revealing that the narrator has failed not only to express,
but even to recognize all of her wishes and hopes.

Mrs. Thornton's characteristic mode of self-presentation in-
volves denying the claims of her ego while simultaneously asserting
them in devious boasts of traditionally feminine virtue. Recounting
her mother's generous legacy to her, for example, she concludes, "All
which I confesse farre exceeding my merritt, but not her intire
affection, for my constant beeing with her in her sorrowes and
solitudes" (p. 104). Equally typical is her use of illness to compete
with siblings, friends, and spouse: if her neighbor falls down the
stairs, she falls faster and harder (p. 139); if her husband becomes ill or
melancholy, she gets sicker and more depressed (p. 149). Determined
to exceed all rivals in illness, accident, misfortune, or pain, Mrs.
Thornton portrays herself as existing perpetually at death's door, a
representation which, if understandable given the actual perils of her
life, nevertheless jars oddly with the fact that she outlived not only
her husband, but all nine of her children, lasting until what was for
the seventeenth century the remarkably old age of 81.[23] Anxious to
create herself as weak, sick, and pitiful, Alice Thornton was in fact
tough and enduring, a survivor.

Duplicitous humility, petty competition, subversive self-ag-
grandizement turning strength to weakness and weakness to strength:
the disingenuousness that results when these qualities converge in
Mrs. Thornton's subtext can be merely amusing or annoying. Yet
more serious, negative moral implications to her drama of alleged
self-sacrifice are revealed in her account of her marriage, where anger
and aggression are only barely contained by the counter-mythology
of female passivity and innocence that shapes the primary text.

It is when Mrs. Thornton gets married—her "great change" as
she calls it—that the English Civil War plays a leading role in deter-
mining her personal destiny. Suddenly the victorious forces of Oliver
Cromwell destroy the peace of her childhood by seizing on her
brother's estate, "wherein my father's family was fairely designed for
ruine" (p. 61). The Wandesford family's escape from financial disaster
turns out to consist in offering the fifteen-year-old Alice in marriage,
in return for which the designated groom's uncle promises to retrieve

the sequestered Wandesford property: "Thus the bargain was strucke betwixt them before my deare mother and my selfe ever heard a silable of this mater" (p. 61). In other words, Alice Thornton's match was an openly loveless deal, struck for the financial advantage of interested relatives. Although such economic arrangements were the norm for marriages throughout the Middle Ages and the Renaissance, all known evidence indicates that, by the late seventeenth century, individual choice of a partner and, as a consequence, love marriages, were gaining in frequency as well as prestige among the upper classes.[24] Yet, though several of her contemporaries are known to have done so successfully, Alice Thornton does not contest her fate. It is true that she registers open anger at the indignity of existing as an object, bartered and compelled: "Which manner of perswasion to a marriage, with a sword in one hand, and a complement in annother, I did not understand, when a free choyce was denyed me. Tho' I did not resolve to change my happy estate for a misserable incombred one in the married; yett I was much afflicted to be threatened against my owne inclination (or my future happiness), which I injoyed under that sweete and deare society and comfort of my most deare parents' conduct" (p. 62).

Nevertheless she chooses to submerge her rage at this ruthless disregard of her individuality, piously surrendering her feelings and needs to a political and religious configuration of self-sacrifice: ". . . my marriage was laid in the skaile, to redeeme my deare brother's estate from the tiriny of our oppressor, by the sequestration of all that was a freind to loyalty or the Church of God then established in England. But since I was thus disposed, it became my duty to stand my ground in a strange place, and amongst strange people, and that I was resolved to doe, by God's grace and divine assistance" (p. 214ff).

This passage concisely delineates an unresolved conflict implicit throughout Alice Thornton's narrative. Does she regard her marriage as chosen or compelled, a tyranny forced upon her, or a duty cheerfully and willingly undertaken? Here—and in many other passages where she reminds the reader of the inadequacy of her husband's estate in order to protest that she doesn't care—Mrs. Thornton represents the sacrifice of her personal happiness as a deed that, if originally compelled by her family, has subsequently become a chosen act of political and domestic altruism, about which she feels both reconciled and proud. But her ego does not in fact consent to be merged so

crudely with notions of the collective good, and unsuccessfully re-
pressed anger finds an outlet in the revenge of domestic strife.

The nature of this process is clarified in her self-contradictory
account of her relationship with her husband. When Alice Thornton
eventually becomes a widow, she spares no pains embroidering her
sorrow, mourning her late husband as "my cheifest comfort and
suport" (p. 168), and punctuating her life account with lengthy, griev-
ing odes and pious lamentations. Yet throughout her narrative Mrs.
Thornton portrays her husband as a kindly bumbler, whose melan-
cholia, obstinacy, naiveté, and financial ineptitude reach their apogee
in his refusal to listen to her good advice (for example, p. 138). In
Mrs. Thornton's portrayal of her husband's weakness, we can discern
her peculiar, if inevitable, reaction to the collapse of Royalist male
social superiority and political hegemony that so drastically affected
the lives of the women writers under consideration. As we have seen,
Ann Fanshawe, defining herself through relationship, views the social
chaos of the Revolution as an emotional opportunity and makes
creative use of disorder by expanding her wifely role as helpmate and
companion. In contrast, Alice Thornton, defining herself as a victim
of the males to whose power she has surrendered her fate, can only
respond with rage and a bitter sense of betrayal to their loss of control
over their status and property. Like her father, her brothers and,
eventually, her brother-in-law, her husband becomes yet another man
who has failed her. His badly timed death comprises an additional
instance of his desertion (p. 143); furthermore, his failure to make a
will involves her in complicated, exhausting property struggles, ex-
tending the consequences of his fiscal inadequacy well beyond the
grave and providing posthumous material for her anger and disgust
(for example, pp. 181–83).

Undeterred by the magnitude of her own revelations, Mrs.
Thornton insists on describing her awful marriage to the incredulous
reader as that of "a deare and loving couple" (pp. 175, 176). It is not
that, like the Duchess of Newcastle, she bewilders us with the com-
plex ambivalence of her feelings. Her contempt for her husband is
dominating, consistent, and whole. It is rather that, in refusing to
acknowledge her obvious personal rage at being forced to marry a
man she does not respect, she never attempts to reconcile her anger
with the cultural demand that she be a loving and devoted wife. This
inability, or unwillingness, to perceive the roots of her own suffering
constitutes a refusal, even an evasion, of self-knowledge. It becomes

impossible to sympathize with her account. Whatever may have been his virtues and failings, Mr. Thornton appears to the reader not as a person, but as an object, the dehumanized target of his wife's wrath.

This detachment from the feelings and desires—in short, from the emotional reality—of others extends as well to Alice Thornton's treatment of her children. In an uncanny instance of the oppressed become oppressor, she arranges the marriage of her fourteen-year-old daughter to a much older man with the same economic pragmatism and thoughtless domination that determined the identical fate which she had confronted with reluctance and sorrow. But Mrs. Thornton displays neither memory of her own unhappiness nor awareness that she is bartering her daughter's destiny. In recounting her motives for arranging the match, she cites economics and—what else?—illness: "My owne great illness, and many weakness on myselfe . . . did pres much uppon my spiritt, least we both should be snatched from our deare children, and they left in a forlorne condittion of both theire parents gon" (p. 154). In other words, Mrs. Thornton presents her carefully and explicitly calculated decision to marry off her daughter not as a chosen act for which she is responsible, but—to quote Carol Gilligan's study of female moral and psychological development—"as an act of sacrifice, a submission to necessity where the absence of choice precludes responsibility."[25] Furthermore, we learn that Mrs. Thornton rushes this marriage, which was greatly disapproved of by her relatives, in order to quash scandalous rumors that she herself is romantically involved with her daughter's fiancé (p. 229). Never in the lengthy account of this affair do we hear one word about her daughter's feelings or desires. But Mrs. Thornton expresses no doubts that she has behaved with the most scrupulous maternal benevolence since "God is on my side" (p. 230). The dubious logic inherent in such an unacknowledged assertion of personal power comprises an evasion of responsibility that is "critical to maintaining the innocence [the woman] considers necessary for self-respect," although it "contradicts the reality of her participation in the . . . decision."[26]

Alice Thornton's account of her relations with her husband and children therefore reveals the psychological connection between the unacknowledged rage engendered by the ethic of female self-sacrifice and a profound lack of moral responsibility on the part of its protagonists.[27] Turning her husband and daughter into objects without understanding that this is her goal, she follows the golden rule of

revenge, doing unto others what, she makes clear, "has been done" unto her. The passive verbal construction here is relevant. Her acquiescence in the role of victim and object in an attempt to please others has, with irony, made her almost totally self-centered. Her barely suppressed rage corresponds directly to her disengagement from the feelings and needs of other people.

Whatever the obvious limitations of Alice Thornton's chosen identity, her conception of herself as heroic victim did encourage a resilience that, in contrast to Ann Fanshawe, allowed her to extend her narrative self-definition beyond her husband's death. In any event, it is not my purpose either to praise her as enduring and determined, or to discredit her as sentimental, manipulative, and self-deceived. My main interest in calling attention to the angry and subversive subtext in the autobiography of this virtuous widow is to illuminate the ways in which historical circumstance, gender, and genre converge in the literary creation of female personality. When the psychological dynamic of prestigious affliction is transferred from the religious realm and applied to secular female experience, we can recognize a feminine mode of negative self-assertion that is clearly identifiable from Alice Thornton to Alice James.[28]

In the *Memoirs* (1677–8) of Anne, Lady Halkett (1623–99), self-assertion takes a uniformly positive shape.[29] Among the four texts under consideration, Lady Halkett's stands out as the most interesting and successful, in which the author simultaneously confronts and resolves the woman autobiographer's task of narrating a coherent personal identity by merging potentially conflicting aspects of the self. As scholars already acquainted with this text agree, although Lady Halkett did not write for publication, her *Memoirs* deserve recognition as a literary achievement of high quality.[30] A wife, mother, and—when she writes—a widow, she manages to construct a brilliant narrative and authentic self-definition without in any way foregoing her attachment to traditional female values and goals. In the process she displays the Duchess of Newcastle's grace, sensitivity, and loyalty without her paralyzing ambivalence; exhibits Ann Fanshawe's resourcefulness, affection, and courage without her dependency and naiveté; and demonstrates Alice Thornton's resilience and energy without her self-pity and unwillingness to accept moral responsibility for her actions and desires.

How can we account for the superiority of Lady Anne Halkett's autobiography to the texts of the Duchess of Newcastle, Ann Fan-

shawe, and Alice Thornton, women with whom she shares political affiliation, religious persuasion, and social position? Like these three women, Lady Anne is an upper-class Anglican and Royalist, who struggles to define herself within a culturally prescribed conception of femininity while, at the same time, her social and personal horizons are being drastically altered by the Civil War. Part of her ascendancy over her contemporaries must of course be attributed to the intangible factor of greater talent. Yet when Lady Halkett's circumstances and self-image are viewed in contrast to those of the other three women under discussion, a picture of significant differences in the factors affecting her accomplishment comes into view. It should be stressed that this emerging picture reflects differences of degree rather than kind; for this inquiry it has the advantage of illuminating the ways in which a range of subtle variations in psyche and circumstance can converge to affect self-conception and literary achievement in female autobiography.

The first significant difference in Lady Halkett's text is her depiction of her relationship with her mother. Among the four autobiographers discussed here, Anne Halkett alone refrains from idealizing her mother. All four writers recognize the significance of the mother-daughter bond in the formation of their identities. The Duchess of Newcastle presents her adored mother as the perfect embodiment of the Renaissance cultural ideal of the feminine; Ann Fanshawe makes her claim to attention as the special object of her mother's love, gladly subduing her more active personality traits in order to assume with unbroken continuity her dead mother's passive domestic role; and Alice Thornton, angry with almost everyone else in her life, reserves a special respect and tenderness for her mother. In contrast, Anne Halkett's story as well as her independent self-conception begin with conflict between her widowed mother and herself. "In the year 1644 I confese I was guilty of an act of disobedience" (p. 11), she tells the reader, and, with this declaration, her narrative begins.

Lady Halkett's youthful disobedience involves a clandestine engagement to Thomas Howard, eldest son of Edward, Lord Howard of Escrick. As she relates it, this romance was explicitly forbidden by her mother, both for economic reasons and also, as Anne suggests, for motives of sheer intransigence on her mother's part (p. 14). The drama of this episode unfolds as a counterpoint between Anne's audacious romantic strategems and secret encounters with Thomas

Howard and her struggles with her "offended mother, who nothing could pacify" (p. 15). Telling Thomas she will never marry him without parental consent while telling her family she will never break her engagement unless Thomas marries another, she never admits to defying her mother's authority, although her actions clearly reveal that she remains unterrified by parental power. The battle of wills that ensues between mother and daughter takes revealing shape in the following dialogue:

> I said I could nott butt regrett what ever had occationed her displeasure . . . butt I was guilty of noe unhandsome action to make mee ashamed; and therfore, what ever were my presentt misfortune, I was confident to evidence before I died that noe child shee had had greater love and respect to her, or more obedience.

> To which she replied, 'Itt seemes you have a good opinion of your selfe' (p. 17).

Thus Anne's independence and self-respect are interpreted by her mother as willfulness and conceit. Although she refuses to capitulate to parental tyranny, Anne nevertheless suffers painfully from her mother's disapproval. After Lord Howard finally sends his son to France to "secure" him from Anne, Anne's mother declines to speak to her daughter (except to reproach her) for fourteen months, commenting "with much bitternese shee did hate to see mee. That word I confese strucke deeply to my hart" (p. 20). Furthermore, maternal scorn continues even after Anne's troublesome romance is finished. When the young Thomas Howard eventually proves faithless, returning to England to marry an heiress, Anne, grieving sensibly, makes a rapid recovery, in which "nothing troubled mee more then my mother's laughing at mee" (p. 22). Faced with humiliation, defeat, and the double rejection of mother and lover, Anne's response is characteristic: rather than giving in to her grief, she struggles harder against it, finally outwitting her mother by asking a relative to find her a place in a Dutch nunnery for Protestants. The sympathetic relation then persuades Anne's mother to forgive her daughter, "and from that time shee received mee againe to her faver, and ever affter used mee more like a friend then a child" (p. 20).

This last point reveals Anne's romance with Thomas Howard for what, in large part, it was: not only a spirited young woman's

search for passionate adventure, but also—and perhaps more importantly—her struggle for freedom and equality. That she would choose to undertake, rather than to deny, ignore, or submerge this struggle with authority of course distinguishes Anne Halkett from the Duchess of Newcastle, Ann Fanshawe, and Alice Thornton. As her conduct and resolution of the struggle imply, Anne confronts, even instigates dramatic and psychic conflict, using it as a means of attaining independence and personal growth. After Anne wins recognition as an adult from her mother, that authority figure disappears from the autobiographical tale; we do not even hear about her death. Anne Halkett's life story has become truly her own.

Lady Halkett's early conflict with her mother therefore assumes importance both as a revelation of her character and as a means of understanding her narrative technique. As many scholars have argued, the achievement of self-definition through separation and conflict is characteristically masculine rather than feminine.[31] In literature this mode of personal development often takes narrative form as a linear quest motif, in which the hero struggles to attain his destiny. As noted earlier, the conception of destiny as the result of personal evolution achieved through the surmounting of conflict runs counter to the common cultural expectation that women's lives will assume a unified, cyclical form in accordance with unbroken, recurring tradition. Yet an important exception enables the literary representation of female destiny to take the allowable, linear form usually preserved for masculine narration: that is, when marriage is construed as the destiny which the female hero struggles through romantic conflict to achieve.[32] With its origins in religious and romantic story, this structure of course reaches its greatest secular expression in the novel. It is Anne Halkett's confident grasp of this narrative strategy, which she uses to represent her conception of herself as a hero actively creating—rather than avoiding (the Duchess), adapting (Ann Fanshawe), or enduring (Alice Thornton)—her destiny that gives her *Memoirs* such interest and force.

Anne Halkett's penchant for conflict-engendering romance and her narrative skill combine with the Civil War to give scope to her creation of a story and a self. This fortuitous convergence can best be perceived in her account of her long, ambiguous connection with Colonel Joseph Bampfield (designated throughout her text as "C.B."), which comprises the bulk of the narrative. C.B. is a dashing, handsome cad, a non-fictional predecessor of Jane Austen's

Willoughby and Wickham, whom Anne comes to know as a friend of her brother's. This exciting adventurous soldier operates at the center of Royalist intrigue, and he and Anne together engineer the daring, theatrical escape of the Duke of York from England, an episode Anne relates in full dramatic detail (pp. 23–26). In the highly charged atmosphere of the Revolution, love and politics inevitably unite. Although C.B. is married when Anne meets him, he convinces Anne that he has had news of his wife's death, and the two become secretly engaged.

Is C.B.'s wife dead or not? It seems astonishing, impossible, that Anne would not be able to determine this simple fact, yet, whatever measure of self-deception may have influenced her discernment, her account of the sheer difficulty of obtaining reliable information during the chaos of the Civil War, particularly when one is on the losing side, makes the obstacles to her knowing the truth entirely credible. Forced to leave London and hide in the north after her part in the Duke of York's escape, Anne is separated from C.B. and subjected to numerous conflicting accounts about his integrity. Relatives appear from distant parts of England, swearing his wife is alive and well; equally believable witnesses come forth to persuade her that he is indeed a widower. She receives ominous letters from disapproving siblings, one of whom challenges C.B. to a duel, where the latter vows when wounded that he believes his wife is dead and that he is eternally devoted to Anne Murray (later Halkett). Various reunions with her clandestine lover alternately reassure and torment her, and the reader enters sympathetically into her powerfully rendered wavering and frustration. Lady Halkett's skill at involving the reader in the suspense surrounding C.B.'s personal life not only draws the narrative forward; the story of one woman's war-time romance also gradually expands in significance to encompass the larger theme of the impossibility of knowing. In this late seventeenth-century saga of political intrigue and social disorder, the reliability of communications can finally be determined only by inner resolution. Despite recurring doubts, Anne keeps her faith in C.B.'s loyalty until Sir James Halkett comes along and convinces her that C.B.'s wife is still alive. That she believes James Halkett, whose information she has no more apparent reason to trust than anyone else's, simply means that she has overcome her conflict and achieved her destiny by finding her future husband.

Another way to say this is that Anne Halkett creates her nar-

rative self-conception according to the demands of her inner life. The amount of courage required for a single woman thus to view herself and act independently is clarified in the extent to which she both risks and successfully avoids ruinous social scandal. The episode that best makes this point is her account of her virtual expulsion from Naworth Castle where, having sought a purportedly secure hiding place with Sir Charles and Lady Anne Howard after her dangerous rescue of the Duke of York, she finds herself vulnerable to the sexual slander of a duplicitous minister, a Tartuffe in whom she unfortunately confides the details of her relationship to C.B. Although Lady Halkett fully acknowledges her vulnerability as a woman alone, involved in a questionable engagement and supported by neither wealth nor consistent family loyalty, she never succumbs to the temptation of portraying herself as a victim, a misunderstood and mistreated case of injured virtue. Instead she takes full moral and social responsibility for her actions and desires.[33] For example, although recognizing the dubious wisdom of her clandestine relationship with C.B., she nevertheless refrains from blaming his faithlessness for her plight; while she acknowledges a distinction between social appearance and moral reality, she does so without bitterness, refusing to dwell on it as the major issue determining her conduct. Instead she assesses the difficult attachment forthrightly as her own choice, made according to her individual desire:

> I know I may bee condemned as one that was too easily prevailed with, butt this I must desire to bee considered: hee was one who I had beene conversantt with for severall yeares before; one that proffesed a great friendship to my beloved brother Will; hee was unquestionably loyall [i.e., politically], handsome, a good skollar . . . att least hee made itt appeare such to mee, and what ever misfortune hee brought upon mee I will doe him that right as to acknowledge I learnt from him many excellentt lessons of piety and vertue and to abhorre and detest all kind of vice. . . . From the prejudice which that opinion brought upon mee I shall advise all never to thinke a good intention can justify what may bee scandalous . . . And I confese I did justly suffer the scourge of the toung for exposing my selfe upon any consideration to what might make mee liable to itt, for which I condemne my selfe as much as my sevearest enemey (p. 28).

Although Lady Halkett does manage to find essential protectors after leaving Naworth Castle, her text is also full of instances in which

she acts effectively alone, not only in behalf of her property (pp. 79ff.) or her reputation (pp. 53–54), but also altruistically, as when she nurses wounded soldiers with such skill and tenacity that her performance is rewarded by Charles II (pp. 55–56). As she does in the remarks about scandal quoted above, Lady Anne demonstrates in all of these actions her respect for the social and political culture that, in her erotic life, she has defied. Her triumph as a determined, individualistic female is never to become marginal. Acknowledging and acting on her own often socially subversive desires, she avoids the role of the nonconformist, the sinner or saint, choosing neither to be punished by cultural convention nor to transcend it, but rather to struggle toward creating a desirable position for herself in the mainstream of society. This successful reconciliation makes it appropriate that Lady Halkett should end her story by dramatizing the wished-for institutional symbol of public and private life harmoniously conjoined: the marriage that is at once suitable and happy, encompassing stability as well as desire. As an autobiographer writing twenty years after the fact, depicting her long romance with one man ending in her marriage to another, she achieves in narrative form what Gusdorf believes is the goal of the genre: "a recognition of the self by the self—a choice carried out at the level of essential being" (p. 44).[34]

With the partial exception of the religious narrative, female self-expression in late seventeenth-century England was regarded as neither moral nor suitable: Aphra Behn was considered a scandal; Anne Finch lived in bitter seclusion; the Duchess of Newcastle was laughed at as an exhibitionist and a fool. Despite this virtually unchallenged injunction to female silence, a number of women made important contributions to the early development of English secular autobiography during the Restoration. The women discussed here do not write in a prevailing spirit of challenge or defiance. Rather they identify themselves as well-established, often conservative voices within the mainstream culture: they are traditional wives and mothers of the Anglican upper classes, actively loyal to husband, country, and King.

Viewed from historical perspective, the traditionalism of these women—their attachment to established patriarchal values and goals—can be seen to have played a paradoxical role in freeing them to write. All four women are Royalists, confronting temporary social and political defeat in the English Civil War; and their active par-

ticipation in wartime events suggests the way that social chaos, upsetting the conventional sexual arrangements to which they adhere, can generate female creativity.[35] While all four autobiographers witness the loss of social superiority and political hegemony of the men who dominate their world, their consequent attempts to rectify and compensate for this loss of status, money, and power give their lives an added public dimension that drastically alters their horizons. Indeed they discover that the only way for a female effectively and openly to defend the status quo is to break its rules, by violating the culturally prescribed definition of women as modest, passive, silent, and obedient.

In their autobiographical responses to this quandary of conflicting demands, all four women under consideration share certain narrative and behavior patterns that, as scholars of women's literature have been pointing out, can be identified as characteristically female. This material illuminates the ongoing discussion of typically womanly modes of imaginative response. Yet examining women's autobiographies in some detail within their historical context also suggests the variety, the richness of possibility in female self-expression that can occur even among only four women of similar social standing, religious persuasion, and political affiliation writing about the same series of events.

Like their male counterparts, few female autobiographers in the late seventeenth century considered exposing themselves and their families through publication of their work. But the fact remains that, during the Restoration, traditional women assigned enough value to their individual secular experiences to find them worth recording and, in the process, attempted to create themselves in literary form. While the responses of each individual woman to the dilemma of negotiating conflicting aspects of the self vary impressively, their common effort to reconcile public and private identities into a coherent literary form can be recognized as the (often problematic) goal of secular autobiography. Whatever ultimately may be shown to have been the extent of women's influence in creating modern autobiography, the convergence of gender, genre, and history that occurred in late seventeenth-century England should be given full consideration both in relevant studies of the female imagination and in any study of the form.

NOTES

1. See Natalie Zemon Davis, "Gender and Genre: Women as Historical Writers, 1400–1820," in *Beyond Their Sex: Learned Women of the European Past*, edited by Patricia H. Labalme (New York: New York University Press, 1980), pp. 153–82.

2. Cf. Cynthia S. Pomerleau, "The Emergence of Women's Autobiography in England," in *Women's Autobiography: Essays in Criticism*, edited by Estelle C. Jelinek (Bloomington: Indiana University Press, 1980), pp. 21–38, who points out that "writings by women are among the early examples of the form" (p. 22).

3. See Lawrence Stone, *The Family, Sex and Marriage In England 1500–1800* (New York: Harper and Row, 1977), pp. 225–39, Margaret Bottrall, *Every Man a Phoenix: Studies in Seventeenth-Century Autobiography* (London: John Murray, 1958), pp. 7–29, and Paul Delany, *British Autobiography in the Seventeenth Century* (London: Routledge & Kegan Paul, 1969), pp. 11–12, 19.

4. Delany, *British Autobiography*, pp. 22–23. Also see Jelinek, *Women's Autobiography*, pp. 1–20, and Judith Kegan Gardiner, "On Female Identity and Writing by Women," in *Writing and Sexual Difference*, edited by Elizabeth Abel (Chicago: University of Chicago Press, 1980–82), pp. 184–85.

5. Delany, *British Autobiography*, pp. 22–23, and Elizabeth W. Bruss, *Autobiographical Acts: The Changing Situation of a Literary Genre* (Baltimore: Johns Hopkins University Press, 1976), pp. 7, 33.

6. No systematic study has been made to establish the nature and extent of female influence on the development of modern autobiography, although some scholars have been aware of the (unusually) early participation of women in the creation of the genre. For example, see Delany, *British Autobiography*, p. 5, who comments that in the seventeenth century female autobiographers "have a deeper revelation of sentiments, more subjectivity and more subtle self-analyses than one finds in comparable works by men . . . it is not until the seventeenth century that what we now call the 'feminine sensibility' enters the mainstream of English literature—before then it was usually ignored by the male writers who dominated literary life, or obscured by a narrow and stereotyped anti-feminism."

Cf. Pomerleau, "The Emergence of Women's Autobiography," p. 22, who comments that seventeenth-century female autobiographies seem, in contrast to those of men, "more modern, more subjective, more given to self-scrutiny, more like what we have come to know as autobiography."

As Bottrall points out (*Every Man a Phoenix*, p. 1), the first extant English autobiography is "oddly enough" written by a woman. She is referring, of course, to *The Book of Margery Kempe* (1438).

7. Georges Gusdorf, "Conditions and Limits of Autobiography," trans. James Olney, in ed. James Olney, *Autobiography: Essays Theoretical and Critical* (Princeton: Princeton University Press, 1980), pp. 28–48. All citations from Gusdorf will be taken from this translation.

Cf. Bottrall, *Every Man a Phoenix*, p. 5, Stone, *Family, Sex and Marriage*, pp. 227–28, and Delany, *British Autobiography*, p. 116: "Autobiography could progress

as a genre only to the extent that it did more than simply record external life-events."

For a counter-argument, see Jelinek, *Women's Autobiography*, p. 10, who believes that the view of autobiography as "introspective and intimate" is a "fallacy of the first order." Yet when Jelinek's objections are examined, it becomes apparent that by "introspective and intimate" she means "confessional," the author's revelation of private physical or emotional detail, rather than the individual's attempt to narrate a unified and desired personality, which is Gusdorf's concern.

Cf. Lionel Trilling, *Sincerity and Authenticity* (London: Oxford University Press, 1974), p. 58, who distinguishes English "sincerity" from the French confessional manner: "Not to know oneself in the French fashion and make public what one knows, but to be oneself, in action, in deeds . . . this is what the English sincerity consists in."

8. Among the many important books on this subject, those of specifically literary interest include Elizabeth Abel, ed., *Writing and Sexual Difference;* Patricia Meyer Spacks, *The Female Imagination* (New York: Avon Books, 1972); Sandra M. Gilbert and Susan Gubar, eds., *Shakespeare's Sisters: Feminist Essays on Women Poets* (Bloomington: Indiana University Press, 1979); and Sandra M. Gilbert and Susan Gubar, *The Madwoman in the Attic: The Woman Writer and the Nineteenth-Century Literary Imagination* (New Haven: Yale University Press, 1979).

9. Elaine Showalter, "Feminist Criticism in the Wilderness," in *Writing and Sexual Difference*, ed. Abel, pp. 9–35.

10. All citations are from Margaret Cavendish, Duchess of Newcastle, *A True Relation of My Birth, Breeding, and Life* appended to *The Life of William Cavendish, Duke of Newcastle* (London: John C. Nimmo, 1886).

11. Virginia Woolf, *Women and Writing*, ed. Michèle Barrett (New York: Harcourt Brace Jovanovich, 1979), p. 82.

12. Mary G. Mason, "The Other Voice: Autobiographies of Women Writers," in Olney, ed., *Autobiography*, pp. 207–35. Also see Spacks *The Female Imagination*, pp. 245–52. In support of her point, Mason argues that the Duchess appended her own life story to her biography of her husband, *The Life of William Cavendish* in 1667, but, as Mason concedes, *A True Relation* first appeared in 1656 as part of a miscellany of the Duchess's verse and prose, *Natures Pictures Drawn by Fancies Pencil to the Life,* and can be considered as a separate document.

13. For two of many examples of Renaissance moral literature on this topic, see John Louis Vives, *Instruction of a Christen Woman*, trans. Richard Hyrde (London, 1557), and John Dod and Robert Cleaver, *A Godly Form of Householde Government* (London, 1598).

Also see Ian Maclean, *The Renaissance Notion of Woman* (Cambridge: Cambridge University Press, 1980); Carroll Camden, *The Elizabethan Woman* (New York: The Elsevier Press, 1952); and Suzanne W. Hull, *Chaste, Silent, & Obedient: English Books for Women 1475–1640* (San Marino, Ca.: Huntington Library, 1982).

14. The phrase is taken from the title of Suzanne Hull's book, cited above.

15. The Duchess produced twenty-two folio volumes, including plays, poems, essays, sketches, philosophical treatises, and "orations of divers sorts." For a complete list of her works, see Douglas Grant, *Margaret the First: A Biography of Margaret Cavendish, Duchess of Newcastle 1623–1673* (London: Rupert Hart-Davis, 1957), pp. 240–42.

16. All citations are from ed. John Loftis, *The Memoirs of Anne, Lady Halkett and Ann, Lady Fanshawe* (Oxford: Clarendon Press, 1979), pp. 101–92. On pp. 91–99 Loftis provides a textual history and chronology of the major events in Lady Fanshawe's life.

17. Examples of the most popular literature expounding this ideal include Heinrich Bullinger, *The Golden Boke of Christen Matrimonye,* trans. Miles Coverdale (1543), William Perkins, *Christian Oeconomie or Houshold Government* (1631), John Dod and Robert Cleaver, *A Godly Form of Householde Government* (1598), and Samuel Hieron, "The Marriage Blessing," in *The Sermons of Master Samuell Hieron* (1635).

18. See Northrop Frye, *The Secular Scripture: A Study of the Structure of Romance* (Cambridge: Harvard University Press, 1976) for a study of this narrative structure.

19. This distinction is made by Adrienne Rich in regard to motherhood, in *Of Woman Born: Motherhood as Experience and Institution* (New York: Bantam, 1977).

20. All citations are taken from the *Autobiography* of Mrs. Alice Thornton (London: Surtees Society, Vol. LXII, 1873).

21. See Stone, *Family, Sex and Marriage,* pp. 68, 79, who reports that expectation of life in England in the 1640s was only thirty-two years, with newborn infants most at risk. Between a quarter and a third of all children of English peers and peasants were dead before they reached fifteen. "For women, childbirth was a very dangerous experience, for midwives were ignorant and ill-trained and often horribly botched the job, while the lack of hygienic precautions meant that puerperal fever was a frequent sequel."

22. Mason, "The Other Voice," p. 213. Cf. Wendy Martin, "Anne Bradstreet's Poetry: A Study of Subversive Piety," in eds. Gilbert and Gubar, *Shakespeare's Sisters,* pp. 21–22. Martin relates that, for Bradstreet, "suffering was a form of joy because the disaster that occasions it is a sign of God's love . . . For the Puritans, affliction is a sign of the intimate bond between God and His children, it is not an indication of cruelty."

23. See Peter Laslett, *The World We Have Lost* (New York: Scribner's, 1965), p. 99, who reports that in late seventeenth-century England, "though so few people reached the age of seventy, it was regarded as the allotted span of life all the same."

24. See Stone, *Family, Sex and Marriage,* pp. 179–80; pp. 270–81. Among the women under discussion Lady Anne Halkett is the best example of the "shift in basic attitude from deference to autonomy" that Stone describes. Also see the

Autobiography of Mary, Countess of Warwick, ed. T. Crofton Croker (London: Percy Society, 1848), Vol. 22, for another first-person account of a late seventeenth-century woman who defied her father and married the man of her choice.

25. Carol Gilligan, *In a Different Voice: Psychological Theory and Women's Development* (Cambridge: Harvard University Press, 1982), p. 86.

26. Ibid., p. 86.

27. By "protagonists" I mean the men and women who together create and adhere to this ethic.

28. See Jean Strouse, *Alice James: A Biography* (Boston: Houghton Mifflin, 1980). I am grateful to Bruce Redford, Department of English, University of Chicago, for first calling this connection to my attention.

29. All citations are taken from Loftis, ed., *Memoirs*, pp. 9–87. Loftis provides a textual history and chronology of the main events in Lady Halkett's life on pp. 3–7.

30. See Loftis, ed., *Memoirs*, pp. x–xiv and Bottrall, *Every Man a Phoenix*, p. 149.

31. See, for example, Gilligan, *In a Different Voice*, whose analysis of female development is based on studying this distinction between the genders, and Nancy Chodorow, *The Reproduction of Mothering: Psychoanalysis and the Sociology of Gender* (Berkeley: University of California Press, 1978).

32. See Abel, ed., *Writing and Sexual Difference*, in which many of the essays treat this issue. Also see Carolyn G. Heilbrun, *Reinventing Womanhood* (New York: Norton, 1979), pp. 104–105, 124–97 and Lee R. Edwards, "The Labors of Psyche: Toward a Theory of Female Heroism," *Critical Inquiry* 6 (Autumn 1979): 33–49.

33. Interestingly Loftis, the recent editor of Lady Halkett's *Memoirs*, completely misses this point. Although he admires Lady Halkett's intelligence, talent and charm, he chooses to see her as a victim and her story as "a poignant account of humiliation and suffering" (p. xi). Thus, by choosing to pity her, Loftis unwittingly denies Lady Halkett her dignity and power as an active protagonist in her own life.

34. It should be mentioned that Lady Halkett's *Memoirs* break off abruptly in 1656 (the year of her marriage), and that there are several missing or mutilated leaves in the manuscript, which could shed further light on her relationship with C. B.

35. Cf. Bottrall, *Every Man a Phoenix*, p. 11, and Keith Thomas, "Women and the Civil War Sects," *Past and Present* 13, (April 1958): 42–62.

Index

WOMEN IN THE MIDDLE AGES AND THE RENAISSANCE

was composed in 10½-point Mergenthaler Linotron 202 Bembo and leaded 2½ points by
Coghill Book Typesetting Company, Inc.;
with display type in LeGriffe by Rochester Mono/Headliners,
and in Post Mediaeval Light Italic by Eastern Graphics;
printed sheet-fed offset on 50-pound, acid-free Glatfelter Natural Hi Bulk,
Smyth sewn and bound over 88-point boards in Holliston Roxite C,
also adhesive bound with paper covers by Braun-Brunfield, Inc.;
with dust jackets and paper covers printed in 2 colors by Braun-Brumfield, Inc.;
and published by

SYRACUSE UNIVERSITY PRESS

SYRACUSE, NEW YORK 13210